# Making Believe

# TMI TECHNIQUES of the MOVING IMAGE

Volumes in the Techniques of the Moving Image series explore the relationship between what we see onscreen and the technical achievements undertaken in filmmaking to make this possible. Books explore some defined aspect of cinema—work from a particular era, work in a particular genre, work by a particular filmmaker or team, work from a particular studio, or work on a particular theme—in light of some technique and/or technical achievement, such as cinematography, direction, acting, lighting, costuming, set design, legal arrangements, agenting, scripting, sound design and recording, and sound or picture editing. Historical and social background contextualize the subject of each volume.

Murray Pomerance

Series Editor

Jay Beck, *Designing Sound: Audiovisual Aesthetics in 1970s American Cinema*

Lisa Bode, *Making Believe: Screen Performance and Special Effects in Popular Cinema*

Wheeler Winston Dixon, *Death of the Moguls: The End of Classical Hollywood*

R. Barton Palmer, *Shot on Location: Postwar American Cinema and the Exploration of Real Place*

Murray Pomerance, *The Eyes Have It: Cinema and the Reality Effect*

Colin Williamson, *Hidden in Plain Sight: An Archaeology of Magic and the Cinema*

Joshua Yumibe, *Moving Color: Early Film, Mass Culture, Modernism*

# Making Believe

## Screen Performance and Special Effects in Popular Cinema

LISA BODE

**Rutgers University Press**

New Brunswick, Camden, and Newark, New Jersey, and London

Library of Congress Cataloging-in-Publication Data
Names: Bode, Lisa, 1970–author.
Title: Making believe : screen performance and special effects in popular cinema / Lisa Bode.
Description: New Brunswick : Rutgers University Press, 2017. | Series: Techniques of the moving image
Identifiers: LCCN 2016043412| ISBN 9780813579986 (hardback) | ISBN 9780813579979 (pbk.) |
ISBN 9780813579993 (e-book (epub))
Subjects: LCSH: Cinematography—Special effects. | Digital cinematography. | Human locomotion—
Computer simulation. | Movement (Acting)—Technique. | BISAC: PERFORMING ARTS / Film &
Video / History & Criticism. | TECHNOLOGY & ENGINEERING / Television & Video. | COM-
PUTERS / Digital Media / Video & Animation. | ART / Film & Video.
Classification: LCC TR858 .B63 2017 | DDC 791.4302/4—dc23LC record available at
https://lccn.loc.gov/2016043412

A British Cataloging-in-Publication record for this book is available from the British Library.

∞ The paper used in this publication meets the requirements of the American National Stan-
dard for Information Sciences—Permanence of Paper for Printed Library Materials, ANSI
Z39.48–1992.

www.rutgersuniversitypress.org

Manufactured in the United States of America

To Scot

# Contents

# Making Believe

# Introduction

In the age of virtual reproduction, the star
body has become the test bed of authenticity,
the last stand of the real.
—Manohla Dargis, "Ghost in the Machine,"
*Sight and Sound*, 2000

It wasn't Mix at all. A double was used and the
window was made of candy.
—Johnny Agee, "Tom Mix's Stunts Held
Tricks of Film," *New York Times*, January 25,
1933

From its beginnings, the cinema has been a heterogeneous art, synthesizing different categories of image making, illusionism, and fragments of recorded material realities. It is an arena for our pleasure in fascinating faces and breathtaking bodily feats, but it is also bound up with tensions between trickery and transparency, technologies and flesh, artifice and authenticity. This book is about the history of these tensions and their import for how we understand and respond to performing faces and bodies onscreen, and how we value screen acting as a craft. As I explore, the tensions between acting and trickery in cinema seem to become most visible

and worrisome during periods in which significant technological change prompts a heightened attention to cinematic illusionism.

For instance, in 2007, the journalist Ben Hoyle revealed that digital effects technicians were secretly tweaking elements of screen actors' performances in post-production. He told of invisible puppeteers working to retime or erase an actor's blinks, dial an expression up or down, freeze the tell-tale breathing signs of those playing dead, splice performance moments from different takes into one seemingly continuous shot, and, in the case of Jennifer Connelly in the Oscar-nominated film *Blood Diamond* (2006), trace one silvery tear down her cheek where, when the actress had performed before the camera, that cheek had been dry.[1]

It is by now common knowledge that digital processes are routinely applied in film and television post-production to transfigure raw footage in various ways. A small group of extras can be cloned to produce a boisterous, teaming crowd of thousands. A gargantuan sea monster can menace a familiar metropolis such as New York or Hong Kong. Electricity pylons, cars, and other signs of contemporary life can be erased from a shot of countryside to produce a bucolic eighteenth-century landscape. Color grading and lighting adjustments can change the hue of sweaters, cars, trees, or skies, their shade or luminosity. Actors' bodies and faces are not quarantined from such tinkering, but Hoyle framed the digital manipulation of actors' performances as of a different, more troubling order, and a "dirty little secret." According to an anonymous "leading technician" quoted in Hoyle's article: "Acting is all about honesty, but something like this makes what you see on screen a dishonest moment."[2]

This characterization of acting as "honest" and the application of effects as "dishonest" reminds us that the work of actors and the work of visual and special effects technicians have tended to be seen as separate spheres of labor, engaging with very different frames of value. Special and visual effects are designed both to persuade as illusion and to be appreciated as the spectacular visual manifestation of a complex apparatus of technologies, research, technicians, artisans, time, and money. By contrast, despite the fact that acting, too, is a labor of illusionism (as actors make a living from pretending to be people or beings other than themselves and manifesting the outward signs of emotional states that they may or may not actually feel), actors' performances are perceived as emanating from a material reality: manifestations of actual living, breathing, thinking, feeling bodies. The established ways that we value screen performance (according to

mainstream film reviews and award ceremonies) applaud the appearance of sincerity, truthfulness, naturalism, and authenticity, even as the definitions of these terms shift over time. This can have the effect of making screen acting seem like natural behavior, and the actor's face, body, and voice as identical with those of the character. Indeed, it is for this reason that actors out of character can seem so fascinating or perturbing, as we wonder at the implications of their deception for all our social interactions with others. Are people ever as they seem? Whether we understand actors as engaged in authentic expression or skillful pretense, however, most people would perceive them as responsible for their own performances. Our awareness of digital effects can complicate this perception.

Such concerns, though, have continuity with and parallels in the past. As the film historian Tom Gunning observes, "Recent film technology seems to raise new issues, while . . . pointing out their continuities throughout film history, and even beyond, lingering deep in the technological imagination of history."[3] In the early decades of cinema we find behind-the-screen stories circulating in fan magazines, and photoplay acting advice about such things as makeup to create expression lines, the use of stunt doubles, and a dab of glycerin for producing the glistening "counterfeit teardrop" in close-up.[4] Early film critics and fan magazine writers worried about what those forms of artifice meant for authorship and authenticity (then called "realism") in screen performance. Over time, many once troubling performance-enhancing practices have come to be seen as unremarkable, routine parts of the filmmaking process. Some caprices, such as the use of glycerin, have been bracketed from evaluations of screen acting. Others, such as stunt performers, performance doubles, and transfiguring makeup, have gained a kind of uncomfortable acceptance: beneath notice in the contexts of some screen performances, glaringly bothersome in others.[5]

In the age of digital filmmaking, acting and technological trickery are increasingly tangled up in each other, and the value, meaning, and authority of acting onscreen are once again less certain. This uncertainty has emerged within a wider cultural disquiet about digital images and their ability to trick the eye. As Stephen Prince notes, since the 1990s "much of the writing on the transition from analog to digital imaging has sounded an anxious tone, posing crises of form and function and meaning. By eroding the indexical basis of photography (in its photo-chemical mode), digital images are said to undermine the reality status of cinematic images, rendering viewers doubtful about the credibility of all cinematic images."[6]

Within such a context of doubt, actors and acting are a particular focus of fascination, scrutiny, suspicion, and debate because they are cinema's most recognizably human and "real" element. In addition to concern with the invisible digital manipulation of performance, much attention has been paid to digital face-replacement, compositing, greenscreen, and spectacular digital techniques that blur the line between acting and animation, such as performance capture.[7] These and other visual effect processes augment, replace, or alter the contours of the actor's body and performance, or insinuate that performance into fantastical or perilous interactions and scenery. What kinds of impact are these processes having on the ways actors work? What are their implications for how we respond to an actor's performance, our continuing investment in shifting notions of realism, and for the actor's contribution to meaning and affect? Depending on one's perspective, human performance in the age of digital effects and animation is either suffocated or liberated by technological processes. It is either pushed to the edges of the screen and the industry or occupies the center. It is overvalued in promotion and difficult to evaluate in criticism. According to Pamela Robertson Wojcik, the age of digital effects cinema has triggered a "crisis in the conception of acting."[8]

## Acting in the Age of Digital Trickery

For film critics like Armond White, actors are increasingly squeezed to the margins of the screen by the Hollywood blockbuster's obsession with digital spectacle. In his view, digital effects tend to provide an affectless experience of frantic motion and busy visual fields. Their tell-tale glossy digital patina drains film worlds and characters of their credibility and life, as actors are reduced to delivering lines to tennis balls and greenscreens. As he notes: "This digital grand-standing suffocates what I—and D. W. Griffith and André Bazin and past generations of theorists, critics, and cinematic practitioners—once considered the essence of cinema: nature and the human face."[9] Such claims have sometimes been confirmed by actors themselves: Meryl Streep and Liam Neeson have both complained in interviews that the overly technological regimes of digital effects filmmaking—in particular greenscreen—disorientates and suffocates actors and the acting process, dimming the energy and spark of performer interactions.[10]

However, other actors (including John Malkovich, Andy Serkis, and James Franco) have asserted that techniques like performance capture and compositing actually "liberate" their acting process in different ways. Performance becomes abstracted from the inherent visual qualities of the actor's body and face into ways of moving, gesturing, and speaking. As Prince says, this provides "opportunities for actors to play types of characters and to inhabit situations and environments that were foreclosed to them in the analog era."[11] The specific conditions of performance capture also allow actors to sustain and build a performance flow unpunctuated by endless delays for new camera and lighting set-ups, or alterations to costume, makeup, or set.[12]

Screen performance scholar Cynthia Baron argues that, far from being pushed to the margins, acting has become more central than ever to the twenty-first-century entertainment marketplace. Many actors now work across film, television, animation, and video games, and she points to a proliferation of training schools, vocational guides, and the ways that acting principles and theory have infected other spheres of screen labor beyond the work of acting, such as character animation, CGI, and visual effects.[13] Moreover, articles with titles like "'Avengers' Proves Actors Still Matter" position the actor as cinema's empathy-injecting rescuer, and the still-palpitating heart of all films that resonate with an audience. As the one seemingly material and organic element on the screen, the actor serves as a fleshy linchpin, the key mediator between audience and illusion and, as Manohla Dargis puts it, "the last stand of the real."[14]

Within the discourse of visual effects and the animation industry regarding performance capture, however, actors are sometimes the target of resentment and skepticism. Visual effects artists, animators, and creature designers are losing jobs to outsourcing and, increasingly, protesting for creative recognition and working conditions befitting their contribution.[15] In this context the actor—or to be more precise, the star actor—can be seen as an above-the-line drain on production finance, an overvalued promotional figure taking credit for character expressivity that might be, in actuality, largely animated. Mindful of this possibility, some film critics have complained that layers of digital augmentation take over from the work of acting expression, making acting harder to evaluate when it is so tangled up with the labor of animators.[16]

Indeed, several scholars suspect that the function of actors in digital effects cinema is sometimes more discursive than expressive. Animation

scholars like Mihaela Mihailova argue that the promotion for films like *Avatar* (2009) and *Beowulf* (2007) has actually tended to "misrepresent the motion-capture production process in order to strengthen their digital characters' claim to bearing indexical traces of famous actors."[17] Certainly this seems borne out by the claims of Jerome Chen, the senior VFX supervisor on *Beowulf*, who stressed that sixty animators worked on that film for a year to transform the "flapping puppets" driven by the actors' performance data into digital characters with an adequate aliveness.[18] In trying to understand why the publicity of such films centers on the actors more than the animators, Barry King posits that the maintenance of a link (such as *Avatar*'s incorporation of recognizable elements of its stars' facial structures into its digital alien character designs) to the profilmic star body functions as a counterweight to the technological shift in cinema away from what he calls "corporal sign production."[19] For King, such human reassurance is driven by Hollywood's continuing economic dependence upon stars for attracting production finance and promoting its wares. Similarly, Tanine Allison and Lisa Purse suggest that actors and discourses of acting around films like *King Kong* and *Avatar* are promoted to "make audiences more comfortable" with the technology where technological change in filmmaking and in general is seen as a cause for anxiety.[20]

For Purse and Kristen Whissel, defining the nature of the actor's contribution to a screen body is perhaps less important than understanding what might be new or different in the expressive qualities of the screen body (whether animated or a hybrid of live action and CG animation) in digital effects cinema. For instance, Whissel points to a new "digitally enhanced verticality" that, as it allows the staging of spectacular falls from dizzying heights or the soaring defiance of gravity, "emblematizes" the downfall or aspirations of movie protagonists and antagonists.[21] Purse borrows from phenomenological film theory and focuses on the motion, velocity, and power of digitally animated bodies onscreen in flight or fighting sequences. The pleasures of effects-heavy action and superhero movies, as she points out, are in how they "provide an aspirational, empowering vision of the human body functioning at the extremes of what is physically possible."[22] Whissel and Purse remind us that the screen body and the actor are not synonymous, and suggest in some ways that it might not matter whether or not the body we see onscreen originated in a womb or a computer, as long as it still moves in ways that are comprehensible to our own bodies.

It is not my aim to dismiss any or all of these claims so much as to historicize such uncertainties around the contribution, meaning, and value of screen performance in eras of technological and industrial change and moments of illusionistic pressure. Just in terms of the recent past, we can see that many recent arguments and uncertainties about the contribution or value of acting are haunted by slightly earlier debates about the synthespian or computer-generated actor.

## The Specter of the Synthespian

In the 1990s until the early 2000s, the computer-generated actor or synthespian seemed to haunt the future viability of stars and screen actors. From the early 1980s, computer animators had pursued the realization of a photorealistic aesthetic in digital imaging. Journalists reporting on these developments speculated that if a computer-generated image could mimic live action, then eventually expensive flesh and blood actors could be replaced by cheap, malleable, and obedient digital performers.[23] As of the mid-2010s synthespians have not usurped actors, although, as Jason Sperb observes, they have replaced some of the onscreen human labor of stunt performers and crowd extras in ways that foreground disquieting issues about post-human labor.[24] In 2001, however, the release of *Final Fantasy: The Spirits Within* and the promotion of its computer-generated star Aki Ross brought such speculation to a head. Waves of debate were generated around the extent to which the textural details of Ross's freckled skin and swishy hair could fool viewers into believing she was human (or, conversely, how the uncanny automaton-like qualities of her glassy-eyed stare gave away her nonhuman status), as well as about the future possibilities of the synthespian in popular entertainment. She was presented in the science and technology press as a benchmark in the evolution of computer-generated human simulation—one that only needed finer and finer attention to synthesizing facial micro-expressions in order to reach the "Holy Grail" of a totally convincing artificial human.[25] Ross was also given a rudimentary extratextual star persona. She was promoted in a "photo shoot" in the men's magazine *Maxim* as a nubile starlet wearing an alarmingly high-cut black bikini, and "interviewed" for newspapers about her likes and dislikes. But Ross was critiqued in reviews for her blank, affectless

"performance" in the film and, despite the attention she received across different media venues, the film itself was a box office failure.

It did, however, spark ruminations about what, if anything, was so special about stars and actors that filmmakers and audiences would want to hold onto. After all, according to Lev Manovich's highly influential argument, animation (as a once peripheral and particular case of cinema) has become the dominant cinematic form in the age of digital imaging. In this argument, motion rather than photography has been revealed as the unifying essence of all cinema, and live action (a term that only came into being in the age of digital animation, just as the coming of sound gave definition to "silent cinema") is now merely a particular subset of cinema-as-animation.[26] By this logic, if cinema is essentially animation, why should it matter whether the characters onscreen originate in an actor's body or in the imagination of a computer animator or AI? Indeed, as Sidney Eve Matrix noted, Andrew Niccol's rather didactic 2002 film S1MoNE (in which a director played by Al Pacino replaces his demanding and unreliable star with a virtual actress) suggested that audiences would soon not be able to tell the difference. Matrix pondered briefly on whether or not audiences might have had their tastes and imaginations restructured by cyberculture, digital effects, Photoshop, video games, and plastic surgery to the point of being untroubled by virtual stars, and "OK with fake."[27]

Barbara Creed, however, considered the implications of what she called the "cyberstar" for audience identification. She argued that our identification with human figures onscreen is predicated on the knowledge of what we share with them as fellow human beings through our embodied experience: birth, desire, loss, and the knowledge that we will one day die.[28] We might argue via animation studies or literary studies (or even the audience for any Pixar film) that it is completely possible to find points of identification and empathy with fictional characters whose bodies are not rooted in a life beyond the fiction. After all, how many gallons of tears have been shed for Woody from *Toy Story* (1995), and Ellie and Carl from *Up* (2009)? It is still fair to say, however, that our knowledge of the human actor's lived existence beyond the screen supplies other affective layers that can deepen and enrich or rub against our understanding of and feelings for the fictional character they play onscreen. Moreover, it is not just that we read what we know of the actor's persona or her appearance from other roles into the character we see onscreen, but a real face onscreen, unlike the face of an animated character, also belongs to a real thinking person. This brings an

added complexity to one of the fundamental activities of viewing people onscreen in narrative cinema—what Carl Plantinga and the cognitivists call "mind-reading."[29]

Matrix and Creed focused on the synthespian as synthetic human or as cyberstar. Within the commercial Anglophone film industry, however, the specter of the synthespian has led to a progressively deeper consideration and more detailed articulation of what a computer cannot simulate, and therefore what is unique about what actors do. Earlier journalistic writing on synthespians in the 1980s, 1990s, and early 2000s tended to hypothesize along two divergent lines. Either actors could be replaced by artificially intelligent synthespians because they were just costly, unreliable prima donnas of dubious talent, or, conversely, actors could never be replicated by a machine because of some vague unquantifiable human "magic" that would always elude technology. For entertainment journalists at this time, actors' contribution to cinematic meaning and affect seemed uncertain and ill defined: either technologically enhanced illusion or wafty humanistic, spiritual mystery.

By 2011, however, bolder, more detailed, and persuasive claims were being made about the specific qualities of acting as an art form that could only emanate from thinking, feeling bodies, and not disembodied AI. For instance, David S. Cohen in *Variety* wrote, "People imagine the future of movies as something like the holodeck in 'Star Trek.' Want Marilyn Monroe in your scene? Tell the computer, 'Add Marilyn' and voila! You're directing Marilyn Monroe." But, he argued, "computers can't yet, and won't soon, reverse-engineer the thinking that led to an artist's choices. . . . What's more, a performance isn't just the actor's conscious choices. It's how the body reacts unconsciously."[30] The kind of language Cohen employs here about "choices" and the unconscious "reactions" of the body did not spring from the ether. These terms run through contemporary North American acting theory, training schools, and vocational guides, and in the past decade they have started to filter into actor interviews and journalism on acting in the digital age, in turn sharpening popular definitions and understandings of what actors do.[31] This is partly because, as Danae Clark demonstrates in *Negotiating Hollywood*, actors are laborers and social agents with a stake in the discourses of stardom, or the perpetuation of what Kevin Esch calls "acting mythologies" that serve to bolster their connection to an audience and their artistic standing as craftspeople within a system of mechanical reproduction.[32]

The technological threat (virtually) embodied by the synthespian served as a catalyst for actors, theorists, and critics to clarify the specificity and value of acting. Boundaries were drawn around acting as a human, embodied, conscious endeavor defined in opposition to the technological virtuality of the synthespian. These reconceptualizations of acting drew from a well of established acting theory, and as theater historian Joseph R. Roach has so elegantly explained, these discourses have themselves been repeatedly shaped by evolutions in the dominant explanations of what it is to be human, to be alive, and to be a social creature.[33]

## Acting at the Intersection of Art, Technology, and Culture

The synthespian is not the concern of this book, however. For the moment, that particular discussion has subsided. Rather, I am concerned here with the various intersections and hybrids of screen performance and cinematic illusion that incorporate the actor's performing body, working on or with it in different ways. Cynthia Baron, Diane Carson, and Frank P. Tomasulo tell us that film acting is "best understood as a form of mediated performance that lies at the intersection of art, technology, and culture."[34] This intersection, I argue, is complex, slippery, uncertain, and unstable. As this intersection moves with technological, cultural, and aesthetic shifts, so too there are modulations in our conceptions of screen performance and its value. My central point is that acting values such as expressivity, mimesis, versatility, proteanism, presence, embodiment, and authenticity have been rearticulated and accrued different kinds of meaning within the historical tensions, debates, uncertainties, and shifting boundaries of technological artifice in filmmaking.

A "discourse on film acting" first emerged in the period after 1907 in North America when, as Richard deCordova argues, the performer on film became recognized as playing an enunciative role in the screen fiction.[35] This discourse has continued to evolve. It shifts, embellishes, and sprouts different strands in different contexts of technological and illusionistic pressure such as the ones that we are seeing now. In tracing these strands through a range of materials such as North American film reviews and editorials, actor and crew interviews, trade and fan magazine commentary, actor training manuals, and film production publicity materials, we gain a greater understanding of screen acting discourses. We can more clearly see

the conditions through which they emerge, and how they connect with, reenergize, or revise ones from the past.

For instance, during the period of studio, star system, and narrative filmmaking consolidation in the 1910s, there was an intense industrial and filmgoing interest in both the differences between acting for the legitimate stage and acting for the camera, as well as the use of trick effects to fragment, multiply, or substitute doubles for performing star bodies. Some of this attention to acting, credibility, authenticity, stars, and their value rose again in the early sound period of the late 1920s, with dubbing and voice recording, as well as in response to developments in special effects makeup in the 1920s and early 1930s. Within such periods, actors and other performers, along with visual and special effects crew, camera personnel, and makeup artists have often engaged in struggles with each other, the industry, and critics to proclaim their contribution, and to define the aesthetic value of their work in an industrial system of technological reproduction.

I consider actors, then, to be more than just fleshy, material ballast used to anchor the immateriality of the technologically produced image, and more than profilmic celebrities renting out the publicity value of their likenesses and personas. They are creative laborers and self-interested agents helping shape conversations about how we should understand and continue to value acting in the context of significant technological change in filmmaking. Moreover, the behind-the-scenes talk about what actors do in preparing for roles, or the challenges actors face when working in new technological environments, tends to cue audience and critics to understand or evaluate what they see onscreen in particular ways. For as Richard Dyer suggests, it may be that how particular performances are received "depends importantly on what we know of how they are produced. That is, there may be in some instances little formal difference between given performance traditions, yet the theory of performance that informs them may be sufficiently widely known for this to inform in turn how they are read."[36]

At the same time, in considering actors as creative laborers, I take some leads from Jacob Smith, who calls for a "performer-orientated" approach to film history and cinematic spectacle that is attentive to "the permeable boundaries that existed between film technology and bodily technique."[37] This suggests to me that we need to examine what is actually achieved when performance, technology, special and visual effects, and animation work together both on and behind the screen. Take Robert Patrick as the liquid metal T-1000 in *Terminator 2: Judgment Day*

(1991). The terror of this technological creature is often linked to its digital plasticity: it can transcend form, mimic, and replicate the inanimate and the animate, slither and melt through iron bars, heal around wounds and seamlessly clone human voices and appearances. Plasticity is the key physical characteristic of the T-1000's body; however, it does not in itself constitute the lasting impression we have of the T-1000 as a character. Think of his agile single-focused stride, and the way he runs with stiff, bent arms, his limbs chopping through the air like helicopter blades. As the T-1000's human form, the actor holds his head perpetually forward, scanning the environment with the chill of unblinking eyes. This way of moving, this posture, and this attitude communicate the character's hyper-vigilance and its incomprehensible computational power. Even Patrick's odd pointy ears as they turn out from his head at right angles seem like little sonar devices extending the machine's reach into its environment. Clearly, what actors do on either side of a sequence in which their body is replaced by a digital effect matters to the impression their character leave upon us. So too, what they do in performance-capture roles, in greenscreen environments, behind prosthetics, and in performing with doubles—these things all matter to the processes of meaning and making believe.

Industry journals such as *Cinefex* and wonderful books by special effects historians and industry experts like Richard Rickitt provide us with invaluable insights into the technical aspects of screen illusionism.[38] Centering the discussion on acting in these arenas, however, provides us with a different perspective on historical fluctuations in how cinema's illusions have addressed the viewer. Besides attending to performance details in understanding the actor's place in these fluctuations, we also need to attend to the strategies used both on- and offscreen to make the presence, labor, and value of the actor's performance visible and audible, when it may be obscured by transfiguring makeup or computer-generated imagery, or produced during highly regimented circumstances. Examining these things, and tracing the extent to which they remain constant or shift over time, helps us not only to understand better what matters to us about actors and acting. It also provides a unique perspective on broader historical patterns in cinematic illusionism and realism.

## Organization

In the interests of providing the reader with an orientation, here is a sketch of the book's six chapters. Each takes a thematic rather than solely chronological approach. Chapter 1, "Acting through Machines," situates performance capture systems such as those developed for *Avatar* and *A Christmas Carol* (2009) within a longer history of technological systems that record and reproduce actors' performances. It surveys the problems and possibilities of performance-capture systems in terms of their "fidelity" or what they can or cannot register of the actor's performance, the technology's blind spots, its idiosyncrasies of attention, and the way actors are calibrating their performances for the requirements of the technology. These are compared to the issues and solutions that have arisen in earlier working-out periods of recording acting: the camera and lighting configurations of the 1910s, and the emergence of synchronized sound in the late 1920s and early 1930s. This chapter asks: What impact has technological change in recording performance had on actor training? How have actors in each case had to modify their performance techniques to both register on the machine and eliminate distracting extraneous detail or noise from their performances? What are the wider consequences of the ways these technologies have redrawn attention to aspects of the face, voice, gesture, and micro-expressions, and for the ways that human emotion expression and social communication are understood? I take what Jacob Smith calls a "soft technological determinist line" here. Smith recognizes that recording technologies produce not just problems but horizons of possibility for cultural expression, and these are seen as such and ignored, or taken up, depending on reigning cultural and aesthetic values and institutional requirements.[39]

The second chapter, "Behind Rubber and Pixels," follows a strand of performance that has been traditionally neglected in acting scholarship, where actors perform behind prosthetic makeup, often so transfigured as to be unrecognizable to their audiences. Prosthetic makeup has been used as an analogy for performance capture by actors like Andy Serkis and Sigourney Weaver as well as directors like James Cameron, as they seek to bestow aesthetic (and labor) legitimacy on performance capture. In attempts to make the actor's contribution visible and sustain acting hierarchies within a regime where stars are invisible onscreen, Serkis's work in performance capture has been compared to great prosthetically obscured performances of the past, such as those of Lon Chaney Sr., and of John Hurt in *The Elephant*

*Man* (1980). This chapter traces the emergence and applicability of the prosthetic makeup analogy to performance capture. At the same time it explores the ways that makeup effects and practical prosthetics have had, in themselves, a vexed relationship to screen performance's value, notions of character authorship, and historically contingent views of cinema realism. Through this we come to understand something of the changing status of makeup effects in relation to screen acting, in a North American cinema that has operated within, and contributed to, shifting ideas about realism and character interiority.

Chapter 3, "In Another's Skin," tests utopian claims that have been made about performance capture and other means of transforming the contours of the actor's body and face: that these herald the end of typecasting. It has been argued that because the actor's size, shape, and color are rendered irrelevant for casting, so too are all the markers of their social identity such as gender, age, and race. These claims raise questions such as the following: To what extent and in what sorts of ways do both makeup and the digital reshaping of actors' bodies threaten to restrict, or promise to expand, the labor market for actors? To what extent is typecasting attenuated or reshaped by actual digital performance practices and why? In order to answer these questions, I trace some of the historical complexities around how typecasting has functioned in the cinema and for actors, and elucidate some of the past and present inequalities in the screen performer's labor market, namely, the extent to which such things as the shape or color of actors' bodies has enabled or obstructed their proteanism and their mobility across different kinds of roles.

Chapter 4, "Double Trouble," moves away from performance capture to a consideration of a form of illusionism that tries to conceal itself: the realistic composite performing body. This chapter launches from the controversy over the use of digital face replacement in *Black Swan* (2010) and the misleading promotion about the extent of Natalie Portman's dancing in the film, and asks: Does digital face replacement differ from earlier kinds of screen performances that relied on concealed performance labor, such as that of stunt, voice, and body doubles? In the 1910s and 1920s, publicity about stunt and body doubles triggered discussions about the ethics of trickery in performance and the acceptable limits of substitution. These reemerged again with the first sound films when it was revealed that the advertising claims that film stars like Richard Barthelmess were singing their own songs were false. The responses of surprise, outrage, and

disappointment that have tended to accompany such revelations point to the continuing investment in an authentic performing star body. This investment is evolving, and I examine the historical complexities that have led to the acceptance and, indeed, celebration of particular kinds of performance substitution, including stunt doubles, and how, through these complexities, the boundaries around the actor's responsibilities and value have sharpened in different ways.

Chapter 5, "Performing with Themselves," turns to films in which the actor's presence on film has been multiplied, and when actors have performed against "themselves" in dual or multiple roles. In the 1910s and early 1920s, there was a substantial and long-forgotten cycle of films that used double or multiple exposures to allow one actor to play two or more parts onscreen simultaneously. These films featured spectacular sequences of illusory interaction between actors and their own image(s). Well over one hundred such films were made and, although most are lost, the discursive material surrounding such films suggests they were used as a vehicle to demonstrate characterization versatility against common charges that actors onscreen were just personalities playing themselves. These films foregrounded illusory performance as pleasurable spectacle, but also promoted values that have since become more marginalized in popular discourses around screen acting such as split-second timing, rigorous concentration, and strict discipline of movement. The reasons why such films became much less common are complex. Later films, such as the 1940s twin melodramas *A Stolen Life* (1939; 1946) and *The Dark Mirror* (1946), as well as *Dead Ringers* (1988) and *Multiplicity* (1996), have had a very different kind of critical reception from the films of the 1910s–1920s cycle. The reception reveals evolutions in dominant acting discourses and conceptions of cinematic realism since the 1910s. There are signs of a further intensification of these conceptions in more recent films of the digital age such as *The Social Network* (2010) and *Harry Potter and the Deathly Hallows Part I* (2010).

Chapter 6, "There Is No There There," extends on some of these issues such as the anxiety about acting to "nothing" when actors perform in greenscreen environments. Focusing on the values of persuasiveness and believability, the chapter analyzes the criticisms leveled at George Lucas's digital effects–heavy *Star Wars* prequel trilogy (1999, 2002, 2005), comparing them to the mid-2010s publicity around J. J. Abrams *Star Wars: The Force Awakens* (2015) as embracing "real sets" so as to "feel real." However, since the beginning of cinema, actors have performed lines and actions to

"thin air" or an abstracted eyeline reference point, with other characters and scenery added subsequently through editing, double exposure, mattes, or rear projection. Why, then, is acting in greenscreen environments perceived as somehow more disorientating for the actor, and "feeling unreal" for the audience? Tracing a history of such filmmaking practices and their publicity, we see a growing conviction since the 1960s about actors as conduits for audience belief and emotional investment in cinema's fantastic worlds. In this view, the actor's success as a conduit relies on them engaging physically with material objects and having genuine dynamic interactions with other cast members. I seek explanations for this gradual shift and how it informs many digital greenscreen film productions today. The factors I consider include the valorization of location filming, the rise of more immersive and tactile approaches to creating film worlds, and a parallel with forms of Method acting and post Method-actor training underpinned by conceptions of behavior and identity as shaped by processes of environmental feedback. These emphasize interaction and interrelational dynamics as important on set to elicit more "truthful" behavior from actors.

Finally, an acknowledgment about this book's limits. This book is about acting practice, reception, commentary, publicity, and context and the evolving discourse on film acting in the Anglophone popular cinema context through the silent, sound, and current digital eras. There are a couple of reasons why the focus is tightened in this way. One is simply manageability. The book would never be completed if I were attempting to trace its subject not just over a century of filmmaking but across different filmmaking cultures or through the shifting complexities of serial television. Another reason is language, as the book relies in part on the examination of discourses in film reviews, actor interviews, industry commentary, and such. It may be, too, that there is an industrial and cultural specificity to many of the discourses about acting and technological trickery that run through early North American cinema, the Hollywood Studio system, and what we might call Hollywood International cinema. The conclusion to this book elaborates a little on this point, with a brief consideration of recent discussions about digital effects and screen performance in Bollywood and Chinese blockbuster cinema.

For the most part, too, this book attends to illusionism and its persuasiveness in the service of a film role, rather than illusionism in the service of star glamour. Despite the emergence of Photoshop, digital youthening,

and slimming by effects houses such as Lola FX, and their continuity with soft-focus, nose jobs, girdles, and other pre-digital tricks and caprices, there is not sufficient space here to examine the implications of technological change for the maintenance of star youth and beauty. I am concerned with transformations that are presented as temporary and/or attached to acting as a craft—although the line between stardom and acting value is, as I readily acknowledge, often blurred.

Those looking for detailed technical explanations of changes to filmmaking processes will be well served by the many technical books on the subject or issues of *Cinefex*. For useful scholarly explanations and perspectives on the broader aesthetic and ontological implications of digital post-production and effects-driven filmmaking, I recommend the fine work of Stephen Prince, John Belton, Sean Cubitt, Scott Bukatman, Vivian Sobchack, Julie A. Turnock, Aylish Wood, Dan North, Bob Rehak, Leon Gurevitch, Lisa Purse, and Kristen Whissel, among many others.

If you are interested, though, in how the image of acting in cinema has evolved and continues to evolve through intersections between acting philosophies, technological change, illusionistic practices, and discourses of realism, then I hope this book will provide some fresh and useful perspectives.

# 1

## Acting through Machines

Fidelity and Expression from
Cameras to Mo-Cap

What vocalized films will do to the stars . . . has
become an agitating question. And what new
type of screen actor they will develop is another
question dancing on its heels.
—James O. Spearing, "Now the Movies Go
Back to Their School Days," *New York Times*,
August 19, 1928

Soon after the release of James Cameron's *Avatar* (2009), Mark Harris
tackled the troublesome question of whether or not the lanky, cerulean
aliens played in that film by Zoe Saldana, Sam Worthington, Sigourney
Weaver, and company could be considered manifestations of "acting." His
question tied to a broader industrial and cultural uncertainty about per-
formance capture's status—an uncertainty most visible in the way it has
been classified by various screen awards organizations. For example, for the
role of Gollum in *Lord of the Rings: The Two Towers*, Andy Serkis won the
Critics Choice Award for Best Digital Acting Performance (2003), but was

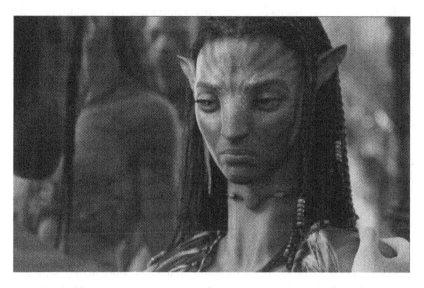

FIG. 1  Zoe Saldana as Neytiri in *Avatar*: performance or "superb visual effect"? (Blu-ray capture)

nominated as simply Best Supporting Actor for the Chicago Film Critics Association Awards. He won Best Voice-Over Performance in the Online Film and Television Association Awards, but the Visual Effects Society gave a collaborative award: Best Performance by an Actor in an Effects Film (2003) *and* Outstanding Character Animation in a Live Action Motion Picture (2004). These awards were all for the same role. In part Harris was attempting to settle such uncertainty, but he was also responding to Cameron's famous claim that the performance-capture technologies developed for *Avatar* "get 100 percent of what the actor does. Not 98, not 95, but 100 percent. . . . Every nuance [of] their creation on the set is preserved."[1] Rejecting Cameron's statement, Harris argued, "The fact is, a computer can't pick up every nuance of an actor's work, because great performances have nuances that are ineffable and unquantifiable, not to mention vulnerable to eradication with one thoughtless flick of a digital paintbrush. 100 percent? Not even close."[2] Turning to the most impressive character in *Avatar*, Neytiri, played by Saldana, he concluded: "Neytiri is a superb visual effect enhanced by an actor, not a performance enhanced by F/X."[3]

There are several points here that this chapter takes up, including problems around the status of performance capture, Cameron's hyperbolic "100 percent" claims about the technology, Harris's somewhat fixed conception of what constitutes technologically mediated acting and what does not, and his view of how "great performances" are produced and evaluated. My approach to these matters here is to think about performance capture as a suite of technologies in flux, and to argue that while the practice and conception of acting for performance capture has some key differences from conventional movie acting, it is worth asking what kinds of parallels and resonances performance capture might have with early film acting and acting for early sound films. For the developmental trajectory of performance capture repeats many of the same moves of earlier emergent forms of recording and reproduction technologies in their initial "working out" periods.

Moreover, it is worth remembering that early film acting was also befogged with ambivalence concerning its status. In the early decades of cinema, according to Richard deCordova, "Acting was a profession associated with the legitimate stage, and the contention that people acted in films was neither immediately apparent nor altogether unproblematic."[4] As he observes, it was only around 1907 that the term "acting," rather than just "posing," with its more passive connotations, came into use for what people did onscreen. The shift in terminology was not without resistance: in 1913, the American stage actor David Warfield claimed that "acting is acting and moving images are only photography. Real art will not be replaced by anything artificial."[5] In this view, what people did for the camera was something passive and highly mediated, more akin to modeling for a photographer, and lacking the vital ingredient for acting: the voice. We might hear Warfield's sentiments echoing in Mark Harris's words about "great performances 'captured' the old-fashioned way" as both have a static conception of what acting can be, and a sense that the actor's work can only be diminished in a new medium that, in one case, robs them of speech, and, in the other, discards their face. Before trundling too much further down this historical path in search of insights into the present, however, it is helpful to consider what performance capture actually entails, and why its status as acting is muddy.

## Is It Acting?

The main issue for the classification and value of performances created through performance capture is the extent of mediation involved—that is, the number of steps or processes involved between what actors do on set and how their performances appear onscreen. Most people are now familiar with behind-the-scenes footage of actors in motion capture get-up. We see grainy video of them with dots on their faces, wearing tight-fitting and inelegant unitards covered in motion sensor markers, head-mounted cameras sprouting in front of their faces, making them look like hi-tech angler fish. Sensors (often optical, but some work using radio transmitters) track and store the moment-by-moment spatial coordinates of these markers on an actor's body and facial structure as information that can be translated to a 3D digital character rig (essentially a virtual puppet), driving its movements, gestures, expressions. The performance of a character's face may be further finessed in a few different ways.

For instance, the MOVA system, which was used in *The Curious Case of Benjamin Button* (2008), records facial performance separately. It treats actors' faces as topographic maps, and it records their facial expressions as distortions in this topography. Their faces painted with a phosphorescent powder, actors sit perfectly still in a booth, surrounded by tiny cameras, each of which record a portion of the face as it produces the appropriate expression. The performance data is targeted to corresponding points on a digital character face.[6] *Avatar* used a system that tracks the dots on the actors' faces, and auto-matches their facial performance information to the appropriate expressions located in a FACS (Facial Action Coding System) library of up to ninety-seven of their facial expressions. To produce this library actors sit before a scanner for many hours, making facial expressions and isolating micro-muscle groups around their eyes, mouths, and forehead, winking, scrunching their noses, curling their lips, clenching their jaws.[7] What is more, the expressions and micro-expressions actors produce for this FACS library accord with those defined by Paul Ekman and his team of researchers. Ekman, a key figure in contemporary understandings of facial expression, the extent of its universality, and its relations to emotion and cognition, developed this system through the analysis of thousands of hours of faces on film and video.[8]

At the current (as of writing) state of development, the performance is still further fine-tuned by animators working closely to match the

character's expressions to those produced by the actors on set and captured by these tiny head-mounted cameras. According to Cameron and others, though, the aim is to eventually eliminate the animator's role in the process, by developing a system that can automatically target performance in real time to a fully rendered character. With all these steps between performance and its manifestation onscreen, performance capture has little of the perceived direct transcription we associate with the camera. Fittingly, animators and scholars such as Maureen Furniss and Mark J. P. Wolf have in different ways situated motion capture as a new version of rotoscoping for, like rotoscoping, it functions onscreen to lend a disquieting lifelike quality to the movement of animated characters. As Kristin Thompson points out too, the further problem is that the characters being played often bear little resemblance to the actor. In the case of Saldana and Neytiri in *Avatar*, the eyes of the character are so much larger than those of the actor. Neytiri, unlike Saldana, also has expressive animated feline ears and a long flicking tail, which serve to communicate things like wariness, annoyance, and feistiness in an animalistic way. This creates problems for attribution, as seen in both Harris's remarks and the film industry uncertainties of how to classify these performances.[9] The common industry strategy for deflecting such questions is to frame performance capture as akin to acting behind transfiguring digital prosthetic makeup, and this is a claim I explore in more detail in the next chapter.

Despite all the layers and steps between what actors do and how their work appears onscreen, however, Colin Firth, John Malkovich, Andy Serkis, and others assert that acting for performance capture is just like any other form of acting because it requires similar forms of preparation. As with any other role in popular film or theater, actors must analyze characters in a screenplay to work out their drives and moment by moment objectives, and work out how these drives and objectives should manifest themselves in voice, bearing, and movement. It is partly on such grounds that, since at least 1999, the Screen Actors Guild (SAG) has pushed to substitute the label "performance capture" for "motion capture." "Motion capture," as *Screen Actor* pointed out, could refer to the captured motion of animals, machines, or inanimate objects, such as a ball rolling down some stairs. However, "whenever actors are involved," the magazine instructed, "this field of activity should be referred to as 'performance capture.' . . . The goal is to create complete awareness of the human performance aspects of this fast-growing digital technology."[10] At stake in how this work is defined

are not just the salaries of actors working in the medium (including supporting actors, background players, and extras), but also ancillaries such as health and pension coverage.[11] Thus Cameron's assertion that performance-capture technologies "get 100 percent of what the actor does" not only serves to promote the technology's spectacular transparency, but also positions performance capture as a form of acting. Other directors, such as Robert Zemeckis and Rupert Wyatt, have similarly established themselves as allies of actors working in performance capture.

## Fidelity and Perceiving Anew

Cameron's "100 percent" statement is hype, however, and a kind of hype that has a long history in the excitement surrounding new recording and reproduction technologies. From the earliest phonographs and cameras, through stereos, TV sets, and more recent hi-definition digital video and Blu-ray, each technology has been trumpeted for its uncanny ability to faithfully reproduce the full perceptual reality of what it records or reproduces. For instance, in the late 1920s, newspapers reprinting publicity lines from the trade press declared *The Jazz Singer* "a triumph of science" and that the "delicate mechanism ensures that vocal sounds—both speaking and singing—and instrumental music are reproduced with astonishing fidelity."[12] Cameron's claims thus are not just hyperbole, but also disingenuously premature: he is a director who consistently positions his work at the technological bleeding edge. As Jonathan Sterne has pointed out, recording and reproduction technologies are always in a state of progressive development toward an imagined perfect fidelity, bringing ever finer and finer granularity of vision and sound to our attention. Marxist views of film history have tended to explain technological progress in terms of a gradual effacement of the medium, concealing or diminishing technological noise in its own operation, so it appears "natural."[13] However, as James Lastra argues in his detailed and incisive account of Hollywood's transition to sound, concepts like naturalness, fidelity, and realism, and perceptions of their manifestation, are slippery and an unfixed horizon.[14] What is more, recording and reproduction technologies do not simply reduce their own "noise" as they foreground pure "signal": they change the very nature of that signal.[15] According to cinema sound theorist Michel Chion, the advent of Dolby sound has made a significant difference to our experience

of the voice on the sound track: "Dolby helps to give a direct, close, and palpably physical presence to the voice, entirely changing the way we perceive it. More generally, it focuses finer attention on vocal texture, subtle variations of timbre, vibrations of vocal cords, resonances."[16]

Similarly, advancing HD and, more recently, High Frame Rate (HFR) shooting formats bring ever minute details of the human face to our attention: the rapid pulsations of pupils in an actor's eyes responding to infinitesimal shifts in light and processes deep in their bodies; sweat beading on a brow; and pores and fine down catching the light on a cheek.[17] So, although sound and image technologies of the cinema are usually developed along trajectories of perceptual fidelity, they are also championed for how they allow us to perceive the world anew. Similar claims are recycled again and again. As the *Dallas Morning News* wrote in 1913, "The eye of the camera is superhuman, and the big eye sees and registers what the human eye would not notice."[18]

Over the past decade, motion-capture technologies and techniques have been driven and received along not dissimilar developmental trajectories. While CGI, as Stephen Prince notes, moves ever closer to goals of perceptual realism, motion capture is conceived as reconfiguring our perception of the actor's presence. Critic David Kehr noted this reconfiguration in 2004 when, impressed by a demonstration of performance capture behind the scenes for *The Polar Express* (2004), he was enthusiastic seeing Tom Hanks anew in the actor's performance data. Even though the actor appeared to him as mere "points of light floating in a dark three-dimensional space," Kehr extoled, "the connect-the-dots figure moving on the computer monitor was recognizably Mr. Hanks. It walked like him, gestured like him, and most importantly, crinkled and smiled and frowned like him." Kehr remarked that, in the final film, it was "almost as if his DNA had been digitized along with the landscapes."[19] The configuration of moving dots are seen by Kehr to convey the distinctive *essence*, or "DNA" in his words—the Tom Hanksness of Tom Hanks—even as the surfaces of Hanks's body and face are nowhere to be seen onscreen. Performance capture then has been conceived as entirely new in terms of how it manifests the presence of actors, and redefines their "essence" as being not in their surface details but in their distinctive way of moving. It draws new attention to gait, gesture, and expression.

Each new film produced using motion capture is touted as capturing more performance data and achieving finer detail and nuance in character

performance than previous uses of the technique. It might be that by 2030 the level of performance data that can be reproduced will make the Na'avi in *Avatar* seem like blue animatronic semi-feline mannequins by comparison. Harris is right, then, to question Cameron's "100 percent" claim. Recording or reproduction technologies can never reach an end point of perfect fidelity, because this is an impossible chimera. They must always evolve, and each new evolution must claim to reveal ever more granular detail in what can be recorded and reproduced. At the same time, Harris's claim that "great screen performances 'captured' the old-fashioned way" have "ineffable and unquantifiable" qualities indicates a faith in the relationship between acting and the camera as well as a static conception of acting and acting value, both of which require some probing.

## Mediated Acting and Acting for Machines

At the risk of stating the obvious, great screen performances are not simply performances that have been recorded. For one thing, they are more usually moments of acting recorded in fragments, sometimes months apart if the actor has to be brought back for reshoots. The actor's voice may be recorded separately in Automatic Dialogue Replacement (ADR), and their line readings sliced and diced, massaged and mixed into the sound track as one sonic element among many. In the age of digital post-production, even if the film has been shot on celluloid, the negative is routinely scanned to produce digital files that enable the integration of digital effects but also more subtle tweaks of an actor's expressions and timing, and the cosmetic adjustments of complexion color and texture or the hue of an iris in the digital intermediate (DI) process.[20] We are rarely aware of the laborious manipulation and layers of technology involved unless the actor's body and face are obviously ornamented with spectacular digital effects, or their voice is audibly made strange: dubbed for comedic or linguistic purposes and resulting in a mismatch between voice and face, or sound waves processed or pitch-shifted to create the alien, robotic, or demonic voices of science fiction, fantasy, and horror films.

For another thing, actors always perform to meet the conditions under which they will be seen or heard. As James Naremore puts it: "Movie actors . . . learn to control and modulate behavior to fit a variety of situations, suiting their actions to a medium that might view them at any

distance, height, or angle and that sometimes changes the vantage point within a single shot."[21] Clearly, what actors do in a large auditorium of 1,000 people will be different from what they do in an intimate theater, and different again for a camera close-up. This difference is commonly understood as a scaling down or paring back for the smaller space and the closer view of the camera. Michael Chekhov, the Russian American actor-director whose teachings and techniques have influenced American actors for several decades, instructs actors that, before the lens, they must still feel whatever they are feeling as intensely as they might onstage, but attempt to draw a "veil" over their expression.[22] As we shall see, performance capture requires actors to think about what they do in quite a different way as they have to consciously externalize their characters' thoughts and feelings. But so, too, acting for the camera was not always about veiling or scaling back—indeed, as screen acting theorists from Naremore to Sharon Marie Carnicke and Cynthia Baron have acknowledged, the extent to which actors onscreen scale up or down depends on genre and the kind of character they are playing. There are, however, at different times, dominant conceptions of the most appropriate way to act for the technological conditions of filming.

This brings me to the question that drives the remainder of this chapter: in what kinds of ways is the practice and conception of acting for performance capture in the 2000s to the mid-2010s similar to or different from acting for the camera in the transitional era of roughly 1907–1918, and acting for the talkies in the period where the Hollywood studios made the transition to sound, 1926–1931?[23] A key factor I examine across these periods is the shifting interrelationship between the actor's presence and the machine's noise. First, though, we must consider how the broader context of acting practice, philosophies of acting, and cultural beliefs about personhood inflect and shape the development and use of the machine, and cultivate value around screen performance.

## Performance Practice and the Machine

Although machines may reconfigure performer presence, they don't technologically determine the forms or values around performance, as these are cultural. As Jacob Smith argues, technologies such as microphones and cameras open up a variety of expressive possibilities by foregrounding or refocusing on aspects of what they record, but only some of these

opportunities are taken up, or extended, or shaped. The ones that are taken up can be seen to resonate with broader cultural-historical preoccupations with, say, "realism," "intimacy," or "authenticity."[24] More than this, when performers move into a new medium, they bring with them their preconceptions, their established ways of working and thinking about acting. For instance, with regard to early screen performance in the 1900s and 1910s, invaluable research from Lea Jacobs and Ben Brewster has shown the influence of stage pictorialism on the arrangement of actors in tableaux, and an acting style deploying poses and gestures to both produce pictorial effects and convey narrative information.[25] Roberta Pearson's fine-grained analysis of acting styles in the films D. W. Griffith made for Biograph between 1908 and 1913 has illuminated a shift from "histrionic codes" to "verisimilar codes" of acting, both of which stemmed from theatrical influences.[26] Janet Staiger has argued that as directors and actors were enticed from the legitimate stage to the lucrative and more stable work of the screen, they brought with them the ideological values and practices of "good acting," and David Mayer has rightly urged us to recognize the multiplicity of screen performance styles in the 1910s that were the result of performers' varying backgrounds in the circus, dance, burlesque, vaudeville, and legitimate stage.[27]

So too we can see that the development of the performance-capture apparatus has been informed by acting practices and values established in theater and film. Here cameras form part of the process. Tiny ones are mounted on the actors' heads to record detailed facial data, but camera operators also work on set to "dance" with the actors, as Jim Carrey puts it. They construct the scale and angle of the shot and give the actor a frame of reference for the visibility of their face and gestures. But it did not work this way at first. Zemeckis made *The Polar Express* (2004) and *Beowulf* (2007) and began making *A Christmas Carol* (2009) within a camera-less "volume." The volume—a controlled and confined performance environment similar to a soundstage and designed to eliminate extraneous motion "noise" so as to capture only performance data—uses sensors on the walls that continually capture actors' movements in 360 degrees, feeding the raw motion data to a computer. Zemeckis had reasoned that using a volume of just sensors, without cameras, would allow him the freedom to construct all the angles and scales of his shots in post-production. For some actors this way of working without shot set-ups was perceived as liberating: no marks to hit, no blocking, no waiting around for new lighting and camera

set-ups. A scene could be performed in its entirety, allowing the actors freedom of movement and the power to sustain and build their performances rather than delivering their work in fragments. John Malkovich gushed that the sustained temporality of performance was like "doing a play," and Colin Firth said, "It's even more authentic than doing theater because there is no imaginary fourth wall."[28] Without a camera and the implied audience concentrated in the eye of that technology, there was nothing to perform to.

At the same time, this greater level of freedom could be daunting, requiring great trust in the director to make the right choices in post. As Chris Coppola put it: "You had to create your own close-ups," that is, exercise judgment on where a close-up would be most required in a scene, and scale or veil the expressions accordingly, so that the director would be encouraged to bring the shot in tighter or risk losing the expression.[29] On *A Christmas Carol*, however, Firth and Carrey complained about "the lack of a proscenium" and asked Zemeckis to bring a Steadicam onto the set for them to "dance" with, so they could orient the scale and angle of their performances. While Zemeckis used the camera more for the actor's reference point and to make the editing process easier by limiting his choices, Cameron has used it as an additional source of performance data. In *Avatar* up to twelve cameras were placed in the volume with the actors at any one time, with the aim of capturing "what the actor was thinking."[30] So there are some parallels across early cinema acting and performance capture in terms of how preexisting practices carry over and mold the new medium. What comes to light if we consider the impact on acting of the machine's "noise"?

## Noise, Intelligibility, and Making the Medium Disappear

If we think about conventional filming, the level of surface detail and therefore the minutiae of acting expression that the camera can capture have depended on the camera's proximity to the actors, the quality of lighting, lenses, film stock, exposure, and projection. Variables in these factors were one of the early sources of noise in screen performance. Reviews from 1907 and into the 1910s often evaluated the extent to which the faces of those onscreen were visible or obscured behind a "haze-like curtain" caused by poor exposure, faulty focus, or less than ideal exhibition set-ups.[31]

Although now film actors talk of scaling back their performances for the camera lest what they do appear too exaggerated, too theatrical, and insincere, between 1907 and 1909 the most common value associated with film acting in North America was intelligibility, or "getting it over."[32] This was partly to compensate for problems of visibility, but also because, without speech to provide exposition, the burden of communicating meaning fell largely onto the shoulders of the actor and their talents in pantomime. It was not yet common for films to use varying shot scales and editing to focus audience attention on what was important in a scene. As Mayer points out, the majority of films around 1908 were shot with static cameras, using lenses with restricted focal depth. These factors, he argues, constrained what actors could do and how they could move within the frame, meaning that in order to remain in focus and retain visibility, actors were restricted in how close they could come to the camera.[33]

"Insistency and force" were needed from the actor, declared *Moving Picture World* in 1908.[34] Crisp, clearly delineated gestures were required in order to register on the machine. Moreover, even when the problems of image clarity and visibility were solved and, as we shall see, rapidly shifted the discussion around acting for the camera, the problem of speed and movement remained. Until twenty-four frames per second became standard recording speed for films, actors had to be mindful that the machine could make their performance seem confusing, jerky, or ridiculous. John E. Ince saw speed as a problem for intelligibility, as well as perceptions of affective gravity: "This speed destroys the passage of the actor's intentions to the audience. The acting becomes a blur. It is muddled, Staccato, jerky, nervous."[35] Even if the camera was cranked more slowly, Richard Koszarski points out that there was still the problem of over-sped projection.[36] Griffith favorite Lillian Gish explained that in order to compensate for such noise, it was not just a slowing down of performance that was required, but actors should "do a thing and then stop, then do another."[37] Inez and Helen Klumph agreed that to do otherwise would result in a "jumble of movements," and that pausing between actions, thoughts, and expressions allowed the audience to comprehend their significance.[38]

Similar problems of visibility beset actors in early television. As Earle Larimore explained in 1940, "A great deal of business that is splendid in the movies and on the stage is just a total loss on television," before he instructed the would-be television actor not to rely on the eyes to register emotion but to express it in the "whole body."[39]

As we know, with the early talkies there were also significant problems with dialogue recording and reproduction before such things as the adoption of noise-reduction technology in 1931 and the improvement of theatrical acoustics and playback systems.[40] These problems were evident to reviewers such as Mordaunt Hall, who wrote that while he enjoyed the singing in *The Jazz Singer*, he found that the film's reproduction of dialogue "does not always catch the nuances of speech or inflections of the voice so that one is not aware of the mechanical features."[41] Similarly, the *New York Post*'s review of *His Glorious Night* complained that "the sound recording [is] so cavernous, so unnatural and so unpleasant that what the characters have to say matters very little."[42] The noise in the system required testing and training to push through it and make dialogue intelligible. Late 1920s Hollywood deployed complex scientific methods for the testing, analysis, and classification of voices and the training of the voice for the microphone. Obviously, articulation and volume were crucial for the voice to be audible and understood. Crafton discusses the early emergence of the short-lived "enunciative style" of speaking for talking pictures, in which lines had to be intoned slowly and clearly. This was not just so lines could be picked up by the microphone, but also to minimize electrical distortion.[43]

Writing in 1930, Helen Klumph said it was now time to stop blaming the "faulty mechanisms" for "the muddled bellowings of the screen," indicating that for the first year or so of the talkies, actors whose voices reproduced poorly had been given the benefit of the doubt. It had become apparent, she said, that there *were* superior actors who could "register" a lively and clear performance through the sonic interference, become present, and through the force of their performance make the viewer "hardly conscious of the mechanical phase of the production."[44] A good actor, in this context, was one who could make the medium seem to disappear. For instance, Hall wrote of Lionel Barrymore in *The Lion and the Mouse* (1928): "Mr Barrymore's knowledge of diction, linked with his splendid acting, overwhelmed the other players, who were evidently handicapped even in their gestures and expressions by the fact that they were aware that they had also to be heard," although he conceded, "Once or twice the mechanics of the Vitaphone failed him, sometimes making his voice a little too resonant and on other occasions giving him more than a suggestion of a lisp."[45] Klumph declared that "now we have heard the crisp vibrant speech of John Barrymore, the dulcet tones of Ann Harding, the thrilling clarity

of William Powell's voice, we know that tonal beauty is possible in talking pictures. We are forced to grant that when a voice is brash, or uneven, or hard to understand, the fault lies with the player."[46]

In part what we can see here is that if actors and stars were to hang on to their cultural esteem and individual value, it was important to foster the perception that actors ultimately owned the responsibility for how their own voices sounded. *Photoplay* had acknowledged that voices *could* be technologically manipulated, modulated, intensified, or their frequency raised or lowered. But lest this knowledge place the authenticity or value of the actor's voice in doubt, Albert Boswell insisted that a good voice could not be produced from a bad one, as "not all the frailties of the human machine and the temperamental 'mike' can be rectified by the mechanical widgets."[47] We should note that very similar reassuring claims that a "bad performance cannot be made good" are replayed in contemporary discussions about the digital manipulation of actor's facial expressions and timing.[48] In the early sound era, the extent of invisible mediation involved in recording, adjusting, and manipulating the voice threatened to undermine belief in the revelatory powers of the apparatus—something I explore further in chapter 4. In contrast, the actor's face in a close-up was seen to be irrefutably *them*, no matter how shot, lit, or made up. For as John Belton says, the filmed "image possesses a wholeness that serves as further testimony to its 'integrity.'"[49] In such shots, the actors were seen as responsible for controlling their own facial expressions.

In considering the issue of noise and a kind of acting style that can cut through it, what resonances can we find with performance capture?

## Performance Capture: Performance Detail and Digital Puppets

Zemeckis and Cameron's attention to the amount, detail, and quality of performance data indicates that it is data that largely determines the persuasiveness and nuance of the digital character's expression. This suggests that insufficient good data is the performance-capture equivalent of noise. Data quality can be compromised by basic factors: markers can fall off an actor's body, sometimes accidentally reattaching to someone or something else in the volume; in an optical system, parts of actors' bodies can be occluded if they step behind objects or other actors. Of course, these are

the kinds of goofs that don't make it to the screen, but we cannot discount the impact of a more integral data issue, and that is the expressivity built into the digital character body, or the way this body is rigged.

For a digital character's range of expression is largely determined by the parameters designed into its virtual muscle, skin, and eyes, and the level of calibration between its rig and the actor's coordinates. For instance, in *A Christmas Carol* and *Beowulf*, you can tell who the stars are, not simply because the characters share the recognizable facial architecture of Bob Hoskins, Jim Carrey, or Robin Wright, but because they seem to have more muscles in their digital faces, and more avenues of expression than the background characters. The background characters of *A Christmas Carol*—the eel mongers, the street urchins, the carollers, the brown-bonneted mothers pulling their children along by the hand all have curiously blank and generic plump white rosy faces with broadly conveyed doll-like expressions, even as their bodies move like those of living people. By contrast, it is evident that more time and effort has been expended to make the faces of characters played by the stars distinctive, detailed, and expressive, and naturally, they have more camera time and close-ups.

Additionally, there is a problem in reception with a heightened audience attention to the artifacts of technology. This may go some way to explain why so many commentators remarked that Kevin Spacey's eyes in 2014's *Call of Duty* computer game appear so "dead" and vacant, like those of a cod that had been left in the refrigerator for three days. At the same time, I would suggest that in this case, what is perceived as a technological artifact may actually be part of Spacey's idiolect—the term used by Naremore to describe specific gestures and expressions associated with an individual actor. For there are often moments in *House of Cards* (2013–) where Spacey's eyes seem like dull hard pebbles in his face. In *American Beauty* (1999), when from the bleachers he first lays eyes on Mena Suvari's nubile cheerleader at the basketball game, and we move into a rose-petal strewn scopophilic fantasy of her dancing just for him, he allows his face to hang doughy and lax, and his eyes seem empty, uncomprehending, and dazed.

There is a difficulty, then, in separating strengths and weaknesses in the actor's performance from technological artifacts in the process of recording and reproduction, and this is not dissimilar from similar problems in the early movie acting and talkie eras. There we had the haziness of the image, the distortion of projection speed, and, with the talkies, problems of audibility and clarity. In the case of performance capture it is almost a

"muffling" of performance that the actor must work to cut through. As one reviewer of *A Christmas Carol* says, the apparatus "smothers the A-list cast with the digital equivalent of cellophane."[50] At the same time, just as with the early talkies when Barrymore was praised over his co-stars in *The Lion and the Mouse* as having the appropriate skill set for the microphone, there is critical recognition that some actors and acting styles seem to rise to the challenges of the technology better than others. In this case, we might say that they work to produce easily legible emotion and expression data for their character.

For instance, several reviewers of *A Christmas Carol* noted that Jim Carrey, as the spindly joyless miser Ebenezer Scrooge, and his three spirit characters (Christmas Past, Present, and Future), manages to "get through the digital goo."[51] But other actors—notably Colin Firth, as Scrooge's jolly nephew—are less successful. Firth's signature gestures from other films and TV series are present: the assured stance, the hands held wide askance in a swing about the room while he expresses disbelief at his uncle's curmudgeonly behavior. His eyes, however, move in their sockets like dull marbles. The character's face, remade as slightly wider than Firth's own with a more generous mouth and more prominent chin than the actor possesses, appears, as Dan North puts it, like "a waxy monstrosity," and his booming jolly voice seems to force its way out of a plasticine visage.[52] But why should this be? Is it that his character has just not very much to do compared to Carrey's Scrooge, who by contrast runs through the entire gamut of emotion from suspicion, avariciousness, and disdain to terror, misery, and unbridled joy? Has less time been expended on the design of Firth's character rig? Or might this also be, in part, an issue of differing facial structures, different performance styles, and different approaches to performing for the performance-capture apparatus? After all, when you look at Firth in his other roles, it is notable how little his face, save his eyebrows, tends to move in comparison to that of Carrey's notoriously elastic mug. While Carrey seems sometimes in danger of swallowing the camera with his enormous toothy mouth, Firth issues lines from a small guarded mouth that barely opens. Perhaps this is why he lends himself so well to aloof but charismatic aristocratic characters. Let us compare the two in more detail.

One noteworthy feature of Carrey's performance in *A Christmas Carol* is how much he does with his hands, although, granted, his character features have been elongated—the nose and chin and the fingers made substantially longer, more grasping, bony, and spindly. The expressive

gestures of these fingers are the focal point in our first encounter with him, at the side of the coffin of his dead partner, Marley. Scrooge handles money for the undertaker with a caricatured careful precision: his fingers' tremble in their tight reluctance to release their pincer-like grip on a penny, and shrink into tight fists. In the way Carrey oscillates his fingers he evokes that other miser, Mr. Burns from *The Simpsons*: limbering them up hesitantly with great delicacy before plucking a solitary penny from his purse. This is a performance that uses his whole body to communicate the character's essence: his hunched posture, his sour, crumpled face, and the mouth curled in away from the world. It is not just broad and bodily, though. Carrey produces rapid saccadic eye movements as he cringes in his armchair at the sound of dragging chains and ominous thuds of Marley's ghost approaching his door. He plays the Spirit of Christmas Past with a too manic wide-eyed gaze, and his head wobbles like an ethereal, whispering Irish version of Carrey's character from *The Cable Guy* (1996). By separating motion from the actor, motion makes greater claims on our attention, just as the face and voice have done at earlier moments in film history. I find I notice more gesture, posture, expression, and other issues of movement when they are not bound up with the actor's natural appearance. In Stacey Abbott's words, performance capture "makes the invisible visible."[53]

Jenna Ng, however, notes that the visibility of motion is at the expense of those parts of acting that are normally visible: the surfaces of the actor's body and face are erased from the screen.[54] As the surfaces of the actor's face and body are erased, so too are the aspects of performance that cannot be communicated through motion alone. This erasure returns us to Harris's comments about the ineffable or unquantifiable in performance with which this chapter opened. For instance, he asks if Saldana blushed when playing Neytiri's love scenes, before pointing out that if she had blushed we would never know, because the computer could not pick it up: a blush is an internal motion in the capillaries, only visible on the surface of the skin. Like a vein popping in anger or tension at the side of the forehead, a face draining of blood in a waxen pallor upon hearing terrible news, or pupils expanding in empathy or contracting in suspicion, it is a matter of physiological processes, chemical signals, and blood circulation. Of course, even if *Avatar* had been filmed conventionally with Saldana playing Neytiri in blue body-paint and silicon prosthetics, we would not have been able to detect her blush under the layers of artifice! Nonetheless, it seems true, as

director Simon Wells acknowledged at a SAG performance-capture event, that the apparatus "does not suit the very internal acting."[55]

Internal acting—popularly understood to mean conjuring a character's thoughts and emotions within and allowing them to reveal themselves on the surface of the body, rather than ostensively producing their signs in gesture and expression—is something at which Firth excels. Witness his face as Mr. Darcy in the BBC *Pride and Prejudice* (1995) series as, from across the room, he silently watches Elizabeth Bennett turning the music pages for his beloved younger sister Georgiana, who plays the piano. Firth's face here is immobile and yet curiously warms, as though a fire has been lit and stoked within him, emanating a passionate affection through his dark eyes. It is fascinating to watch, and it is perhaps, as Harris says, "ineffable," as it presents us with a mystery as if a trick of the light. But yes, such moments reveal the "blindness" of the performance-capture apparatus, even as that technology might in other ways magnify the actor's breathing, twitches, tics, or other more careless motions—to a degree even more so than the camera. For this reason, similar to the camera and the microphone, performance capture requires actors to develop a different way of thinking and controlling their body and face in order to register effectively on the machine.

I will get to the nature of that difference in a moment, but first I want to briefly historicize and, therefore, denaturalize the value that is placed on "internal acting" in both contemporary and early discourses of acting for the camera. Moreover, returning to the 1910s also highlights an alternative model of value in acting for the camera—one that does have useful resonance for acting for performance capture.

## The Camera, Sincerity, and the Actor as Puppet

Into the 1910s, the conditions under which the details of actors' faces were visible underwent a rapid change. Barry Salt has tracked in precise, hair-splitting detail the improvement of lenses, emulsions, and indoor lighting during the years following the formation of the Motion Picture Patents Company.[56] With greater clarity of image, a higher expressive value was placed on conveying emotional and mental processes through the face, and with it came a heightened sense that the camera required the actor to generate her character's thoughts and feelings internally so that they would

FIG. 2 Fascination with facial expression in 1910s movie culture (courtesy Media History Digital Library)

rise naturally to the surface. For instance, the actress Clara Kimball Young argued that as film was a photographic art that could capture real mountains and real sky, it also required real feeling from actors. She believed that the camera revealed "every defect" and "untruth" in a performance, and, as a result, she said that it was impossible for her to fake love with an actor she didn't like, or fake fear with a villain played by an actor with whom she

was friendly off-camera.[57] "Acting on the screen is not acting, it is being," insisted Inez and Helen Klumph, adding, "Portrayal begins in the mind . . . and the human body naturally conveys that mental conception to the audience."[58] Similarly, Pearson notes that D. W. Griffith believed that good actors actually experienced the emotions of their characters. For Griffith the camera as a teller of "truth-in-detail" could "capture these externalized feelings": "register every quiver of the facial muscles, every gleam of the eye, every expression of the face, every gesture."[59]

In contemporary film acting discourse, this is a kind of truism. Tony Barr, in the opening lines to *Acting for the Camera* (one of the standard contemporary go-to books for actors adapting their craft to film and television), says, "The camera allows no deceit."[60] Barr claims that the camera's ability to magnify and focus audience attention, coupled with the audience's innate skill in reading faces, means that anything "dishonest in relation to what the character is thinking or feeling will be noticeable to the audience. . . . On the stage, you can give a performance. In front of a camera, you'd better have an experience!"[61] In his command to "have an experience," Barr suggests that the camera's proximity demands a kind of authentic behavior or sincerity from actors, to the point where they are no longer performing but, in that moment, being.

This mythology of modern acting has a long pre-cinematic history, as Matthew Wikander explores in his work on the longstanding tropes of antitheatricality in Western culture.[62] Despite the persistence of this mythology, however, it is often difficult to distinguish the mask of sincerity from "the real thing." Denis Diderot argued that we should admire the actor who can skillfully pretend to feel and elicit feeling from us, more than the one who conjures up authentic feeling within his or herself. Even if hypocritical actors who engage in skillful pretense can seem more threatening to a social order that values intimacy and the confessional, actors of authentic feeling are in danger of feeling too much, being inconsistent in their performance, and losing their own identity in a part.[63] Such debates about the relative values of sincerity and hypocrisy in acting persist to this day, but they have also been further complicated by the popularization of scientific theories of emotional expression. In the nineteenth century, Charles Darwin's work on the expression of the emotions argued that the human face and body had evolved involuntary external responses to internal feelings, and that the signs of internal turmoil and character were written on the face, beyond the voluntary control of most individuals. Those

few who could manipulate their faces to repress or produce signs of emotion were, he thought, inheritors of traits passed down through generations of actors.[64] Still, popular late nineteenth-century ideas of the face as a privileged site of revelation of a person's true internal states worked with the truth connotations of photography and the magnification of the face in the close-up to inform beliefs about the best way to act for the camera.

While many of these claims about sincerity in acting for the camera suggested that the medium challenged Diderot's preference for the actor who can produce convincing surface effects, not everyone agreed. Actress Florence Lawrence, for instance, advocated for highly codified expressions like those developed into a system in the nineteenth century by François Delsarte. She conceived the parts of her face and body as the movable segments of a marionette, or keys on a piano. Explaining how holding one eyebrow up in skepticism signified "You lie, villain," she concluded, "The eyebrow must be on the job all of the time, likewise the lips, the nose, the mouth, the eyes, the arms, the fingers, and even the feet. The eyebrows and the lips are, however, most important of all, and they must work in harmony."[65] It is this more self-conscious approach to acting for the camera, where the face and body are explicitly treated as an expressive instrument, that has the clearest affinities with acting for performance capture.

## Actor as Puppeteer/Marionette

In a fascinating and useful essay, Sean Aita, an actor who specializes in performance capture, argues for an outside-in or "psycho-physical" method. This is very different from generating an emotion internally and having faith that it will reveal itself naturally in the body and face, and that this revelation will in turn register through the technology.[66] This is an inverse approach, where the assumption of a pose, gesture, or expression can temporarily trigger the appropriate feeling within the actor. It is in line with popular cognitive and neuroplasticity research that has found that, like the clichéd saying "Fake it till you make it," we can trick ourselves into feeling positive through practicing smiling until the smile becomes genuine, or we can develop inner confidence by swaggering and strutting with our shoulders back.

In a similar vein, Carrey speaks of imagining himself as a puppeteer, using his face and body to manipulate his avatar, and keeping in mind as

he moves a sense of the parameters and appearance of that avatar. It is clear that he built into his performance of Scrooge an awareness of his character's extra-long fingers, nose, and chin, and how these could be exploited to express the character's way of being in the world. Similarly, Serkis has explained that "you are kind of both marionette and puppeteer at the same time." Just as film actors have always benefitted from playback and analysis of their own expressions and voices, so too Serkis and others iterate the importance of analyzing one's performance in playback. He says that "it's like looking into a magic mirror, working out how your performance is going to read physically, and then adjusting. The digital puppet can be calibrated to your movements, so you're finding a happy medium between what you're doing as a performance and as an actor and what the puppet is capable of."[67]

In this view it becomes apparent that a successful motion-capture performance depends on the detail and design of the "marionette," how many "strings" it has, and how the actor to whom these strings are "attached" works to externalize his relationship to his character body, in order to bring this dormant digital doll to life. Such a process necessitates that actors think of their body and face and what and how its components can communicate, in a more conscious way.

## Parallels, Continuities, and Distinctions

What I have tried to argue here is that acting for performance capture may be very different from contemporary on-camera acting, but that in its provisional state in the 2000s and mid-2010s there are comparisons to be made with early film acting and early acting for the talkies that bring elucidation. In the 1910s, stage acting practices and the filmmaking apparatus engaged in a dance of mutual adjustments to meet reigning cultural values and industrial requirements. We see a similar dance occurring as movie directors and actors have reshaped the motion-capture apparatus to meet their established ways of working, while at the same time actors have to rethink what they do. As with both early acting for the camera and acting for the talkies, though, much work still has to be done by actors to make their performances register as intelligible and clear, and to cut through the noise of technology. Clearly, at the time of writing, acting for motion capture is far from a transparent recording process, even as those working to

hone the technology of the apparatus claim that their aims are to make it disappear, or fade into the background for the actors. The capture process is becoming less cumbersome: more finely calibrated and less artificial, as actors in motion-capture suits can now perform outside, interacting with other actors, working in more conventional ways in more natural locations. In this way performance capture is following similar trajectories to earlier recording technologies, such as synchronized sound recording.

Early film acting and acting for the synchronized sound film managed to cultivate esteem. At first, esteem was accorded to actors whose performances managed to register through the machines and who were intelligible and lively rather than stilted or mechanistic. But ways of evaluating and appreciating screen performance also flowed out of and fed back into preexisting aesthetic and ideological values such as "sincerity" "intimacy," "naturalism," and "verisimilitude." These were qualities that both the camera and the microphone seemed to magnify and amplify in their respective capacities to isolate and reveal visual and sonic details of the world and people. The camera allowed us greater opportunity to study the tiny fleeting details of the face in thought and veiling or exaggerated emotion. Sound recording allowed us to analyze the grain, timbre, and pitch of voices. As these revelatory qualities of the camera and microphone were foregrounded, and the values of intimacy and naturalism promoted, the high level of control that actors are required to exercise over their bodies, faces, and voices as they perform for machines has tended to become invisible. It becomes visible again with motion capture. This is in part because as motion capture jettisons actors' natural appearances, it tightens the attention to motion, gesture, gait, the crinkling and stretching of muscles, the quirks of expression, and other moving intangibles of persona. It requires that the actor develop exceptional control over his or her movement. This kind of conscious, controlled, externalized performance is not new, however, if we recall Florence Lawrence's comments in the 1910s about her precise control and manipulation of her face, like the keys on a piano or a typewriter. In the 1910s, conceiving of acting as conscious and controlled was one way of making the craft of acting visible, in a context where the popular view was emerging that acting on camera required not so much acting as "being," due to the camera's photographic proximity. In a not dissimilar way, the conceptualization of the actor as both puppeteer and marionette in motion capture serves to reiterate acting as a craft.

There are some key differences between motion capture and its technological precursors, however. The coming of sound prompted a concern for the impact of the new technology on actors' professional futures, and led to elaborate testing procedures and the studio formation of microphone training schools. Unlike the microphone, though, motion capture is not forcing a wholesale change in how all films are made, but sits alongside the dominant of conventional live-action performance for the camera. Performance for motion capture is perceived, then, less as a threat and more as a desirable skill set that, if acquired, can diversify an actor's avenues to employment across not just film and television but into video games.

Moreover, as motion capture jettisons the actor's appearance, its strengths and value as an expressive medium are seen to lie less in a revelatory naturalism, but in casting otherwise uncastable roles (such as animals, aliens, and monsters). It allows the realistic integration of such othered characters into live-action environments. It can also be used, as Zemeckis has, to allow the visualization of storybook worlds, with the more seamless integration of the actor's performances into imaginary universes that may be aesthetically distanced from the concrete materiality of conventionally recorded live action. However, because of these representational factors, the character does not usually resemble the actor, and there are a substantial number of steps that occur between the actor performing on set and the manifestation of her character onscreen. This visual non-congruence between actor and role, and our awareness of the extent of digital effects and animation required to bring this role to the screen, continues to cast doubts on the actor's contribution. The result is that, despite the ways that motion capture draws our attention to motion, the direct attribution of the performance to the actor remains a challenge for some critics, and this, in turn, is a problem for the cultivation of value.

There are two main ways, however, in which the actor's presence in and contribution to the role can gain greater visibility and esteem. One strategy is to cast an actor with a recognizable idiosyncratic repertoire of expressions. For instance, in his review of Mark Rylance's performance as the friendly giant in Steven Spielberg's *The BFG* (2016), Peter Bradshaw marvels at how the actor plays the giant as a "real human character." Perhaps thinking of Carrey's caricatured performance in *A Christmas Carol*, he says "a lesser actor would have gone in for brow-knitting grumpiness, sub-Shrek rage, coy shyness and giggling." Most of all, however, Bradshaw seems captivated by how the medium brings Rylance's idiolect to his attention in a

new way, as he says it is "a thing of wonder to see his trademark nuances and facial moues, generally so studied and small, magnified to the size of an Easter Island statue."[68] Reminiscent again of the praise afforded Barrymore in the talkies, Bradshaw suggests that Rylance's performance is enough to make the medium disappear, while at the same time revealing the medium to be a thing of wonder in its transparency.

The other way to make motion-capture acting visible is to reframe it as a performance behind "digital makeup." This places it within a different evaluative frame from recorded performance as, historically, the actor's invisibility beneath rubber and paint has also created problems for the evaluation of his or her performance. Moreover, evaluation has not just had to deal with the problem of the actor's invisibility, but problems of verisimilitude in makeup aesthetics. In the next chapter, I examine the changing strategies that have been used over time to make the invisible visible, and to cultivate persuasiveness and value around constructed bodies onscreen.

# 2

## Behind Rubber and Pixels

---

### Mimesis, Seamlessness,
### and Acting Achievement

> Like the protean specialty of a lightning
> change artist in vaudeville, heavy drafts are
> made upon the make-up kit and almost none
> on the best talents of the actor.
> —Norbert Lusk, "Seven Faces," *Picture Play
> Magazine* (February 1930)

*Rise of the Planet of the Apes* (2011) is both prequel and digital reboot of
the *Planet of the Apes* franchise that began in 1968. Giving the story fresh
origins, it also digitally reimagines the physicality of the apes. The original
*Apes* films and subsequent television series featured actors such as Roddy
McDowall walking about upright as highly evolved talking apes in John
Chambers's Oscar-winning makeup designs. As praised as they were at the
time, our aesthetic horizon has shifted, and with their stiff muzzles and
fake fur, they now seem so unyielding, inexpressive, and unnatural. The
2011 version shifts the franchise from camp artifice into the realm of com-
paratively plausible, biologically grounded digital realism. These apes lope

FIG. 3 Kim Hunter (left) and Maurice Evans in John Chamberlain's makeup for the 1968 *Planet of the Apes* (Blu-ray capture)

effortlessly on long hairy arms and strong fingers, clamber vertiginously, and bound and swing across dining rooms, hostile cityscapes, and exhilarating forests, followed by a swooping giddy camera. In their motion they convey a fully embodied simian quality familiar from David Attenborough documentaries or trips to the zoo. If their bodies are convincingly apelike, their wrinkled flattened faces manifest raw recognizable mammalian emotions such as aggression, delight, terror, and despondency, but also complex cognitive processes that we usually associate with the average human, such as ready comprehension, evaluating, and strategizing. The impression of powerfully realistic chimp-yet-human characters we see here is something commonly called "seamless": a term of praise used for those illusions that we are aware of as illusions, but which do not, in the first viewing encounter, betray the signs of their artificial construction.

In the special features that accompany the region 4 Blu-ray release, however, the illusion is pulled apart to reveal its construction, heighten our appreciation, and apportion credit for the creative labor involved. An array of talking heads, including Simon Clutterbuck, head creature designer at the visual effects company Weta Digital, focus on the film's lead character—an intelligent and empathetic chimp called Caesar—and the other apes we see onscreen, informing us of the correct anatomical structural

FIG. 4 Weta Digital reveal of the anatomical structure "inside" Caesar's body for *Rise of the Planet of the Apes* (Blu-ray capture)

detail below the surface of these chimps, gorillas, and orangutans. We are shown digital musculature and nerve bundles that were attached to digital ape skeletons in order to "fill the inside of the creature with the stuff that drives it."[1] The visible layers of the character are also framed with recourse to biological science: on the surface what we see is informed by structural knowledge of ape hair, ophthalmological knowledge of chimp eye muscles, corneal surfaces, and tear films. This knowledge in the special features fleshes out our impression of Caesar's body, moving beneath the surface reality effects of photographic realism to proclaim: there are no actors in rubber masks here!

From his furry skin to the marrow in his bones, Caesar is digital through and through. There is no physical seam between the actor's body and the synthetic flesh and hair of the character. While this allows the apes in the film to be more ape-like than those in any of their previous *Planet of the Apes* film or televisual incarnations, it does create a problem for the location and evaluation of acting.

Acting is located and celebrated, however, in another featurette that was widely disseminated on YouTube before the film's release, as well as included on the Blu-ray. Titled "The Genius of Andy Serkis," it foregrounds Serkis's

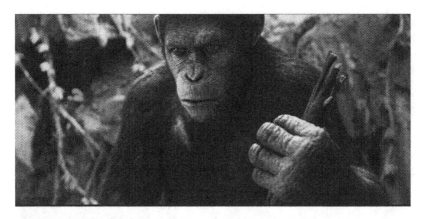

FIG. 5 The "soul" inside the "digital chimpanzee skin": Andy Serkis as Caesar in *Rise of the Planet of the Apes* (Blu-ray capture)

contribution as the primary animating force that breathes life into this ape body. The featurette's prominent use of split-screen footage allows us to compare a grainy record of the profilmic performance event and the final glossy digital image, side by side: Serkis on set crouching in a grey unitard covered in mo-cap sensors, his face scrunched in a snarl or lit in a wide mouthed cackle, juxtaposed with footage of the fully rendered Caesar apparently mirroring his expressions. Here we see Serkis and Caesar enraged. Here we see Serkis and Caesar triumphant. Here we see them both morose and dejected. Moreover, the features and interviews around the film from cast, director, and producers claim that what Serkis contributes to the role is more than his kinetic data and voice. Rather, Caesar is a manifestation of the actor's very *soul* cloaked "in a digital chimpanzee skin."[2]

Together, the film and its production publicity seek to elevate the artistic standing of performance capture in quite complex ways. In digitally remediating the prosthetic makeup of the *Planet of the Apes* franchise, they position Serkis-as-Caesar within a cinematic lineage where actors have performed with their faces obscured or unrecognizable behind prosthetic appliances. This lineage, though, is also exceeded, for in terms of their anatomical realism these ape bodies are promoted as far superior to what could be achieved through the application of latex and fur to an actor's body. Moreover, it seems the digital ape body sets the actor free to pursue a nobler task: the expression of the character's soul, an almost pure interiority. In this way the film and its publicity suggest that performance capture

achieves some of the longstanding aesthetic aims of prosthetic makeup performances: not just anatomical realism, but the complete disappearance of the seam between the body of the performer and the synthetic flesh they wear, and, by extension, the seam between the character's artificial exterior and their interior.

When we consider makeup and acting together in terms of seams and seamlessness, it is apparent that the seam between makeup and actor is not just something that is visible to the eye. Yes, the history of makeup effects, craft, and artistry is one of continual problem solving and progress toward greater and greater powers of persuasiveness in the visual texture of materials from rubber to latex to the translucency of silicon. Yes, the visual seamlessness of prostheses are judged onscreen by the way they catch the light, sit on the actor's skin, and move with the body and face. As Murray Pomerance observes: "The constant technical improvement of latex appliances is aimed at the project of sustaining the moment of viewer belief over longer and longer shot durations and through progressively closer points of vantage."[3] I want to consider here, though, how our appreciation or criticism of prosthetically transfigured faces and bodies on the screen are informed, not just by an idea of how skin and hair appears under various conditions in our everyday reality but by other competing and shifting aesthetic values about how art should approach the real, and how, ideally, an actor should bring a character to life.

This chapter enlarges upon these concerns in part to explore the ways that performance capture has been compared to acting behind prosthetic makeup. What is the nature of this comparison, and to what extent does the analogy stand up or fall down? In order to further test the analogy we need to understand better the nature of the relationship between prosthetic makeup and acting, the problems of surface and depth, interior and exterior, and the various discourses that have emerged to cultivate esteem for individual performances.

Much has been written in special effects histories on the astonishing makeup designs and techniques of a long line of exceptional "geniuses" such as Lon Chaney Sr., Jack Pierce, Dick Smith, Stan Winston, and Rick Baker. In scholarly discussions of acting, however, prosthetic makeup is usually elided except in its use, discussed by James Naremore, as an "expressive object" where it has a diegetic status in the film as "makeup" or mask rather than "face."[4] Think, for example, of Bette Davis's powdery clownish mask as the ageing delusional actress in *Whatever Happened to Baby Jane?*

(1962) and what her character's application of this lurid grotesquery reveals of her self-perception and way of engaging the world.

But if we attend to the reception, commentary, and publicity around films where the mask or prosthetic is meant to be read as the character's face rather than an expressive object, this can further our understanding of how the actor's creative contribution to the expression of interiority is conceived, and highlight factors in film viewing that cue perceptions of phony artifice, or seamlessness and transparent realism. Indeed, it can also help us to understand what we mean when we use such terms, and this understanding, in turn, can shed light on performance capture.

## Performance Capture: "Applying Makeup after the Fact"?

As the previous chapter explored, discourse around performance capture has some illuminating commonalities with those that responded to and shaped early film and sound film performance. However, unlike traditional means of recording performance, the performance-captured actor's face and body are absent from the screen. This means that, apart from her voice (which, even though equally malleable, is usually taken for an authentic reproduction), her creative contribution to what the audience experiences of the screen character is always uncertain. The Screen Actors Guild (SAG) publication *Screen Actor* worried in 1999, "What you do in front of a camera (or perhaps a computer screen) will have little resemblance to what audiences actually see."[5] Between the profilmic moment of performance and the box office release, there are many layers of mediation and much labor of character designers, animators, and VFX artists. Awareness of these mediating layers casts doubt on the actor's contribution. These are doubts that the special features and publicity interviews of films like *Rise of the Planet of the Apes* attempt to assuage, even as they heighten our consciousness of the artifice involved.

How to sustain stardom and the artistic value of actors' contributions to films in a context where their face and body are invisible? This problem has required a discursive strategy that lends an air of legitimacy through association with established acting traditions in which actors have won Academy Awards for roles where their features have been disguised. As Lisa Purse states, "Persistent calls from co-stars, directors, and studio executives for these performance capture 'star turns' to be considered in the acting

categories of the Academy Awards [are] commonly based on the argument that the digital imaging work involved represents little more than the digital equivalent of a practical prosthesis or make-up."[6]

It was Peter Jackson who first publicly raised the notion that audiences should understand and appreciate performance capture within a prosthetic makeup paradigm (rather than as a new form of animation in the tradition of rotoscoping). Arguing in support of Andy Serkis's Oscar nomination bid for his motion captured/digitally animated role as Gollum in *The Lord of the Rings: The Two Towers* (2002), Jackson said: "To be honest, I think that what Andy has ultimately achieved with Gollum is as relevant an acting performance as 'The Elephant Man' with John Hurt. Hurt's buried beneath inches of rubber, but he has to use his acting skills to push this prosthetic around and fuel the character. Andy is really doing the same thing. He's the driver manipulating this pixelated skin that we see in the film."[7] Hurt, performing inside Christopher Tucker's elaborate latex appliances, played real-life nineteenth-century sideshow exhibit and medical curiosity Joseph Merrick—a man hideously deformed by neurofibromatosis—in David Lynch's 1980 sentimental, horror-inflected biopic.[8] Although his face was completely obscured, Hurt gained a Best Actor Oscar nomination. Hurt's nomination drew attention to the yawning disparity in esteem between makeup and acting, as there was no award category in which Tucker's craft could be recognized. It was this film that prompted the Academy to include a makeup category the following year.

The fact that an actor could be recognized for work where his face is buried beneath rubber, though, is the central point of comparison for performance capture. Serkis himself quickly warmed to this analogy. "It's like applying makeup after the fact, only the overlay isn't with latex before the performance. It's digitally after the performance, with computers."[9] Such "digital makeup" claims have been reiterated by James Cameron and Sigourney Weaver on the set of *Avatar*; Rupert Wyatt, director of *Rise of the Planet of the Apes*; Steven Spielberg; Tom Rothman, head of Twentieth Century Fox (the studio releasing the film); and Serkis's co-star in *Apes*, James Franco. From the perspective of actors and directors working together in a performance-capture volume, it would make sense to conceptualize the process as "digital makeup" rather than animation, even if such a label seems to downplay the significant work done in post-production to bring the character to the screen.

The digital makeup analogy is also, however, filtering into reception. Besides Hurt, other Oscar-winning reference points have been occasionally

cited, such as Nicole Kidman's performance with a prosthetic nose to play Virginia Woolf in *The Hours* (2002) and Charlize Theron's artificially coarsened, snaggle-toothed appearance to play real-life serial killer Aileen Wuornos in *Monster* (2003). Some reviewers and interviewers have started to use a much older reference point for Serkis: Lon Chaney Sr., the so-called "man of a thousand faces." Thus Serkis has been labeled "the Lon Chaney Sr. of CGI" or "the modern Lon Chaney, a man of 1,000 faces grafted on digitally."[10] This characterizes Serkis as a protean actor, a chameleon able to disappear into any role. The prosthetic makeup lineage cited for performance capture is pretty selective, then, and does not include Roddy McDowall in the original *Planet of the Apes*, much less Ricou Browning in the Gill-man suit from *The Creature from the Black Lagoon* (1954). This is because performances such as the lumbering and glassy-eyed reptilian Gill-man do not express any inner torment or psychology. Lurking and attacking, the creature functions as the narrative's primal antagonist, threatening violent death and the possibility of rape. Like the shark in *Jaws* (1975), it just is and does. It does not solicit our comprehension of its motivations or experience of the world. The original apes in *Planet of the Apes* are, of course, not in this same category. The content of their characters is revealed through their words and action more so than performance per se. Neither *Creature* nor *Apes* have accrued the critical reputations, though, that would help build a case for performance capture's aesthetic legitimacy within a lineage of "great performances." For a performance to gain critical recognition, the actor must have the opportunity to make the character's interiority legible.

Apart from Stephen Prince, though, most film scholars reject the prosthetic makeup analogy for performance capture, although less on expressive than on ontological grounds. Lisa Purse, Scott Balcerzak, and others argue that the promotional discourse is at odds with the actuality of how the expressivity of digital bodies is produced. As Balcerzak says, "Heavy makeup alters the appearance of the body while mocap removes the physical reality of the body and replaces it with something or someone digital."[11] With digital screen characters like Caesar or Neytiri (Zoe Saldana) in *Avatar*, we can only take on faith (and with the assistance of the behind-the-scenes documentation) that what we see onscreen has a direct indexical relationship to the gestures and expressions performed by the actor. Hundreds of animators may have worked on that character face, tweaking, dialing expressions up or down. With prosthetic makeup, though, we know

(from deduction or promotional information) that there has to be *someone* inside the rubber suit or behind those grotesque layers of latex pushing it around. I say "someone" because, of course, problems of attribution plague conventional acting behind masks too. If we think of Darth Vader, people routinely attribute the performance to James Earl Jones, as he provided the iconic voice in *Star Wars IV, V,* and *VI,* but they rarely remember that it was body-builder David Prowse who wore the suit, replaced by stuntman Bob Anderson in the fight scenes.[12]

For some film critics leery of CGI's purported weightlessness, a distinction between prosthetics and performance capture seems important to make. For instance, Michael O'Sullivan in his review of *Rise of the Planet of the Apes* compares "Andy Serkis, in motion-capture CGI [and] rendered by computer animation," to the earlier actors in makeup, such as Roddy McDowall in Franklin J. Schaffner's original 1968 film. While conceding that the digital apes here are "frightening—and believably emotive," O'Sullivan complains that because they are digital "they're less than fully present." By comparison, he found that McDowall was "paradoxically, more real, even in his stiff rubber mask." O'Sullivan's belief that computer animation rather than an actor in a mask is largely responsible for what he sees seems to block his engagement with the character as diegetically "real."[13] The ontology of the performance feeds into epistemological issues: for him, a belief in the actor's presence before the camera is more important to the construction of cinematic reality than how visually and emotionally convincing the end result may be.

However, when practical prostheses worn by actors have been digitally animated or composited with digital body parts, it sometimes becomes difficult to know whether or not an actor *is* actually present before the camera. At what point is Deadpool digital and when does he become Ryan Reynolds again? In *Prometheus* (2012) Daniel James wore fifty-five pounds of silicon to play the Sacrificial Engineer—a marble-fleshed alien, of regal bearing, like an enormous breathing onyx-eyed example of Ancient Greek statuary, who imbibes a ritual substance that dissolves his body, so that his DNA may seed The Earth. According to Joe Fordham, Weta Digital animated rapid decay on the prosthetic body before quickly transitioning to a fully CG figure. As the change is seamless, and the decay could only be achieved digitally, watching the film without reading the background information we might assume that the Engineer was CG for the entirety of the sequence.[14]

My argument here, though, is that the mere physical presence of someone inside the suit or behind a mask does not entail a fully realized performance, or mean that what the hidden actor does onscreen will be easily evaluated as such. Prince posits that "few observers would deny that an actor performs a character when wearing a costume or a mask or elaborate prosthetic makeup. No one says that the mask replaced the actor."[15] True, they are unlikely to dispute that the actor is performing in the makeup or mask, but reviewers often seem distracted by transfiguring makeup effects, finding the performance beneath difficult to locate or read.

Take some of the reviews for *J. Edgar* (2011). Joe Morgenstern characterizes Leonardo DiCaprio's and Armie Hammer's performances as "partially animated waxworks" due in part to the "ghastly slatherings of old-age makeup."[16] In his review, Peter Bradshaw invokes the comically grumpy, felt-faced Muppets, Statler and Waldorf, feeling that Hammer and DiCaprio are "hampered with plastic, padding, and wigs." He sees DiCaprio as bringing much more substance and nuance to the portrayal of the younger Hoover than when he "has his plastic old guy face on."[17] Indeed, the makeup artist on the film, Siân Grigg, has said herself that "layers of prosthetics are like acting with a paper bag on your face and Leo had to learn to exaggerate his expressions so they would show through the appliances."[18]

Conversely, when an attractive star like Nicole Kidman "obliterates her celebrated beauty" with a latex appliance such as a fake nose to play Virginia Woolf, there can be the perception that a serious performance must be taking place if glamor is to be so defaced.[19] In such cases the prosthetic, so glaringly distinct from the actor's face (the opposite of seamless), is sometimes judged as standing in for character. Characterization is reduced to superficial appearance—an errant body part—as if Woolf's defining feature was that she did not have a dainty button nose.

These signal longstanding ambivalences in the status of prosthetic makeup, both in cinema and in relation to acting. As I shall explore below, in Western cinema, transfiguring makeup has often been uncomfortably situated in relation to photographic conceptions of realism. At the same time it has been a necessary means to support the visual persuasiveness of characters. In one discourse on acting, makeup has functioned as merely an extension of the actor's art, part of their protean toolkit. But another acting discourse persists in which transfiguring makeup is disparaged as a crutch for characterization or an obstruction that impedes the visibility

of the actor's work. Holding these often entangled uncertainties up to the light allows us to see how they have prompted particular, almost defensive strategies to cultivate esteem in both the practice and discourse around prosthetic makeup design and performance. Mapping this terrain will then allow us to turn our gaze back to performance capture and see more clearly its similarities and distinctiveness and how it seeks to extend and exceed the legitimating practices of prosthetic performance.

## Cinematic Realism, Protean Acting, and Makeup as "Crutch"

In the 1921 guide *How to Become a Film Artiste: The Art of Photo-play Acting*, Fred Dangerfield and Norman Howard instruct the reader:

> In the matter of artistes the requirements of the camera differ widely from those of the stage, and one peculiarity is that the cinema player must not only act but look the part. A young man cannot make up to take an old man's part—it must be taken by an old man. A woman of middle-age, though she may succeed in a young girl's role on the stage, cannot play the part before the camera. Because of the enormous mass of detail which the camera absorbs, an old "make up" on a young face would look unusual, odious and ridiculous when it reached the "close up" views, if not before.[20]

In this context, transfiguring makeup was seen as inappropriate for the medium, a hangover of the stage, especially as the camera's closer view made defects more apparent, and so had "tolled the knell of the spirit-gummed beard."[21] Anything that might distance the audience and remind them of artifice should be avoided, as Dangerfield warned: "Whatever realism the picture is supposed to portray is lost when the make-up becomes noticeable. The characters on the screen no longer seem real, but become merely puppets."[22]

Similarly, Hugo Münsterberg wrote that the "artificial make-up of the stage actor" should not be required for the screen and, moreover, the photoplay, being voiceless, did not require trained actors—simply people cast on the basis of their physiognomy and build.[23] Such views on casting often informed publicized searches for lookalikes to play historical persons

onscreen, such as Prince Albert or Abraham Lincoln. *Photoplay* reported on a search for a visual double of the younger beardless Lincoln to appear in *The Copperhead*. After a protracted search, an unknown waiter, N. Schroell, was found, "a tall, clean-shaven man a little awkward, his long arms and legs seeming to be in his way" who was fitted with the requisite coat and collar and a wig, but "little other makeup was necessary."[24]

In a tension between the desire for realism and the desire for artistry, however, the practice of casting on the basis of physical types was countered by the emerging discourse on film acting. In this discourse, to appear or to simply *be* before the camera was not sufficient. To demonstrate artistry of a kind comparable to performance on the legitimate stage, actors needed to be seen to perform an interpretation of a role distinct from themselves. Those commentators who championed the development of photoplay acting as an art disparaged the casting of types and elevated those actors who could be seen as demonstrating "versatility" or proteanism.

Florence Turner's publicity, for instance, emphasized her chameleon-like abilities. *Moving Picture World* proclaimed that Turner could take on a wide range of roles due to her "powers of makeup" through which "she can absolutely transform her face or obliterate her own charming personality."[25] This versatility-in-makeup angle was also pushed for the Imp star King Baggott. A description of a two-reeler action melodrama *Shadows* (1914) reported that the actor took on no fewer than ten roles in the one film. The review tells us that, "as a closing feature to the play—one intended to convince the spectator of the fact that Mr. Baggott enacts every role—we have various short scenes showing the artist in the make-up of each character and removing the make-up as each scene fades into another."[26] This tantalizing snippet of historical information suggests an early parallel to the kinds of extratextual strategies that are deployed today for performance capture, where split-screen publicity shots show final rendered characters and profilmic images of actors in mo-cap suits, side by side, in order to convince the spectator of the actor's presence in and contribution to the role.

Within another popular view that emerged out of nineteenth-century realist theater, however, such makeup transformations had dubious aesthetic value when compared to a more "authentic" kind of proteanism produced within the actor's body rather than applied to its surface. The surface transformation is associated with a "trick" rather than sustained deep characterization. We see such discourse circulating around two actors known for their skills in transformation, Lon Chaney Sr. and Paul

Muni. For instance, Norbert Lusk's review of *Seven Faces* indicated that he was not impressed with Muni: "Like the protean specialty of a lightning change artist in vaudeville, heavy drafts are made upon the make-up kit and almost none on the best talents of the actor. The result is a stunt rather than the sustained inspiration."[27] Chaney's protean quality was central to his stardom, as evidenced by the popular 1920s joke, "Don't step on that spider—it might be Lon Chaney." While he was popular as a box office draw, his use of makeup put his status as an actor in doubt, and numerous reviewers held his work in low regard. He clearly saw makeup as an extension of the actor's art rather than a substitution for it, but journalists nevertheless tended to characterize what he did in somewhat sneering terms as "queer tricks with greasepaints and wigs."[28]

Of course one problem is that Chaney's makeup was always framed as a special effect in publicity, in order to invite scrutiny and appreciation of his craft as makeup artist. Articles from 1925 indicate that the makeup for *The Phantom of the Opera* was kept secret until the picture was released. Chaney's contract insisted that in all photos taken on set, his face would have to be blanked out, so as not to spoil the "surprise."[29] Within the film itself Chaney spends the first part of the film hidden behind a benignly smiling creepy mask that resembles the face of a plump shop-window dummy. The mask, along with whispers from characters about the extent of the Phantom's true hideousness, builds anticipation for the face we eventually see. At the same time, the blatant artifice of the mask is designed so as to persuade us that the face beneath is the character's authentic flesh. In the unmasking scene, the achingly curious Christine (Mary Philbin) creeps up behind Erik while he faces the camera in medium shot, playing the organ. To their mutual shock, she removes his mask to reveal a cadaverous face: a shining dome of a forehead, tombstone teeth, and staring eyes. However, as publicity had already cued the viewer to see this not as an actual face but as Chaney's latest makeup transformation, it became for some reviewers the focal point of their appraisal. Rather than actual skin and bone, they saw materials and labor: artfully applied putty.

Critics and interviewers often expressed a definite preference for the roles in which Chaney performed characters where his face appeared to be unadorned or, as one writer put it, "self as made."[30] For instance, a review in *Photoplay* of *The Unholy Three* (1925) praises Chaney's performance as a ventriloquist con man who takes on different identities, and speculates that audiences may "appreciate him because of his abandoning his makeup

except during the moments of his disguise."[31] Expressive uses of makeup for a character to signal overt disguise were acceptable, but transfiguring uses of makeup to signal a character's natural face held less esteem because they were framed as spectacle rather than character, and so invited a scrutiny of materials and their application, rendering performance secondary.

While in part these views were shaped by an idea of the aesthetic specificity of film and about how characters should function onscreen, they also seem ghosted by the moral opposition between nature and artifice that emerged in the era of Romanticism—in which nature was read as truth, and artifice as deception. On the most obvious level we can see this anti-artifice lineage endure in the appreciation we have for the perceived bodily authenticity of performers (whether actors, singers, acrobats, dancers, or athletes) who sustain impressive physical feats with their bodies, voices, and faces unsupported by technologies of illusion, unenhanced by drugs. This is an appreciation that, as I shall explore in chapter 4, tends to gain greater value in contexts of awareness of technological illusionism and manipulation.[32]

The higher value placed on the self-transformation, though, is not just about the esteem for a performer's authenticity. In some frameworks it was and indeed is informed by beliefs about depth and truthfulness in characterization. In this view the use of artificial methods to transform an actor's appearance is seen as a distraction or a visual crutch that means the actor has less work to do in signifying character. The criticism is that character itself is reduced to its surface appearance, or what in late nineteenth-century literature and theater was sometimes denigrated as "photographic realism."

One of the most famous and respected proponents of this view on the late nineteenth-century stage was the actress Eleonora Duse, an early adopter of Stanislavskian principles and a significant influence on Lee Strasberg. She wore little makeup onstage but instead, according to her biographer, Frances Winwar, "made herself up morally. In other words, she allowed the inner compulsions, grief and joys of her characters to use her body as their medium for expression, often to the detriment of her health."[33]

Duse's disciples attempted to adapt her philosophy to cinema acting, repurposing it for the camera's close scrutiny of the face. For instance, the Danish actor Jean Hersholt "scorned" makeup for his characterizations, including old man roles. Hersholt was of the view that makeup is a "crutch of artificial aid" and to produce "natural" characterizations the true actor

needed only a firm "mental conception of his character."[34] Makeup was not just a "crutch"; it was an obstruction to expression. He told the *Los Angeles Times* that he was "opposed to burying the expressive qualities of a countenance under layers of paint and wash": "I want the pores of the face to show on the screen . . . for that gives a final irrefutable touch to naturalness. Then the power of will can put the light of youth in the eye and take it out." The newspaper, however, could not resist a dig at the limitations of Hersholt's appearance for casting in film, noting that due to his "rotund" face and body, he could not have been cast as a romantic lead such as an exotic sheik. It reminded its readers of the aesthetic dominance in Hollywood cinema of an acceptable (and remember that "acceptable" is always culturally contingent) visual affinity between actor and character—a subject I explore further in the next chapter.[35]

As we see in contemporary reviews, there is a persistence of some of these aesthetic tensions, but it is also worth considering some of the ways the lines between photographic surface and character interior have been negotiated in order to habilitate makeup within frameworks of cinematic realism and acting artistry. Looking at the fan, trade, and news press of the 1920s and early 1930s we see evidence of attempts to habilitate transfiguring makeup for the screen within frames of cinematic realism and acting achievement. We see their continuance in the work of Chris Tucker's makeup for the title character in *The Elephant Man* and John Hurt's performance inside that prosthetic. We see attempts to mold makeup's connotations of stagey tawdry artifice into models of empirical mimesis. We see defenses mounted against the suspicion that makeup is a deceptive surface effect, a crutch for characterization.

## Anatomy, Observation, Surface, and Depth

From about 1922 Chaney was working defensively in interviews to reframe the public perception of his makeup and performance. He attempted to distance his work from stagey surface artifice and bring it into alignment with the more highly valued frames of realism and character depth. For instance, he proclaimed to the *Washington Post* that he did not "depend on whiskers and makeup for his parts," but closely studied people of the street, following them and mimicking the posture and behavior of the individual types he found in the street that might inspire his characterization: "The

man himself had to be studied, and not merely his outward appearance.... The most important thing in being able to enact a character is not to paint the character's face over your own."[36] Rather, Chaney believed that character was manifest in such things as "gait, a careless shuffle; by his slouchy carriage." In a key interview from 1927 with the *New York Times*, Chaney takes the reader through his process of preparing for a role, building on his previous comments about street observations and mimesis in performance, and framing his prosthetic makeup designs in terms of anatomical realism and knowledge of the human face: "Chaney never draws a line or builds an artificial contour that is not based on an exact study of anatomy. To do otherwise, he declared, would mean failure.... Muscle by muscle he builds it up." He stressed that his transformations were never simply about the surface of things. Rather, his synthesis of makeup and acting for each role relied on "a knowledge of human anatomy and the observation of human characters in action."[37]

Like Chaney, Paul Muni had come from the theater (European repertory traditions rather than the American vaudeville stage) and aligned himself with a more elevated discourse of "naturalism" even as he deployed obvious artifice for his character bodies. The fan magazines presented Muni as a star trying to define himself as a "serious actor" against the norm of stars capitalizing on and emphasizing their good looks and youth. Muni had a different approach to characterization from Chaney, however: inside out rather than observational mimesis.

Like Hersholt, Muni claimed to create his performances through thought, which transmitted naturally through the eyes and the voice. An admirer of Duse, he adapted her principles of working from the inside out. But he also understood the importance of makeup to enable him to sell a transformation in close-up. Makeup had to work with acting. For an aged character, he said, it was important to not simply put on the old-age makeup, but to "think old, and then your eyes look old."[38] Both Chaney and Muni saw makeup as an extension of proteanism in acting rather than a substitute for it, even though their approaches to characterization were quite different. Muni spoke of producing his characterizations from deep within himself, allowing his thoughts and feelings in character to manifest something fundamental to his character's identity in his body (which could be augmented with makeup). Chaney claimed to observe human bodies and "human nature" with a scientist's eye, and replicate what he saw with his makeup kit and body working together. Both claimed to use

strategies that fused performance and makeup, imaginatively transforming rubber into character flesh. These strategies provide the templates through which both makeup artists and actors behind makeup construct frames of aesthetic legitimacy around their work. Of course both Chaney and Muni, and before them Turner and Baggott, were promoted as actors who extended their proteanism with their skills in makeup application. Within the studio system, however, the makeup artist became a specialized industry position, distinct from acting, as Jack Dawn from MGM founded an association of makeup artists in 1926, and the major studios established makeup departments by the end of the 1920s.

The professional separation of makeup from acting, and the devotion of resources to makeup departments, served to further develop the craft, art, and science of makeup effects. In the early 1930s, for instance, *Film Daily* and *Hollywood Filmograph* individualized "make-up men" (for they were usually male) as creative craftspeople, charted the trajectories of their careers, and feted them on its front pages, with annual prizes for their work.[39] As a result of the new visibility of the craft of makeup artists, there developed a shift in how makeup effects were discussed and how, in turn, actors positioned their characterization development and performance process in relation to makeup.

Here we see the beginnings of a demarcation of responsibilities: while the makeup artist takes care of the character's appearance, the actor looks after the character's interior. As with performance capture, such demarcation means the actor has to do a little more to make their contribution visible and to connect their performance of interiority to the character's body. I want to turn now to the dominant prosthetic acting reference point for Andy Serkis, Hurt playing Merrick in Tucker's appliances. In what sense is this "seamless"? How was an illusion of actual suffering flesh achieved in the synthesis of foam latex and acting?

## Latex Layers and the Elephant Man's Breath

At the time of *The Elephant Man*'s release, the *New York Times* reviewer, Vincent Canby—a persuasive advocate for the aesthetic recognition of makeup effects in the context of historical biography and biological realism—praised the film, actors, and makeup artist. But he also acknowledged the potentially problematic status of Hurt's elaborate disfiguring

makeup, in terms of its generic associations: "John Hurt, as John Merrick, is a monster with a bulbous forehead, a Quasimodo-like mouth, one almost obscured eye, a useless arm, and crooked torso. It's to the credit of Christopher Tucker's makeup and to Mr. Hurt's extraordinary performance deep inside it, that John Merrick doesn't look absurd, like something out of a low-budget science-fiction film."[40]

We might see this as a special achievement considering that Merrick's appearance is gradually revealed through the murky visual register of horror. Shot in black and white so as to reduce the garish and artificial appearance of the makeup, the film recollects the Universal horror films of *Frankenstein* and *The Mummy*. The early framing of Merrick as a monster is deliberate, in order to take the viewer on a journey from gawker of an abject body to, eventually, a much more empathetic alignment with the man who lives inside this body, subject to the gawking and horrified gazes of others. The film reimagines and expresses the relationship of inside to outside, of character to body. It moves us spatially and emotionally from being a voyeur of Merrick's almost faceless exterior to understanding something of his interior. It brings us inside Merrick's experience of his own body, and attempts to conjure unseen anatomical and psychological depths. We are led to his onscreen revelation from behind the craning necks of gasping crowds and grubby freak-show exhibit curtains. We see him next as a distorted silhouette behind a medical screen exhibited to bearded respectable scientists. Finally we encounter him as a meek-voiced figure, his face hidden by a burlap sack. Once fully revealed, what we see is a misshapen figure and the faint glimmer of a wary eye from deep within rubbery masses of tumorous flesh.

It should be acknowledged that it is also the performed responses of his co-stars that in part scaffold or authenticate the character's deformity as "real." If we think of the moment in which Anthony Hopkins's character Frederick Treves first lays eyes on Merrick in the sideshow: this is a creep zoom into a sustained shot of Hopkins's reaction, where we see his eyes widen, overcome by what he sees, speechless in horror and pity as tears fill his eyes and stream down his cheeks. According to Hopkins, this shot was taken before the Merrick makeup was complete, so he was heavily reliant on his imagination to conjure the horror of what his character sees. We are privy to several reactions shots through the film: a nursemaid's terror; a stage actress's pity and compassion; various characters' disgust and discomfort.

FIG. 6 John Hurt completely unrecognizable and obscured behind Chris Tucker's makeup in *The Elephant Man* (DVD capture)

Although springboarding from creature horror into melodrama, this is a biopic, and this monstrous body refers to a real historical personage of whose physiognomy photographic, skeletal, and life-cast evidence exists. Tucker used the remains of Merrick's body to provide structural information for the prosthetic design. He found references in photographs of the real Joseph Merrick, written testimony from medical journals, as well as Merrick's skeleton and plaster life-cast of his face and torso (with the man's hair still embedded in the plaster), borrowed from the London Hospital Museum. From this he discovered the extent of Merrick's visible and invisible deformities. Protuberances (impacted wisdom teeth, a bone projecting through his jaw into the back of his spine) obstructed the man's breathing, speaking, and eating, while painfully twisting his torso. Tucker constructed an elaborate set of prosthetic appliances comprising twenty-two different pieces that had to be built up on Hurt's body and face, section by overlapping section, from a teeth plate worn inside the actor's mouth to the liberal use of foam latex in the simulation of the "large warty, smelly masses of flesh" encasing his cranium.

Hurt's performance is also informed by knowledge of the interior deformation of Merrick's body, as well as the plate in his mouth and the brace that forced him to limp. In terms of his physicality, he moves asymmetrically and stiffly, and becomes almost an object frozen in fear rather than flailing, when passed around by the cruel vicious underclass who torment him nightly. The actor's viscous snuffles, groans, and wheezes, his excruciating pauses and inhalations, his audible exertions to breathe and speak give a fleshy, suffering

FIG. 7  Anthony Hopkins's performance of the horrified, pitying gaze authenticates the horrifying "reality" of Tucker's makeup/Merrick's appearance before we see it (DVD capture)

materiality to rubber, a sense of mouth and airways obstructed by wayward growths and bony protrusions. The altered tempo of breath and wheezing tells us of his inner state from moment to moment. Hurt's performance does not just communicate a lifetime of agony in this body; he also conjures something of Merrick's lived social experience. When Hurt speaks, the timidity of his voice suggests he has spent a lifetime in this body. His utterances are not just strangled by internal deformations but he has also internalized the revulsion mirrored in the faces of those around him. This too is the impression described by some critics at the time. Roger Ebert, although disliking the film's shift from framing Merrick as object of horror to object of sentimentality, singled out Hurt's performance as "remarkable for somehow projecting a humanity beyond the disfiguring makeup."[41]

Canby raved: "The wonder is that the performance and what you might call the physical disguise are so decently matched that the only seams are those that join the sweetly patient, incredibly genteel John Merrick to the monster he inhabits."[42] Tucker's painstaking craftsmanship created a convincing facsimile of Merrick's appearance, but it was Hurt's largely vocal performance, and the reactive performances of those around him, that turned dead rubber into living, breathing, suffering flesh.

The way the actor and makeup artist work together to conceive the relation between interior and exterior are key to synthesizing a unified character body. We see variations in the ways contemporary actors speak about the relation between the visual aspects of the makeup and their performance.

These reflect different conceptions of the relationship between interior and exterior (or how appearance reflects or shapes character) and of the actor's contribution to the role relative to that of the makeup artist. On the one hand, we have actors like Tom Hanks who considers his long-time makeup artist, Danny Striepeke, a "partner" and collaborator in creating "the most physical manifestation of an actor's interpretation of his role."[43] In consultation with Hanks, Striepeke and his team design a face and a complexion for a character that, in the furrows of its expression, its porous or smooth skin texture, its scars or red wattling on the nose, function as an index for the kind of life the character has led up to this point. Past actions, environment, proclivities, appetites, and temperament are scored as if through time into the skin. This is an embellishment of the "inside-out" conception of character. But on the other we have an "outside-in" conception, with statements that attest to how we relate to our own reflection both in the mirror and through the eyes of others. For instance, a 1990 article on special effects makeup artist Bryan Holt, titled "It's Special Effects That Make the Actor," includes an interview with the actor Gary Burghoff, who the month before had worn elaborate makeup while shooting a film called *Small Kill* to play a psychotic killer who takes on his mother's identity. In makeup for six hours, Burghoff recalls looking in the mirror once the makeup had been applied: "When you look in a mirror you see a different person. It does something to you inside that makes the character come to life."[44]

To return to performance capture, how does it extend upon this lineage of makeup verisimilitude? When we focus on the interior/exterior relations that work the seam between makeup and acting, in what meaningful ways is acting for performance capture comparable or distinct from acting behind layers of rubber, latex, or silicon?

## Anatomical Verisimilitude and the Actor-Prosthetic Connection

Clearly the way prosthetic makeup artists like Chris Tucker draw upon anatomical verisimilitude for their character designs has foreshadowed the ways 3D character designers use detailed anatomical knowledge and models in the service of realism. We see also the ghosts of Chaney's observation and mimesis tactics in stories of the time spent by the motion-capture performers, who were largely ex-gymnasts and circus performers, attending

"ape school" in *Rise of the Planet of the Apes*. There, according to Terry Notary (the ex-stuntman who plays two ape characters), they observed apes and learned the principles of ape locomotion—allowing the front limb to absorb one's weight and squaring the shoulders before moving the back limb—and the ways apes focus intently on one object at a time. These actors wear prosthetics to extend their arms, enabling their bipedal human bodies to approximate the loping four-limbed gaits of the animals, and fangs to distort the human architecture of their faces. There is an evident continuity between makeup prosthetics and digital creature design and animation in terms of the forms of anatomical, kinetic, and behavioral knowledge that these spheres both draw upon.

As we have seen, the visual aspects of the makeup are important to some kinds of performance preparation, as they allow the actor to build a picture of their character's social experience behind this face: "What must it be like to move through the social world, encountering others, with a face like this?" Likewise, makeup artists often consider, "What are the life experiences that have molded this character, and how might this life leave its imprint on his or her skin in scarification and expression lines?" However, the most common discussion point for actors in interviews when talking about how a significantly transfiguring prosthetic appliance forged their connection to their character is their body and its discomfort—the time, the boredom, the itchiness, or the weight. Since Chaney and Karloff stressed the excruciating pain that their transformations required, references to the actor's physical discomfort in makeup prosthetics, the time spent in makeup, and the constrictions on the actor's body have been used to demonstrate their dedication to their art, as well as to authenticate their performance. For any such role we read about what the actor had to endure in terms of physical constraints on movement, vision, eating, drinking, bathroom breaks, not to mention the hours of boredom and waiting. For instance, *The Elephant Man*'s publicity placed emphasis on Hurt's seven hours daily in makeup for the role. We hear of the discomfort endured by his own body in the service of transformation, reminding us that beneath the foam latex is a man who for six weeks during filming could only eat "two eggs beaten in orange juice . . . sipped through a straw," and could not lie down while in makeup, so would have to nap, sitting up, "exactly like Merrick."[45] This is slightly different from the way that Ricou Browning's performance of the Gill-man inside the cumbersome and heavy suit in *Creature of the Black Lagoon* is discussed. The creature suit was just seen

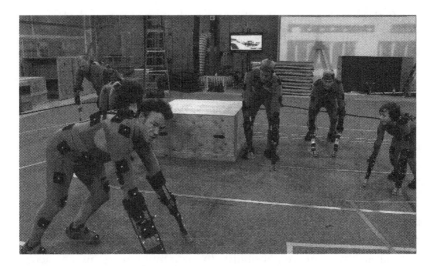

FIG. 8  Terry Notary and other motion-capture artists performing with arm-lengthening prostheses for *Rise of the Planet of the Apes* (Blu-ray capture)

as an encumbrance to sight and movement, something physically taxing: an obstruction, rather than an aid to a performance that communicates the experience of being this body.

While the suffering under latex line is a common discussion point, making the actor's labor legible and authenticating his performance, it can also play into the "makeup as crutch" line of criticism in which the prosthetic molds or dominates the portrayal, distorting the actor's stance or gait and forcing his mouth and limbs into shapes that produce the performance. For instance, Donna Peberdy, writing on *The Elephant Man* and Eddie Murphy's performances in the remake of *The Nutty Professor*, asserts that the prosthetics "dominate, obscuring or restricting the actor so that his agency is more difficult to determine."[46] While moving on to consider Hurt as "incorporating" the prosthetics into his performance, she refers more approvingly to the various late twentieth- and twenty-first-century stage productions of *The Elephant Man* in which the actor playing Merrick wears no makeup, but instead concentrates on manifesting a suggestion of Merrick's deformity through his own powers of bodily contortion and voice alone. Indeed, in a 1991 article praising the stage production, Stan Barouh disparages Hurt's performance in the earlier film with the line: "A few pounds of latex, a mouth full of marbles, a burlap cap and your aunt could play the Elephant Man."[47] In part Barouh is suggesting that visually

it is Tucker's makeup that does the work in the film to convey the horror of Merrick's body to the audience. But aurally too: the mouthpiece John Hurt wore restricted the dexterity of his tongue and teeth, and Barouh implies that the labored snuffling speech is not really something over which Hurt had a choice.

Performance capture, by contrast, according to *Iron Man 2* (2010) visual effects supervisor Janek Sirrs, is just like post-production applied prosthetics "but without the suffering."[48] Physicality and labor are still emphasized, but now this is consistently framed through terms like "empowering" and "liberating." Stripped of costume, wigs, masks, and the extra weight of suits and rubber that may itch, constrict movements, or involve debilitating excess weight to carry, the actor in the lightweight gray performance-capture suit has physically more freedom, more creative choice, and therefore, arguably, more responsibility for communicating his character's embodiment through his own contortions and movements. From this perspective, at least, performance-capture acting can claim a greater level of actor autonomy than does acting behind prosthetic makeup.

Besides liberation versus constriction, the other major difference we see between performance capture and prosthetics is the location of the performance and the communication of interiority in relation to the exteriority of the artificial body and face. If Chaney as the Phantom could (for retrospective viewers at least) use his languorous hand gestures to indicate an inner melancholic grace behind the cadaverous face, Hurt used vocalization to give a sense of a timorous suffering person inside horrific deformed features, as well as fleshing out a sense of his deformed interior. In the case of Caesar, however, Serkis's gesture and voice are of course present, but, rather than compensating for what the actor's obscured face cannot show, these performance elements supplement a digital conveyor (rather than a mask) of facial expression. According to reviews, Caesar's face brings us the uncanny sight of a fully sentient animal that, while silently observing, calculating, and strategizing, expresses a character arc from trust to bewilderment to anger and resolve, largely without words.[49]

It is telling how many reviewers praise Caesar for his unprecedented levels of "expressivity," in comparison to previous motion-captured performances.[50] But this comparison also means that digital effects become the film's point of evaluation, giving technology credit for the character. As Manohla Dargis says, "When Caesar scowls, as he increasingly does, you don't see just digital wizardry at its most expressive; you also see a plausible,

angry, thinking character."[51] Reading Dargis's review I am reminded of Dan North's analysis of Gollum in *The Lord of the Rings: The Two Towers* (2002), where he observes: "The character's face, assembled from pixels and programming, forms the visemes that correspond to emotional cues for the spectator to interpret as evidence of emotional states, and even though these are the result of a machinic mimicry of Serkis' own face, the computer's ability to convey those effects is what renders them spectacular."[52]

North foregrounds the extent to which we are encouraged to wonder at the technical apparatus that "conveys" the character's emotional states, wherever their originating point. So too, the spectacular value of Caesar's face for Dargis is that his expressivity is generated by computers rather than recorded by a camera. But other reviewers like Peter Travers and Dana Stevens, determined to give Serkis credit for Caesar, use his previous role as Gollum as a legitimating reference point: if that character and Caesar are both so compelling onscreen compared to the performance-capture characters in *Beowulf* or *Avatar*, then Serkis, as the common denominator between the two, must be responsible.[53] Moreover, he must be an actor of extraordinary expressivity for his performance to register through so many mediating and potentially manipulated layers of digital muscle, skin, and eyes. Nevertheless, as Roger Ebert admitted in his review of *Rise of the Planet of the Apes* while marveling at Caesar: "One never knows exactly where the human ends and the effects begin."[54]

In the face of such doubt about the actor's contribution, "fidelity," as we explored in chapter 1, becomes a key if problematic term—for fidelity is relative rather than absolute. It is used repeatedly by Serkis and in some industry articles to frame both the performance-capture apparatus and the relationship between Caesar and Serkis. The digital character rig is seen not as a mask or even as just a conveyor of character expressivity but, importantly, as a conveyor of human performance. Jon Landau, the producer of *Avatar*, argues that performance capture is "more organic and more true to the performances" than acting "behind half an inch of latex."[55] This also means that as a visual effect, Caesar functions very differently from Chaney or Tucker's prosthetic faces.

Due to its direct physical contact with the actor's body and face, prosthetic makeup gathers part of its spectacular value from the way it transfigures actors and makes them unrecognizable, even when they are onscreen. Confronted with images of an actor both in and out of prosthetic makeup, we are invited to marvel at the points of difference between Chaney's or

Hurt's real physiognomy and that of their characters. For instance, Tom Buckley marvels at the dramatic difference in bodies between Hurt, "a slim man of medium height," and the bulbous, misshapen figure onscreen.[56]

In contrast, the digital character, being already a wholesale replacement in screen-space of the actor's body and face, gathers its spectacular value from the ways it appears to retain a recognizable connection to the actor. We saw this in chapter 1 with Peter Bradshaw's excitement at recognizing Mark Rylance's "trademark" expressions in the giant of *BFG*.[57] So too, the split-screen footage that pits Serkis against the final rendered Caesar invites us to compare and marvel at the ability of the technical apparatus to convey or remain faithful to the performance, no matter whether this is directly and automatically informed or animated from reference footage. Performance, then, is conceptualized in some reviews not as something "beneath" or "inside" the digital character, but as the actor's kinesthetic trace, through which Serkis "invests" or "imbues" Caesar with personality, "life," or "soul."[58]

I would argue, however, that despite these different conceptualizations of the actor's location in the role between makeup and performance capture, there is some commonality of achievement in how both Hurt and Serkis make their characters seem alive and present onscreen. *The Elephant Man* has been commonly understood as being about the horror of a gentle soul trapped in a beastly body, and of Hurt "projecting the humanity" behind this mask. Serkis's contribution to Caesar has been promoted in similar terms as the "soul" in the ape's digital body. In both cases, this Cartesian model for conceiving the actor's relation to a character body is too narrow, and does not account for how these characters move us. I have said that Hurt communicates Merrick's embodied existence: not just his physical suffering, but his internalization of the revulsion of others. It is only by trying to imagine what it is to live in this body and accrue the wounds of its social and physical history that he can imagine Merrick's interiority. In a truly seamless performance, the interior and exterior are fully imbricated.

So it is with Caesar. Caesar works not because Serkis plays him as a human soul in an ape suit, but because he plays him, even as an ape with superior cognition, in a fully embodied way. Caesar's fortunes and experiences, his ways of being in the world, and his persona are very much tied to and shaped by his chimpanzee body—not just this body's capacities, flexibility, strength, and unbridled joyful movement, but how this body has been treated by others. Because of his animality, humans have coddled, stroked, and engaged

him, but then they have abandoned him, deprived him of his freedom, humiliated him, and cruelly doused him with freezing water.

As we have seen, there are challenges for actors who are invisible onscreen, either behind transfiguring makeup or lending their performance to a digital character. Even when actors communicate a compelling interiority for their character and seem fully connected in their performance to their character's body, their creative labor can be effaced by critics who conflate character exterior and interior rather than seeing the work entailed in making the two connect in a seamless fashion. Broadly, then, performance capture does sit with the lineage of prosthetic makeup, as it has extended upon the same frames of value for both acting and the creation of artificial bodies.

There are some key differences, however. Caesar's body is, as we saw at the start, anatomically correct all the way through. It is not built up, piece by piece, upon Serkis's body. This lends it greater verisimilitude as an ape's body in the way it looks and moves than if it had been produced through prosthetic makeup. Moreover, on this furry chimpanzee face are written all Caesar's emotions and thoughts. Performance capture enables Serkis to communicate his characters' interiority with facial expression, as well as voice and gesture, where in the past, prosthetics, no matter how flexible and thin, have often been a distraction or obstacle to facial communication. In this way the technology positions itself as overcoming some of the aesthetic and performance problems of makeup as it recuperates cinema's most cherished site of character interiority, the face, even if this face does not belong to the actor.

# 3

## In Another's Skin

---

### Typecasting, Identity, and the Limits of Proteanism

> It is a question to my mind whether this reverting to type of the film player can ever be combated. It has become such an inherent part of the film art, and there are at present set limitations in makeup, and opportunities for variety of expression, that a player simply cannot lose himself in a role that is alien to his previous experience.
> —Edwin Schallert, "Just By Way of Argument," *Los Angeles Times*, June 18, 1922

One of the more utopian claims made about performance capture is that it promises to revolutionize how screen roles are cast. "It's the end of typecasting," declared line-producer Remington Scott in an interview in 2001; "looks don't matter for these actors."[1] While promoting *The Polar Express* (2004), in which he played five roles, including children, Tom Hanks was effusive: "You will no longer be limited by your size, shape, skin color, gender, none of that is going to matter. If you have the interpretation that the

director wants for the role, then you can play any role, I could play Florence Nightingale, I could play Abraham Lincoln, Meryl Streep could do the same thing."[2]

Similarly, when promoting *A Christmas Carol* (2009), Jim Carrey said, "If I have it in my soul to play a certain character it doesn't matter what my face looks like and what my age is and that's liberating."[3] As long as the actor can muster the appropriate posture, gait, gestural repertoire, expressiveness, voice, or "soul" for that character, FX artists or animators will take care of the character's contours, physiognomy, distinct capabilities, and complexion. Prosthetic makeup has long supported such actorly transformations, as we explored in the previous chapter. On the face of it, tools such as performance capture (and in related ways, digital face replacement and other means of transforming, augmenting, or reducing the actor's body or features) promise to extend the range of an actor's transformation, making their embodied identity irrelevant. If true, this has significant implications for not just the performer's labor market, in which appearance plays such a central role for casting, but also for wider sociocultural issues around representation. As Tanine Allison suggests, in an essay on the politics of race in performance capture and animation, "Severing performance from bodies with particular racial, ethnic, and gender identifications, motion capture might hold open the promise of a truly post-racial form of representation."[4] Her conclusions in this regard, though, are ultimately pessimistic: she argues that George Miller's *Happy Feet* erases the black tap-dancer Savion Glover from the screen while appropriating his black performance style for a "white" penguin, voiced by Elijah Wood. This suggests similarities to Scott Bukatman's arguments about morphing, which, "like so many tantalizing digital dreams . . . holds out the promise of endless transformation and the opportunity to freely make, unmake, and remake one's self," but, when understood historically against the background of what Michael Rogin calls "American self-making," reveals a dark underside in which some identities are erased, appropriated, or excluded.[5]

In this chapter I take a wider view of various bodily and, by extension, identity constraints on protean acting. After a discussion of typecasting and proteanism in performance, I turn to specific bodily considerations in casting, such as height, gender, and race, and the ways they intersect with economic, aesthetic, and sociohistorical conditions, to limit or enable actors' mobility across roles. By examining the nature of these various limits on protean acting, we can see something of the extent to which digital

bodily transformation techniques are reconfiguring the screen performer labor market, and the relevance or irrelevance of the actor's body and appearance to the casting and reception of roles in which they are invisible or digitally transfigured.

## Typecasting and Proteanism

Typecasting—the term for a historically shifting cluster of interrelated casting practices related to the idea of the individual as a visual representative of a "type"—precedes the cinema. According to Pamela Robertson Wojcik, it is an industrial practice historically continuous with the nineteenth-century repertory theater, in which actors specialized in different categories of roles (leading man, comic sidekick, ingénue, matron, villain, etc.) suggested by their appearance.[6] Characters as stock types are much older, of course, if we think of the masked stock characters of the commedia dell'arte. In film, typecasting practices have been shaped and sustained by film's relation to photography and actuality, and the close-up's revelation of facial detail. Film, much more than the stage, has a requirement for things and people to look and sound as we expect them to look and sound, except where meaning is served by having that expectation subverted. Indeed, Edgar Morin, referring to the work of Vsevelod Pudovkin on "natural types" in cinema, insisted that the dominant concern in casting an actor was "the immediate, natural signification of his face and body" and that "the physical type tends to equal or surpass in significance the traditional imitative skill of the character actor."[7] Some decades later, Barry King acknowledged the implications of the "gross details of physical endowment" for how we read type and character, and saw that actors had limited prospects for being "moved out of naturalistic personality implications of his or her physique, however stereotypically or factually wrong these are."[8]

Wojcik provides a couple of benign examples: in the Hollywood system of facial casting, the ingénue is more likely to be played by a young, fresh-faced actress than one who is heavy-set and elderly, and an actor who has a squashed nose and cauliflower ears is more likely to be cast as a heavy or boxer rather than a banker or other executive type.[9] This particular example of what we might call "phenotype casting" is underpinned by a belief that the face and body manifest the exterior marks of a career, or

how a life has been lived, and so provide the audience with an unadorned visual shorthand to character: a kind of person, a kind of life.[10] According to the historian Miles Orvell, such beliefs have a cultural history as, in the nineteenth century, photographic portrait galleries disseminated and cemented conceptions of individuals as representative of social types. He notes that while photography was conceived in artistic terms as being able to truthfully "capture the living quality" of the individual subject's specific selfhood, at the same time it perpetuated the generalized social category of the "type," whether that be a type defined by an occupation, an ethnicity, or a category of race, gender, or class. This is not at all to say that the idea of social types originated with photography—indeed, we see them in caricatures, cartoons, and in the theater, long before this point—but photographic practices seemed to bring a scientific and "objective" precision, reinforcing beliefs about appearance as containing verifiable markers of identity and character. Visual type categories were reinforced through exhibition or booklet captions, discourses of phrenology, or face-reading. To an extent, then, phenotype casting draws its representational power from (and sustains beliefs about) social, racial, and ethnic categories perpetuated through photography, literature, journalism, and pseudo-scientific frameworks.

At the same time, though, typecasting is not entirely determined by physiognomy, and natural signification has often required artificial assistance to produce characters as types—whether that be plastic surgery, wigs, diets, corsets, shoe lifts, padding, or makeup. As Wojcik explains, typecasting or typeage provided guaranteed continuity of work in the repertory theater companies of the nineteenth century by allowing actors to specialize in particular kinds of parts or a "line of business," for which they provided their own costumes and makeup.[11] Similar practices shaped early film casting too, as photoplay producers employed a company of performers, each of whom could slot into particular kinds of roles suggested by their appearance. Most of the photoplay acting vocational guides of the 1910s have a chapter urging readers to scrutinize their own face for signs of a recognizable type (the wide-eyed, button-nosed, hometown girl; the sloe-eyed vixen; the heavy-featured, double-chinned matron; the heavy-browed villain) that they might cultivate with hair, costume, and makeup and delineate with bearing and performance style. For actors to find employment, they had to shape themselves in advance into a recognizable exploitable social category and character archetype. The star system took over this

task, molding raw actors into types, experimenting with them in different roles and costuming until the audience seemed to approve a fit.[12]

We saw in the previous chapter, though, that the actor as type was seen as a problem for building esteem for movie acting, and at various times in film history the type has been held in opposition to the more esteemed protean actor who, chameleon-like, disappears into various roles. As Wojcik says, "In most modern discourses on acting, the notion of the actor as type is viewed as a sign of the actor's lack of talent, a limitation imposed on the actor by a brutal and unimaginative studio system, a sop to audiences' inartistic tastes, or a combination of all three."[13]

According to Michael Chekhov, "the desire and the ability to transform oneself are the very heart of the actor's nature."[14] At a Screen Actors Guild event in early 2012, one of the growing number of actors who specialize in performance capture, Julene Renee, claimed that it is a more demanding form of acting, because it strips away all the externals of physical appearance. Without makeup, hair, and costume, the actor is left with nothing to rely on but their "acting skills."[15] So, too, Sean Aita argues that separating actors from their appearance emphasizes the value of "transformational character acting skills," enabling actors to explore identities, inner lives, and ways of being far from their own.[16] Performance capture, Aita says, allows actors to more easily shed their own skin and to fulfill Chekhov's instruction to "clothe" themselves in the "Imaginary body" of a new character.[17]

Chekhov believed the actor's imagination should conjure into being a character body that might be older, younger, taller, thinner, or fatter than his or her own. After developing a clear picture of this body and how it moves, the actor should transfer her physical body into this "Imaginary Body," following the "characteristic movements and shape of the Imaginary one."[18] Ideally, the two bodies, real and imaginary, should be merged into one. But he acknowledged that such a merging was not always possible, for "there are limits given by the nature of the actor's body." This means that Joan of Arc could not be "acted by a heavy elderly lady" and "Falstaff cannot be produced by a young, thin boy." Nonetheless, he urged actors to avoid "narrowing down all the parts to their own bodily capacities," for no "true actor" should continuously repeat or confine themselves in this way. A true actor should aim for proteanism, pushing the transformative capabilities of the body to its limits.[19]

However, even with the demise of the star system in the 1950s, and the corresponding rise of the actor as freelance worker, most actors still sustain

a screen career by specializing as a particular type of persona, expressed as a combination of physical and personal characteristics. For instance, it is difficult to imagine Joe Pesci playing anything other than a fast-talking, volatile street tough. But it is not Pesci's unremarkable face with its deep naso-labial folds, small eyes, and generous nostrils that confines him to this type, and neither is it his compact body. Considered in isolation, his body and face might just as easily lend themselves to an affable uncle in a cable-knit sweater. Pesci's type is less located in phenotypical appearance than a persona: a voice (that semi-helium New Jersey trumpet) and a rhythm and energy of compact movement and speaking that evokes Jimmy Cagney in the way he switches from deceptively soft to mean and jabby in quick pugnacious bursts. His occupation of this type is, of course, largely due to the actions of casting directors who have continued to place him in such roles, but it could also be seen as something fostered by the 1970s New Hollywood context in which he emerged. This is a context that Julie Levinson sees as shaped by the rise of identity politics and the performative flaunting (rather than effacement) of ethnicity in screen acting.[20] In repetitions and variations, this is what he has become known for over a number of films—witness *Goodfellas* (1990) and *Casino* (1995).

Christine Geraghty usefully creates a typology of acting stardom that distinguishes between stars as celebrities (who, like Gwyneth Paltrow, are known more for their offscreen life), stars as professionals (those actors, like Pesci, who are known for their personification of a type in their roles; Karen Hollinger adds Meg Ryan's and Julia Roberts's "romantic comedy" personas to this category), and stars as performers.[21] It is in this last category, Geraghty says, that stars are the most esteemed because they engage in "impersonation" rather than personification. We might classify protean actors such as Meryl Streep, Daniel Day-Lewis, and of course Andy Serkis within this category: in each case, their star image foregrounds their acting skills and their abilities to transform themselves from role to role. As we shall see, Geraghty's distinction between personification and impersonation in acting stardom is useful when it comes to determining the rationales used for casting actors in performance-capture roles. Her distinction helps us consider what it is that a particular actor brings to a part in which appearance is supposedly irrelevant.

Geoff King says that the star as professional/personifier is more common than the star as protean performer/impersonator, as specialization makes "strategic sense" in a labor market in which actors are in oversupply,

and the vast majority are usually out of work. Marketable personas turn acting stars into "profitable commodities with unique selling points, individual brand images."[22] Barry King argues, though, that the contemporary landscape of stardom requires a greater plasticity and proteanism from stars (even as their brands have to remain recognizable), in order to deal with the vicissitudes of the fickle entertainment marketplace and the proliferation of media avenues through which they can be known or exist "in public."[23] King is talking about the plasticity of the star's persona and projection of mutable, multiple, offscreen selves. A level of proteanism or versatility, however, is increasingly important for actors onscreen as well as off. Being protean onscreen has many advantages: when actors perform across genres (action, melodrama, gross-out comedy, hard SF), they can multiply their appeals to different audiences and increase their marquee value. Their mystique is deepened as they seem to reveal and flesh out various facets of their selves on the screen, making any glimpse of a veridical self seem ever more elusive.

It is also commonly recognized that acting awards and nominations are routinely skewed toward actors (most usually white) taking on identities, conditions, and appearances very different from their own, such as mental or physical conditions (Joanne Woodward in *The Three Faces of Eve* [1957], Sean Penn in *I Am Sam* [2001], Dustin Hoffmann in *Rain Man* [1988], Russell Crowe in *A Beautiful Mind* [2001], Eddie Redmayne in *The Theory of Everything* [2014], Julianne Moore in *Still Alice* [2014]); transsexuality (Felicity Huffman in *Transamerica* [2005], Hilary Swank in *Boys Don't Cry* [1999], Redmayne again in *The Danish Girl* [2015]), and, going further back, nonwhite (Luise Rainer in *The Good Earth* [1937], Yul Brynner in *The King and I* [1956], Marlon Brando in *Viva Zapata!* [1952]).[24] Indeed, it is evident that Andy Serkis, when vying for an Oscar nomination for his role as Caesar the chimpanzee, sees himself as working in this same tradition of identity switching.

While these actors have won praise and recognition for their humanized inhabitations of otherness, this reminds us that characters defined by their otherness have been longstanding exceptions to the casting norm of natural signification. Very few actors who are actually transsexual or disabled get to perform characters onscreen in significant, fully fleshed ways, and when on occasion they do, they are generally perceived as playing a version of themselves. Marlee Matlin, the deaf actress who won the Best Actress Oscar for *Children of a Lesser God* in 1986, is one notable example.

Television seems to be leading the way in authentic casting, with transgender actresses Candis Cayne in *Dirty Sexy Money* (2007–2009) and Laverne Cox on Netflix's *Orange Is the New Black* (2013–), and R. J. Mitte, an actor with mild cerebral palsy, playing Walter White's son on AMC's *Breaking Bad* (2008–2013). But again, oftentimes audiences do not fully credit such actors for playing someone much different from themselves.

In a previous era, the same constraints applied to actors of color. Indeed, activist groups point out that this is still the case, as such performers tend to be pushed into marginal supporting roles or roles centrally defined by their race and ethnicity. As Tom Gunning reminds us, "The option to transform is not available to everyone."[25] The great majority of actors who are given license to transform their appearances and identities to play humanized "others" are white, able-bodied, and embodying the gender they were assigned at birth.

In understanding who gets to transform and who does not, the rationales for casting actors in particular roles where their bodies are transformed, and the extent to which this changes in the age of techniques such as performance capture, it is necessary to consider actors' bodies. In placing actors' bodies at the center of this discussion, it is helpful to consider different performers as working along a continuum from "fixed" (seen as playing "themselves") to "protean." For it is not just their transformative acting skills or their industry rank, but the signifying properties and physical range of their bodies that determine how far they can move from the fixed to the protean end of the continuum. I examine those who have greater or lesser mobility along this continuum below, but first let us look at those performers who, by virtue of their bodily characteristics, usually occupy the "fixed" end. These are performers with highly distinctive body types, defined by their unusual stature (with Andre the Giant at one end of the scale and Verne Troyer at the other), shape, or disfigurement. Their bodies place the strongest limits on their possible range of physical transformation as they occupy specialized labor niches in which they are usually, with some notable exceptions, cast for the distinctive qualities of their appearance.

## Lines of Business, Body Size, and Digital Dwarfs

Take actors of very short stature. With the exception of a very few actors, such as Peter Dinklage and Warwick Davis, who have managed to develop reputations for range and screen presence, these actors are more usually

limited to those roles that are primarily defined by their physical size. Very short actors find work as dwarfs, the furry teddy-bear-like Ewoks in *Star Wars VI: The Return of the Jedi* (1983), the Munchkins of *The Wizard of Oz* (1939), the Oompa Loompas of *Willy Wonka and the Chocolate Factory* (1971), and sometimes, too, precocious young children. Some activists within the restricted growth community deplore the casting of dwarfs in fantasies to play what they see as essentially "warm props" that further stigmatize or "other" short-statured people. Given that such roles are rarely fleshed out or sufficiently individualized, they have unwelcome echoes of the freak show.[26] But little people who have chosen to become performers covet such roles as a source of income and a venue for creative expression.

So it is understandable that digital technologies that can shrink or replace a normal-sized actor's body with that of an anonymous smaller one (on a much lower wage) are perceived as a threat to their line of business. After all, where *Willy Wonka and the Chocolate Factory* in 1971 cast at least ten dwarf actors (uncredited, and all male) to play the orange-faced, green-haired Oompa Loompas, only one, Deep Roy, was cast in Tim Burton's 2005 glitzy remake *Charlie and the Chocolate Factory*. Roy was digitally cloned to produce 165 perfectly identical Oompa Loompas performing elaborate synchronized dance numbers. Burton's choice here apparently had an aesthetic purpose of absolute weird technological sameness rather than being born necessarily from the desire to cut labor costs. Nonetheless, its net effect was to close down an employment opportunity for performers whose casting versatility is already tightly restricted by their stature.

Little actors lost potential employment again in *Snow White and the Huntsman* (2012), as seven "normal-sized" British character actors, including Ian McShane, Bob Hoskins, and Ray Winstone, were cast to play the Seven Dwarfs "through a combination of visual effects and old school trickery."[27] By "old school trickery" director Rupert Sanders refers to the use of selective camera framing from waist height, with actors on platforms or trenches to create height differentials between the normal and dwarf characters. Dwarf actor doubles in prosthetic masks were also filmed in long shot, or shot closer with their faces digitally replaced by those of McShane, Hoskins, et al. Moreover, the normal-sized actors themselves also had to contribute to the illusion of their own shrinkage, by having to learn how to walk as if their legs were very short. They reduced the length of their stride and changed their bodies' center of gravity so that they seemed to rock from side to side as they perambulated through the forest.

The casting move was met with protests from various small actors and organizations such as Little People of America, who threatened the film's studio, Universal, with a "Hundred Midget March." Their argument was that such roles should only go to short actors, and that this was the equivalent of minstrelsy or blackface. As Warwick Davis argued, "It is not acceptable to 'black up' as a white actor, so why should it be acceptable to 'shrink' an actor to play a dwarf?"[28] While not an entirely apt analogy, as we shall see when I explore race-change performance below, the impact on the labor opportunities for dwarf actors still stands. Universal, however, chose to ignore both the labor market and social justice terms of the criticism, and instead reached for an argument about artistic respectability and the fiscal reality of filmmaking. A spokesperson for the studio thus claimed that the casting decision for the roles was based not on "body-type" but the "pedigrees and recognizability" of actors such as Bob Hoskins.[29]

However, there are no opportunities for actors to become recognizable and, by extension, valuable unless they are given roles that are individualized. If confined to employment as "warm props," lending atmosphere to movie environments, they can never develop a reputation and in the digital age are all too easily replaced. It is notable, perhaps, that Dinklage has, wherever possible, played individualized characters and refused such "warm prop" roles—in his first speaking role in *Living in Oblivion* (1995), a film about making a film, he plays a disgruntled dwarf actor who walks off the set in disgust at being asked to function as part of a surreal atmosphere. He has developed and embellished a persona across films, one with enough balance of recognizability and proteanism to allow him mobility. Nonetheless, whatever character Dinklage plays will always be one that is defined by its short stature. It is difficult to imagine that *his* "recognizability and pedigree" would lead to him being cast in a normal-sized role that deployed digital heightening techniques, in a labor market so crowded with normal-sized actors.

The great majority of actors, including stars and supporting players, range across the long middle of the continuum, with smaller or larger ranges for each, and greater or lesser opportunities for proteanism. McShane, Hoskins et al., even though digitally transformed into dwarves and wearing a lot of prosthetic makeup, were cast to be recognizable. The aim in casting them seems to have been to create the spectacle of the familiar rendered slightly unfamiliar, while requiring the actors to evince something from within the persona ranges they had established over their previous

roles. And yet there was still some proteanism here, in the physical sense. The work the actors had to do in order to seamlessly embody the dwarves by learning to walk with a different center of gravity, rocking side to side, might remind us of Chekhov's statement about an actor having to conjure his character's Imaginary body and work to merge his real body with the Imaginary one.

And yet, how should we understand the limits of the actor's real body in relation to the Imaginary one in performance capture, if there appears to be little congruence? To what extent is it actually true that appearance is irrelevant in performance capture? I turn here to look at the casting of the five-foot-ten, barrel-chested, middle-aged Ray Winstone to play the six-foot-six, strapping, tanned, blond-braided Viking warrior of legend, Beowulf.

## "Uber-buff" Beowulf and Ray Winstone's "Salt of the Earth" Masculinity

Most of the other lead and supporting actors in *Beowulf* (2007), such as Anthony Hopkins, John Malkovich, and Angela Jolie (with the addition of some enhanced curves, gilt-dipped skin, a sinuous tail, and bizarre stiletto-heeled feet), drove digital character bodies that were modeled on the appearances of the stars themselves.[30] Beowulf, however, with his rippling six-pack and straining quads, bore little resemblance to Winstone. Facially we might see a little of Winstone's porcine squint and high nasal bridge built into the character's golden, square-jawed physiognomy, as if the two were distant cousins. Truly, the actor's appearance here counted for naught in casting the role. But could we say that allowing Winstone to shed his portly beer-fueled frame and clothe himself in this new body emphasized his skills in transformational character acting? Apart from the fact that it allowed a character actor to become a leading man—thus challenging King's declaration that "Ernest Borgnine can be made into a better-looking Ernest Borgnine, not another Robert Redford"[31]—it was not really understood or valued as an instance of acting proteanism.

In part this was due to the connotations attached to this particular type of character body. Beowulf's appearance is one loaded with the markers of contemporary masculine star glamour. Such bodies—like those of

Channing Tatum and Chris Hemsworth—are indexes of the labor that goes into maintaining their contours and surfaces, such as disciplined workouts with personal trainers, regular spray tans, facials, and body waxes. For journalists, the substantial differences between Winstone's body and that of his character were a topic of fascination, bringing the focus squarely back to issues of appearance. "How Did Ray Winstone Lose 30 Years and 70 Pounds?" asked one headline, above an image of Beowulf clasping a sword, his lightly muscled arms swinging wide, abs clenched, in a posture of warrior-like readiness. Writer Geoffrey Macnab explained: "His body, in short, is not exactly his own. [Robert] Zemeckis has used the same digital chicanery he brought to *The Polar Express* to give the warrior-hero an uber-buff physique."[32] Macnab reads Beowulf's body in relation to those of flesh-and-blood action stars such as Johnny Weissmuller, Steve Reeves, Arnold Schwarzenegger, Daniel Craig, and Matt Damon. He argues that such screen bodies are appreciated mostly for the grueling discipline and effort of their owners in following and sustaining an exercise and diet regime. As Richard Dyer explains, the white muscle-bound or "built" body tends to be read as an index of its owner's willpower and self-discipline, a visual manifestation of character, or "the spirit reigning over the flesh."[33] And so, Macnab suggests, how can we be impressed by a transformation for which the actors themselves can take no physical responsibility?[34] Winstone had to make his labor in the role apparent by stressing his physicality in driving Beowulf as a body of *action* rather than just a figure marked by great hair and muscle tone. Claiming that he broke "two or three ribs," Winstone insisted that playing Beowulf was "the most physical job I have done in my life. I was on wires, running up walls and spinning."[35]

So, for reasons similar to those explored in chapter 2 about the need to locate the presence of the actor in a performance-capture role, entertainment journalists such as Kevin Maher drew a line of connection between actor and character that focused on Winstone's "inner toughie." This was an image of character collated from the actor's interview anecdotes of punch-ups in London's East End, which were told in an accent that bore the origins of his working-class upbringing in Hackney, and his previous roles as gangsters, hard men, and working-class wife beaters. Maher concludes that "Winstone projects... roughhewn authenticity and salt-of-the-earth machismo."[36] Although the body was not Winstone's own, the actor's pedigree and screen persona imbued Beowulf with a kind of "authentic" masculinity rooted in the streets and the boxing ring, rather than the spray-tan salon and red carpet.

This makes visible some basic contradictions of contemporary white consumer-culture masculinity, as it is increasingly caught between an image of an ideal body (a body that requires diligent grooming and maintenance in order to deem it acceptable as a visual commodity) and a traditional masculinity as hewn in action without regard to one's fitness to receive an approving gaze. In this light, Winstone's casting seems a strategy both to offset the technological artifice of Beowulf's digital origins and to ground the character's masculinity in roots that suggested a warrior's heroic and active life, rather than the disciplined cultivation of an appearance for its own sake. In this case at least, the actor was selected not so much for what he would do in the role but for the connotations of his offscreen appearance and type. The actor's persona ghosts the onscreen character (a character who, if human or human-like in appearance, may itself evoke typage connotations). The actor as type and the digital body's phenotypical associations are brought into a conversational dance. But the cultural politics of some kinds of casting are more historically fraught than others, and different kinds of conversational dances between actor and role are more vexed.

## Pale Imitations and White Mediations

Consider the furor surrounding the casting of Zoe Saldana to play Nina Simone. For this role, Saldana, a Black-Latina actress, had to darken her caramel skin to a dark cocoa hue, don a tightly curled Afro wig, and wear a prosthetic to broaden her nose. The use of facial structure prosthetics, wigs, and makeup to approximate the appearance of a historical figure is usually unremarkable in biopics (unless poorly achieved). But in this case there was a lot of anger from both Simone's family and some African American critics, with charges of "blackface" and "pale-washing." From their perspective, here was a lighter-skinned, finer-featured actress, whose mixed-heritage looks have allowed her a commercial mobility, being given an opportunity over darker-skinned, less commercially mobile actresses to play an iconic black singer who defiantly put her own blackness at the front and center of her identity. Despite the best efforts of the actor and makeup artist to merge the real and imagined-real body into a living unity, reception can refuse this unity. Unity here is refused on political grounds that maintain an awareness of historical patterns in casting and representation.

Moreover, roles for both Latina and African American actors are so scarce that it should not be surprising that they are so contested.

At the same time, though, Saldana has claimed that the darkness of her skin has blocked her from being cast in Latina roles. Despite her heritage, she has not "looked" Latina enough to casting directors, who have instead cast her persistently in African American roles. Her career trajectory speaks to the fluidity and ambiguity of racial and ethnic identities, and the problem of racial phenotypes in casting, given that they serve to perpetuate narrow conceptions of racial appearance. As most social theorists recognize, race is less a biological fact than a complex social construction. It is a myth that has, through the accretion of historical policies and practices of social division stemming from colonialism, become a "social fact," even as that "fact" and the boundaries of its divisions are in continual flux. Yet the criticism of Saldana's casting as Simone threatens to police and demarcate racial boundaries and maintain a fixed conception of *authentic* racial phenotypes.[37] We might ask, if the social divisions of race have caused so much harm, why work so hard to maintain them? Such a question implies that the playing field of actorly transformation and racial fluidity would be an equal one for all actors, if only people weren't so hung up on perceived racial authenticity. History, however, suggests it is not that simple.

As noted above, the option of transforming one's racial or ethnic identity for a role has been overwhelmingly the privileged domain of white actors, such as Brando, Muni, Chaney, Rainer, but also more recently Angelina Jolie in *A Mighty Heart* (2007) and Jake Gyllenhaal in *Prince of Persia* (2010), among others, or those of ambiguous racial appearance, such as Anthony Quinn, the Mexican American actor who over his career played Native American, Greek, Italian, and Mongolian characters.[38] Nonwhite actors (of Chinese, Native American, or African American heritage) in such films have been relegated to support or background, their function reduced to authenticating atmosphere and validating the lead actor's racial performance.

The reasons why the "natural signification" tendencies in Hollywood facial casting have consistently *not* applied when casting nonwhite roles are complex, bound up with industrial factors and conceptions of race, ethnicity, and normality/abnormality. For instance, Karla Rae Fuller explains why the role of O-Lan, the long-suffering, fragile Chinese martyr peasant in *The Good Earth*, went to German actress Luise Rainer rather than to the biggest Asian American star of the 1930s, Anna May Wong. In part this

was because Paul Muni had already been cast as O-Lan's husband, Wang, and the film was made under the Production Code, which had strict rules against even hinting at racial miscegenation. The anxiety of miscegenation could be conjured by pairing an Asian actress with a Caucasian actor, even though in this case they were both playing characters who were Chinese. As Gunning says, such casting "protects the Caucasian audience from a direct contact with the ethnic Other."[39] The other problem, according to Fuller, was that actual Asian actresses did not fit the romanticized orientalist conception of Chinese femininity that the producers had in mind. Rainer, her delicate frame straining nobly under bushels of wheat, won the Oscar, Fuller quips, because "it takes a white person to portray a real Asian."[40] This is part of a longer pattern in which performances by or of race or ethnicity have been shaped by white cultural conceptions.

Similarly, in her work on the "Indian Pictures" produced from 1907 to the mid-1910s, Alison Griffiths notes that while many pictures were promoted as featuring "real Indians," often the lead roles were cast with non–Native Americans in costume and makeup. As she points out, it made no difference whether or not actual Native Americans or Euro-Americans played the roles, "since many native people do not conform to stereotypical preconceptions" and racial and ethnic identities are "fluid and multidetermined."[41] What is clear when examining reception, however, is that urban audiences perceived the casting to be authentic when the onscreen behavior of Indian characters matched their expectations of Indianness. Such expectations had been generated through popular literature, nineteenth-century paintings, and traveling Wild West shows. These cultural forms had constructed the Native American as a tragic and noble remnant of a dying people trapped between cultures and times, beyond the capability of assimilation. For instance, a 1910 review of a Kalem picture, *Indian Pete's Gratitude*, makes no mention whatsoever of casting, whether authentic or otherwise, noting only that the film is pleasingly melodramatic and "depicts the well-known Indian characteristic of gratitude for a kindness done."[42] By contrast, a few pages later, a review of one of D. W. Griffith's many Indian pictures for Biograph, *The Song of the Wildwood Flute*, registers amusement at the "pitiful endeavors" and contortions of white actors attempting to "impersonate Indians."[43] The reviewer seems oblivious to the fact that the lead male role was performed by Dark Cloud, a Native Canadian actor of the Algonquin people. They indicate only that "white people" are impersonating Indians when they cannot (not "should not," for the

reasons of cultural sensitivity we hear today, but "cannot," due to perceived irreconcilable racial and cultural differences).

The persistence of particular tropes around race and ethnicity (as well as other forms of otherness) sustains prisons of belief, expectation, and judgment. These are very difficult to break, as through persistent repetition they gain the status of truisms. The power of blackface to naturalize narrow and damaging conceptions of blackness was reflected in the views of ambivalent African Americans surveyed by *Radio Digest* in August 1930 on *Amos 'n' Andy*. This was the hugely popular radio sitcom set at a Harlem taxi company, built around two black characters played by white minstrel performers, Freeman Gosden and Charles Correll.[44] The survey, which in itself suggests some level of institutional unease or uncertainty with race-change performance, asked participants: "1) If Amos and Andy were negroes what do you suppose your attitude would be toward them? 2) If you were white and they were negroes, what do you suppose this attitude would be?"[45] Some respondents claimed to find the pair amusing if foolish, and a couple even claimed to have been surprised when they discovered they were actually white. However, an attorney, H. P. Dew from Hartford, Connecticut, said: "It is a question in my mind whether any two negroes of equal merit would be given the popular reception into the hearts of the public these men are receiving. If I were white I should not be opposed to their cutting the fool. I should think it was just natural with the two."[46] Dew recognized that in part, the applause for *Amos 'n' Andy* indicated a marveling at clever white mimicry of blackness, and the perceived distance between the real identity of the performers and their roles. If Amos and Andy were played by black performers, the distance and applause would collapse, as performance would be read as merely "natural" behavior.[47]

With the coming of sound, a significant influx of authentic African American musical performers, including Paul Robeson and Charles Gilpin, rendered the appearance of white actors in burnt cork or black greasepaint visually anachronistic, pale imitations. Certainly a 1930 article on makeup for African American actors for the screen indicated that blackface makeup "shows up very badly on the screen in many pictures with Negro players."[48] It is true that roles we might call "permanent blackface" in which white actors played characters meant to be read as African American disappeared during this period. But temporary blackface continued to flourish. This is the mode of performance in which white musical stars like Bing Crosby (films include *Mississippi* [1935]; *Road to Singapore* [1940], *Holiday*

*Inn* [1942], *Dixie* [1943]), Fred Astaire (*Swing Time* [1936]), and Judy Garland (*Everybody Sing* [1938], *Babes in Arms* [1939], and *Babes on Broadway* [1941]) "blacked up" for jazzy musical numbers or "good ol' days" nostalgia. Increasingly blackface could only be produced through a frame that designated it as "of the past."

But as Stephen Johnson writes in *Burnt Cork*, although it is marked now as "socially unacceptable," blackface hasn't disappeared.[49] Its designation as past has moved from a frame of nostalgia to one of regression, or of a "less enlightened time." We see this in TV shows like *Mad Men* (alongside pregnant women puffing on cigarettes, littering, or morning alcohol in the office). In films like *Tropic Thunder* (2008), it is used as a marker of an actor character's pretentious hubris, as he takes proteanism to its extremes. Even when not visually present on the screen, blackface shapes templates for black characterizations and performance, and as a historical wound it continues to uneasily ghost the reception of films in the present. In this it is not dissimilar to how Fuller sees the lasting legacies of yellowface performance: "Certain archetypal figures (such as the asexual Asian male, the dragon lady, the china doll, the sinister and inscrutable Asian villain) remain central sites of contestation and reconfiguration to this day."[50]

Meanwhile, white actors continue to be cast across racial and ethnic lines in what is commonly called "white-washing." But now the defensive ground of financing is routinely used to justify such casting. Recent films like *Exodus: Gods and Kings* (2014) and *Gods of Egypt* (2016) eschewed actors with Egyptian heritage in favor of spray-tanned white actors like Joel Edgerton, Sigourney Weaver, and Gerard Butler. Ridley Scott, director of *Exodus: Gods and Kings*, defended the film's casting: "I can't mount a film of this budget, where I have to rely on tax rebates in Spain, and say that my lead actor is Mohammad so-and-so from such-and-such. I'm just not going to get it financed. So that doesn't even come up."[51]

The screenwriter for *Noah* (2014), Ari Handel, defended the film's white cast with a more revealing statement suggesting that the finance argument might not be the whole story. His argument was that as *Noah* is a mythical story, race did not matter. Casting nonwhite actors risked turning it into "a Bennetton ad" in which race would become a distracting factor for viewers. Casting with whites, however, made the characters "stand-ins for all people."[52] Thus we see the persistence of the belief that to be white is to be considered racially unmarked and universally human. But there are

other contemporary films that, even if they don't necessarily succeed, have attempted to push, and push hard, against such beliefs, deploying a multiracial cast and positing instead a universal humanism that transcends race, even as it is embodied in differently racialized bodies.

## *Cloud Atlas* and the Limits of Post-Racial Fantasy

One such film is *Cloud Atlas* (2012), Tom Tykwer and the Wachowskis' sprawling, ambitious film exploring the journeys of various souls across bodies, time, and space. Starring a multiracial cast including Halle Berry, Doona Bae, Xun Zhou, Tom Hanks, Jim Sturgess, Hugh Grant, Susan Sarandon, and Keith David, each playing multiple roles, the film flits around the world and skips back and forth across six time periods and genres in the blink of a cut. Across these fragments of narrative, the cast often appears in heavy transformative makeup, teeth, and wigs, looking sometimes convincing, sometimes grotesque, and sometimes utterly unrecognizable. So while Tom Hanks is more or less Tom Hanks in prosthetic noses of varying bulbosity, skin-tags, wonky teeth, wigs, and scars, Doona Bae is still recognizable as a freckle-faced, green-eyed, crinolined Englishwoman in the 1850s, but barely so as a frumpy and owlish bespectacled Mexican woman in the 1970s. Hugh Grant is only vaguely visible across roles: grotesquely Eurasian with narrowed eyes, goatee, and long stringy hair in the mid-twenty-first century; a portly, swollen-featured, old white codger in another timeline; and a mohawked, face-painted warrior in the post-apocalyptic future. Halle Berry is a silent slave boy in the 1850s, a honey-blond Jewish aristocrat with hazel eyes and a roman nose in the 1930s, and completely unrecognizable as an elderly, bald, wispy-bearded Asian doctor with a heavy accent in the 2140s.

As the timelines and characters are interleaved, the film can be difficult to follow. But rearranged in a simple chronological chain of cause and effect, the plot is this: on a ship in 1850, a young white lawyer's life is saved by an African slave, the event transforming the lawyer and his wife into abolitionists. In 1930s England, the lawyer's diary is discovered by a white homosexual composer and inspires his music while he writes of them to his lover. Through a chance encounter in San Francisco in the 1970s, the composer's letters are passed on to a black female journalist, and she tracks down the musical composition as she fights the evil heavies behind

FIG. 9 Halle Berry utterly disguised as an elderly Korean man in one of her roles for *Cloud Atlas* (Blu-ray capture)

a corporate conspiracy. Her memoir is read by an aging white publisher trapped in a cruel British nursing home in the 2000s, who, once he escapes, writes about his own ordeal, which in its movie adaptation inadvertently inspires a revolution of young Korean female clones in a futuristic Seoul. Several centuries later, a video message recorded by the awakened clone has inspired a benevolent and enlightened religious movement in a post-apocalyptic society, and a black woman from a technologically advanced society rescues a primitive white tribesman from a group of tattooed white headhunters.

Sure, the diaries and letters we write, and the music, films, books, and videos we create can continue to connect with others, triggering ripples long after our deaths. But the film also posits that our souls persist, moving over time among different bodies and different lives. It is the actors

FIG. 10  South Korean actress Doona Bae made up to play a white woman in one of her roles for *Cloud Atlas* (Blu-ray capture)

who provide us with the means to follow these souls, to see whose character remains fixed and whose is mutable, as we track them in their various guises, narrative functions, and relationships across these timelines. For instance, Grant's characters across the timelines all tend to be beneficiaries of the status quo, feeding off the misery of others. His 1850s slave owner becomes the 2140s exploiter of workers, and becomes, in the post-apocalyptic timeline, a literal headhunting cannibal. Berry's earlier characters (the 1850s slave boy, the Jewish woman in the lead up to World War II) function as silently accusing witnesses, registering injustice with their eyes while restricted by their circumstances. In subsequent postwar and post-civil-rights-era timelines, her soul is given impetus and license to act, becoming an intrepid illuminator of injustice, a figure enabling the enlightenment and transformation of others. Some pairings are significant, too:

Jim Sturgess as the lawyer of the 1850s and his wife, played by Doona Bae (in auburn wig, freckles, a prosthetic nose, and pale contact lenses), become in 2140s Neo Seoul the Korean savior (Sturgess in black wig, arched eyebrows, and eyelid prosthetics) and the clone (Bae in a glossy bob and latex dress) awakened to injustice and revolution, respectively.

The film sees the core of identity, then, as located in the "soul," a soul that is universally human and utterly separate from the body, transcending it and all its markers of social identity: gender, race, sexuality, class, and so on. But it also recognizes that the body's markers of social identity have at times constrained or enabled what is possible for souls to do. In its optimistic universal humanism, *Cloud Atlas* presents an interconnectivity among all human beings living and dead, and the possibility of a progressive evolution toward a state of enlightenment, in which the ways we identify, classify, and treat others according to gender, race, ethnicity, class, age, and sexuality will one day be seen as anachronistic. As Lana Wachowski put it, the movie "is about transcending our fear of 'other' in so many ways and transcending the boundary of 'other.'"[53] In this way, on a meta-level the film taps into the same utopian drive to transcend the body as the utopian rhetoric around performance capture.

But even as the film received a standing ovation at the Toronto Film Festival for the courageous scope of its well-meaning ambition, it was also dismissed as unwieldy, bloated, goofy, and bizarre. The dominant complaint was about the casting and makeup, which at best turned the film into a game of "spot the actor" but was deemed to be at its worst in the Neo Seoul scenes, where the "hideous approximations of 'Asian eyes'" were applied to the predominantly white male cast in what Violet Lucca called "the rather odious (and unconvincing) practice of race-bending."[54]

In particular, Guy Aoki, president of the Media Action Network for Asian Americans, took issue with the transformation of white actors such as Jim Sturgess, Hugo Weaving, and Hugh Grant into Korean characters. This criticism hinged on three points: labor, aesthetics, and the history of racialized roles and narratives in Hollywood cinema. On the issue of labor, white actors were taking roles that could have provided work for Asian male actors who are underrepresented onscreen compared to their proportion of the North American population. The casting of Jim Sturgess as a Korean hero who rescues Doona Bae's clone slave and brings her to heightened consciousness so that she in turn sparks a revolution was read as yet another iteration of the "white savior" trope in the line of *The Blind*

*Side* (2009), *The Help* (2011), *Amistad* (1997), and countless other films.[55] Regarding aesthetics, there was a risible lack of quality and care taken with the makeup to transform white actors into Asian characters. It relied on a simplistic phenotypical shorthand: a stiff black wig and an epicanthic fold for each, conjuring the long vexed history of yellowface performance. Much more care and detail was evident in the way Halle Berry and Doona Bae had been transformed into white women, with individualized skin, eyes, hair, and facial structures. This, said Aoki, sent the message that "it takes a lot of work to get Asians to look Caucasian, but you can easily turn Caucasians into Asians by just changing the shape of their eyes."[56]

Jeremy Woodhead, who supervised the prostheses for the Neo Seoul storyline, countered these criticisms by pointing out that it takes place 130 years into the future, and "what we anticipated was that in the future, countries and states would become more homogenized, so it wouldn't be absolutely necessary for anybody to be 100 percent any ethnicity. It could be a genetic mishmash of many cultures."[57]

Despite his claims, the end result is not a genetic so much as a prosthetic mishmash, as the white actors do not resemble Eurasians but white actors in stereotypical Asiatic makeup. The appearance of the makeup supports criticism that race-change makeup tends to reproduce particular assumptions about the "essential qualities" of nonwhite phenotypes (in this case that for an individual to have any Asian genetic material in their makeup means they will have an epicanthic fold and stiff black hair), versus the humanized idiosyncrasies of white faces. So despite the film's good intentions and boldness, and its argument that race, gender, and sexuality are artificial boundaries and divisions between people, it is in the end undone by the way it inadvertently reproduces some of those same divisions in its casting and makeup aesthetics.

## Ghostings, Appropriations, Invisibility

Can performance capture escape such historical entanglements through its greater visual verisimilitude and its distance from actors' real faces and bodies? If Ray Winstone's body and persona ghosts Beowulf, to what extent can an actor leave her race behind in a performance-capture role, especially considering the weight of this history? Scholarship and criticism of nonwhite performers in performance-capture roles have tended to

FIG. 11 Hugh Grant (left) in one of the many criticized "yellowface" makeup roles in *Cloud Atlas,* with Doona Bae closer to her natural appearance (Blu-ray capture)

argue that race remains central to casting rationales and the ways we are encouraged to interpret the character, even when the actor is completely unrecognizable. Tanine Allison, as we saw at the beginning of this chapter, has critiqued *Happy Feet,* arguing that it did not allow Savion Glover (the tap dancer, whose motion-captured performance gave Mumbles the penguin his signature moves) the opportunity to transcend his race so much as appropriate his work under a white vocal "mask." Critiquing the film for continuing the association of black performers with corporeality and music, she argues that "motion capture acts as a medium through which African American performance can be detached from black bodies and applied to white ones, making it akin to digital blackface."[58] Her point is that Glover's dancing for Mumbles incorporated a history of black performance techniques, routines, and steps from particular black dancing stars of the twentieth century (Gregory Hines, Jimmy Slyde, and Chuck Green). But detached from Glover's corporeality, and transferred to a digital penguin with a white voice, the blackness of Mumble's fluid dance steps and the performance heritage they point to is digitally whitewashed. This instance looked like white appropriation of black culture, especially as Glover's name was buried down in the end credits, far below the names of the voice-acting stars.

Even when black or other nonwhite performers in performance-capture roles are *not* deploying performance techniques associated with a racial or

FIG. 12 Hugo Weaving in one of the many criticized "yellowface" makeup roles in *Cloud Atlas* (Blu-ray capture)

ethnic heritage, though, the relationship between the performer and the type of digital body they have been tasked to play is still usually understood through the prism of race or ethnicity. For instance, Alice Maurice positions *Avatar* within a longer historical study of race and cinematic technology. She notes that the colonizing humans who take Na'vi form are played by white actors, Sam Worthington and Sigourney Weaver. The main native Na'vi (Neytiri, Mo'at, Eytukan, and Tsu-tey), however, are all played by actors of color. Zoe Saldana, CC Pounder, and Laz Alonso are all African American, while Wes Studi, who plays Eytukan, is Cherokee. Why, she asks, should this be, when the characters they play are long-limbed, blue-skinned aliens with ears and tails who do not resemble the actors? What part did their race play in casting? After considering their role in promotion as possible authenticators for the characters, given their ancestral heritage in colonized peoples, she bypasses movement qualities to land on what she sees as a key answer: voice, specifically a cultural idea that she argues has persisted through cinema since the sound era, of the "black voice" having particular qualities of warmth, depth, and resonance.[59] Primarily, then, she argues, the casting in this case is about infusing the digital characters with a racial authentication and embodiment. In a sense, such a casting rationale is not dissimilar from the "salt-of-the-earth machismo" that Winstone's working-class masculinity was hoped to bring to *Beowulf*, but if in his case it was located in the individual actor, in the case of *Avatar*

Maurice suggests the characters' authentication was located in a wider racial and ethnic category.

And yet, are all instances of nonwhite performance-capture casting to be scrutinized through the prism of race rather than what else a performer might bring to or do within a role? This is not to say that examining the rationales for casting do not matter (they do!), but an argument that actors have been cast solely because of their race or ethnicity in itself risks dehumanizing them, diminishing their craft, and perpetuating the same problem. White actors like Serkis, Hanks, and Streep get to define themselves as "actor" first and foremost—their whiteness is irrelevant (except, that is, for the way it allows them the freedom to be protean, unconstrained, and unmarked by ethnicity). Is it possible for nonwhite actors to do the same? I think it is, if we return to the fixed/protean continuum, and Geraghty's distinction between stars as professionals who personify a more fixed range of types and stars as performers who foreground their skills in protean craft.

Lupita Nyong'o has said she enthusiastically embraced the opportunity to use performance capture to play Maz Kanata in *Star Wars VII*. Maz is a short, wizened, owlish, bar-owning ex-smuggler who, sensitive to The Force, sees much and knows all. Many have dubbed Maz the "new Yoda," and with her compact frame and enormous walnut-like head the character bears absolutely no resemblance to Nyong'o, an extremely photogenic young Kenyan Mexican actress with a slim physique, large expressive eyes, full lips, and elegant bone structure. In taking the role, Nyong'o was evidently desirous of stretching her protean abilities, but there seemed also something larger at stake for her beyond creative satisfaction. She was drawn to performance capture, she said, because it allowed her to perform in a medium that was not dependent upon the visibility of her "body and what was being done to it." She is referring here in part to her physically exposed and psychically draining role as Patsey, the enslaved woman in Steve McQueen's *Twelve Years a Slave* (2013), who is subjected to beatings, naked whippings, and violent rape. But she is also talking about how, as a young, gorgeous, and black rising star, her physicality has become the main prism through which she is discussed (as fashion icon, and as a new standard of beauty with her modelesque figure, unbleached skin, and natural hair). Playing Maz, she hoped, would allow her to temporarily jettison the confining weight of all the meanings and expectations about her race, gender, and sexual attractiveness, and swiftly bring the focus back to her acting skills in gesture, expression, and voice.[60] She

signals clearly a desire to forge a mode of stardom as performer rather than as professional. Indeed, she brings to the role nothing of a celebrity ingénue or of Patsey, a slave driven to the verge of cracking, but disappears completely, playing Maz with a hearty older woman swagger, a bold resonant voice, gentle jibing, and a shrewd observance in her depths.

There were some critics, however, who, rather than focusing on what Nyong'o actually brought to the role through her performance, essentialized her casting through the prisms of race and stardom. Andre Seewood argued that casting Nyong'o as a homely alien was a terrible insult to her race and wasted her beauty by making her invisible. Moreover, he considered that Maz's appearance conjured an Asiatic caricature (presumably due to her gnarled yellowish skin, stature, and enormous goggles), and thus, because she is played by Nyong'o, Maz's narrative function was reduced to that of the "magical negro."[61] Yes, the character somewhat resembles Yoda in terms of its helper function and short stature, but focusing on the actress's blackness as the dominant casting rationale, I would argue, actually diminishes Nyong'o's talent as an actress. Certainly Seewood's point that there needs to be a greater range of roles for nonwhite performers is uncontestable (and it would help matters if white actors were not routinely cast in nonwhite roles), and his sensitivity to the racial dimensions of the casting are understandable when seen against the long history of race-change performance detailed above. However, the insistence that Nyong'o, because she is black and beautiful, should be visible onscreen as a recognizable version of "herself" (like any young beautiful white star, such as Keira Knightley or Scarlett Johansson) seeks to constrain her to the fixed professional end of the continuum. I would like to suggest that Nyong'o is cast here for her protean skill rather than her color. She completely disappears into Maz—not just visibly, but in terms of her persona. Nyong'o worked closely with Serkis to learn the unfamiliar process of acting for performance capture and, as she reminds us, it was acting rather than stardom that was the profession for which she trained.[62] Through Nyong'o's performance, Maz feels truly present and alive on the screen. This shows that it is important to differentiate between instances of proteanism and typage in acting, so that we might recognize glimmers of progress. Proteanism, as we have seen, is important for an actor's professional identity, mobility, and, I would add, longevity in the labor market.

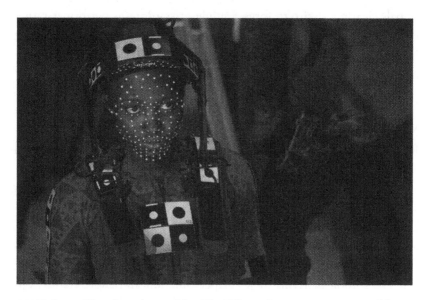

FIG. 13 Lupita Nyong'o on the set of *Star Wars VII* in performance-capture suit and face markers for optical capture to play Maz Kanata (Blu-ray capture)

To close this chapter, I would like to return to a hypothetical rather than an actual case, signaled by the Tom Hanks quote above where he quipped that, through performance capture, Meryl Streep might play Abraham Lincoln.

## Biopic Roles, Artistry, and Pushing the Limits of Resemblance

The limits of the actor's body in transformation are most apparent in the biopic, especially when the real historical person being played has a well-photographed recognizable appearance. In order for us to believe that we are witnessing a plausible version of the famous person, there is a base expectation of a certain resemblance. This does not mean that the actor has to be remade into a perfect visual and vocal facsimile of the person she is playing. Indeed, James Naremore suggests that an appearance and voice too uncannily close to that of the original public figure has less value than a performance that illuminates something core to the person's character:

FIG. 14 Final fully rendered screen version of Maz Kanata, as played by Lupita Nyong'o in *Star Wars VII* (Blu-ray capture)

their self-perception and way of being in the world.[63] As Dennis Bingham argues, "A performance made up only of researched physical traits, skills, habits, looks and characteristics at certain historical points would be mechanical and empty."[64] Moreover, too much proximity of appearance and mannerisms, Naremore says, serves paradoxically to draw focus to the little ways in which the actor does not resemble the person they portray.[65] However, too much distance can also be a distraction and undermine a film's claims to reveal something of the real person.

So what if Meryl Streep did play Abraham Lincoln? Certainly with makeup and costume she can easily be made visually presidential (and indeed, she has played Margaret Thatcher). But an attempt to make her Lincolnesque with prosthetics would surely just make her look comical. The distance between their appearances is too large to bridge with makeup, wig, and prosthetics, and this is not just a matter of gender. After all, Cate Blanchett played Bob Dylan (or at least, Jude Quinn, one of six fictionalized aspects of Dylan's identity) in Todd Haynes's *I'm Not There* (2007) with just the aid of a suit, a bushy dark haircut, a wry quizzical expression, a defensive hunched teeter, and a reedy pitching of her voice. The other five Dylan facets, with the exception of a young black actor, Marcus Carl Franklin, cast as Dylan's "Woody" persona, were more conventionally played by white males of different ages (Christian Bale, Richard Gere, Heath Ledger, and Ben Wishaw). It was Blanchett who was the standout: the most Dylanesque of all the Dylans, maybe because Blanchett's Dylan

was, out of them all, the most evocative of his most glamorous youthful celebrity self of the 1960s—this was Dylan at the height of his fame and popularity. But another reason for the success of her performance was that Blanchett's tall, pale, angular physicality easily meshed with the younger Dylan's elfin androgyny. Like a Venn diagram, these parts of their physicality overlapped, and Blanchett could take us the rest of the way from a body to a persona with gait, voice, and posture. Even so, the casting for *I'm Not There* was considered remarkable and risky, being both multiple and a challenge to the dominant view that the actor chosen to play a historical individual should share some common factors of social identity, biography, and appearance.[66]

By comparison, even as chameleon-like as Streep has shown herself to be, it is hard to imagine such spaces of overlap in physicality, voice, or persona between her and Lincoln. The promise of performance capture, though, is that it would allow Streep to shed her skin and shift her shape, clothe herself in a digital rendering of the lean, lanky, awkward, whiskered, scarecrow Lincoln garment, and beam forth her interpretation of his wry, benevolent persona. However, if the delight and artistry of the biopic role is not in a mechanical "empty" facsimile, but in recognizing the actor stretching the limits of her own body in reaching toward plausibility, it is easy to imagine a performance-captured Lincoln provoking an uncanniness, an aesthetic displeasure in its uncanny, too-close, physical resemblance. Really, Streep as Lincoln would be stunt casting.

# 4

## Double Trouble

### Authenticity, Fakery, and Concealed Performance Labor

> Our personal opinion is that if a lady can
> neither ride, swing, nor dance, she should either
> learn how or yield the palm of stardom to one
> who can.
> —Emma-Lindsay Squier, "Nix on the Double,"
> *Film Fun*, February 1919

Darren Aronofsky's Oscar-winning ballet psychodrama *Black Swan* (2010) opens with a long shot of a lone dancer. Illuminated in a cone of light against a black void, her pale tutu fans from her waist as she strikes a graceful pose. She begins to move to the sound of low, mildly ominous strings, and we cut to a view of her baby pink satin-clad feet, shuffling in dainty steps en pointe, flattening, rising, and pivoting effortlessly in a virtuosic display of delicate strength and control toward the camera. The camera slides backward as if to give her room to move, and continues to follow her entranced, still at foot level, as she rises on tapered calves, steps, pirouettes, and again shuffles lightly on her toes across the stage, before gracefully folding her legs and sinking

down to the floor and into the shot. As she floats her hands down like a pair of birds and turns her head with an air of poised expectancy, we see her face and discover that the dancer whose skilled precision we have been invited to admire is the actress Natalie Portman.

Except, apparently, it wasn't. This and other dance sequences in the film were examples of what Stephen Prince calls digital "recombinant" performance,[1] comprising fragments of Portman's body and movements seamlessly stitched together with extended footage of more complex techniques executed by a professional ballet dancer, Sarah Lane, by Look Effects into continuous shots. The most demanding moments of dancing virtuosity were achieved by first filming Lane dancing in full costume, hair, and makeup with dot markers on her face to track her motion and guide the mapping of Portman's facial performance. Portman was then shot in identical attire, walking through the steps of the sequence on flat feet, with great care taken to match the lighting, angle, and motion of her head to that of Lane's. 3D head and 2D face replacements shots were used in numerous places—sometimes for hallucinatory effect, when Portman's character, Nina, is haunted by her smirking doppelganger—and sometimes for moments of technically demanding ballet that we are supposed to take as diegetically real.[2]

Considering the level of technological construction we have examined so far in screen performances, and how common the use of doubles are in filmmaking, we might wonder: Does this substitution matter, and if it does, *how* does it matter? Film critic Matt Singer argued that it didn't matter, as "movies are illusions. To create those illusions, filmmakers employ tricks like special effects and doubles. Replacing Lane's face with Portman via some computer-aided trickery is just a technologically advanced version of a technique done for decades."[3]

However, in an intriguing discussion of stunt doubling as a "routinized . . . invisible, and thus in a way more disturbing" aspect of screen performance, Murray Pomerance notes that as "an actor need not always be present in order to appear in a film . . . the way in which an actor is *not there* when his character is *there* affects, as we consider and digest it, our deep experience of the filmic moment."[4] Pomerance leaves open the question of how exactly our experience is affected by the actor's not-thereness in their character's body. In characterizing the use of doubles as both "invisible" and yet something which we can become aware of, however, he indicates a vacillation in viewing mode. We can realize or, conversely, we may remain oblivious to the fact that the character is not always embodied by the actor whose face, voice, and persona otherwise define them.

FIG. 15 Natalie Portman's face on Sarah Lane's body in *Black Swan* (Blu-ray capture)

This prompts some questions that drive this chapter, such as: What are the ways in which we might come to the realization that the actor is "not there," and to what extent do techniques such as digital face replacement and recombinant performance shift the grounds of our realization? What difference does an awareness of an instance of doubling actually make to our deep affective experience of a film or a character, or to our perception of an actor? If it does make a difference, is this difference always the same across all kinds of doubling, and has it been the same over time?

*Black Swan* provides a useful opening example here to illustrate the functions that the invisibility of a double can serve, and the ways that different viewing modes can be cued. As we shall see, it also fits within a longer historical pattern in which different kinds of doubles (stunt, voice, dancing) have been disavowed before becoming publicly visible, each time raising ethical as well as aesthetic questions about acting, which in turn have served to reshape our expectations of actors as performers.

## *Black Swan* and Portman's Metamorphosis

Certainly we can say that digital face replacement assisted our immersion in the film's world by selling the character's reality as a dancer. By digitally placing Portman's face onto a professional dancer's body, and showing us

this dancer gracefully twirling en pointe through extended takes, the film fostered the illusion of Portman's continuous presence in the role. If we think about how, before face replacement, films have sutured the bodies of actors and dancers together for similar sequences, camerawork and editing have been key. The body needs to be fragmented by camerawork in order to be remade as whole in the editing suite: shots of graceful feet, dexterous hands, an elegant back, a long shot of the whole body, mid-shots of the star shot above the waist, and close-ups of the star's face. Sometimes our perception can be bamboozled by the consistent use of a more fragmented music-video editing style. Many have been surprised, for instance, to learn that Jennifer Beals's much-imitated audition scene from *Flashdance* incorporated the labor of not one, not two, not three, but four different performers, one of them male. The most astonishing moment of the scene, in which, across a series of fleeting match-on-action shots, Beals appears to pirouette, leap through the air, dive, and roll into a breakdance backspin, is an amalgamated spectacular body—a "dancing machine," in Adrienne L. McLean's terms—composed of a jazz ballet dancer, a gymnast, a male breakdancer, and Beals herself, all clad in identical high-cut black leotards, legwarmers, and curly wigs.[5]

Without distracting cuts between dancing feet and the actor's face, however, it is easier to make believe we are seeing one unified person, rather than a person who sometimes is embodied by Portman but who, when she dances, is possessed by someone else. In this sense, the continuity of Portman's presence as Nina was a well-crafted illusion. However, Portman's dance double, Lane, was not just rendered invisible in the film through digital techniques, but worked as a structuring absence in a publicity narrative that served to inflate the contribution and value of Portman's performance.

I watched *Black Swan* in the cinema upon its opening in my city, cued by advance publicity and reviews that acclaimed Portman for transforming herself through a year and a half of training into an "accomplished ballerina" for the role of the obsessive perfectionist Nina and for performing "most of the ballet sequences herself."[6] The primary emphasis in interviews with the director and star was on Portman's physical commitment to and preparation for the role. Both stressed that the actress had danced until she was thirteen, so already had the foundations of a dancer in her body's muscle memory. Portman trained for months in classical ballet to transform her body "into muscle and bone," putting herself through "extreme physical pain" in the service of her metamorphosis into Nina.[7] For the lay

viewer it was easy enough to believe that Portman had merged with her character, in part because the actress's elegant, sinewy build, small features, and dark doe-like eyes create an easy imaginary fit with the physical type of the dancer.[8] Moreover, a scan of the closing credits seemed to confirm Portman's total self-actualization in this regard, because there was no dance double listed for the role.

This illusion was not seamless for all viewers, however, for, as Pomerance observes, viewers always measure a film's claim to realism against their own knowledge or expectations of what they know or believe to be real or true.[9] According to McLean, for those viewers who have trained as dancers or know intimately the markers and carriage of the dance-honed body, much of the dancing in *Black Swan* is laughably phony. The suggestion that an actress could transform herself into a ballet dancer in a little over a year is comically implausible, for a ballet dancer's body is like a bansai, growing into a form dictated by its daily practice. McLean says that the feet and toes— the foundation of the dancing body—have their telltale markers, and Portman's "flipper"-like foot is improbable as a foot that has supposedly danced in pointe shoes since childhood.[10] For viewers who dance, their embodied knowledge rips apart the seams of the dancing body.

None of this is to say that Portman did *not* transform her body, train rigorously, connect through endurance and physical suffering with her character's psyche, or perform none of the dancing whatsoever. As an article in the dance section of the *New York Times* acknowledged, "faking it" as a dancer onscreen, even with a double, is not easy: "If you're going to look and move like a professional ballerina, you were going to have to train like one" and develop the "physical markers for the ballet dancer"—"sinewy lean muscles, upright carriage, pressed down shoulders and tell-tale elongated neck."[11] This kind of information made it into peripheral publicity—interviews and articles written for specialist audiences. But the dominant publicity narrative was one of Portman's journey from actress to actual ballet dancer. This involved not just placing the emphasis on Portman's transformation story, but the muting of other forms of information that might dilute its meaning.

This information was unmuted in March 2011, soon after Portman had won the Golden Globe and Oscar for her performance, when Lane came forward. She alleged that Portman had only performed 5 percent of the full body shots, while Lane performed most of the technically challenging parts such as pirouettes and dancing en pointe in her stead, her face digitally replaced: "The full body shots, the feet, the turns . . . that's all me."[12]

FIG. 16 Natalie Portman portrays Nina's embodied mental anguish in *Black Swan* (Blu-ray capture)

After training very hard, Portman could move her arms convincingly but it takes a lifetime to produce the bodily strength and technical facility of a professional dancer, and the actress could not effect the technical footwork en pointe or the pirouettes. Not only was Lane not credited for this work, but she claimed that a producer from Fox Searchlight had asked her to refrain from giving interviews during the promotional and pre-Oscar phases of the movie's publicity: "They were trying to create this façade that she [Portman] had become a ballerina in a year and a half . . . so I knew they didn't want to publicize anything about me."[13] Wendy Perron, editor-in-chief of *Dance Magazine*, also noted that the original visual effects reel, which had revealed the use of face replacement with arrows and text onscreen, had been removed from YouTube and replaced with another version where this information was erased.[14]

As this information came to light, it prompted debates about the value of Portman's performance and the extent to which the publicity narrative, rather than her performance manifested onscreen, had led to her winning the Oscar. For some commentators, like Singer, the issue boiled down to just simmering professional resentments between dancers and actresses. It should not matter to anyone else beyond the dance community, the argument went, because only a gullible dupe would believe that an actor could become a professional ballet dancer.

## Can We Believe Anything We See?

In some ways *Black Swan* bears out Christian Metz's argument in his 1971 essay about the operational levels of what he calls *trucage* (trickery) in cinema. He delineates three levels, each defined by the kinds of calls they are supposed to make on our attention. The first, "visible *trucage*," refers to illusions where something spectacular has been added to the image—we might place Caesar in *Planet of the Apes* (2011) in this category, or the performances I explore in the next chapter, in which actors share the screen with their own image. The second, "invisible *trucage*," is also supposed to call attention to itself, but it does so through the disappearance or removal of something onscreen, such as objects that seem to be moved by invisible hands, the apparent presence yet transparency of the actor's body in *The Invisible Man*, and the optical removal of a wire harness from Christopher Reeve so that he may seem to fly in *Superman: The Movie* (1978). The third level of trickery is "imperceptible *trucage*," which refers to tricks that are supposed to bypass our awareness as well as our vision, such as the substitution of a double for the actor, or an actor standing on a box to seem taller next to a co-star. What is interesting for our purposes here is Metz's argument that all trickery is avowed in the cinema, and that even an imperceptible *trucage* is avowed and revealed at some point (whether in the general sense of "all cinema does this" or in the specific sense of "this particular film," he does not make clear), due to the need for cinema to flaunt the mechanisms behind its ability to create illusions that can deceive as much as they can astonish. Cinema's need to flaunt its mechanisms, he writes, in the end trumps "temporary and timely silence" around imperceptible *trucage*, "the divulgence of which would be injurious to another publicity—to that of the actor, for example."[15]

In looking in detail at doubling as I do here, however, we find that the relationship between the avowal and disavowal of doubles is rather more complex. It is bound up in a fluctuating tension between cinema's desire on one hand to flaunt its mechanisms and its desire on the other to make us believe that we are watching a recording of a real person do something truly extraordinary. There are historical modulations in the ways doubles and dubbing have functioned in cinema's illusions and the ways their concealment or revelation has operated. For instance, some kinds of doubling, such as stunt doubling, are now routinely avowed, where once the practice was concealed. Moreover, these historical modulations have

weaved through what I shall argue is an unofficial compact. This compact emerged in the 1910s between viewers and the Hollywood screen and its publicity, with the earliest articles about what could be taken as "fake" and what could be taken as "real" onscreen. As I will show, film producers and exhibitors of the 1910s quickly realized that if we can believe *nothing* of what we see, a significant aspect of filmgoing pleasure and evaluation collapses. My interest here is in the kinds of debates about the moral and aesthetic dimensions of substitution in screen performance that have occurred when such illusions of authenticity have been revealed to be just that: illusions. These moments of revelation and the debates that follow have sometimes prompted a shift in practice. Indeed, I argue that it is in part because of the perceived ease of trickery that such value has developed around performer authenticity and the punishing self-transformation of the performer's body that is often upheld as the height of mimesis in acting.

## Stunt Doubles: "Real Men [and Women] of Action"

The double's function in filmmaking is to serve illusion, but not all doubling work is treated as equivalent. Take stunt doubles. As Sylvia J. Martin puts it, such performers offer themselves up to be "hurled and hit" for the camera and are paid to "absorb the physical risks" of spectacular action so as to preserve the "commodity value" of actors' "health and good looks."[16] Martin says the stunt is valorized in the film image as the most dangerous component of the action, spectacular in its dangerousness, yet the labor that underpins this spectacular action is typically veiled in order to preserve the illusion of a singular body. Stunt doubles are typically shot from a distance, head persistently turned away from the camera, face obscured by strategically flailing arms or a mop of hair. This has been the case since the early days of cinema. However, there have been shifts in the ways offscreen knowledge around stunt doubles has been allowed to circulate.

Jacob Smith gives a fascinating account of how, with the rise of the star system, many of those who had previously performed in funfairs, outdoor stunts, or in single-reel "thrill" shorts as stars in their own right came to serve as doubles in feature-length narrative fiction films, "their performing bodies sutured to the film stars' faces" and their existence hushed by the industry in order to maintain the "unity of the star image."[17] But while

stunt doubles are still faceless and voiceless onscreen, they have in recent decades been increasingly credited for their work and have accrued a particular cultural status unavailable to other kinds of doubling work.[18]

For instance, compare how stunt doubling was handled in *The Place Beyond the Pines* (2012) to how Lane's work was erased in *Black Swan*: Ryan Gosling plays a stunt motorcyclist, Luke, with the aid of two different stunt riders. I know this from both watching the film and reading the publicity. The opening sequence establishes Luke as a world-weary, flick-knife-twirling drifter with prison tattoos, muscular torso, and closed-in face before demonstrating his occupation as a death-defying stunt rider. It has him ride a motorcycle with two others in tightly synchronized vertical and horizontal loops within a steel "globe of death" at a funfair. It allows us to entertain the illusion that the red-jacketed Gosling/Luke we see straddling the bike in the circus tent, grimly ignoring the hoots of the crowd, is the same red-jacketed Gosling/Luke we see risking his life in the globe of death. But it does not insist upon this one-to-one relationship. Rather cleverly, it uses a refocusing technique—a bait and switch—rather than a cut. Gosling dons his helmet and then makes a hand signal to the other two riders as he revs the bike and then rides out of shot, leaving only his fellow riders in view to pull our focus. As they putter away from their starting positions to follow him, the camera turns to follow them into the globe, where a figure on a bike, wearing the same distinctive red jacket, awaits, his back to us. The cage is closed and the riders move quickly, a looping crisscrossing blur of tires, and there is no attempt to show a close-up of Gosling's face within the globe cage. There is no attempt to insist via face replacement that "yes this is he!" What we have seen in this one continuous shot is enough to foster our sense of the persistence of Gosling in the character.

The credits inform us that Rick Miller was "Luke Stunt Double" and Monte Rex Perlin was "Luke Globe Stunt Double"—for it is the character that badges the double, not the actor. Moreover, the film's publicity is careful to separate actor from character. An MTV interview with the film's stunt coordinator, Brian Smyj, tells us that Gosling's work on the bike was minimal and heavily monitored by insurance assessors, giving approval in increments for him to ride at particular speeds of over six miles per hour.[19] Such publicity proclaims the necessity of this illusion. It places the decisions about what Gosling is or is not allowed to do onscreen within the hands of insurers—the economic structure underpinning the

illusion—removing the responsibility for the decision from the actor, and therefore the possibility of questioning the actor's character.

As such, stunt doubles have developed a particular kind of visibility in contemporary popular culture. We have seen stunt woman Zoë Bell play herself, willingly strapped to the hood of a speeding car in Quentin Tarantino's *Death Proof* (2007). Many Hollywood stunt performers, such as Yakima Canutt—stunt double for John Wayne and Clark Gable, among others—and Dick Grace have published biographies upon their retirement. Two recent ones, Hal Needham's *Stuntman! My Car-Crashing, Plane-Jumping, Bone-Breaking, Death-Defying Hollywood Life* (2011) (a quote from Arnold Schwarzenegger on the cover calls him a "real man of action") and Vic Armstrong's *The True Adventures of the World's Greatest Stuntman: My Life as Indiana Jones, James Bond, and Other Movie Heroes* (2011), also suggest that if heroic characters are defined by their actions, it is the stuntman rather than the actor who has a greater claim upon the character. This view has sometimes manifested in a kind of hyperbole, as in Arthur Wise and Derek Ware's claim that "the stuntman challenges all those restricting forces—gravity, death, age—that hem humanity in. Not only does he challenge them. He overcomes them. He is man as god."[20]

Ann Chisolm suggests that the stunt performer's special status among film doubles lies in the connotations and ideals of masculine action. She contrasts this with the more passive feminine associations of the body double who lends their photogenic body parts, such as breasts, bottom, legs, or hands for an insert that will enhance the star's sexual desirability. Chisholm's gendered explanation provides a compelling and useful history of Hollywood's labor movements and the ways that gendered assumptions have figured into the definitions and value of different kinds of performance labor. Her focus is on the ways in which the feminized labor of the stand-in, extra, and (from the 1960s on with the relaxation of the Production Code) the nude body double have been economically and culturally marginalized. Her focus necessarily takes the stunt double's higher status as a given, rather than looking at how it shifted.[21] Jacob Smith's work, however, explains how stunt performers (whose genealogy lay in the funfair and circus) came to serve the labor hierarchy and industrial logic of the star system through their concealment. It was very rare for a double to be linked to a specific film and specific star in the 1910s and 1920s. And yet they were never concealed entirely, and it is by considering the ways in which stunt doubles *were* visible within the context of an evolving narrative about cinema trick effects, illusionism, and realism that we can

also see how their status changed and fed into moral and aesthetic debates about the limits of substitution in film performance.

## "The Real Thing": Stunting, Thrills, and Dummies

If we think about how much emphasis is placed on the stunt double as a "real" man (or woman) of action, it is significant that the earliest substituted body in cinematic and pre-cinematic action was not human, nor able to perform actions: it was the senseless prosthetic dummy. Smith's book abounds with tales of nineteenth- and early twentieth-century daredevil celebrity sensations who staged breathtaking physical feats in circuses or public spaces: acrobatics, death leaps, tightrope walks, and free-climbing "human flies." Naturally, acrobatics and "human fly" climbing could never deploy an inert dummy, as they required a moving figure. But in perilous jumps from large structures such as bridges, cliffs, or waterfalls, where the top of the structure was distant from the observer, it was sometimes suspected that a dummy, its legs weighted with stones so it would sink to the bottom of a river, "performed" the jump in the place of the human daredevil. The performer would then emerge soaking, triumphant, and unscathed from a hiding place in the water. Smith rightly sees a continuity between such faked feats and the use of dummies for the illusion of "seemingly impossible or dangerous stunts" in early films such as Thomas Edison's *The Execution of Mary Queen of Scots* (1895), Edwin Porter's *The Great Train Robbery* (1903), and Walter Haggar's *The Life of Charles Peace* (1905).[22] How much awareness was there though about the use of dummies, and what was the impact of this awareness on viewer credulity?

The open-air stunt celebrities—the human flies, the lion tamers, the bridge, cliff, and waterfall jumpers—all had a great stake in the preservation of their reputation as physically strong, dexterous, agile, and with a death-defying courage; as Smith indicates, they always denied the use of dummies. In early motion pictures, however, things were different. Industry and fan journal columns eagerly revealed the clever tricks employed by the cinematographer to create shocking illusions of bodily destruction: decapitation, trains running over inattentive photographers on rail tracks, people being flung from clifftops to be dashed to pieces on the rocks below, or automobiles being driven off cliffs or bridges into tumultuous bodies of water. For instance, a 1907 issue of *Moving Picture World* featured a lengthy article over

several issues, which began by saying that many of the scenes people see in the "photographic pantomime" are "not real, but feigned." The author then went on to reveal details of how such scenes of cliff falls, for instance, were routinely constructed for the screen by filming a struggling living performer, stopping the camera just at the point of imperilment, and joining this shot to one of a dummy in long-shot at the moment of calamity.[23]

The main line here was the cinematographer's cleverness as an illusionist, in the vein of Metz's "flaunting." This fascination with the mechanics of cinematic illusionism persisted into the transitional era of filmmaking. Certainly, through the 1910s and 1920s, articles in the trade, fan, and news press detailed all manner of illusions. They explained the use of miniature models to simulate train wrecks, and multiple exposure or mattes to create composite spaces for a shot of a rider on horseback leaping across a rocky abyss, or to fake interactions between a screen heroine and a lion. So there was a continuing fascination with and desire for insider knowledge of the mechanisms and constructions of screen tricks and illusions—what Neil Harris has called an "operational aesthetic."[24] But at the same time in the 1910s, as Jennifer M. Bean has explained, this fascination with trickery existed in tension with a high value placed on "the affective sensation of realistic thrills and grounded in the practice of on-location shooting."[25]

This tension spilled into debate about how realism should be achieved onscreen and how much and what kind of information should be provided to audiences about how films were made. For some producers and exhibitors, the dissemination of the screen's secrets was believed to undermine viewer faith that the thrilling action on the screen was indeed "the real thing," thereby diluting its true affective value. As early as 1910, a review of *The Little Station Agent* discusses a moment of sensation in which three freight cars detach from the end of a moving train and roll down an incline, carrying the "insensible" hero with them. He awakes and tugs in vain at the brake. "This is no fake but the real thing. . . . We wonder . . . if the mild citizen sitting in his chair at the photo-play appreciates to any adequate extent the amount of strenuous and hazardous effort that has gone to make that thrill which stirs his torpid blood."[26]

The "mild citizen sitting in his chair" by the mid-1910s had become a common figure of anxiety in the trade and fan press. Such viewers were thought to be not just unappreciative of "the strenuous and hazardous effort" behind the action image but often actively skeptical, smashing illusions for others in the movie theater. Such viewers could be overheard

remarking that it was "only a dummy" when seeing serial action star Lillian Hamilton leaping from a stagecoach into her co-star's arms in *With a Girl at Stake* (1915), or explaining to fellow viewers that "they do all these things by double exposure" when seeing Lionel Barrymore brave the rapids while barely clinging to a tree in *The Devil's Garden* (1920).[27]

As a response to this apparently affectless skepticism, from the mid-1910s onward there were efforts to authenticate the action onscreen via publicity. Slogans such as "no trick photography" and "no fake studio stuff" accompanied advertising for animal, aviation, westerns, automobile, and action-adventure serials and pictures. Reviews and promotional text provided explicit viewing instructions, directing readers to attend to camera work and the placement of edits so as to authenticate action for themselves. Take, for example, a short review from 1914 of a stunt film *Wrecked in Midair* starring the intrepid daredevil "Arizona Bill," a.k.a. French performer Joe Hamman: "There are no 'cuts' or trick camera work to deceive anyone. That scene in which the act occurs is punctuated by no sub-titles or 'cuts' and shows him enter the vehicle, rise 75 or 100 feet in the air and fall to earth amid a blaze of smoke and fire."[28]

Some films and action serials tried to lure audiences by listing the injuries sustained by the cast during filming. Promotion for the serial *Trey o' Hearts* (1914) included a "doctor's report" on injuries to the cast: "Cleo Madison, a badly lacerated kneecap and severe bruises about the back and shoulders; George Larkin, one ear nearly torn off and bruised and battered legs and body."[29] *Terrors of the Jungle* (1915) was promoted with the headline "Marie Walcamp Attacked by Ferocious Lion—Has Narrow Escape from Death." The reader was informed that the film "embodied all the conceivable terrors that are usually associated with life in the unknown heart of Africa."[30] As more stories of serious injuries and even reports of deaths (such as that of the stunt pilot Ormer Locklear) began to accrue, insurance began to be mentioned, and so too articles revealing the existence of stunt doubles began to emerge. They were only discussed at first in generalized terms, however, and not explicitly linked to specific stars or films until the 1930s. For instance, English fan magazine *Pictures and the Picturegoer* asked, "Have [you] seen your favourite heroine jump unhesitatingly off a tall cliff or swim an ice-choked river? You never knew she could swim? Nor does she. Another movie trick is what you have seen. Movie stars seldom do such things. Professionals, dressed exactly like they are, and made up to resemble them, do this part of the stunt for the real actors."[31]

The ways in which the stunt double was discussed in fan magazines, and circulated within wider popular culture, was complex. In a context of increasing public suspicion that all cinema was naught but riskless illusion, it made sense to publicize the work of stunt doubles. Even if it wasn't the star necessarily, the acknowledgment that *someone* onscreen was risking his or her safety could help reauthenticate the film image's relation to a physical embodied reality. This acknowledgment, however, also destabilized the illusions of stardom, and in so doing it forced a reformulation of film acting values and hierarchies.

## The Moral and Aesthetic Dimensions of Using a Double

There is a key distinction between how stunt doubles were framed in the 1910s/early 1920s and how they are discussed now. To use a stunt double at all (never mind conceal their use) was framed in moral terms as a deceptive practice—a misrepresentation of the star's capabilities—rather than an acceptable, routine, and necessary aid to illusionism in cinematic storytelling and acting. Fan magazines in the late 1910s predicted that the double would soon be a thing of the past, driven out by the public demand for greater authenticity. They envisaged that the market for would-be stars was becoming so crowded with actors jostling for a place on the screen that the phony idols would be driven out by "real" actors willing to do for the camera whatever the action demanded. This difference between idol and "real actor" was made clear by a 1919 article in *Film Fun*: "It is justly unpopular, however, and two factors which will aid in its annihilation are, first, the burlesques being presented by the comedy companies which ridicule it unmercifully, and, second, the genuine scorn a real actor feels for the 'idol' whose contract stipulates that no hazard goes with his performances. A vast number of capable players from the speaking stage are able and anxious to do good work before the camera, and most of these hold 'doubling' and 'camera tricks' in contempt."[32]

The comedy burlesques this article refers to were no doubt similar to Ben Turpin's comedy western *The Daredevil* (1923). A stunt precursor to the Cinderella-esque narrative of *Singin' in the Rain* (1952), the film lampoons a fictional western star as lazy and cowardly, while Turpin, who plays the stunt double, proves himself through a series of mishaps to be the real hero and gets the girl. Because stunt doubles lent themselves to such

narrative framing, they were also a subject for short fiction in the pages of newspapers and fan magazines. For instance, Fannie Hurst's short story "The Young Hercules" appeared in Hearst newspapers in 1925. It told of a fictional stunt man, Joe Delaney, sitting in the back row of the cinema, his face curled in contempt, hearing the crowd's adulation for the "daring, courage, and beauty" of the star Monte Carr, whose face "with laid-back ears and sensitive nostrils" and a body of "rippling muscles" brought him a salary of $2,000 a week. For onscreen, with "a trick of the camera," Carr seemed to "scale seemingly unscaleable walls, to dip, to soar, to dive," but the crowd did not know that the star "went back to his dressing room to a couch and a cigarette" while it was ordinary freckle-faced Joe who, for sixty dollars a week, performed the daredevilry they were applauding. Joe, when he leapt from a steamship, his "blood sang" for "the crash of the surf," and his "body cut through the air like the flight of a bird," feeling the "joy of elasticity" in his body, heart, and spirit.[33]

This story casts the stunt double as an adrenaline junkie, a charge often denied today by stunt performers who stress cautious planning and safety measures. But it also distinguishes between Joe's body—a body shaped by the work of spectacular movement: flexible, wiry, and elastic—and that of Monte the star. Monte's body is passively photogenic, with rippling muscles that are used for nothing but their own visual display. The richly paid thrill picture star was, the story implied, an illusion resting precariously upon the anonymous bravery and work of a courageous lowly double who was paid five to fifteen dollars a day, or sixty dollars a week. These yellowing fan magazine pages seem permeated with an anxiety about the nature of film stardom and performance, and a nagging question about whether or not those living persons on the screen were deserving of adulation and financial reward. The view that the screen star was an image without substance had to be countered by attempts to define and quantify the labor of film acting and give special standing to those who eschewed doubles:

Some have contentious scruples against what they regard as misrepresentation, and this feeling must certainly affect their work in those particular roles. A desire to stick literally to the truth and earn her sixteen hundred a week is what prompted Bessie Love's great effort to learn horseback riding. Her company travelled with a circus for two weeks during the filming of "The Sawdust Ring." Willingness to take reasonable chances and ability to do many things

are a part of the photoplayer's equipment, and with all due appreciation for the manager's natural desire to save his star—made or in the making—the "fans" have a right to ask that their idol be not a false one. Acting is the actor's job; we want to pay him in homage for just what he does, but we don't like to feel that something has been "put over" on us.[34]

Germinating here, we see the seeds of an important differentiation between different categories of screen performers: an illusory "false idol" who lends her face and persona to the role, versus a "real actor" who through hard work cultivates the bodily techniques of her character. In such stories the idol was not just all image and no substance, but something worse: her evident willingness to benefit from and failure to acknowledge the labor of others indicated a character of questionable morality. By contrast, a "real actor" was a performer of substance, hard work, and sincerity. I should use present tense here, as these values continue to permeate the discourses that circulate through contemporary interviews with actors, including the promotional material around Portman in *Black Swan*.

Such distinctions between idols and actors fed into the emergence of an aesthetic argument for authenticity in performance. This aesthetic argument is intimately connected with the view that film should strive to be an art composed of real living people, actual locations, and genuine actions rather than illusory transformation and magicianship. It also connects to the belief that good acting requires the actor to strive toward the manifestation of a unified, rounded, coherent character. As an article on the tendency of the "real" actor to eschew a double put it: "There are good psychological reasons why many photoplayers refuse help by a double. It is bound to detach a player temporarily from his role. He loses the 'spirit'—at least, for a few minutes—and may not properly warm up again——at least, not soon enough."[35]

Using a double to live through part of the role in the actor's stead would, according to this logic, automatically lead to a perceptible disunity or incoherence in the character. How could the actor truly connect with the spirit of a heroic character, if, when the character enacted this heroism by, say, swimming through rapids to rescue a drowning baby, the actor retires into comfort and safety and another takes his place? Of course, such reasoning falls apart the moment you ask if an actor playing a villain has to actually strangle, stab, or shoot someone in order to connect to the character's malevolent spirit. Similarly, it can't be supported if we recognize that

whether an actor uses a double or not, the very technological conditions of filmmaking are disintegrative: actors must embody a character in fragments of time and with pieces of the body, and as Vsevolod Pudovkin has argued, this fragmentation always already poses obstacles for the actor's struggle to create a lifelike image of "organic wholeness."[36]

The acknowledgment of doubles as a routine (though unspecified) practice became used as a grounds to highlight the exceptional nature of stars who did perform their own stunts. This has continuity from Errol Flynn to Tom Cruise and Angelina Jolie. Cruise's stardom particularly revolves around a defiant energetic individualism. He is a star so powerful that he can, we are told, actively defy the wishes of anxious studio executives and send a film's insurance premiums into the stratosphere by insisting on doing his own stunts. He has indicated in promotional interviews that his decision to be filmed, for instance, dangling off the 112th floor of a building for *Mission: Impossible—Ghost Protocol*, is not just about lending substance to his own value as an entertainer, but is an attempt to reinject physicality and thrills into an action cinema that some claim has become weightless and affectless in the era of CGI. So, too, in the 1910s, the context of erstwhile trickery provided a marketplace in which the "real thing" could gain in value.

Similar to now, the problem was how to authenticate the performance in a context where viewers were aware of the possibility of cinematic deception. Then as now, promotional paratexts performed much of this work. As Bean relates, a layout spread in 1918 highlighted the filming of an Irene Castle stunt, claiming that "the magazine possesses documentary proof, in the form of statements by witnesses, that the flying figure shown in this picture is the slim form of Irene Castle, diving across death-menacing rocks, into the water, fifty feet below."[37] Such use of "evidence" has remarkable continuity with the ways Cruise's stunt work for the fifth *Mission: Impossible* film, *Rogue Nation*, was authenticated on the *Daily Mail* website in 2014 with blurry telephoto stills of what purported to be the star clinging to the side of an A400M Airbus and the statement, "Yes that really IS him."[38] Then as now, there were situations where the image alone, being shot from such a distance, or with the knowledge of double exposures, mattes, or now greenscreen to locate a performance in a space of diegetic peril, could not be relied upon to provide evidence of its own reality. Publicity had to do this job.[39] If it is actually true that Cruise risks his very expensive body, face, and life in the service of his own star image and the

enhanced kinetic realism of his action films, this is definitely the exception rather than the rule.[40]

It is more common now to position the star and his stunt double(s) as a synergistic screen presence: working and training together to synchronize gesture, action, charisma, and character psychology. The body becomes an exciting, dynamic action machine, especially with the superhero film, which necessarily pushes the possibilities of bodies to their limits and often beyond. Take Black Widow in *The Avengers* (2012). In our first encounter with her, she is Scarlett Johansson, wide-eyed, feminine, and vulnerable in a little black dress, ostensible damsel in distress, cuffed to a wooden chair in an abandoned railway warehouse, interrogated by some unimportant Russian baddies who have unmasked her duplicitousness. She appears outnumbered, imperiled, and helpless. But at a key moment, she turns the tables, kicking out and flipping herself in her chair, using its wooden legs as stakes to crush feet, bruise shins, and wind her opponents. We know Johansson is not a gymnast, and she has never claimed to be one. The credits and several interviews happily reveal that when Black Widow is at her most kinetically acrobatic, she is the wonderfully named Heidi Moneymaker in a red wig and a cleavage-enhancing brassiere. The essence of the illusion lies in the speed of motion and camera work, the wavy red shoulder-length bobbed hair that can fall over her face in moments of exertion, and very short shots of fragmentary views of action that create an impression of plausibly precise violence. It is pleasurable to watch this strong sleek body in acrobatic motion and the *schadenfreude* of bumbling villains taken by surprise. It does not depend on soliciting a response such as "Wow, that ScarJo sure is an amazingly acrobatic fighter!" In interviews, Moneymaker speaks glowingly of Johansson as a hardworking actress whom she herself trains in fighting for the Black Widow role.[41] Together, training, fighting, practicing, learning to mirror and shadow each other's moves, they can work in synergy to create this seamless, deliciously competent, steely-eyed, fighting body.

This is not, then, a Cinderella narrative of the double doing the work while the lazy star takes the applause, but a story of two professionals working together to create a superhero screen body, lending parts of themselves to a whole.[42] And when we watch, it is doubtful that we are wondering too much about when Black Widow is Johansson and when she is Moneymaker. We are just enjoying Black Widow kicking ass, and maybe wondering when Marvel will give her an origin story movie of her own. But how

did the stunt double come to gain this status, and how did this kind of performance come to be reconceived as an acceptable synthesis rather than a fraud that cast doubt on an actor's value?

## Cultivation of Acceptance

Two key things shifted the moral terrain around stunt doubling and the acceptance of illusionism. There was growing public awareness of the dangers for extras and doubles involved in making thrill pictures. *Screenland* raised awareness of the shockingly unsafe conditions in which extras and doubles worked, presenting such performers as the martyrs of "jaded" viewers, with an illustration of crucified extra girls, and directly asked the reader, "Are YOU the one to blame?" for the toll of injured and dead.[43] The *Los Angeles Times* featured a story highlighting the mortal injuries, concussions, and actual deaths sustained by stunt doubles, and their low rates of pay compared to that of the stars with which they worked.[44] Such stories were in part strategic, shaming the studios into enforcing better working conditions, while at the same time continuing to authenticate physical action on the screen. They also could bring to mind the possibility of death and injury to beloved and valuable stars if it was insisted that they performed this work themselves.

By the late 1920s physical risks that had previously been framed in the fan magazines as "reasonable chances" were now being positioned as unreasonable risks for the star to take, for largely financial reasons. Frank R. Adams's 1928 short story "Something Just as Good" featured a case of mistaken identity and romance, as Katy, stunt double for the glamorous Aileen Conrad, is asked to impersonate her on a date with a studio executive. It can be seen as almost didactic in its explanation of the rationale for doubles. Unlike the earlier stories where the split between star image and stunt labor was seen as a moral one, this story explicitly reframes the issue in purely practical and economic terms—the institution relies on the star to maintain her value and the double serves this important purpose. The star here, the story took pains to point out, was not "a coward or a physical weakling. But she had recently been elevated to stardom by the Paragon Film Corporation at a considerable exploitation expense. A lot of money would be wasted if Aileen got drowned, disfigured, or even seriously ill. Katy could be replaced for ten or fifteen dollars a day."[45]

Concurrently, *Photoplay* and the *New York Times* ran lengthy articles that educated readers on the increasing cleverness of the screen's illusionism, arguing that it had reached a level of seamlessness now that made it impossible to distinguish the real from the fake. "Does the Camera Lie?" *Photoplay* asked, and then, over the course of nine pages, explained in detail with reference to miniatures, glass painting, and double exposure, how filmmaking entailed lying through "artistic" and "scientific" means in order to avoid prohibitive expense, or subjecting players to "unreasonable risk." But it also presented a progressive narrative of technological illusionism which we might find familiar: "While you are trying to figure it out, the illusion, which is often more effective than realism, will continue to become more and more perfect, more and more convincing."[46] Such articles were instrumental in shifting the moral and cultural terrain of movie trickery from hoax to well-crafted illusionism. This meant that when it came to stunts, the screen was no longer expected to bear the burden of the actual in the service of realism.

## Ghost Voices, "Marvellous Counterfeits," and Bad Art

In the late 1920s, moral and aesthetic debates that in the late 1910s had surrounded stunt doubles reemerged in slightly different ways with the coming of sound and the revelation of dubbed voices in singing performances. As Katherine Spring writes, "Song performances raised the stakes of authenticity because the act required specialized skills and also capitalized on the culture of the singing star."[47] Several films were publicized in 1929 as featuring not just the talking but the singing voices of their star. One of these was *Weary River*, a sentimental gangster pic starring Richard Barthelmess as a criminal whose crooked soul is eventually straightened as he becomes a radio singing sensation. Warner Bros.' publicity proclaimed, "Hear Richard Barthelmess Sing and Talk!" with promotional art of the star, arms spread, musical notes issuing in a wave from his open mouth. Many newspaper critics, however, were suspicious of Hollywood ballyhoo, and aware that, as the sound and image had to be synchronized, this meant that voices were potentially interchangeable. Some exercised caution in their reviews, for example, "Whether or not Barthelmess actually sings the song I do not know."[48] It was subsequently revealed that a saxophonist and singer at the Cocoanut Grove, Johnny Murray, had been contracted to produce Barthelmess's singing voice in all his films for 1929.[49]

Just as, when watching *Black Swan*, dance literate viewers claimed to see the seams between Portman's and Lane's bodies, so too some musicians in 1929 noted the tells in Barthelmess's visible singing body that suggested he was not singing at all. While he mouthed the words, his throat and chest lacked sufficient motion to belt out a tune.[50] In the wake of what the newspapers called a "scandal," Lilian Bamburg's acting guide of that year advised against using doubles for performance. While, she said, using a stunt double for moments of dangerous action was proper and acceptable, substitution of performance was rapidly becoming obsolete, for "the producers have learned that the screen's greatest demand is for naturalness and a rigid adherence to actuality."[51] Unlike the stunt, singing or dancing required a sustained performance, remaining in view for longer. Singing should only be done on camera by an actual singer, as "the rigid inflation of the lungs affects the whole muscular poise of the singer, and it cannot be imitated."[52] Director Ernst Lubitsch argued that it was not just technically bad for realism, but artistically bad for the actor's unified expression of feeling. He said "no matter if the synchronization with the player's lips is mechanically perfect, the effect is bad. The feeling behind the words does not coincide with the expression on the actor's face."[53]

Largely, though, the argument against voice doubles was moral rather than aesthetic, it being dishonest to claim another's voice as the star's own. Muriel Babcock claimed that "an irate and hero-worshipping public" had complained bitterly to the studios and fan magazines that Barthelmess, a star they had seen as "noble," "should stoop to such a cheap trick as to pretend someone else's voice was his."[54] As with the revelation of stunt doubling in the 1910s, newspaper columnists in the late 1920s proclaimed that song doubling was on the way out due to a demand for authenticity. But *Picture Play*'s "Information Please" column in late 1929 responded to curious reader queries about whether or not such-and-such a star had performed their own singing with "It's impossible to find out, because the film companies pretend that stars do it themselves."[55] If the sound and image were well synchronized and the voice well chosen, few viewers could actually tell. Consequently, doubt was cast on the authenticity of every star's voice, singing and otherwise: "Now so many talkie stars have voice doubles, we'll never be quite sure, when we hear John Gilbert saying passionately 'I love you,' that it isn't a five-dollar-a-day extra."[56]

In this context of doubt, stars lined up to authenticate their screen voice and talents. Lon Chaney and Colleen Moore published signed affidavits

in the national daily newspapers declaring that the voice you heard issuing from their mouths onscreen was genuinely produced by their own vocal chords. It was reported that Gloria Swanson invited reporters to hear her in person in an informal concert. Buddy Rogers, in response to rumors that his multi-musicianship in *Close Harmony* had been faked, toured several cities with the movie. During personal pre-screening appearances, he reportedly picked up each of the seven instruments played in the movie in turn, and demonstrated his abilities in order to silence the skeptics.[57]

Film critic Nelson B. Bell insisted, however, that like himself most fans had been skeptical of the studio's claim that Barthelmess had suddenly, after over a decade of stardom, "sprouted" a voice. It was suspicious that a star with such a voice had never previously cut a phonograph record or demonstrated his voice on radio. Nevertheless, Bell praised *Weary River* for its technical achievements, as its sound-image synchronization was a "marvelous counterfeit."[58] Spring argues that while a proportion of audiences and reviewers claimed to be disturbed or appalled by the idea that singers did not really sing their own songs, seeing it as a "lie" or deception, others positioned voice doubling within the acceptable illusions of cinema as akin to makeup and special and visual effects. As long as the illusion was well made and its construction undetectable, this would be enough for an acceptable realism.

The focus shifted to the difficulty of faking it. Mark Larkin wrote a column in *Photoplay* on voice and music doubling. He stressed the difficulty for the actor in miming accurately enough—fingering the strings of a banjo so that they corresponded to the sound track—to sustain the illusion, especially knowing that musicians may be in the audience.[59] As Portman and Kunis demonstrate in *Black Swan*, and Johansson and Moneymaker in *The Avengers*, "faking" particular kinds of actions and vocations still requires performing skills and the acquisition of bodily techniques in order to bridge the cut between bodies with a match-in-action. Indeed, in the mid-1920s, June Mathis advised would-be actors to learn to dance in case they had to portray a dancer, saying that "yes, when you're a star you may have a double to do your dancing for you, but if you don't know how, you can't take the proper pose for close-ups, you won't be convincing and you won't have command over your body at all times."[60]

When a star was learning enough to fake a skill for a role, however, the studio publicized their lessons and dedication in ways designed to foster the belief that the star may have mastered the skill in question. Benjamin

Winters notes that the Warner Bros. press book for *Deception* (Irving Rapper, 1946) tells us that in preparation for their roles as musicians, Bette Davis had daily piano lessons for a month and Paul Henreid practiced cello for two to three hours a day. Winters argues: "Thus we are encouraged not only to marvel at their work ethic, but also to entertain the notion—however fleetingly—that the actors may have performed, or at least been capable of performing, their own music; that their talents extended to acquiring some of the skills of a musician."[61]

Then as now, the authenticity of performing bodies, or of its well-crafted impression, was thought to have a high cultural value in a hierarchy of performance. What counts as "authentic" and what is valued as really real in acting, however, has continued to mutate. It has operated in a continual shifting tension with periodically renewed redefinition of the ways in which movies work or should work as illusions, as well as the redrawing of what George Kouvaros calls "the image of acting."[62]

## Modulations in the Image of Acting since the 1950s

It is no accident, Kouvaros suggests, that the rise of the Method in 1950s Hollywood emerged around the same time as the demise of studio-contracted stardom and the rise of the agent. By the early 1960s, stars were no longer studio commodities but independent contractors attempting to construct a sense of their own value. Actors had to increasingly disentangle themselves from the illusionistic apparatus of the Hollywood star machine and reshape themselves as individual self-determining artistic laborers. As a result, Kouvaros argues, many stars such as Marilyn Monroe and Paul Newman shifted from being seen solely as serving an image of glamour to developing acting skills and marking themselves as artists of substance, at work, reading, concentrating, remembering, creating an image of serious absorption.[63] While Kevin Esch sees the 1950s image of Method acting as bound up in Marlon Brando and James Dean—behaving badly, acting out, and rebelling against the system to assert a rugged individuality,[64] Kouvaros finds a different perspective. He focuses on the photographs taken by Eve Arnold that show us Paul Newman listening and concentrating in an acting class, and Marilyn Monroe reading and thinking: images of acting as a mental labor.

As actors uncoiled themselves from the star-making illusionism of Hollywood and began to redefine what they did onscreen, doubles, once part of the star-making machinery, were allowed to become more visible in their own right. Actors began to talk openly about using stunt and voice doubles such as the singer Marni Nixon, who began gaining recognition after singing for Natalie Wood in *West Side Story* (1961) and for Audrey Hepburn in *My Fair Lady* (1964).

The mental and emotional labor of acting, however, is increasingly inseparable from the actor's body and the work the actor does to transform his or her body for a role. As Esch observes, since Robert De Niro's attention-grabbing bodily transformation to play boxer Jake LaMotta in *Raging Bull* (1980), there has been much "hype and publicity" given to such fully embodied approaches to screen role preparation. Moreover, since the 1980s we have seen a steady increase in the proportion of bodily transformations—such as weight gain or loss—among actors in Oscar-nominated and Oscar-winning roles.[65] The visibly altered contours of an actor's body and the acquisition of techniques (such as boxing or butchering meat, in the case of Daniel Day-Lewis in *Gangs of New York* [2002]) become an index of discipline and commitment to the role, and the source of a screen character's heightened unity and physical coherence.

As we saw in chapter 2, the weight and constraints of prosthetic makeup and fat suits are often articulated as determining something of the actor's embodied experience. In their physical discomfort, such devices allow the actor to connect temporarily with the character whose fabricated flesh they wear. The self-fashioned body, however, generally occupies a much higher place in the hierarchy of acting value than the temporary prosthetic. The reasons for this are multiple. The actor's transformation of his own body through sustained dietary changes and exercise regimes creates the external physical markers of the character type he is playing. In this way, they turn their own bodies and faces into a kind of spectacle, offered up to our often horrified fascination as the camera lingers on the outline of their skeletons thrusting through pallid skin (Christian Bale in *The Machinist* [2004], a role for which he apparently ate only an apple and a can of tuna per day for three months) or the hefty bloat of their jowls (Charlize Theron in *Monster* [2003]). Such self-fashioning is taken as irrefutable proof of the actor's inner character, for they have had to endure such discomfort and engage in self-discipline over a period of time, outside and beyond the illusory apparatus of filmmaking, as the preparation usually requires months.

Such performances are also taken as evidence of something *really undeniably real* at the heart of the moviemaking process. The increase in the number of self-fashioned screen performances over the 1990s and 2000s has occurred in parallel with other drives toward authenticity. During this period we have also seen the increasing cultural status of the stunt double and the fetishization of practical effects over the digital (and vinyl records over compact discs, and "organic" over genetically modified grains and vegetables). Dismissing the overuse of what he sees as "CGI bullshit," director Quentin Tarantino says of the "Crazy 88" fight scene in *Kill Bill Vol. I*, "My guys are all real." As Dan North points out, however, Tarantino's fighters with their prosthetic limbs pumping fountains of fake blood were no more "real" and no less of a cinematic construction than the sequence in *The Matrix: Reloaded*, where Keanu Reeves as Neo fights rapidly multiplying Agent Smiths played by Hugo Weaving, many stunt doubles in masks, and digital doubles.[66] Nonetheless, in this context of heightened awareness of digital illusionism, the excitement that greeted *Mad Max: Fury Road* (2015) had as much to do with the paratextual circulation of its behind-the-scenes material of stunt footage, with real people driving and colliding dusty mutant vehicles tearing up the Namibian desert, as with its purported feminist subtext. In some ways these authenticating desires can be seen to parallel those of the 1910s, where the heightened awareness of and appreciation for cinematic trickery corresponded with a rise in value for aspects of cinema that claimed to show "the real thing."

The actor's self-transformation, however, is doing more than this. It is not just promotion-fodder that speaks of their moral character—their seriousness, their discipline. It is not just a strategy to combat perceptions of artifice, or to sustain character unity and coherence across the fragmenting effects of filmmaking. It is also seen as visible evidence of an actor's embodied "journey" into their character's psyche—a sustained one-to-one connection with character experience through the body. Arguably, this is traceable back to Stanislavskian beliefs that "every thought and feeling is connected to a physical action, that mind is merely the subjective aspect of an objective process called body."[67] It was in this frame of value that Portman was lauded for reaching almost a breaking point as she pushed her body beyond its limits, and, through doing so, gaining an internal affinity with the obsessive neurosis of her character, Nina. As the Aronofsky quote in the production notes claims: "Somehow, with her incredible will and discipline, Natalie became a dancer. It took ten months of vigorous

work, but her body transformed and even the most serious dancers were impressed. I'm convinced that the physical work also connected her to the emotional work."[68]

We can see the physical evidence of Portman's work and exertions written in the straining sinews of her neck and arms as Nina breaks apart emotionally onscreen. Reevaluating Portman's performance in terms of embodied emotion rather than as a display of technical virtuosity, I find her believable in the role in the easy yet nervy lightness of her movements, as when she hurries to rehearsals, as if her body were perpetually fueled by anxious adrenaline and kale. It is in the numerous sequences where we bear witness to her obsessive care of her body—the stretching and cracking of bones in her feet, the busted toenails, the tendons of her shoulders. Yes, sound design creates the material sense of the distorted damaged joints beneath the satiny skin, and yes, prosthetics create the sickening bloody swollen toe and split nail (the one that made viewers in my screening hiss through their teeth), but it is, in part, the way Portman embodies the role that makes these details appear as if they are *really* happening to *her* body, and her embodiment is shaped by her exhaustive preparation and training. Indeed, the film is centered more on an exploration of an embodied neurosis than on the display of dancing virtuosity.

If to us her anguished face and the fragile exhausted cracking of her voice ring true; if she seems, in her trained body and in its movements, for the purposes of screen fiction *real enough* as a ballet dancer: why then go to such lengths to conceal the fact that a professional dance double was used to flesh out the character's talent? Indeed, this was an unnecessary misstep on the producer's part that, once revealed, only succeeded in muddying the perceived value of the star's performance, as it replayed the Cinderella-esque discourse that we saw emerge around earlier erasures of doubling performance labor. We no longer have a moral aversion to the use of doubles, nor do most of us have an aesthetic aversion if the substitution is technically well crafted and affective. The suturing of another's body or voice to the star's face is not perceived, in itself, as deception in filmmaking. It only becomes so when the performing labor of a professional is actively concealed in the publicity in an attempt to bolster the perceptions of authenticity around the star's performance—authenticity that largely accrued such value in the context of our awareness of the cinema's capacity to trick us.

## The Importance of Sustaining Belief and Wonder

I have sketched here a historical narrative of how over a century the value of bodily authenticity in performance has periodically emerged and reemerged, and how it has been reshaped in contexts of doubt about technological illusionism. In dance performance on the screen, the image used to be able to authenticate itself by relying on the minimization of cuts and on a play of proximity and distance with the camera. Such strategies are used in Moira Shearer's extended dizzying ballet sequence in *The Red Shoes* (1948), in John Travolta slicing up the disco floor in *Saturday Night Fever* (1977), or in Fred Astaire and Ginger Rogers floating like dandelion clocks and gliding like warm butter through any of their films: the authenticity of the performing body's skill is signaled with extended takes. These are shot from enough of a distance as to capture the full body so that we can appreciate the virtuosity of the dancer's movements, and yet close enough to recognize the star's face. This is all Moira/John/Fred+Ginger, all the time, such shots proclaim. Such camerawork, as André Bazin argued, serves to "send us back to reality," inviting admiration of what performers can do with their bodies.[69] Before the era of digital filmmaking, the authenticating power of the extended take depended entirely on our firm belief in what John Belton called the "integrity" of the film image—the belief that it could not be broken down into smaller units.[70]

Digital effects dissolve the integrity of the image, and it is important to note that *Black Swan*'s opening also contains cues that could serve as a warning that we should not believe our eyes. As Nina/Portman is joined by a male dancer and they whirl and spin, the shot is held as their costumes magically transform. With a flourish of his arms and the sound of heavy wings unfurling, the male dancer in conventional stage makeup and a black unitard becomes a dark-feathered demon with golden glowing eyes in a black face. When Portman wheels out from his grasp, we see that suddenly the simple white flowers in her hair have become the white-feathered crown of the swan queen. These instant, impossible transformations reveal the presence of digital elements and underlying manipulation: microsurgeries in the tissue of the film's reality. They indicate that the image should not be understood as a raw recording of a profilmic event, but a composition of layered elements, some that *may* have

happened before the camera and some that definitely did not, unless we are to believe in magic.

In the late 1920s, the awareness that sound and image were separate, and the revelations of dubbing for star voices, worked to cast doubt over the authenticity claims of all screen star vocal performances. So, too, the revelation of face replacement here to mask the use of a double might undermine the authenticity of all apparent physical achievements onscreen. If we must doubt everything, can we appreciate the wonder of anything? Will actors, as in the early sound era, have to produce signed affidavits attesting to the authenticity of their onscreen feats, or must they rely on the talk-show route as a means to demonstrate their skills before a live TV audience?

If having the wool pulled too far down over our eyes in this way concerns us, as it did for viewers of the 1910s and the early sound era, we can attempt to hone our perceptiveness. We might remember the comedic form of the implausible composite dancing body in *Naked Gun 2½* (1991). There, Leslie Nielsen and Priscilla Presley's goofily choreographed dance-floor conversation (complete with hand-jive, playground hand-claps, and chicken dance steps counterposed to the seriousness of their facial expressions and conversation) becomes, in background long-shot, an improbably elaborate acrobatic routine. It uses professional doubles with astonishing athleticism far beyond what we would expect from Nielsen and Presley, or what would be required of their characters in this world—dancing not being integral to the plot. Such comedy provides reassurance by making implausibility and the construction of illusion easily legible. It takes to extremes the outlandish claims that cinema sometimes makes about its stars' actions or physical capabilities, and the ways in which these claims stretch the plausibility of its illusions and the compact with the audience.

But the driving myth of digital compositing, just like all of cinema's illusionistic arsenal since the late 1910s, is that such inconsistencies are being progressively smoothed out. The illusion is being perfected, the seams erased. Eventually, so such myths go, we will never know for sure just by looking at the image itself. If we can't locate the seams in the image, we can at least be vigilant and consider the plausibility of what the image and publicity claims to show us. I would also argue, however,

that if film producers (and, indeed, media producers in general) want us to believe in the actuality as opposed to the illusion of any action we see onscreen, if the particular spectacle of specialized performance skills are to be retained, then it is important that a compact continues to be observed. The screen may create wonderful illusions, but publicity should resist the urge to deceive.

# 5

# Performing with Themselves

## Versatility, Timing, and Nuance in Multiple Roles

> I imagine that anyone entering a studio for the first time and chancing to find an actress in the midst of a double exposure scene would think he had stumbled into the state lunatic asylum.
> —Marguerite Clark, "Co-starring with Myself," *Miami Herald*, September 12, 1915

Amid the behind-the-scenes production publicity for *Harry Potter and the Deathly Hallows Part 1* (2010), the penultimate film in the *Harry Potter* franchise, one spectacular shot, labeled "Seven Harrys," was highlighted for particular attention. In a film with such a grim and thunderous emotional and visual texture, this shot conveys a rather delightful and humorous interlude. Before the film's narrative takes its more catastrophic turn, six friends and allies (the twins, Fleur, Ron, Mundungus, and Hermione) are involved in a plan to act as decoys. Each is magically disguised as Harry Potter in order to confuse the Death Eaters, thereby allowing the

boy wizard to escape Voldemort's bony clutches. To don the temporary disguise, each character gulps from a cup of polyjuice potion containing a strand of Harry's hair, passing it from hand to hand, grimacing, their facial features bulging and twitching into weird combinations, until the room is filled with seven Harrys, including the original. The other six gripe as they strip and redress in a copy of his clothes. This comically magical sequence is made more spectacular by the way that it is apparently captured in one sweeping circular pan.

The shot is a highly complicated and worked-over composite, comprising two sequences and several months of performance and visual effects work. The first part of the shot features the transformation of six different actors into six copies of Daniel Radcliffe (effected largely through the deployment of combined digital doubles and facial animation—a process taking five months and the labor of fifteen visual effects artists). The shot's second effects sequence gives us simultaneous multiple performances by Radcliffe. Each of his performances works to produce the impression of a different familiar character inhabiting Harry's skin. While websites like *Animation World Network* and *Computer Graphics World* focus largely on the labor and skill of the visual effects artists working on the shot, the "Seven Harrys" featurette that was released on YouTube, as well as a special feature on the region 4 Blu-ray, highlights Radcliffe's acting work.[1] Aimed at general audiences and fans, it underscores the acting challenges involved in the sequence, with its subtitle inviting the viewer to "See How Daniel Radcliffe Re-Created the Personalities of the Multiple Harrys in the Privet Drive Scene."

Here we are invited to take delight in a concentrated display of performing skills: mimicry, character differentiation, and a heightened discipline and control over body movement. Radcliffe describes the daunting task of using his own body to differentiate the seven physically identical Harrys and render the six other character personas—as they are embodied by his fellow actors—instantly recognizable to the audience. Recognizability is admittedly aided by the dubbing of the different actors' voices over Radcliffe's performance (for polyjuice potion, it seems, only alters outward appearances, and not the body's vocal apparatus). Watching the film communally on its first theatrical release, however, there was evident vocal enjoyment in Radcliffe's ability to show different selves. In these momentary vignettes, the audience chuckled or squealed their recognition of the Ron-ness of Ron and the Hermione-ness of Hermione, reproduced by

Radcliffe's body while divorced from the bodies of the actors who usually play them—Rupert Grint and Emma Watson, respectively. We are encouraged to delight in and admire Radcliffe's comic gifts of mimicry, seeing him caricature the gait, bearing, respective looseness or tightness of limbs and shoulders, and the way the head sits on the neck for each character. This allows us to spot the twins in a performance of loose-limbed strutting cockiness; see Fleur's feminine delicacy, upright coyness, and evident discomfort in inhabiting this young male body; and the fussy, tight-shouldered pedantry of Hermione.

Impersonation, mimicry, and imitation require actors to observe, attune, and reproduce in their own body another's recognizable ways of relating to the world in their gait, mannerisms, and idiosyncratic repertoire of gestures and expressions. As James Naremore has recently pointed out, though, such skills are not often afforded the same level of praise that is given to an actor's ability to seem to express a truthful interior "self." Perhaps, because they are seen as concerned with the production of surface signs of personhood rather than expressing hidden interiorities, they have not held as much esteem in the frameworks of "good acting" that have developed out of a heritage of Ibsen and Stanislavsky, consolidated by the motion picture close-up's emphasis on subtle displays of emotion and thought on the face. Nevertheless, he argues that they are a crucial part of what actors do, especially in particular genres like biopics and comedy, and are "often a source of recognizable pleasure for the audience."[2]

But there are other key performing skills on display in the "Seven Harrys" sequence too. These tend to garner even less critical attention than mimicry, perhaps because they are dictated by the technological conditions of filmmaking. They are rendered invisible and so taken for granted. For instance, Radcliffe speaks of the ninety-five takes performed before a motion-controlled camera, and the precise bodily control needed to act in this visual effects sequence where the relative position and movement of his character in screen space has been strictly pre-circumscribed. The actor requires rigid physical discipline because moving one inch too far in one direction or another can mean their body crosses into the space that another version of their self is meant to occupy. It is, as Radcliffe tells the camera with evident excitement, "the film-making equivalent of a magic trick," and he is positioned here as taking up the role of magician showman, as well as the magician's assistant, or the living body whose timing and skill in producing the illusion is crucial to the business of sleight of hand.

FIG. 17 A composite shot of multiple performances by Daniel Radcliffe portraying Harry's friends disguised as Harry, for *Harry Potter and the Deathly Hallows Part 1* (Blu-ray capture)

We have seen numerous instances of the actor multiplied onscreen in recent films, including Tom Hardy as the real-life 1960s London gangsters the Kray twins, in *Legend* (2015); Christian Bale and Hugh Jackman both in Chris Nolan's meta-cinematic film about a bitter rivalry between nineteenth-century stage illusionists, *The Prestige* (2006); Arnold Schwarzenegger in *The 6th Day*—a futuristic world where sinister secret cloning is rife (2000); Nicolas Cage as screenwriting brothers in *Adaptation* (2002); Michael Keaton as a man who clones himself to cope with the demands of his work/life balance in Harold Ramis's sci-fi rom-com *Multiplicity* (1996); Kevin Kline in the rom-com *Dave* (1993); Lindsay Lohan in *The Parent Trap* (1998), following Hayley Mills in an earlier version (1961); Jackie Chan fighting "himself" in the action comedy *Twin Dragons* (1992); and Jeremy Irons's celebrated, subtly sinister turn as identical twin gynecologists in David Cronenberg's *Dead Ringers* (1988). Decades before these, there was what feminist film theorists such as Lucy Fischer and Mary Ann Doane have identified as a "cycle" of female good/bad twin films, *A Stolen Life* and *The Dark Mirror* (both 1946),[3] and before that the surrealist depiction of a man's battle with his disapproving superego in *Un Chien Andalou* (1929).[4] All of these films in which an actor has to perform "against" his or her self might be thought of as presenting some of the acting challenges highlighted above in the "Seven Harrys" sequence, to greater or lesser degrees, depending on complexity of staging.

The greatest concentration of multiple-role film production, however, took place during the 1910s and early 1920s, with well over one hundred films made in North America alone, comprising shorts, multi-reelers, and at least one fourteen-part serial, *The Trey O'Hearts* (1914), starring Cleo Madison. Their plenitude was such that by 1920 *Photoplay* wearily remarked that Hollywood producers saw the double role as a "necessity in the screen career of any actress."[5] As I argue below, such films highlighted key screen performance skills that contributed to the development of discourse around film acting's connections to, and differences from, acting for the legitimate stage. These skills—performer versatility and the timing and bodily discipline required to convincingly perform both sides of a split-screen illusory interaction between the actor's two or more characters[6]— form the through-line of this chapter. I examine the ways these skills are highlighted or otherwise downplayed in multiple-role films and their reception within different periods of film history. Tracing the changing status of the multiple-role film and the ways its related skills have been conceived, we again see shifts in ideas of realism and the status of illusionism in cinema, the impact of the popularization of the Method, changing ideas of selfhood, and shifts in what constitutes "good characterization" within serious dramatic roles.

## The Double-Exposure "Fad," the Stage, the Screen, and Realism

In *The Transformation of Cinema, 1907–1915*, Eileen Bowser briefly discusses a "great revival of interest in the double exposure beginning about 1912."[7] The double exposure was a device that could be done in camera by running the film through the camera twice (or more), masking a portion of the lens, and then unmasking it for the second pass, or shooting against a neutral background. It was commonly used to show dreams, visions, and memories, but also manifested "in a fad for playing double roles, where one actor would appear in the same scene with himself."[8] In such scenes the actor would perform twice (or more), each time in a different section of a clearly demarcated set that would be recorded in an unmasked portion of the film frame, with both the camera and set held rigid. Bowser names a handful of double-role films from 1912 and 1913, such as *The Corsican*

*Brothers* (1912), *The Twin Brothers* (1913), *A Stolen Identity* (1913), and *The Twin's Double* (1913), and contextualizes them within the transitional period of filmmaking. In this period, as Tom Gunning and André Gaudreault have observed, cinematographic tricks, once attractions in their own right, were refined and integrated into cinematic storytelling.[9]

Yet this "fad" actually ran for well over a decade. Evidence pieced together from scattered archival sources, including reviews in *Variety*, *Motion Picture World*, and historical newspapers, points to over one hundred such films made between 1912 and 1925 in North America. The vast majority have long been discarded, allowed to rot, their ghostly doublings eroded and lost forever. But archival ephemera such as newspaper articles and reviews, trade and fan magazines, and novelizations provide clues that the split-screen multiple-role film can be understood as more than just a transition-era novelty or one variation of trick-film narrative integration equal to the rest. In emphasizing the intersection of human performance labor and mechanical illusionism, the way these films were positioned in their era both extended and complicated the "discourse on acting" that Richard deCordova has located as emerging around 1907, when the activity of those who appeared on film, with some uncertainty, "began to be characterized, after a theatrical model, as acting."[10]

First, many dual-role films at this time were adaptations of plays, which in turn had been adapted from well-known novels. Duality has a long history in literature and theater, with plots centered on identical twins, impersonations, or mistaken identities common in the work of Shakespeare and in popular nineteenth-century texts like Alexander Dumas's *The Corsican Brothers* (1844), Mark Twain's *The Prince and the Pauper* (1882), Anthony Hope's *The Prisoner of Zenda* (1894), and Wilkie Collins's sensational melodrama *The Woman in White* (1859). Before 1920 there were six screen versions of *The Corsican Brothers*, three adaptations of *The Prince and the Pauper*, two of *The Prisoner of Zenda*, and four of *The Woman in White*. But the versions produced after 1911 or so do not function as mere filmed theater. They should be understood instead as what Richard Grusin and Jay David Bolter have called "remediations," functioning to foreground the special qualities of the film medium as affording both greater realism and greater spectacular value than could be found on the stage.[11]

For instance, with its ability to multiply the performer's image through double exposure, film was promoted as solving a problem inherent to staging stories of identical twins and coincidental doubles: the visualization of

a plausible physical resemblance between characters. Joseph Berg Esenwein claimed that double exposure "made possible the screening of innumerable good stories which would otherwise have been almost impossible."[12] Journalists raved at the "remarkable sight" of King Baggott as both Louis and Fabian, shown "actually conversing" in *The Corsican Brothers* (1915).[13] A short review of Marguerite Clark's appearance in *The Prince and the Pauper* (1915) declared that "by allowing two characters on screen at the same time photography has rendered possible strict adherence to the original of the charming tale, and in the future it will be to the motion picture that the public will turn for the most enjoyment of the story."[14] These statements about the theater are borne out by performance scholar Richard Fotheringham who cites Ben Jonson, from as far back as 1619, complaining about the difficulty of mounting a production of *Amphitrio*. For a key scene of impersonation he could not find two actors who looked enough alike to "persuade the spectators they were one."[15] Stage plays and adaptations of twin-plot novels have thus often used just the one actor performing quick changes, with sleight of hand in plotting so that the twins or doubles never meet.

Even as late as 1920, the *New York Tribune's* review of Wallace Reid's good/bad brother film *Always Audacious* made a point of claiming that the double exposure trick contributed to the greater realism of film over the stage in telling such stories: "If a similar situation were presented on the stage it would be necessary to find two men who have the same stature and features, and then make up would be resorted to for the common denominator. And, further, it would not be unlikely that there would be a dimming of lights to make similarities seem the more striking."[16]

By the late 1910s and early 1920s, the biggest acting stars moved from performing in what were by then clichéd stories of genetic or coincidental resemblance into films in which they could play two or more physically distinct roles. Mary Pickford took on mother and son in *Little Lord Fauntleroy* (1921), as well as plain and poor versus beautiful and rich girls in *Stella Maris* (1918). Gloria Swanson attempted to play young and glamorous and old and decrepit in *The Coast of Folly* (1925). Another article about the screen's advantages for realism over the stage discusses the Lon Chaney film *A Blind Bargain* (1922), in which the actor played two utterly different characters, an "insane doctor" and "a victim of the doctor's insanity." If the audience had not been warned in their programs, the writer insisted, they would not know "that the figures on the screen really were the same

person." For the motion picture's "power of deception serves to hide the subterfuge, and makes both characters seem as real as if they had been played by two different persons."[17]

These claims for film's greater diegetic realism over the stage were seen to feed into the film industry's emerging quest for viewer immersion through the creation of "a seamless fictional world."[18] At the same time, however, the desire for viewer absorption in fiction operated in tension with the ways that the staging of an interaction between an actor and their image was, as Radcliffe reminds us, intended to be appreciated as a marvelous "magic trick." While on the one hand it supports the visual realism of the screen, on the other, as a trick, it calls attention to film's technological foundations and cracks the illusion of reality. Film commentator Wid Gunning found this to be a fundamental problem for audience attention and pleasure in narrative film: "There is always an element of artificiality about the situations, because we are constantly reminded of the fact that one artist is playing two parts. This is particularly true where we have double exposure or scenes where someone fakes one part, the fault with such situations being that the audience is forcibly reminded of the mechanics of the production, which is bound to mar the effectiveness of the story values."[19]

Such complaints about the default artifice of dual-role interactions, however, were a minority view at this time (albeit one soon to gain traction). In then-dominant conceptions of film's aesthetic superiority over the stage on the grounds of realism, the reality of resemblance between screen characters apparently trumped the reality of co-presence before the camera. At the same time, the fact that so many of these films were produced in the 1910s and early 1920s, and the generally positive patterns in their publicity and reception, also indicates that a fascination with cinema's technological base, and a desire to flaunt it, was very much still in play.

Moreover, the continuing visibility of cinema's technological foundation during this cycle also allowed for the elaboration of other strands in the early discourse on film acting. These discursive strands emerge out of the performance demands and audience expectations of different genres and their different performance lineages, different ways of positioning the photoplay in relation to the legitimate stage, and different assemblages of humans and technologies. Some of them tangle with others, thicken, and become dominant, while others fray to a bare and marginal thread. The multiple-role split-screen performance brought into sharper view some of the ways that performance had to be oriented to technological conditions of filmmaking. It was

also a means to counter the common belief that the illusion of screen realism was best served by casting natural types on the basis of the connotations of their appearance, rather than for their acting abilities.

As we have seen in chapter 3, the preoccupation with actors as types appeared in written advice on how to get into the movies, often found in vocational guidebooks and magazine and newspaper articles. This was a relic of the theater that was carried across to film companies, and, as Pamela Robertson Wojcik argues, casting to type had a labor market function providing actors with continuity of work through avenues of specialization.[20] In film, however, it also supported the discourse of the medium as a realist art (and perhaps also served the fantasies of stardom for the would-be star, reassuring her that with the right look she would require no extraordinary talent). Yet film reviewers often praised "versatility" in actors, arguing for its importance in the artistic development of the medium. They disparaged actors who were cast as types as relying passively on appearance. As the focus on proteanism in chapter 3 bears out, and as Fotheringham observes, the ability of an actor to transform herself "makes us aware of the actor as individual artist, as performer," rather than allowing us to believe that actors are just playing themselves.[21]

## A Platform for Versatility

It is in roles of transformation or doubled differentiation that Fotheringham says "acting virtuosity is most obviously demonstrated."[22] The use of transfiguring makeup to effect a visual transformation, however, has, as we have seen in chapter 2, a vexed relation to perceptions of virtuosity in acting, sometimes seen as masking or detracting from the actor's facial expressions, inflecting their performance with the taint of unreality if too visible on the skin, or even artificially signaling character on the actor's behalf. The double role, however, does not require wholesale physical transformation in order to demonstrate virtuosity. The majority of dual-role parts in films were for stories of mistaken identity, twinning, and coincidences of resemblance in which the actor had to rely on what they could do with their bearing, expressions, and gestural range more so than on wigs, costume, and makeup, to signal innate differences of character under the skin.

In 1910s reviews, the emphasis in all appraisals of dual-role performances was on the actor's ability to adequately distinguish the two or more

characters, and thus demonstrate a capacity to move beyond one type. For instance, a *Variety* review of *Hinton's Double* (1917) starring Frederick Warde (an actor who, the writer noted, had made the transition from the legitimate stage) asserted: "Mr Warde has proved that after all it is the actor and not the 'type' that the screen needs, for in nothing except his face was there the slightest resemblance between the characters of Joshua Stephens and John Evart Hinton."[23] Likewise, a review of the Essanay comedy *Identical Identities* praises the actor's "versatility" clearly displayed in the differentiation of two characters, effusing that "Mr Calvert is happy in the twin roles. Bill is a sport, who knows more about ragtime than he does about hymn music. Andrew is a pious goody-goody, with a face long enough to take him to heaven. Mr Calvert's versatility in presenting faithfully these widely different characters commands appreciation."[24]

The *Miami Herald's* appraisal of Gladys Brockwell's performance in *The Moral Law* (1918) further championed versatility as an important value in the hierarchy of film acting: "She displays characters and feelings that are as different as can possibly be imagined. So clearly are these two types drawn that there is no possibility of confusing them."[25] Bessie Barriscale (another stage actress who migrated to the screen) was praised by reviewers for her differentiations in *The Snarl* (1917) with the words, "Miss Barriscale has so clearly distinguished these two personalities from one another that, while they are alike in appearance their mannerisms, their conduct and their facial expressions are totally unlike." Describing the same film, the *Evening News* said, "She has so differentiated the two characters it is hard to believe they are interpreted by the same actress."[26]

Overwhelmingly, 1910s and early 1920s reviewers lauded performances of legible distinctions; however, we also find evidence of an early consideration of subtle shadings in twin characterization on film. In a one-page review of the three-reeler *The Man from Outside* (1913), Louis Reeves Harrison appraises the "quiet intelligence" of Irving Cummings's performance as two brothers whose only physical difference is a scar on the wrist of one. Harrison makes some observations on how the double exposure serves Cummings's delineation of the good brother/bad brother characters. The process, he says, "enables the actor to present a complex of intellectual and emotional habits in what might be called hereditary harmony and acquired contrast. This would be completely nullified by defective or inferior double exposure."[27] Harrison saw double exposure's potential as a supporting platform for more subtle and complex gradations of character distinctions.

This allowed the audience to see and judge side-by-side both the "harmony" and the "contrast," as well as to better evaluate the actor's craft in these subtle distinctions.

But this kind of commentary was the exception rather than the rule. Most reviewers seemed to prefer sharp rather than subtle character differentiation. This may have been in part a carryover of the need for intelligibility in performance in the early 1910s. At the same time, character binary pairs (such as good versus evil twins) were emphasized most at this time because clear character distinctions or opposites allowed the most undeniable evidence of "acting." As well as the visibility of acting in such roles, we also see in these reviews a fascination with actors' abilities to evince different interiors beneath the same exterior. This has some affinities with the discourses on makeup, theatricality, and disguise, namely, the idea that people are not necessarily what they *appear* to be. We might see a link between the rise in interest in books, plays, and films of the late nineteenth and early twentieth centuries about the non-congruent relationship of appearance to character and the displacement of phrenology and physiognomy as legitimate sciences in previous decades. But the idea of casting film actors on the basis of build and physiognomy shows that old beliefs such as these are never obliterated, just complicated by new explanations of the relationship between personhood and appearance.

## Mechanical Precision in Staging an Impossible Interaction

Another common attraction of the 1910s/1920s films was the sight of actors' interactions with their own images. Reviews and publicity foregrounded such interactional set pieces even though it was not absolutely necessary for the characters portrayed by a single actor to be seen together in one shot. As Esenwein explained, much of the difficulty of presenting the interaction could be minimized by cutting between close shots of each character.[28] Indeed, this is the strategy deployed in *Stella Maris* (1918) as Mary Pickford's two characters, Unity and Stella, are shot separately, and their one interaction in the film relies entirely on eyeline matches to position them in relative screen space and sell the illusion of two separate people interacting. Nevertheless, the interaction two-shot appears to have

been a central attraction of the dual-role cycle. This meant that interactions that might be wholly unremarkable (diegetically speaking) became spectacular once read as clever illusionism. We see this in a review of *The Compact* (1912), where Reeves Harrison notes of Wilbur Crane's two characters: "Their expressions and movements are in strict harmony with what two different men might be expected to do in a single scene. They evince surprise on meeting each other and in noting the marvellous resemblance, converse, one listening while the other talks, and the caller takes a seat in response to the visible invitation."[29]

Unremarkable actions such as conversing and taking a seat in response to a gesture are suddenly worthy of notice when the ordinary action is a result of illusionism. Bowser states that the more complexity involved in producing a double-exposure sequence, the more publicity value it had. Complexity and cleverness could be increased by the number of exposures in one shot—witness Buster Keaton's *The Playhouse* (1922), for instance, which features a sequence where he plays all the members of a minstrel show onstage, the members of the band, and the entire audience! But for the more common dual-role melodrama, it was the trickiness of staging that could generate publicity. Numerous articles and reviews highlight sequences that show handshakes, embraces, or "the star actually battling with himself." Small pieces of publicity are titled "Kisses Herself on the Screen!" or "Hits at Self in Film." The latter headline is followed by a short piece on a Theda Bara vehicle, *La Belle Russe* (1919), which begins neither by noting the star nor providing a synopsis, but instead with the news that "the spectacle of a woman walking up to herself and laying her hands threateningly upon herself while she gazes into her own face has been achieved in motion pictures."[30]

Publicity for such films addressed a cine-literate audience. For instance, the *Los Angeles Times* headline "Weird: 'Crosses the Line': Double Exposure Feats in 'Snarl' Are Said to Raise New Standard" assumes a reader aware of split-staging and the masked camera required in double-exposure shots.[31] The cameraman often received the accolades for a particularly tricky double-exposure sequence. But as a by-product of this sustained public fascination with the illusory interaction, articles emerged in the mid-1910s and continued into the 1920s about the actor's role in making the illusion appear real and natural, and the particular mental concentration and physical control and dexterity required of them. Such shots needed rigorously precise counting for "the moves of the two characters" in synchronized

action, as "one man, playing two different characters, must face himself and keep the action natural and convincing at all times."[32] Edwin Schallert explained the process in some detail to *Picture Play* readers:

> No double exposure of this kind can be made successfully unless the movements of the actor portraying the two roles are timed to the fraction of a second. In very difficult scenes a metronome aids in keeping the proper tempo, and always when the action is in progress the camera man counts one, two, three, four, etcetera. The actor will be instructed to speak on the count of twenty, to laugh on the count of twenty-four, to look insulted at thirty, and to "shake hands with himself" at thirty-five. Record is kept of this count, so that when the second exposure is made—on the same film, of course—the actions of both characters, which a star plays, may, by identical timing, be made to synchronize. Even with these precautions a man playing two roles will occasionally get angry a bit too soon or become insulted too late, or else shake hands with himself at the wrong time—with very weird results, or dismemberment, owing to the division of the scene into two parts. Then the entire proceeding will have to be gone through again.[33]

A 1925 *New York Times* article explaining the process referred to the individual numbering of each frame and the accurate synchronization of the actor's motion in the two parts to make the illusion work.[34] The challenges such sequences posed were borne out by actresses, who, more commonly than their male counterparts, seem to have been recruited to speak of the technological and psychological conditions on set. Canadian actress, writer, and director Nell Shipman in her fictionalized account of her film career, *Abandoned Trails*, wrote of the intricate challenges of shooting double-exposure encounters (as she had in *Back to God's Country* [1919]) between two characters. "God, but that scene had been tricky! Hours of re-take, matchless precision of action—moving exactly on counts so that the dual characters would turn, speak and dove-tail their every gesture."[35]

Seasoned stage comedienne Marguerite Clark even penned a full-page article titled "Co-starring with Myself" that explained the peculiar cinematic labor involved in staging an illusory interaction for *The Prince and the Pauper* (1915). She wrote of the tight, precise rehearsals required to work out the timings for each character's response and counter-response, and described performing in clearly demarcated portions of screen space with a thread running down the center of the stage. The article begins with her reporting the

instructions from the director: "Don't stand too close to yourself. Remember that you are over at that side door and in the center of the room. Don't come too far down in the center or you will look twice as big as yourself—we must watch the perspective all the time."[36] This, as well as the psychological confusion of playing two characters who are in disguise as each other (essentially four characterizations), and having to constantly switch between them, she said, led to "frazzled nerves . . . and shredded energy."[37]

Such interviews, explanations, and publicity fed a discursive strand in which the double role was seen as the ultimate screen test for a would-be lead actress. For instance, a review of *The Girl in the Checkered Coat* (1917) sees the fact that Dorothy Phillips (who, like Marguerite Clark and Bessie Barriscale, had moved "from the speaking stage to the silent stage") has been cast in a double role as "evidence of the regard in which an actress is held by a producing company."[38] For "to be effective in double exposure, a player must needs be one who has had considerable experience before the camera, as well as being capable of delineating two personalities."[39]

The split-screen interaction thus brought into even sharper outline some of the regimentation in the timing and spatial orientation of film acting that we have examined in chapter 1. In a context where the labor and artistic value of appearing before the camera was debated, the double exposure film was understood as the most challenging form of acting in the age of mechanical reproduction—requiring tight, exhausting rehearsals rather than opportunities for improvisation, and necessitating a higher level of bodily control and mental concentration than that required in the theater.

It is easy to think of the actor as reduced to a living puppet here, a worker within a Taylorist-Fordist system of industrial production, who is alienated from the organic moment-by-moment processes that we have come to associate with "good" natural acting. But the successful dual-role actor was valorized as *virtuosic within* the most challenging technological conditions of filmmaking. Such actors orientated their bodily control and mental discipline to the requirements of the mechanical process, and they made high artifice and illusion appear believable and seamless. For a brief period, those in thrall to the new championed this form of acting as the most modern. At the same time, however, it could be seen to be drawing upon, and gaining legitimacy from, much older mechanistic traditions of performance that had emerged out of the theater.

Although the theories of particular acting theorists are not mentioned in reports and interviews from the split-screen sets of the 1910s, the

precision of movement, location, and timing required for this kind of photoplay acting has affinities with procedures devised by Johann Wolfgang von Goethe in *Rules for Actors* (1803) and later Lev Kuleshov's systems for Soviet Formalist cine-acting. For instance, Joseph Roach tells us that, for Goethe, the stage had to be clearly divided into a grid, with the actor learning a pattern of movement within the squares, rehearsing meticulously while "the director beat time with a baton and after which he imposed fines to penalize haphazard execution."[40] Jeremy Butler tells us that Kuleshov, inspired by the theater of Vsevolod Meyerhold and his "futuristic fascination with machinery," also demanded that the actor imagine the set as a grid in three dimensions in order to control their directions and degrees of movement in space, their rhythm set using a metronome.[41] It is important to remember that despite the mechanistic artifice of such systems in terms of process, the end result was designed to be realistic. They were aiming to craft a well-calibrated impression of reality for the viewer, just using a very different process from those, who, like Stanislavsky, believed that rooting performance in an actor's real emotions, memories, and experiences would produce a stronger effect on the audience.

Mechanical forms of acting process already had an established artistic value in acting theory, and could be appropriated to serve the exacting requirements of cinema trickery, as well as to assert that the photoplay actor had full conscious control over his or her body and face. At the same time, in the context of a critical discourse about the photographic close-up favoring the casting of types, the dual role proved that versatility had value in photoplay acting and that emerging stars had an identifiable acting talent in their ability to delineate two characters and transform, rather than just appearing as themselves.

But, like the morph, which in 1990s film and television shifted from object of technological wonder to ubiquitous visual effects cliché, so too the publicity value of the split-screen double role waned, and production of such films dropped away by the mid-1920s. Commentators such as Schallert in the early 1920s saw this waning as evidence of a shift in filmmaking's artistic values. Similar to Wid Gunning's arguments about audience knowledge and the mechanisms of illusionistic realism from a few years earlier, Schallert argued that while dual-role pictures may be "technically" perfect, they lacked "artistic reality." By this he meant that the awareness that one person played two or more roles was distracting, as it drew attention to "the adroit piece of technical business." No matter how furiously an

actor fought herself on the screen, or how ardently she declared devotion to herself, the viewer, distracted by the techniques of the illusion, would "lose sight of the meaning of the scene." For this reason, he said, double exposure and other optical tricks worked best in "spiritistic" pictures to represent memories, dreams, and spirits rather than material realities, like two characters co-present in unified space and time. For these reasons, and the increased emphasis on immersive realism in film, he claimed that "dual roles have lost their popularity with the best producers."[42]

With the waning of interest in this particular trick and the decline in production of such films, the wider function they had within the discourse of film acting diminished. I am not suggesting, however, that the decline in split-screen dual-role films led to the shift in acting discourse away from mechanistic values and the dilution of emphasis on versatility. Rather, in the 1920s we see the full aesthetic and discursive institutionalization of the star system, the move to sound in the late 1920s, and increasing praise for "spontaneity" in performance. The dual role, as we know, had a brief resurgence of interest in the late 1930s and 1940s with a cycle of female twin melodramas. In the next section I examine their reception and what it makes visible of this changed context. Such shifts over different periods of filmmaking reveal something more about changing ideas of realism, characterization, genre, stardom, and, tangled up in these, discourses on acting.

## The 1940s Twin Melodramas

The dual-role melodramas of the late 1930s and 1940s were reviewed very differently from similar films of the 1910s and 1920s. As we have seen, in those early decades dual-role films were seen as a platform for the actor's or actress's skills in delineating two characters. But reviews of Elizabeth Bergner's performance in the 1939 British version of *A Stolen Life* (remade in 1946 with Bette Davis in the roles) indicate a shift in perspective. For Richard Coe the film gives Bergner "the opportunity to indulge her peculiarly gamine personality both for good or evil."[43] Frank Nugent notes Bergner's style of "lightning change" performance, which he describes as having a tendency to vacillate between opposing emotional states. This vacillation is seen less as an indication of talent than as a symptom of the star's natural "disposition," an expression of her feminine excess. The dual role gives her a chance not to be someone other than herself but to demonstrate

her feminine duality, as she is seen to channel some of her "too vast . . . store of attitudes, emotions and expressions"[44] into one character, and some into the other. At the same time, Nugent snidely critiques her for just producing two characters that are inconsistent in their disposition and temperament, both, really, "like Miss Bergner," and then dismisses the film and its assumed audience by calling it "a picture stenciled for the feminine trade." Neither reviewer sees the dual role as a challenge for Bergner's skills as an actress, but more a means to "indulge" or channel "fascinating" or "too vast" expressive qualities of the star.[45]

We might see this shift from value placed on creative versatility in the 1910s to "indulgence of personality" in the 1940s as evidence of how star discourse had come to eclipse the image of acting at this time, but also how Freudian psychoanalytic conceptions of (feminine) split selfhood had filtered into popular discourse. The star system institutionalized the conception of fascinating personalities, revealing different aspects of their selves onscreen. A short article in *Film Daily* fifteen years earlier signaled that stars such as Richard Barthelmess, Anita Page, and Mary Astor were increasingly moving away from demonstrating versatility in making up for different roles or "submerging" their own personality in that of the character, but instead had come into demand "on the pure strength of personality." It concluded: "They can all act, but their acting is, in most cases, secondary to their natural personalities."[46]

In this context, Bosley Crowther, the rather truculent reviewer for the *New York Times* in the 1940s, painted the dual-role picture as a vehicle for star narcissism, which allowed a (female) star to multiply her screen presence. Of Olivia de Havilland playing identical twins in the murder mystery *The Dark Mirror*, he opines that she "does nothing that will add to her stature as an actress," asserting that "few actresses have ever achieved distinction in this hazardous undertaking."[47] Of the remake of *A Stolen Life* starring Bette Davis, he writes, "It is a distressingly empty piece of show-off for the multi-Oscar winner to perform," adding that both her usual "types" (the "good-girls, long-suffering and selfless" and the "bad girls, inclined to spite and greed") were on display here as "surface illustrations of fictional dames." Most telling is how he writes of the numerous extremely complex interactions staged between the twins "with the mechanical aid of trick photography"—this "illusion is more optical than dramatic."[48]

In the late 1910s and early 1920s Gunning and Schallert had criticized split-screen interactions on the basis that the knowledge that it was an

illusion would disengage viewers from the story. Crowther, more than two decades later, suggested that more is in play. It is not merely that his eyes are deceived while his mind knows better, but that this knowledge of Davis's singularity makes him more attentive to the dramatic flatness of performance. Is there something missing dramatically, something "empty" or false about the dramatic notes Davis hits in the scenes where the twins Kate and Patricia interact? Is there anything in the performance itself that alerts an audience to the fact that Davis is not actually co-present with herself? Watching Davis interact with herself in a sequence where one sister walks behind the other's chair, lights a match on the heel of one dainty shoe, and ignites her sister's cigarette, it is difficult to find fault with her dual performances. Murray Pomerance provides an engrossing explanation of how this astonishing illusion of "simultaneous presence" was achieved with stand-ins, meticulous performance timing, mattes, and optical printing. His focus is on how the sequence works to sustain its illusion.[49] However, the impossibility of Davis interacting with Davis, while wondrous as what Pomerance calls a "delicate assembly" of pieces "stitched" into a special effect, might also lend an oversensitivity on the viewer's part to the places where dialogue delivery seems a little overly rehearsed and declamatory.

But then, we could also argue that Davis's screen performances, while usually electrifying, were also sometimes perceived as somewhat solipsistic. A review from the *Dallas Morning News* of *All About Eve* (1950) backhanded her with praise: "For the first time in her unaccountable career she remembers her part, not her insincere, artificial thespie self. She remembers, also, that other actors are in the show not merely to feed her lines and tote her sables."[50] Riveting us with those famous flashing eyes and that masterful play of fingers and breath with cigarettes (her favorite expressive object), she could express temperaments ranging from queenly slyness through caustic fury to lovelorn vulnerability. But she also often declaims, and while others speak she continues to flash and mug, conscious that she is stealing the scene, showing lightning reactions rather than truly listening to, or being present with, her scene partner. This tendency in her performances, however, described by several critics as less acting than "showing off," could also be read in *A Stolen Life* as serving some of the interaction between the sisters. For instance, the twins' cigarette-lighting interaction presents us with the emotional tensions between the two, a saccharine sisterliness, a wariness born from years of game-play, rivalry, and

manipulation. But, at the same time, as Davis famously declared: "Natural! That isn't the point of acting."[51]

Two decades after the initial dual-role boom of the 1910s and 1920s, many things had changed besides the entrenchment of the star system. The coming of sound brought the addition of vocal performance and with it the possibility of viewer attention to tell-tale false notes in the voice's modulations. Film criticism had become properly established in metropolitan newspapers such as the *New York Times*, with writers, usually masculine, addressing an intended audience of somewhat cynical or sophisticated readers. In comparison to the reviews from the 1910s and 1920s, these later writers attend much more to differentiating the value of films from particular genres and the imagined tastes of their audiences, and in line with this there is a more pronounced gendering in discussions of performance. While in the late 1910s *Photoplay* started to link young female stars to the dual-role picture as a kind of career-building cliché (though I have found no evidence that female dual-role pictures were more prevalent at the time than ones starring men), in the 1940s Crowther saw the dual-role film as a project driven primarily by female star narcissism.

There were, of course, opposing views, but these were also inflected by genre/gender framing. For instance, Nelson B. Bell for the *Washington Post* (who, unlike the snarkier *New York Times* reviewers, had a tendency to act as a cheerleader for Hollywood's output in the 1930s and 1940s) had high praise for *The Dark Mirror*. He made particular note of de Havilland's "delicate shading and skillful modulation [in] the intricate business of making the sane sister appear on the verge of insanity and her mentally ill counterpart seem completely normal."[52] Unlike Crowther, who positioned *The Dark Mirror* in relation to a well-worn feminized cliché of feminine duality, Bell saw it as part of an exciting and clever cycle of films informed by contemporary psychiatry, and therefore as somehow an "authentic and believable" exploration of mental health and human identity. Moreover, in tandem with Crowther's argument about Davis's "surface illustrations of fictional dames," Bell's attention to "shading" and "modulation" indicates that the idea of psychological depth in characterization and acting had taken a stronger hold by this time in evaluations of acting. We might see these as evidence of the beginnings of a postwar shift in how popular understandings of the self, and related understandings of the acting process, fed into perceptions of its value and credibility.

It is worth attending to additional acting discourses that were becoming dominant in this context, and their explicit rejection of the mechanical principles that had been valorized in some circles in the 1910s. In a 1924 article titled "Spontaneity in Acting," Raoul Walsh holds forth on the need for actors and actresses to have more personal freedom in their playing of scenes, bringing "the correct thought back to the action."[53] This, he saw, was necessary if motion picture acting was to "progress." He writes of directing a well-known actor who was "stiff and helpless," asking the director "how long he should hold such an expression and whether he ought to turn his head more away from the camera and all that sort of thing." "Overdirection," he said, "causes players to be self-conscious, mechanical and as colorless as dolls or marionettes on a string."[54]

Similarly, Stanislavsky in *An Actor Prepares* (first translated and published in the United States in 1936) made a case for an actor's attention to thinking and feeling through the moment-by-moment circumstances of her character, which would be channeled toward making the character "alive." He explicitly criticized the actor who worked on mechanical principles rather than drawing upon "a living process." "With the aid of his face, mimicry, voice, and gestures," he declared, "the mechanical actor offers the public nothing but the dead mask of non-existent feeling."[55] As Butler notes, Richard Boleslavski, a student of Stanislavski, first brought his teacher's ideas to Hollywood in the 1930s, directing Marlene Dietrich, the Barrymores, and Charles Laughton.[56] But the greatest success in this strand of more "organic" acting theory, as Sharon Marie Carnicke explains, was found with Lee Strasberg's adaptation of Stanislavsky's tenets to American stage and screen, and, importantly, American conceptions of "the self" under the banner of "The Method."[57]

Strasberg's posthumously published essay "A Dream of Passion" showed how naturalism in acting had been rethought by this time, its central aim being to create "the illusion of the first time." The key to creating this illusion was for actors to engage in the "continuous process of thought and sensory process" as if they were the characters in a particular situation, responding and thinking moment by moment, but drawing upon their own experience and emotions in order to produce "continuous aliveness." Improvisation was, for Strasberg, the way in to a natural process of "thought and response" that would produce spontaneous behavior, rather than the actor merely "illustrating" the character's reactions and emotions.[58]

## Dead Ringers

The dominance of the Method within the popular image of "good acting" (if not necessarily within the processes that actors themselves draw upon), as well as in conceptions of character preparation, continues to impact the reception and publicity of films involving multiple-role split-screen inter- actions. One of the few exceptions might be something like Cronenberg's serious psychological drama *Dead Ringers*. Jeremy Irons plays twin gyne- cologists Beverly and Elliot Mantle, who swap places in their romantic dealings with unsuspecting women. As if to invoke the mechanistic values of the 1910s, Cronenberg made a point of telling interviewers that Irons was hired on the basis of being a classically trained stage actor, very disci- plined, and not trained in the Method:

> The number of external distractions, the kind of things he had to do . . . because of the way the film had to be made, he had to switch back and forth between Beverly and Elliot maybe twenty times a day. There was no other way to do it; it was a very schizophrenia inducing process, but Jeremy was very dis- ciplined. . . . The role is not really for a Method actor because you do not have yourself to act with, you have nobody to act with. And Method acting gets you into a lot of trouble in those circumstances, you don't have a real person to bounce off.[59]

While this valorization of a (now) non-Method process shows similarities to film-acting values around "discipline" in the 1910s, the ways in which Irons plays the two roles is very much *not* about stark character differentia- tion. He was almost universally praised for the subtlety of the distinctions he brought to the twins, winning several awards for his performances, from bodies including both the New York Film Critics Circle and the Chicago Film Critics Association. The nuance is such that as the film goes on, Bev- erly and Elliot become more difficult to distinguish. As Rita Kempley for the *Washington Post* acknowledged, this is not an aesthetic failing. Irons, she says, "confuses, terrifies and astounds with this eerie performance— like Patty Duke in a house of mirrors."[60] In his review, Roger Ebert seemed bewitched by Irons, who, as "an intelligent, subtle actor . . . does succeed in making the twins into substantially different people. In ways so under- stated we are sometimes not even quite aware of them, he makes it clear most the time whether we are looking at Beverly or Elliott."[61] Somewhat in

common with Bell's review of de Havilland in *The Dark Mirror*, but unlike most of the 1910s and 1920s reviews of multiple-role films, the emphasis in the reception of *Dead Ringers* is on subtlety and understatedness in the distinction, rather than stark differences and "separateness." This indicates a transformation of tastes and the import of popular psychology for later evaluative frames for film acting. Moreover, Irons's performance shows that the impression of "continuous aliveness" does not require a Method performance, or someone to "bounce off" for its foundation.

## Clones, Comedy, and Fantasy

Dual or multiple roles are now more generally the terrain of science fiction films and television shows about cloning (which we expect to contain a slight air of disconcerting unreality), or less reputable genres such as made-for-television melodramas. In such contexts, the kinds of "surface illustrations" Crowther complained about are either acceptable or milked for comedic value in the irritable antagonism between clearly drawn contrasting types or caricatures in fantasy-inflected comedies.[62] For instance, reviews of Michael Keaton's four comically distinct roles as a time-strapped man, Doug, and his three clones, in Harold Ramis's *Multiplicity* (1996) mostly praised the one-time stand-up comedian's abilities in distinguishing between each of these four characters. As clones, these characters are less Xerox copies than split-off facets of the original: the cocky hypermasculine go-getter, the sensitive domestic nurturer, and the befuddled, slack-jawed idiot. But despite early suggestions that this film would spark a digital revival of the multiple-role film, it did not, and the film itself was considered a box office failure.

Nineteen ninety-six was the peak of a breathless journalistic mania for computer-generated imagery in the cinema: its spectacular possibilities, its eclipsing of stars as box office lures, and its future as a central driver of audience attraction to the big screen. In this context, the full-page ad for *Multiplicity* in the *New York Times* featured a long row of identical Michael Keatons lined up to embrace his co-star, Andie MacDowell, while subpar review snippets screamed at the viewer to "quadruple your fun!" with "four times the laughs!" The film's hype promised that the sequences of four Keaton clones interacting would be "greeted with the kind of breathless wonder moviegoers derived from their first view of Forest Gump meeting

JFK."[63] While reviews praised Keaton's comic abilities in characterization, there were stark differences of opinion on the level of the "seamlessness" of the interactions, and who was responsible for when it works and when it doesn't. For Joe Morgenstern of the *Wall Street Journal*, the "visual effects, supervised by Richard Edlund, are unbelievably believable" in this "tricky comedy" to the point where "you simply accept the magical presence of four Michael Keatons."[64]

But Janet Maslin in the *New York Times* was more critical, homing in on more than just the optical qualities of the illusion but on questions of dramatic seamlessness, and how it is evident that the different Keatons are not actually interacting, listening to, or bouncing off each other. Maslin sees the interactions as "sometimes leaving it too apparent that the star did much of his acting in a vacuum."[65] Although his eyelines match flawlessly, the problem might be more in the timing and tone of Keaton's lines. The importance of vocal performance (and sound editing) for selling the interaction and filling the impression of an acting "vacuum" becomes more apparent when we look at another, much more successful multiple-role visual effects comedy that was released the same year, *The Nutty Professor* (1996), featuring Eddie Murphy.

Kevin McManus in the *Washington Post* credits visual effects supervisor Jon Farhat with making the scenes featuring "multiple Murphys appear to be genuine interactions between different individuals."[66] Watching the film, though, it is also clear that the staging, the sound editing, and Murphy's performances in transfiguring makeup, wigs, and fat suits are largely responsible for the success of the illusion. The film contains two lengthy sequences of multiple character interaction, and both are staged around a dinner table. This means that Murphy as Herman Klump and as his mother, grandma, grandpa, and brother performs each of these characters in a fixed position in diegetic space. His multiple characters are shot conventionally, with a wide establishing shot, a couple of two-shots, and then individuals shot singly around the table, intercut with reaction shots from other characters. As a family, the Klumps are a raucous, garrulous group, always cutting each other off, speaking over each other, mumbling inaudibly, cackling with laughter, farting, or, in the case of the more delicately sensible mother Klump, vacillating between enthusiastic approval of her sons and protesting the disgusting manners of her husband. The voices, all Murphy's with the exception of Jamal Mixon's maniacal laughter as Herman's young nephew, fill the space with their cacophony. This provides the

impression of presence for several bodies that do not have to be seen at all times, as long as they are heard. The sound of Murphy's vocal performances all responding to each other is edited to nimbly weave the disparate shots together, and the shots we have of over-the-top reactions while another character is speaking also sells Murphy's multiple presence in the various bodies. The prosthetic makeup also helps, physically differentiating and disguising Murphy enough that we are never distracted by awareness of one actor performing against five versions of himself.

Sound editing, performance, and staging can then be used to sell an illusion of simultaneous co-presence between or among an actor's various screen selves. Despite the growing ubiquity of tools such as digital compositing in popular cinema, however, there has not been a craze for digitally remediating double-role pictures. Moreover, most recent films featuring an actor in dual or multiple roles make a point of eschewing rather than showcasing illusory interaction, and care is often taken to explicitly deflect viewer attention away from the actor's non-co-presence with him- or herself.

## More Recent Strategies: Eschewing Interaction to Diminish Distraction?

Let us return to where this chapter began, with the "Seven Harrys" sequence. When seen against this longer view of split-screen multiple performance, we might notice that none of the Harrys actually interact with each other. Unlike earlier films, which made a show of displaying the spectacle of an illusory interaction between an actor and his or her copies, these Daniel Radcliffes do not attend to each other's presence or touch in any way. Each character instead splits his attention between the weirdness of his own transformation (as they rapidly become oriented in their new bodies, making jokes or comments about its peculiarities, hurriedly undressing and redressing in Harry's clothes) and taking in the instructions given to them by Mad-Eye Moody, who occupies a point in space just behind the camera. This solves a production problem. It reduces some of the complexity of what otherwise would be an even more onerous and difficult shot. It provides no issues with mismatched eyelines or tonally unconvincing dialogue, and it also serves to maintain audience focus on character and

the delight in Radcliffe's impersonations of his cast-mates rather than the distraction of impossible interaction.

In David Fincher's *The Social Network*, the Winklevoss twins are performed by one actor, but attention to the impossibility of co-presence is deflected in several ways. The casting of Armie Hammer, a relative unknown at the time, meant that much of the audience would go in not knowing or looking for the seams of technological fragmentation. It is not presented to us as a visual effect, so we are not distracted from character, characterization, and story by the desire to scour the image for any tell-tale signs of non-co-presence. Even though a doubling of sorts takes place, in that Hammer's facial performance is pasted on cast-mate Josh Pence's body so as to produce an illusion of twins, the bodily interactions are all "real." Pence is not a place marker or stand-in; he authors the performance of the second character, producing the leads that Hammer endeavors to follow with his facial performance in order to be properly integrated with Pence's body into the shot. The bodily interactions, therefore, are genuinely taking place in profilmic space, even if the faces are not.

The eschewal of interaction or the deflection of attention away from faked interactions in recent films seems to indicate an increased sensitivity, on the behalf of producers and reviewers, to a disquieting knowledge of the "vacuum" that an actor has to perform in such situations. One explanation for this sensitivity could simply be that audiences have been tutored in popular entertainment journalism about the non-indexical nature of digital images, and so are more alert to signs of people and things not being present before the camera. But another explanation might also be found in more recent writing on acting by scholars, such as Rhonda Blair and John Lutterbie, who draw on cognitive or computational theories of mind. They conceive of the actor, like all social creatures, as a being embedded in, moving through, and acting within a world of stimuli, of signals sent and received, triggering natural responses and counter-responses. As Mary Ellen O'Brien wrote in the early 1980s in her history and guide for film acting techniques, in order to seem natural onscreen, while on the one hand blocking the camera and the space beyond the set from their consciousness on the other, actors must cultivate an open responsiveness to their acting partners, and conceive of their body as "a kind of biofeedback machine."[67]

We might say, then, that Wid Gunning, back in 1917, had prescient advice for filmmakers deploying dual roles, double-exposure, and split-staging—that it encourages viewers to go looking for it, it distracts them

from the story, it reveals the mechanisms of the film, and the illusion of a fictional reality collapses onto itself. Directors, actors, cinematographers, compositors, and sound editors continue to find ways to deflect this knowledge in order to sell the illusion.

As with transfiguring makeup, the multiple role has provided a platform for actors to demonstrate their ability to escape type. But makeup, originally seen as a relic of theatrical artifice, was, as we have seen, gradually habilitated (although not always, entirely) as *cinematic* within frames of anatomical and behavioral mimesis, and subsequently there was work toward a synthesis of acting and prosthetics in ways that were extended with digital performance capture. Although the split-screen multiple-role film was initially valorized within a frame of cinematic realism, it came to be seen, except in particular instances of deflected attention, as distractingly artificial in the wake of new acting theories, explanations of human behavior, and shifts in the popular conception of realistic performances. This has further import for acting in greenscreen environs, as we will see in the next chapter.

# 6

## There Is No There There

Making Believe in Composite
Screen Space

> Any background in the world can be projected
> on the stage where the actors are performing,
> through a process invented by an eighteen-year-
> old kid, Dodge Dunning. The illusion is perfect.
> —Cyril Vandour, "None of This Is Real,"
> *Modern Screen*, February 1935

On Jonathan Ross's British night-time TV chat show in October 2011, actor Ewan McGregor became increasingly animated as he regaled the host and audience with anecdotes about playing the younger Obi-Wan Kenobi in George Lucas's three CGI-heavy *Star Wars* prequels. Buoyed by the crowd's growing audible mirth, he leapt to his feet, his voice rising in volume and pitch, and proceeded to relive what was for him the most absurd moment of filming: the closing scene from *Episode III: The Revenge of the Sith* (2005), in which Obi-Wan delivers the baby Luke Skywalker into the foster care of the boy's aunt and uncle on the remote desert planet of Tatooine. Within the larger mythology of the films this is a key moment, a

bridge from the prequels to the film that started it all in 1977, *Star Wars IV: A New Hope*.

McGregor's story of filming this scene, however, was one of disillusionment and disorientation. As he tells it, the baby Luke was plastic, and the Lars family homestead on this arid and inhospitable twin-sun planet was a bare greenscreen set with a slightly higher green platform to indicate a hill. His character's mode of transport—a "lizard or somethin'," he said, mock dismissively—was a featureless static green "box" ("it didn't move or anythin'—there was no gimbal!"). To demonstrate his difficulties to the studio and TV audience, he commandeered a chair to stand in for the "box," which had in turn been a greenscreen proxy for a digital creature, and straddled it, rocking sinuously from side; "and I'm goin' like this," he demonstrated, in an attempt to make it seem as though he were astride a living perambulating beast. After explaining how he passed the plastic baby to the actors playing Skywalker's aunt and uncle, McGregor imitated Lucas shouting direction: "Look at the mooooons! Look at the moooons!" Miming the actors looking around wildly at nothing in particular, lost and bewildered, he held his hands out helplessly and bellowed in hammed up exasperation, "No one knows where they fucking aaare . . . the moons!"[1] Ross's audience erupted in applause and gales of laughter.

The actor delivered this anecdote on a bare stage. With just words and gestures, he displayed his powers to conjure a situation into aliveness for our imaginations, while explaining the difficulty of doing just that on the greenscreen set. Green- or bluescreen is a key tool for recording live action and partial sets that will be later composited with background plates, digital elements, and animation. Due to the fact that skin tones contain very little blue or green, the use of non-reflective apple-green painted objects or fabric screens provides a blank environment from which actors' performances can be easily separated and combined with new settings, objects, and creatures.[2] Greenscreen has a functional continuity with earlier forms of both post-production and in-camera compositing, including the inky black velvet backdrops or camera masking of silent cinema's tricks.

In some ways McGregor's narrative harks back to discourse around double-exposure scenes in the 1910s that emphasized the strangeness for actors of having to gesture and speak to empty air, creating the basis for illusory interactions. The double-role films of that decade, though, served the dual function of showcasing cinematic trickery and making the craft of film acting visible. They allowed actors to demonstrate both their

versatility in differentiating characters and their impeccable timing and concentration to make the interaction seem real. McGregor's talk-show performance, however, was not illuminating the operation of a marvelous successful trick. His anecdote was offered in the spirit of an explanation for a failed realism, and the audience laughter (not just of appreciation of the actor's comedic skill, but a laughter recognizing a cultural truth) suggested that it was received as such.

Watching the scene he describes filming, it is visually glorious, and the swelling musical score insists we should see it as momentous, and yet characters and place do not seem fully co-present. Tatooine's digital desert and sky are stunning: dark clouds gather portentously in a gold-and-red-streaked mackerel sky, shading a flat sandy plain in tones of deep lavender, grape, and gun-metal gray. In its visual drama and beauty this place resembles a gaudily painted nativity scene on a Christmas card. However, it does not seem like a real place, and its placelessness is not because of its gaudy painterly "look" so much as the way the characters do not seem at home in their surroundings. They float blankly through space, mechanical and awkward, unmoored from their environment.[3]

"Our sense of place in cinema," Stephen Prince says, "is a manufactured perception achieved by conjoining different categories of images and environments."[4] In the past two decades we have seen a common criticism of films that deploy extensive greenscreen compositing of actors with computer-generated or -augmented environments. This criticism reveals a complexity in our perception of the presence and spatial unity of such fabricated screen places. In film reviews there is the repeated (mis)appropriation of Gertrude Stein's description of Oakland, California, "There is no there there," for claims that a film's digital environment lacks "presence" or that the film does not "feel real."[5] Jim Vejvoda's review of Tim Burton's *Alice in Wonderland* (2010) exemplifies such criticism. He complains that "nothing in this film feels real, either physically or emotionally. . . . Alice feels exactly like what it was: a green screen exercise with actors hamming it up for absent cartoon characters who will be added later," and adds that the interactions do not feel "tactile."[6]

Greenscreen, bluescreen, and digital compositing are, as Prince, Lisa Purse, and Julie A. Turnock point out, just extensions of much earlier process-shot techniques such as rear and front projection, multiple exposure, mattes, glass painting, and optical compositing.[7] Compositing or process-shot techniques have long been a routine part of popular

FIG. 18 Bonnie Pliesse and Joel Edgerton as the young Aunt Beru and Uncle Owen acting awkwardly in a greenscreen composite shot in *Star Wars III* (Blu-ray capture)

filmmaking. They have been used not just to integrate separate performances by one actor, as we saw in the previous chapter, but to extend sets, fabricate places, and insert the performances of studio-bound actors into other locations. The suite of technologies and techniques used in digital compositing (such as green- or bluescreen, CGI mattes, 3D models, animation, and motion tracking to combine photographic and digital elements in mobile cinematography) are understood as realizing longstanding aims in filmmaking, enabling fabricated cinematic environments to become more seamless and more immersive. As Aylish Wood says, "Across the history of special effects embedded in the continuity system, the desire for credibility has taken the form of developing increasingly sophisticated ways of showing that effects and live-action figures are integrated into the same on-screen space."[8]

What is less often considered in visual effects scholarship is the increasing importance of acting to the integration of effects and live action. In accounts of the composited film image such as we find in Lev Manovich or Mark J.P. Wolf's work, actors are conceived of as "graphic elements," little different from a prop or setting, to be "assembled with others" into a coherent unified moving image.[9] I once heard a screen scholar remark at a conference that actors are merely "objects that reflect light, just like anything else." However, in the view I take here, actors are not *just* graphic elements, or objects that reflect light, but conductors of presence and tactility. Their performed interactions and physical responsiveness to their character's fictional environments are key factors in helping us make believe. As

Steven Wilson says in his book on dimensional animation in live-action filming, "A great deal of success of a composite sequence depends on the actor's ability to deliver a believable performance under highly artificial circumstances."[10]

If we consider the long history of actors performing to absent characters, creatures, and places, where have this perception of greenscreen filming and this preoccupation with presence and tactility come from? How is it so that, even in the most artificial of filming circumstances, and the most collaged of film images, actors and visual effects have together managed to conjure a sense of physically being-there? This chapter works toward some explanations and traces a history of screen acting under such artificial conditions. We find that norms have shifted in the ways actors have been expected to perform their relationship to imaginary places and situations in order to make a film world "feel real."

As I show here, with earlier modes of compositing, for several decades the terrain of concern for realism was largely visual. Filmmakers and reviewers focused primarily on things like the consistency of lighting on composited elements in a shot, or reducing the disparity of image quality between background projection and foreground subjects. These visual concerns persist, of course, but it was not until the late 1950s and 1960s that the current critical and industry concern with values like "presence," "thereness," "tactility," and "feeling (as opposed to merely looking) real" began to emerge. In film culture literature of earlier decades, such terms were not used in the same way they are now. In the 1920s and 1930s, for instance, the terms "feel real" or "feeling real" were intensifiers for an emotion like "I feel real bad [happy/sad/mad/ scared/guilty]." "Presence" was used, as it still often is, in a vernacular sense, to evoke an actor's charisma and vivid and electrifying emotions communicated through their performance. The word evoked emotional conviction, but in film it has come to incorporate its spatial and physical meanings too, as in the 1990s and 2000s cognitivists have tried to understand how the psychological experience of "being there" can be produced through virtual as well as actual cues.[11]

In some ways these shifts toward a concern with "presence" and "feeling real" can be explained as being driven by cinema's need to champion its specificity and superior immersive power as an entertainment medium against competitors such as TV, home video, and video games, and more recently to create immersive experiences *for* the huge screens and booming speakers of the home theater. Ariel Rogers, in her work on the ways

cinematic publicity has framed the appeals of widescreen, Cinemascope, and 3D, indicates how central a concern with "spectatorial embodiment," and bodily values such as "tactility" and kineticism, has been to these appeals.[12] As Turnock, Wood, and Prince have shown, the increasing desirability of immersive experiences in the cinema has driven the development of new ways of conceiving and constructing screen-space with greater depth and movement. These changes have had flow-on effects, overcoming some of the technical limitations of process shots, and leading to new workflow models. I would like to extend these views, however, to consider some other factors that I see as relevant to understanding how our horizons of expectations about actors and space, characters and place, have moved. These are the shifting interrelations between the status of location shooting and studio fabrication of place and a rise in psychophysical theories of acting, human behavior, and embodied sensory experience. This chapter is significant, then, for two reasons: it works to deepen our historical understanding of how performance and visual effects are integrated on the screen. But more broadly, it may help us better understand some commonplace beliefs about CGI that link it to the attenuation of "presence" and, by extension, the believability of screen worlds.

## Feeling Real

Tactility, presence, and "feeling real" were key values emphasized in the pre-release promotional rhetoric for J. J. Abrams's *Star Wars VII: The Force Awakens* (2015). This rhetoric explicitly linked the attenuation of such values to CGI. *The Guardian*'s headline, "Star Wars: Episode VII to Limit Cheap CGI Tricks and Keep It Real," made a sly dig at the comparative "unreality" of Lucas's earlier prequel trilogy.[13] Abrams's *Star Wars VII* was positioned as remedying the failed realism of the prequels by minimizing the use of digital environments (even though the film actually contains 2,100 digital-effects shots). This argument was heavily pushed in a three-minute, forty-two-second video released for the 2015 Comic Con. The video begins with a short montage of iconic characters (R2-D2, a stormtrooper) and clapperboards on sets (a desert, a space ship interior), as if to say, "This is not the digital backlot—this is a moment captured by a camera in real space and time," each shot matched with a poignant sustained piano motif in a minor key. Images of concept art,

miniature spaceships half-buried in sand, and workshops filled with silicon puppet heads are seen next. A voice, which we soon discover belongs to Mark Hamill, intones over the footage, "Real sets, practical effects," with shots of actors in the desert running from explosions, and stormtroopers standing on the sand near life-sized spaceship landing gear (greenscreen behind). Meanwhile, we even have Peter Mayhew in his Chewbacca costume, sans head, chirping at the camera: "[We're] getting back to the old days, the old ways of doing things." This is, of course, partly nostalgia at work—especially with the reassembling of the aging 1977 cast in order to anoint the new film with the patina of authenticity. But it also presents the belief that working with "real sets and practical effects" will not just "look" but "feel" more real than CGI to an audience in the cinema. As Abrams said in an interview, "*The Force Awakens* is going for a real feel" and "the thing that struck me, that wouldn't get out of my head, is just how real you knew and felt *Star Wars* was when you first saw *A New Hope*. You couldn't deny it."[14]

What do Abrams and company mean by the "real feel" of the 1977 *Star Wars*? Turnock has made some excellent observations on the look that Industrial Light and Magic (ILM) developed for the film, such as "the roughened look of surfaces, hard directional sunlight, a muted color palette, and handheld cameras."[15] These optical qualities, which (as she points out) we have come to associate with the new realism of 1970s cinematography, go some way to explaining a perception of *Star Wars*' "real feel." However, the issue of practical effects and "real sets" versus CGI is less about optical matters than the thorny issues of presence and belief. In this regard there is common ground with reviewers of *Rise of the Planet of the Apes* (2011) who, as we saw in chapter 2, compared the performance-captured digital apes to the actors in furry suits and rubber faces of the first 1968 version. While admitting that the digital apes were "believably emotive," Michael O'Sullivan said that they were "less than fully present" compared to the apes in the earlier film.[16] His knowledge that Roddy McDowall in his stiff rubber mask was part of our world, reflected light, and was recorded by a camera was apparently more important to his sense of realism than the visual verisimilitude of ape motion and bodies. This is a view in which indexical realism, or the knowledge that something existed before the camera, trumps perceptual realism, the ways in which things look and move in realistic ways.

Roger Guyett, the VFX supervisor for *Star Wars VII*, whose contribution to the film was largely diminished by the "real sets, practical effects"

rhetoric, seemed bemused as he asked: "In the first *Star Wars*, when people watched the X-wing flying down the trench, did audiences really think that was happening? Did they believe it was a real X-wing flying? A model of an X-wing flying? What was their understanding of how real that was? Was it more real because the model was part of our world? Is that what people mean by real, a tactile thing? These are philosophical questions that you have to consider when you're doing a visual effects movie."[17]

Guyett also pointed out that *Star Wars VII* contained 2,100 visual effects shots. The fact that these were so minimized in the publicity raises the suspicion that it might not be so much that CGI in itself looks less objectively "real" compared to "real sets, practical effects." Rather, publicity that highlights the filming of material things and locations that can be walked through and touched is designed to cue the audience's perception of presence. Evidently there are parallels with the ways that 1910s publicity provided authentication for onscreen stunt action in order to counter the emerging audience knowledge of cinematic trickery that threatened to dissolve the thrills in thrill pictures. Likewise, there are similarities to the misleading publicity around *Black Swan* that served to enhance the illusion of a unified dancing body but also to inflate perceptions of Natalie Portman's contribution to that body.

It would be a mistake, however, to assume that shooting in actual landscapes with practical effects produces, by default, a persuasive, living impression of reality; one only has to watch five minutes of a 1950s B-movie with rubber monsters and wooden actors stumbling through the hills outside Los Angeles to realize this. Likewise, digital visual effects, greenscreen, and performing in a "vacuum" do not intrinsically produce film worlds that seem to lack physicality, substance, a sense of place, or a "real feel." It is more a matter of how they are used, and the vision, will, expertise, budgets, and time involved.

## Vertiginous Peril in a Greenscreen Vacuum

We know in Robert Zemeckis's *The Walk* that Joseph Gordon-Levitt is not really gracefully but carefully inching his way along a wire stretched between the North and South Towers of the World Trade Center, his face set in an attitude between intense concentration, cocky cheekiness, confidence, and quiet soaring triumph. Even if those twin giants still stood

today, and even if Gordon-Levitt was capable of the stunt, and willing to perform such a feat in reenacting high-wire artiste Phillipe Petit's historic and momentous illegal stunt from 1974, an insurance policy and a permit to film such a risky act between the towers would not be forthcoming. Gordon-Levitt is instead inching his way along a wire placed on a foot-wide green platform, twelve feet up, linking two rudimentary pieces of World Trade Center rooftop set. According to *Cinefex*, some of the shots when Petit is playfully bouncing on the wire and lying on his back are not even Gordon-Levitt. They are circus high-wire performer Jade Kinder-Martin, performing on a wire twenty feet above a green floor and wearing a harness, while Gordon-Levitt repeated the process for "face-wear repli-cation passes," a digital replica of his facial performance replacing Kinder-Martin's.[18] And yet in the moment of viewing, we hold our breaths for Gordon-Levitt/Petit, and feel truly that we are with him, here balanced precariously hundreds of feet in the air above the streets of New York on a cool, crisp morning in the mid-1970s.

How do we account for the palpable sense this film provides that Gordon-Levitt is really *there*, suspended 110 stories up between the tow-ers? It is partly a matter of the point-of-view shots that anchor us to his body in this dangerous position, placing us in his shoes. As Petit takes his first step onto the wire, suspended over the void, we look down to see the vertiginous drop to the streets below, seeing his feet as if they were our feet, in soft black slippers, sliding and pausing, sliding and pausing on the wire. There were various reports that the vertigo induced by these shots, in conjunction with 3D projection, triggered nausea and vomiting in some audience members. *The Walk*'s VFX supervisor, Kevin Bailie, has explained how he was given permission to hover in a helicopter at 1,400 feet above the WTC memorial footprints. Looking out of the helicopter at the drop below, and thinking of how Petit had walked at this height across a wire a half-inch thick without safety equipment, he was overcome "by complete terror and inspirational awe."[19] He consequently evaluated every shot of his effects team against the memory of that feeling. This reminds me of Vivian Sobchack's description of a film as a "body" that incorporates the body we see onscreen, the body of the filmmaker in the choices they make for cam-erawork and sound, and the spectator's body. It is not just the actor who has to think in embodied terms for their performance. Those behind the camera or in front of computers often use their own embodied memories

when constructing perception in films, with the aim of provoking a bodily experience for the audience.[20]

How we see and how we share his embodied perspective are important, yes, but equally important is *what* we see. As Murray Pomerance says, "In simulating settings the principal issues are optical, not geographical"; "what counts in the end is not how real a place is, but how real it looks."[21] We judge the realism of how places look onscreen by measuring them against our knowledge and expectations of how such places should look, or in this case, as the film is set in 1974, *did* look. Our knowledge and expectations are accrued through previous encounters with a place through images and travel. So much footage of the Twin Towers exists, and we have seen so many helicopter shots over Manhattan in so many documentaries, newscasts, and films, that we know how this place should look. Zemeckis and Atomic Fiction, the FX vendor charged with building a digital 1974 New York City, took meticulous care to ensure this environment accords consistently with the mediated NYC mosaic that informs our expectations.[22] This virtual New York City view from a skyscraper rooftop is truly "grounded" in a photographic reality. Similarly, we may have generated an expectation of how performers hold their bodies on the wire through seeing high-wire performers on TV, in the *Man on Wire* documentary about Petit, or in a Cirque du Soleil show.

Our impression that Gordon-Levitt as Petit is really on the wire between the two buildings is, in part, a matter of optical factors, such as the way light and shadow hit his body and face, moving with the digital sun and clouds. The lighting on Gordon-Levitt is digitally controlled to match that of the environment in which he will be placed. But the actor's performance also needs to be in sympathy with the fabricated environment. Actors play a significant role in transforming image into a materialized world with high stakes and real physical consequences for their characters. It is not merely a matter of eyeline matches, confirming that the objects in this screen world that are visible to us are also visible to them. The actor's body and face are conduits for our belief. As Eric Brevig, visual effects supervisor on films such as *The Maze Runner* and *The Day After Tomorrow*, has explained, "The audience looks to the actor's face in much the way a kid looks to its mother's to see if what's going on is important and real."[23] Doubtless, the plausibility of Gordon-Levitt's performance was enhanced by the eight days of intensive training in wire walking and circus performing that he undertook with Petit himself.[24] Due to this training, he can move across this space with some of

the fluid cautious confidence and nimble optimism required. But he also needs to convince us that one misstep or a strong gust of wind might send him plummeting. He must make it seem practiced but not easy. It helps that his certainty seems to falter in a heart-stopping moment toward the end of his walk, setting off a dangerous wobble, and his body struggles to maintain its equilibrium. In this moment we see a sickening panic flash through his eyes before he regathers himself and breathes, steadying himself: his confidence, defiance, and balance restored.

This is an instance of an actor responding realistically to imaginary circumstances. To state the obvious, if Gordon-Levitt responded only to the material rather than the imaginary conditions of the shoot, we would see him walking nonchalantly across the foot-wide ledge. Together we have a style of virtual shooting that conjures our vertigo, the perceptual realism of the location. The image detail and optics can only take us so far toward an impression of reality—Gordon-Levitt must also create a performance that will sell the corporeal stakes of Petit's situation to us. These are the current norms, at least: that characters are alive to and responsive not just socially but physically to the materiality of their surroundings. This makes the world onscreen seem present.

## Radiating the Real

It is clearly possible for a realistic impression of presence and heart-stopping peril to be produced through such highly artificial means. However, in the digital age, questions of the difference that the materiality of an actor's surroundings makes to his performance have become more pressing. Ethan de Seife, in a recent essay on filmmakers' continuing use of methocel (a viscous goop used as a practical effect doubling onscreen for slime, oil, blood, and mud), says: "When actors do not interact with physical costumes, sets and/or props, they are deprived of objects around which to tailor their performance. There may well be an ontological difference between the two performances that might result from, for instance, an actor stroking the soft fur of a real, live poodle and that same actor miming both the action of petting the dog and simulating the fur, its texture, and his haptic and mental responses to that imagined surface."[25]

If we think back to McGregor's anecdote of frustration, disillusionment, and disorientation on the greenscreen set, we cannot discount the physical

FIG. 19 Joseph Gordon-Levitt in *The Walk*, in a partial set with substantial digital compositing, reenacting Philippe Petit's famous high-wire walk between the Twin Towers of the World Trade Center in 1974 (Blu-ray capture)

and psychological impact that shooting in physically present sets may have on the work of cast and crew. To move to the other end of the extreme in the material conditions of filming, shooting on location is often seen as a warrant for a more believable film world. For some directors this believability is not just due to visual factors such as natural light, or the authentic patina of age, use, and erosion on real buildings, roads, rocks, and trees: locations are also thought to aid the actors, pushing them into more genuine experiences so as to evince truthful behavior that will heighten the affective dimensions of the drama. For instance, Alejandro González Iñárritu was quoted on his decisions to film *The Revenant* (2015) using only natural light in various rugged and remote outdoor locations, such as Alberta, Canada, and the tip of Argentina. Facing several criticisms from ex-crew members who thought many of the shoot's physical difficulties had been unnecessary and location shooting could have been supplemented with CGI to get the right look, he retorted, "If we ended up in green screen with coffee and everybody having a good time, everybody will be happy, but most likely the film would be a piece of shit."[26] Spending days and weeks with the cold and wind biting their extremities, he thought, would take the actors to the limits of physical exhaustion and discomfort—embodied states that would create a thrumming baseline to their performances and the desperate stakes of their characters' brutal struggles against nature and each other.

Nonetheless, there are other, less extreme routes to eliciting convincing, fully embodied performances, and Iñárritu, of course, did not insist that

Leonardo DiCaprio fight an actual bear for the film's most notoriously visceral scene. The fact that the bear was CGI, and that in actuality DiCaprio was jerked and dragged around on wires while being tackled by a stunt performer, did not diminish the realism of the sequence or fail to foster our belief that his character, Hugh Glass, was being viciously mauled.

The debates we see playing out now about CGI versus location filming, material sets, and practical effects are in many ways similar to ones that have intermittently percolated around the aesthetic value and adequacy (for authenticity, for persuasiveness, for production values) of studio *trompe l'oeil* backgrounds versus shooting actors in actual locations or with materially real surroundings since the 1910s. In fact, they go even further back, to the theater, if we consider staging practices in the late nineteenth-century theater of Naturalism, in particular the work of the American stage producer and playwright David Belasco.

In Belasco's view, the best way to achieve realism onstage was to use the real itself where possible. Set décor and props needed to actually *be* what they appeared to be. This was partly for the audience's benefit, as Belasco appealed not just to their sight and hearing but also to their sense of smell—having the actors cooking pancakes onstage in a working kitchen, washing clothes, or scattering pine needles on the floor. This was also about creating an environment that felt "real" for the actor. He believed that having actors cook and eat meals, wash clothes, pull curtains, or poke burning fires would force them to relate both physically and psychologically to the reality of their setting. Such activities are now often called "bits of business," in somewhat disparaging terms that suggest they are mere flourishes of detail to lend verisimilitude. In Belasco's terms, though, this was about finding a more organic route to the impression of realism: "I believe in real things on the stage instead of artificial properties, not so much for the audience to see as for actual contact with the actors. . . . If the actors are thoroughly steeped in the atmosphere, they will radiate it, and there comes the real artistry."[27]

It was not exactly clear how this "radiation" worked, but Belasco insisted that such sets and objects were invaluable aids to the actor's art, as "he does react to the influence, and the audience in turn reacts to his performance."[28] To what extent is there evidence that Belasco's ideas about sets and props as aids for realism in performance transferred from the stage to the early screen? Certainly there was a production value to film in promoting its use of real places and expensive materials rather than their facsimiles, but the extent to which either helped the actor to "radiate" atmosphere was not

foregrounded in early film acting discourse. Indeed, for many observers, because film was reduced to the visual dimension, the value for the audience of recording real places and things in the service of fiction was debatable. In terms of the value for performance, a perception of "the real thing" (diving into real lakes off real cliffs, climbing real trees) mattered for thrill picture stars, as we have seen in chapter 4, because the authenticity of their bodily action was at stake, and the unpredictability of nature heightened the risks. At the same time, as we saw in chapter 5, actors could also be lauded for demonstrating craft in contexts of high trickery, performing interactions and reactions to thin air.

## Screen Places Fake and Real

Filmmaking in the 1910s held in tension two diverging approaches to the creation of realistic or persuasive worlds on film, both of which stemmed from what could be achieved with a camera. On the one hand, photographic realism exploited the camera's ability to travel, record, and assemble the raw visual materials for a story world with a realism far beyond that which could be simulated within the walls of a theater. On the other hand, the camera could be tricked through forced perspective, editing, and in-camera compositing to produce impressions of places that looked plausible but never existed. From the earliest days of narrative filmmaking, producers found it efficient, economical, but also creatively liberating to fabricate the locations for their stories, using whatever means available to them. As Brian R. Jacobson explains, the first film studios were modeled on photographic studios, designed for control of the conditions of filming, the maximization of natural light, protection from rain and wind, but also deploying painted backdrops to simulate interior and exterior locations.[29] Similar, two-dimensional *trompe l'oeil* backdrops had been used since the Renaissance for forced perspective in set design to give the audience the illusion of spatial depth, architectural grandeur, or a continuation of landscape into the distance, beyond the space where the actors stood. Cinema extended such illusionistic practices in various ways, amalgamating footage taken on locations with studio sets, and extending or synthesizing places with miniatures, mirrors, mattes, and multiple exposures.

In the 1910s and 1920s we see a few different views and debates in the trade and fan press about the value of different combinations of actuality

and illusionism in the creation of film worlds. *Moving Picture World* published a small announcement about a method developed by Richard Stanton (a director known for his efficiencies) "whereby costly sets and interiors are dispensed with so far as building expense is concerned." Stanton claimed that for his most recent unnamed "super-picture" for William Fox, he filmed actors on a specially marked floor in front of a black background and cheap furniture covered with black cloth. These performances were then combined "using ingenious double exposure" with photography of much more impressive interiors, including plush furniture.[30] Similar articles were written about the German Schüfftan process, which used mirrors to combine miniatures with live action.[31] Such desires for production cost-savings periodically excited the North American trade press.

At the same time, locational realism had an aesthetic value and guarantee of quality for particular genres, such as westerns and reenactments, and the value of the real could be exploited in promotion in ways that produced "fakery" as a negative value. For instance, we see a proclamation of "no fake studio stuff" in a 1908 advertisement for Kalem Films' feature *The Molly Maguires or Labor Wars in the Coal Mines*, set in Pennsylvania's coal country. Selig's westerns in 1910s claimed to be filmed "on the fields on which the scenes it depicted actually occurred," which allowed for the "embodiment of actual occurrence . . . clothed in the virility of realism."[32] We might see here a documentary-like claim being made about the location and the "embodiment of actual occurrence." In the cinema, such a craving for realism also made its way into a short-lived obsession with material authenticity for sets. Some of this was required to compete with the impressive production values in European screen spectaculars such as Gabrielle D'Annunzio's *Cabiria* (1914), which, in addition to combining stunning trick effects with location filming, also boasted of using real marble for interiors. As the *Kansas City Star* noted, "To say that a scene was made in the studio does not mean that it was skimped or slighted." Real marble was used, the article said, because "imitation marble would not show up properly in the film."[33]

Here we see something akin to the arguments about practical versus digital effects: an insistence that the optical photographic qualities of the real thing are intangibly more credible on film than a painted substitute, as though you can *trompe l'oeil* but not trick the camera. Similarly, there was boasting of "no expense spared" in the pursuit of "realism" for D. W. Griffith's films as he deployed bricklayers and two tons of bricks

for the erection of a brick wall to "represent the back portion of an East side dwelling."[34] A few years later Erich von Stroheim was also praised for the meticulously crafted details of his settings for *Greed* (1924). While for Griffith and von Stroheim, the aim was to create a sense of an expansive world beyond the frame and a naturalistic milieu for character, in promotion, such settings functioned as production values—a guarantee that the money was up there on the screen, and so worth the price of admission.[35]

Debates about the value of actual places or real materials on film, over painted backdrops or in-camera composited images, largely rested on the question of how credible things *looked*, and whether or not the audience could discern the difference between artifice and photographic record. If such things had an impact on acting, this was not noted. These debates continued into the 1930s with the widespread adoption by the studios of rear-projection processes, where a still or moving background plate would be projected onto a screen behind the actors on a soundstage, the foreground and background taken together in principal photography. Called "process shots" at the time in journalistic, fan, trade, and technical discourse, rear projection became ubiquitous as the most efficient and cost-effective way of fabricating locales. By the mid-1930s studio process shots had, with the exception of westerns, largely replaced location filming altogether. Increasingly, such shots were used for not just distant location but most shots of exterior action—saving money in transportation, and avoiding inclement weather, inconsistent lighting, and the need for reshoots.

The fan magazines promoted process shots as a form of amazing technological illusion because framing them as a cost-saver would undermine perceptions of production value. They reported on the use of process shots through a framework that celebrated the technicians of Hollywood magic, pointing to techniques of artifice behind the screen while insisting that the audience would never notice these techniques otherwise. For instance, an article titled "None of This Is Real" said of process shots, "It's a case of the mountain coming to Mahomet. Any background in the world can be projected on the stage where the actors are performing, through a process invented by an eighteen-year-old kid, Dodge Dunning. The illusion is perfect."[36] So, too, a report in *Photoplay* explained the process of filming a bus-ride two-shot on a soundstage with rear-projected street footage and just says, "You'll never know the difference between this and the real thing,

after the movie magicians finish synchronizing the three-dimensional foreground with the two-dimensional background."[37]

Film reviewers and the trade press, however, were sometimes more critical about the "adequacy" of process shots versus location shooting for realism. As with CGI now, it was the poorly produced process shot that elicited scornful comments such as "So phony as to be laughable." A well-produced shot, where matte lines were minimal and the background sharp and unflickering, would usually go unremarked, unless it was fabricating a situation for action that could not have been achieved through other means, such as a shot of an actor casually wing-walking on an airborne biplane. As Philip Scheur for the *Los Angeles Times* wrote, "My enthusiasm for real backgrounds—as against fake transparences is undiminished."[38] He reported, however, that he had received a letter from R. O. Binger from the United Artists process department, who took him to task for his statement that "all process shots are bad." Binger pointed out that the claim should be instead that "all process shots that I am able to identify as such" are bad, because the vast majority go unnoticed and "only the bad ones" attract criticism from the public. When critiquing obvious process shots, technicians and reviewers were usually referring to clear optical discrepancies between the foreground and background. These could be caused by a degraded or poorly projected background plate (or dupe), or issues with lighting that made the actors too light or too dark, or cast shadows on the screen behind them. Nothing, however, was said in reviews about the acting or the extent to which actors seemed absent, static, or awkward in their ostensive locales and situations. The fan and news press only mentioned actors performing in front of rear-projection screens on soundstages as part of the explanation of the process for the public.

## Acting in Process Shots

Awkwardness and non-presence in process-shot performances seem more glaring to us now because our horizons of expectation have shifted. Writing on rear projection from the perspective of a twenty-first-century viewer accustomed to "seamless" integration of film characters with digital worlds, Laura Mulvey characterizes it as "clumsy sublime." In part, Mulvey is referring to the presence of two different temporalities in the shot, as the footage used for the background must have been shot at an earlier, indeterminate

time, before principal photography. But she also observes that the technical requirements of such shots determined the lighting, staging of actors, and camerawork; essentially the mise-en-scène had to be locked down in order to maintain the illusion. These constraints, she argued, shaped performance: "As the stars have to stay in an exact, given spot, their space is constricted, and—often facing artificial wind, water, or vertiginous height—they make the required gestures as though in a mime."[39] Optical concerns also dictated performance for other compositing techniques such as glass matte paintings, where an area of the frame would be occupied by painted scenery or other kinds of virtual set extensions. An *American Cinematographer* article from 1941 instructs directors to ensure their actor "keeps strictly within the bounds of the unpainted part of the glass. Otherwise, as the actor stepped 'out of bounds' and crossed the matte painting line, part of him would suddenly—and for no apparent reason on the screen—vanish."[40] David Bordwell, Kristen Thompson, and Janet Staiger argue that space in classical Hollywood cinema was treated in graphic terms, composed along the lines of post-Renaissance paintings. Lighting, composition, and set design were all designed to give an illusion of depth and dimensionality to the image, but overall the image was conceived as if viewed through a mobile glass window pane.

Even though cinematic space now is conceived in three dimensions rather than two (due to immersive mobile camera work and 3D digital compositing), there are some parallels between the requirements of acting for older process shots and greenscreen now. Actors must be careful to not allow their bodies or parts of them to enter space that will be occupied by digital objects. As Luke Evans, who played a dwarf in Peter Jackson's *The Hobbit: The Desolation of Smaug* (2013), explained, "You have to know certain dimensions and boundaries, otherwise you can immediately tell someone's on a green screen set if they haven't thought out the size of the table, for example, or the height of the dwarves."[41] The goals of spatial coherence and optical seamlessness have remained more or less the same, even as space is now conceived in depth. During the studio period, however, a more naturalistic, physicalized response to the character's fictional environment was not necessarily expected in order to sell the illusion of co-presence.

For instance, in a sequence in Frank Capra's wonderful *The Bitter Tea of General Yen* (1933), there is a deadly gun battle in a Shanghai street. Barbara Stanwyck's character and her child orphans take shelter in an alley behind some sandbags that are subsequently riddled with bullets. The shot

is clearly a composite; it is less the inconsistencies of lighting and exposure, however, that give away the fact that these are two separately recorded images than the stasis of the performers. To the left of the frame, a hail of bullets pierces the bags, bursting puffs of sand, inviting us to shudder as we imagine human bodies in their place. To the right of the frame, Stanwyck hunches, wide-eyed, performing frozen trepidation. Her hands rest on the shoulders of two blankly smiling children. In such a situation, it would be natural to cringe and wince with every bullet that whistles and to shrink down into the space, making oneself as small a target as possible. However, all actors are static and unruffled, apparently oblivious to the noise and dust and projectiles, as if posing for an awkward family portrait.

Watching Clark Gable and Vivien Leigh in one of the hundred or so elaborate composite shots in *Gone with the Wind* (1939), we can see distinctions among what actors do, as they portray Rhett and Scarlett fleeing the towering flames of Atlanta with a horse and cart carrying Melanie (Olivia de Havilland) and Prissy (Butterfly McQueen). Visually, much has been done to assist our belief that the characters are imperiled in the flaming ruined city. According to Alan David Vertrees, producer David O. Selznick had originally wanted the Atlanta evacuation sequence to be shot in widescreen so that "the audience would have the sense that they were in the middle of the fire."[42] The stars' performances with their horse and cart are layered by Jack Cosgrove's process department with matte paintings of silhouetted buildings, minimal sets, and raw footage of a ferociously flaming set, shot separately on December 10, 1938, on forty acres of the Selznick International backlot. This footage uses stunt doubles (the double playing Scarlett conveniently shielding her face with her arm against the intense heat) for the long shots to anchor the characters into the scene. In one shot, Cosgrove has even carefully layered flames into the foreground, placing the human figures behind, to make it seem as if they are among them.

Cutting in to mid-shot, the stars are lit in flickering red light and perform cooperation to calm the horse, as a grimacing Leigh, eyes squinted and teeth bared, tosses a length of cloth to Gable with which to blinker the rearing panicked animal. Gable performs grim masculine action. McQueen and de Havilland's helpless wide-eyed fear in the back of the cart provide the appropriate emotional responses to the narrative situation. But it is only Leigh who attempts to also physicalize her character's response to the flames. She grimaces and winces as if experiencing involuntary physical responses to the intensity of the heat, and this aids the illusion that she and

the flames are physically co-present.[43] Thus, even within the technical constraints of acting for a process shot, there was a certain amount of choice. The priorities for actors in such shots were dramatic and visual: to stay within the bounds of visibility, and to perform the appropriate emotional responses of one's character. Naturalistic, embodied responses to the imaginary stimuli of the diegesis were more an afterthought, possibly because of the relative status of stars versus sets.

## Characters and Settings in the Studio Era

To understand this more fully, it is helpful to think about the norms of setting in relation to character during the studio era from the late 1920s into the 1940s. Gilberto Perez says that "Hollywood in the old days" typically used stock footage of a locale for an establishing shot that could be used as a "shorthand metonymy" to locate the characters and narrative. This might be extended onto the set with other shorthand signifiers of place and time, such as tropical plants or period specific furniture, and more stock footage used in rear projection. "Widely accepted at the time," he says, the actuality of the place is "thinned into a naturalistic veneer, its role strictly subordinate to the actors and drama."[44] This view is borne out in a *Photoplay* article from the early 1920s: "By far the most important element of any picture is the action of the players and the unfolding of the story. The settings serve only to create an atmospheric impression. What does it matter if the feudal castle is only a painting on a piece of glass?"[45] Bordwell, Thompson, and Staiger argue that surroundings, while largely background to action, could also be "significant for their ability to dramatize individuality," and they point to the way props (guns, rings, photographs, dolls, portrait paintings, and of course sleds, if we consider *Citizen Kane*'s Rosebud) are charged with personal meanings and "bear electable psychological import."[46]

According to Cynthia Baron, actors in the studio era were trained to keep their bodies flexible, to develop their powers of concentration, recall, and observation. They studied the script, developed backstories for their characters, and worked out their character's relationships to others in the screenplay. She says that in "filling in character's backgrounds" and reading the script, actors were advised to create a store of "mental pictures," which when recalled during performance could "color" their moods and actions.[47] There is nothing in this account about creating naturalistic

embodied responses to their characters' fictional environments, because it wasn't foregrounded and expected.

Equally, however, if we consider performance in relation to setting, the ways in which particular actors engaged with their physical surroundings was important for what it revealed of their character psychology. Charles and Mirella Jona Affron point to Greta Garbo, who was reported to choose antique objects herself as props for her films, and proclaimed to draw "mood from her surroundings."[48] Garbo's tactile performance in the inn sequence of *Queen Christina* has also been praised by Andrew Klevan for its "responsiveness to physicality and texture."[49] As Affron puts it, "Her eyes, hands, and body seem to fondle the room and its objects, creating a version of a love nest for remembrance. The sense of place emanates from her oblique absorption in self. Her own image is reflected in [a] rustic mirror."[50] The room at the inn becomes present and meaningful only because Garbo seems to absorb it into her character's memory. Otherwise it might just serve as a background to action and relationships, a place where things happen, adequate to that function.

This is not to say that the material conditions of acting were considered wholly unimportant in the 1930s and 1940s. However, the evidence from the time suggests that it was the visual rather than tactile qualities of sets that were believed to have import for actor psychology and performance. For instance, in 1928 there were industry discussions about how to design sets, costume, and makeup in order to get the most natural yet striking tonal range under the new lighting and film stock. A common solution was to use completely monochrome sets, costumes, and makeup, with the idea that the look of a film could be controlled at the profilmic stage. By the mid-1930s a survey of studio cinematographers suggested that the all-gray set was a commonplace requirement for gaining accurate tonality on black-and-white film. However, according to the chief physicist at Eastman Kodak, Lloyd A. Jones, some producers were wary of monochrome sets, believing that actors, due to their "more highly organized nervous system,"[51] were particularly sensitive to color, and that monochrome might have unwelcome "psychological effects" that the actors would have to work to overcome. As Metro-Goldwyn-Mayer cinematographer Oliver T. Marsh said, "The reactions of the players and director to different colors in the set—may well be as important as the purely photographic phase.... So long as the lines and masses of a set are photographically correct, I feel that with present-day emulsions we should be able to adapt ourselves to the set,

rather than selfishly forcing the players to adapt their color-reactions to the camera."[52] Thus, there was some thought paid to the impact of surroundings on performance, but these were largely centered on visual rather than tactile stimuli in actors' environments. How did this change?

## The Shifting Sands of Actors and Environments

From the 1930s through about 1970, rear projection was the dominant technique in Hollywood cinema for combining actors' performances with separately filmed settings, due to its efficiency and economy of being able to combine principal and plate photography on set. But, as Turnock has explained, other compositing techniques, such as optical printing (also called traveling matte), were technologically rejuvenated in the era of the 1970s blockbuster. With optical printing, separate filmed elements could be printed together to create a multi-planar image field with minimal degradation. The aim, Turnock says, was to develop "new strategies for how to stage spatial relations and kineticism on the screen."[53] This was, in part, intermediality at work, as cinema sought to differentiate itself more powerfully from television as an immersive, sensory spectacle worth paying and leaving the house for. The pursuit of these particular aims of kinetic action, sensory engagement, and immersion was also driven, however, by a much earlier shift in cinematic tastes, perception, and aesthetic norms. Late 1970s blockbusters such as *Star Wars*, *Close Encounters of the Third Kind* (1977), and *Alien* (1979), as Turnock argues, grounded their expanded fantastic universes in an aesthetic that had some continuity with the gritty realism that we associate with the New Hollywood of the late 1960s and early 1970s. The seeds of these realisms had been sown in the rise of location filming in the postwar period. With the rise of location filming, there was at the same time greater attentiveness to the material conditions of performance, and a rethinking of how actors could draw on their embodied imaginations as opposed to just "mental pictures" to produce more naturalistic behavior in fictional circumstances.

The perceptual ground began to shift with the earlier rise to dominance of location shoots and deep focus, and their attendant open-air look and detailed mise-en-scène. In the late 1940s, location filming started to become preferred, where possible, for particular kinds of genres, such as westerns and gritty urban film noirs. This was partly facilitated by the

development of more lightweight and portable filming equipment for the military newsreel corps, as well as the desire to economize on set construction.[54] The late 1940s saw the decline of studio power, the emergence of television as a visual entertainment competitor, and influences from Italian neorealism. Cinema began to attend to the detail of setting again, in order to signal its visual superiority over TV, and to draw the audience to the theater for a sensory experience. This began to shift audience expectations about how places should look onscreen.

In the late 1940s, director Henry Hathaway was interviewed about his decision to film a semi-documentary, urban "melodrama," *Kiss of Death* (1947), in actual New York City streets, nightclubs, hotels, prisons, boarding houses, and apartments. Hathaway claimed that audiences were demanding "more and more naturalness" and could "sense real backgrounds and faked ones."[55] In *Hollywood Quarterly*, Kenneth Macgowan contrasted the "never completely convincing trickery of settings" in studios with his perception when watching *The House on 92nd Street* (1945): "There is no question that Bill Eythe and his fellow players are walking the streets of New York." He wondered what gains are provided to the experience of the screen "by giving us the feeling that we are actually abroad with the people of our film stories instead of meeting them under the studio conditions of smart use of simulated backgrounds and process shots that give us a two-dimensional screen version of reality behind the actors and their setting."[56] In both these cases, the comparison between studio fabrication and location shooting was made on visual terms: real locations are valued because they give greater dimensionality and depth perception, natural light, and more detail in the mise-en-scène. In the 1960s, however, discussions in North American cinema culture also began to consider what impact the material conditions of filming might have on screen performances.

## The Rise of Tactility and Embodiment

In 1969, director Richard Brooks shared his enthusiasm about shooting on location: "Using real places does something to the cast. We were shooting in the general hospital in Denver, with real nurses and real orderlies running around. You don't have to tell the actors how to behave. They take on the aura of that reality." Moreover, he insists, filming in "a real house [means] you can't walk through a wall or move a wall. It feels real and it

acts real." With regard to shooting a love scene, he said, "The making of love, real love, is primarily tactile, not visual."[57] A focus on tactility, embodiment, and materiality were apparent in reviews as well, as writers were now paying a new kind of attention to the kinetic qualities of acting in process shots as part of their critique of studio artifice. Over a couple of articles in the mid-1960s, critic Walter Kerr singled out automatic dialogue replacement (ADR) and process shots as turning films into "mechanical collages." In a prescriptive argument about what cinema should be that seemed to look forward to more recent anti-CGI discourse, he wrote:

> The camera as an instrument is meant to record a fact, not necessarily a 'documentary' fact but at least the full fact of what happened when some actors came together and spoke and did things in a given place. Today the place may be falsified by being recorded or re-recorded in a sound-proof room, and although the actors' bodies are still being photographed they are not quite what they once were: the actor's awareness that voice and place may be added later causes him to behave in a somewhat disembodied way.[58]

Kerr's argument refers to his observations of Richard Burton in *The Night of the Iguana* (1964), where we see a rear view of Burton haranguing the congregation and pushing them toward the door. Burton's voice on the sound track has force, but "nothing is going on in his shoulders or in the musculature at the base of his neck. . . . Mr Burton's body is not engaged in the emotion. . . . It is 'walking through' the sequence, uninvolved."[59] As well as such attentiveness to natural or unnatural embodiment in performance, film critics became more vocal about signs of non-co-presence between actors and between actors and situations. Gary Arnold complained about *Trader Horn* (1973), watching Rod Taylor, Ann Heywood, and Jean Sorel "pretending to duck the stampeding animals on the process screen," with "awkward cuts from supposedly threatening beast to supposedly threatened actor."[60]

What had changed? On one hand, critics had become more accustomed to the way films shot on location looked, and the ways actors looked performing in actual environments. This meant that they developed a greater sensitivity to the stilted artifice of process shot performances. There was more in play, however. According to David Sterritt, a key influence on postwar movie acting was the growing American interest in psychological theories and therapies, which understood character as shaped by circumstances

and environment.[61] We might consider this an expansion of what Virginia Wright Wexman calls the more "solipsistic" interpretations of the Method that we see in the anguished performances of James Dean,[62] toward a popularization of a more outward-looking interpretation of Lee Strasberg's teachings. Most pertinent was Strasberg's claim that "acting is reacting to imaginary stimuli." This continues to be a central pillar of much contemporary actor training, as actors are encouraged to develop a fluid openness to their acting partners and their character's surroundings and allow a performance to emerge truthfully from the circumstantial dynamics of their in-character interactions and situation. In some ways this brought the Method back to its roots in nineteenth-century naturalist theater. But unlike Belasco's elaborate staging methods that demanded "the real thing" as an aid to an actor's performances, acting at this time was also about the actor's development of imagination and physicality in transforming the imaginary into a kind of consensual reality.

There had not just been a shift in theories of acting, but a transformation in the kinds of environments in which actors worked and trained. Julie Levinson tells us that, from the 1960s into the 1970s, North American actors were increasingly working back and forth between movies and experimental theater, such as black-box or poor theater. In such theater contexts, actors, she says, developed very different training and acting ethos from the script-centered training of the Hollywood studio system.[63] The poor theater, developed by Polish actor and director Jerzy Grotowski, who trained under Stanislavsky, was a reaction against the spectacular photographic realism of cinema. Poor theater, like black-box theater, strips theater down to an actor on a stage, without sets, costumes, or any of the external aids of acting. It relies largely on the actor to bring a world to palpable life for the audience's imagination, solely through performance.

It is significant, then, that actors who now work in greenscreen environments for film, when talking about the training that is most relevant to this task, often refer to black-box theater. As Joel David Moore, who played Dr. Norm Spellman in *Avatar* (2009), explains, "I really liken it to black-box theater . . . because if you do small theater, you have a table and a chair, and then you have to convince the audience that you're in an apartment in New York, or you're on the safari, or wherever the play takes place."[64]

For *Avatar*, the actors performing on a largely bare soundstage had to act as if they were sprinting through the steamy living jungles of the planet Pandora. One strategy that director James Cameron used to aid the acting

process was to take his cast on a jungle trek in Hawaii. The rationale was that in order to convince us they were in a jungle, their bodies had to have experienced a jungle. The trek, it was thought, would help their bodies acquire the sense memories of humid mossy smells, leeches, and bugs, of what it feels like to jump burbling creeks, how slippery rocks feel under the feet, how to navigate mud, logs, and obstinate plant life. In green-screen performance, sense memories are crucial to the actor's embodied communication of their presence in an immaterial location. According to actor John Bigham, "All that sense-memory stuff you laughed at in Acting 101 really pays off here. Use those skills to imagine what the air feels like, the smells, the texture of the walls and furniture, the sounds of the magic world. Really creating that, literally out of thin air, is a big part of your job, so that it lives for the audience."[65]

In this way, acting theories and practice that emphasize the body and the senses are seen as increasingly important to fulfilling the aims of credibility and presence for constructed cinematic environments. Similarly, "presence" is rearticulated in more recent acting theories as something actors "enact," by cultivating attention to how their character's consciousness is embodied in a fictional situation, an interaction, and a place.[66] This has risen alongside a cinema that is increasingly immersive and sensory.

## The Integration of Actors and Visual Effects

As Aylish Wood, Kristen Whissel, and many others have observed, cinematic space is becoming more immersive and meaningful, as motion tracking, mobile cinematography, and digital 3D transform space from a background to action to a more dynamic, central presence in film narratives. Certainly we see such dynamism in apocalyptic disaster movies like *2012* (2009) and *San Andreas* (2015), where skyscrapers are perpetually collapsing and the ground is on the verge of cracking and falling away beneath the panicked protagonist's running feet. We also see this in the centrality of the jungles and floating cliffs of Pandora to the action and meaning of *Avatar*, but also in films at the more realist end of the scale: the drama of *The Walk* is centered on the Twin Towers and the precarious rope between them.

At the same time, in her analysis of the popular critical reception of late 1990s and early 2000s digital effects cinema, Ariel Rogers notes that terms like "tactility" and "density of detail" have emerged as positive terms

to describe progressive developments in the aesthetic of CGI.[67] Developments like texturizing software, responsible for pores and freckles of skin, and the soft fluffy sheen and nubbiness of fur are highlighted both onscreen as virtual cameras linger lovingly on these details and textures, and in the special features that accompany releases on DVD and iTunes.[68] The rise of greater dynamic integration of live action and constructed elements, and the heightened attention to the moving texture and detailed mise-en-scène of film worlds, is driven and enabled by new tools and techniques. It is also, as Thomas Elsaesser has pointed out, fostered by exhibition factors, especially the enlargement of screens, both domestic and cinematic, and home video. To these we could add the exponential rise of HD formats and the emergence of high frame rate (HFR). These altered exhibition factors demand greater diligence in the seamless construction of visual effects sequences and sensory detail in order to showcase the benefits of hyper-real shooting formats and enormous screens.[69] Certainly reviews of films like *The Revenant*, and other survival films like *The Grey* (2011), *The Impossible* (2012), and *Life of Pi* (2012), sell these films as sensory, full-blown embodied experiences, where we wince at the sickening sound of bones snapping, feel the hot carnal breath of the bear as it roars in your face, and conjure its viscous saliva speckling the skin.

Are these changes all afforded by such things as advances in texturizing software and the demands of exhibition formats? Perhaps, but the actor's corporeality and embodiment of being co-present also play a key part in authenticating these sensory illusions. Many directors and visual effects supervisors are working with actors in processes that are increasingly dynamic compared to the studio era, when the spheres of labor were kept quite separate. John Berton, who was VFX supervisor at ILM in the 1990s and early 2000s, has explained one particular process: "The storyboards start us off, and then we take those and develop them into an animatic [a moving storyboard outlining rough action], which will then inspire the photography, which will be what it is, but then we'll have to do an animatic that's reactive to what the actual background [the live action] turned out to be."[70]

In this case, the rough animatic is used to orient the actor in space and give her a rough visual of the character's environment. The actor has to embellish this visual in her imagination, thinking about how a place, creature, or object would strike her senses if it were actually present, and this sensory imagining shades their interactions and reactions. The VFX team,

in turn, studies the actor's performance and ensures that the other elements in the shot accord with the actor's actions or reactions. For instance, Berton recounts that when Brendan Fraser was performing a fight scene for *The Mummy Returns* (1999) he had to mime poking the mummy in the eye sockets, with two fingers, Three Stooges style. Fraser ad-libbed a disgusted reaction to the imagined viscous body fluids on his fingers, and mimed flicking off the goo. Berton's team was then compelled to add a smidgen of stringy, repulsive animated matter from Fraser's fingers to the mummy's eye socket. It is easy to see how such a shift in working methods can lead to greater physical integration of actor and environment, but the actor has to be properly oriented and know exactly with what they will be sharing screen space.

Different directors and visual effects supervisors use different methods to orient or physically situate their actors. Animatics are perhaps the most common, but for *Oz the Great and Powerful* (2013), Sam Raimi insisted on building a material set and puppets. This was not for the audience, as we saw the actors moving through a largely CG environment, interacting with animated characters and objects—such as when James Franco's Oz delicately repairs the china doll or greedily fondles handfuls of gold coins. These environments and objects served to feed the actors' imaginations and shape their corporeal actions. Similarly, Richard Baneham, visual effects supervisor for *Avatar*, says that "anything the actors needed to come into [physical] contact with, we built it and gave it to them," as there is always a need to "physicalize performance" and have "true forces pushing against each other"; otherwise "it always feels fake."[71]

Actors often have no choice but to "physicalize" their own performance, however, as the forces that hold their characters' bodies at their mercy, being invisible, cannot be produced any other way. For instance, we know that Sandra Bullock and George Clooney are not really floating perilously unanchored and running out of oxygen far above the Earth's atmosphere in Alfonso Cuarón's *Gravity* (2013). They are performing in highly artificial circumstances, suspended on wires in a light box—its purpose to reflect the light of their virtual diegetic surroundings onto their faces to embed them into the shot—in a studio in London. Bullock, with a high quavering voice of barely contained hysteria, wide eyes, and quick breath, communicates her character's struggle to master her highly thrumming anxiety in order to make her way back to a place of safety—similar to the struggle she performed nearly two decades before as the bus driver in *Speed*

(1994). However, her bodily performance is also key to the maintenance of the entire illusion in ways that complicate the common mantra that "acting is reacting." Without the requisite material conditions to provoke an automatic response, Bullock had to proactively use her body to simulate the absent condition of antigravity. When Bullock's character removes her spacesuit, and maneuvers through an abandoned space station, the actress had to exert strength, concentration, grace, and fluid control over her movements so as not to sag on the wires holding her up. She had to move her hands at one-third normal speed, using great effort to make her motion appear effortless.

This brings us back to where we began this chapter with McGregor, Lucas, and the *Star Wars* prequels. While the detail in the digital mise-en-scène was praised, the human characters and performances were routinely described as "lifeless," flat, and "sketchy."[72] Lucas was accused of being "more preoccupied with the grandeur of setting and the multifaceted computerized characters than the magic of acting."[73] In this way Lucas seems to be an exception to this more physicalized way of thinking about the integration of actors and visual effects. By all accounts, he has tended to see filmmaking as akin to painting. He has been known to give his actors little orientation or direction but treats their performances as graphic elements that he mixes into an image, building the world up around them in layers, embellishing here and adding a flourish there. This is why in the prequels, the actors who produced their performances months before will often seem disconnected from their surroundings. As Liam Neeson grumbled at a press conference for *Episode I: The Phantom Menace* in 1999, "You're having a conversation with thin air. At the same time you know, eventually, there will be something there that buzzes or flies or farts or whatever George decides that he's going to do with it and [you will] be totally upstaged."[74]

Neeson's comments foreground an important difference between acting on a black-box theater stage (or indeed, a talk-show stage) and performing in a greenscreen environment. On the bare stage, the creation of environment and situation and the fostering of audience belief are largely the responsibility of the actors and script. Imaginary animate or inanimate objects do not suddenly enter the fictional space of such performances unless an actor introduces them. They only become "real" if all actors working in the fictional space agree to their being "present" and respond to them as if they are so. This presence is built cooperatively and exists in a shared imaginary space between audiences and actors. In greenscreen

performance, the actor is working in a more provisional environment, interacting with creatures and things that, while invisible and immaterial to them, will be brought into vivid visualization by the time the audience encounters them onscreen. Sharon Marie Carnicke argues that actors create naturalistic performances by dispersing their attention to objects in their material surroundings. She says that the way actors engage with their surroundings creates "a necessary bridge to the character's fictional world."[75] For a greenscreen performance, there must be an implicit agreement and trust between actors and visual effects artists as to what will share the screen with the actor so that the bridge between character and world can be forged.

As we have seen, in an era of increasingly sophisticated integration of live action and digital elements and sensory immersive cinematic experiences, actors are considered not just graphic elements but conduits for presence, key to the corporeal authentication of the illusion. This authentication is not just achieved through lighting consistency and eyeline matches, but through an actor's performance that explicitly physicalizes their character's responses to their fictional environment. They might be given objects to touch, climb, and handle, or their sensory imaginations fed with roughly previsualized worlds or experiences designed to build kinetic and sense memories that they can call up when needed. In this way, when the elements harmonize together, even when shot in a greenscreen set, a film world with no material existence can come to feel real for us.

# Conclusion

Tom Gunning astutely reminds us that "cinema has never been one thing. It has always been a point of intersection, a braiding together of diverse strands."[1] The same is true of screen performance, as it is variously defined and valued, in its different intersections of technology, art, and culture. The development of screen performance as craft, its accrual of esteem and cultural status, and our understanding and appreciation of actors' contributions to film meaning and affect have been a multiple-stranded thing. Many of these strands have been shaped by, explicitly rejected, or, conversely, used cinematic illusionism as a platform for visibility and value. Screen performance has depended not just on the modulation of theatrical values of realism in relation to the close-up and the intimate expressions of emotion and cognitive layers flickering across the human face. It has also required ways to visibly demonstrate craft. In this regard, tools of illusionism such as transfiguring makeup and costume, as well as split-screen performance, have not suffocated performance but in different ways have fostered the values of versatility and proteanism in acting. This has happened not without some complications, as we have seen, for such things as perceptions of authenticity, creative contribution, verisimilitude, social and racial identity, and casting inequities.

The historical narrative that has emerged through these chapters is largely one where digital techniques serve more to intensify rather than overthrow preexisting tendencies at the intersection of technology, illusionism, and screen performance. The picture becomes a little more complex, however, when we look at the historical reception of actors

performing with their own images, or to places and characters not present at the moment of filming. For in these circumstances, actors are not just striving through different means to breathe life into a character body, but working to sustain a performance that lends a sense of palpable realism to an illusion of co-presence. In some ways we see that, just as Stephen Prince has argued, digitally augmented performance merely "sharpens the ambiguities" that have always defined acting in the cinema "where actors play to non-existent locations in a process shot or to other characters not present in a close-up."[2] However, the multiple-role sequence where actors interact with themselves onscreen is of a slightly different order of illusionism compared to acting to a place or object not present. The trick and its operation are always foregrounded in a multiple-role film, due to our knowledge that a single actor cannot be in two or more places at once. In Christian Metz's terms, this is always a visible *trucage*.[3] In the 1910s, the visibility of the trick was key to how it operated as a platform to highlight acting craft in versatility, timing, and precision. However, the shifting requirements of realism, and beliefs about acting as requiring more organic natural reactions, have led to a gradual tendency to deflect attention from the trick.

In the increasing integration of live action and animation, and the changing relationship between figure and ground this entails, screen performance has become even more important as a conduit for belief. Of course, performers have always been used to authenticating illusions through eyeline matches—it was always important to foster the belief that the character's eyes could see the objects and characters with which they shared screen space. Beyond optical authentication, though, a more wholly embodied authentication is now required, driven more broadly by a cinematic experience that, as Ariel Rogers, Julie A. Turnock, Scott Bukatman, Stephen Prince, Angela Ndalianis, and Lisa Purse have shown, increasingly addresses our bodies as much as our vision. As the body has moved to the center of cinematic experience, it makes sense that the actor's body plays more of a key role in breathing life and belief into the world on the screen.

At the same time, there are extremes of construction, atomization, and collaboration in screen performances that push our definitions of acting to the limit. Consider the amount of technology and labor that went into bringing a character like *Deadpool's* (2016) lumbering metallic Russian mutant with a moral core, Colossus, to the screen. Besides the visually apparent work we see onscreen of character designers, animators, shaders, and texturizers from Digital Domain, Colossus also synthesizes the work

of several performers. The hulking, 6-foot-9 Andrei Tricoteux performed Colossus on set in platform boots and headpiece, providing a physical reference to which the other actors could respond, with a stunt performer stepping in for fight sequences. Actor T. J. Storm provided much of Colossus's bodily movement, such as his powerful swinging stride, in a motion-capture volume. Colossus's deep, resonant, Slavic vocal performance came from actor Stefan Kapičić. Another stunt performer, Glenn Innis, lent the bulky chiseled contours of his face and recorded a small library of static facial expressions. Finally, Digital Domain's Greg LaSalle drove the character's facial expressivity—its conversation, reactions, and emotions—meticulously timing his performance to the audio files of Kapičić's vocal line delivery.[4] There are no tells of this fragmentation in the character's performance, no sense of character unity being pulled in different directions by different performances. If, as Andy Serkis and Jim Carrey claim, the actor provides the soul that breathes life into a digital character body, who is responsible for Collossus's soul? I am tempted to say that it is in the voice of Stefan Kapičić, as this is where the stoic rumbling human core of the character seems to be expressed, and the metallic face with its blind pupil-less eyes cannot give too much away. But then again, this is a case where such questions are irrelevant, for, unlike *Black Swan* or *Rise of the Planet of the Apes*, the film is not making any claims for authenticity or artistry in performance, although it does solicit our admiration for its visual effects, clever self-reflexive dialogue, and Ryan Reynolds's appealing smart-assery. Colossus is an elaborate puppet with many operators, and, like Yoda or King Kong, all that matters is that he seems plausible, alive, unified, and co-present with his environment and co-stars.

Is it in part because the character looks more machine than human, being ostensibly a kind of impossible living metal mutant, that there is no stake in asserting a reassuring single human source as his interior? This may be a case similar to ones explored by Kristen Whissel in her conception of "effects emblems" as well as by Angela Ndalianis in her work on the digital cloning of Jeff Bridges's younger face in *Tron: Legacy* (2010). Both scholars focus on how the human body is remediated or reconfigured through digital effects as both machine and flesh, dead and alive, and they read these bodies as having science fictional resonance with the themes of the films in which they appear.[5]

As I have sought points of historical continuity, my focus throughout the book has been narrowed to largely Hollywood, Hollywood

international cinema, and Anglophone publicity and reception. I want to end, however, by looking outward and considering briefly the ways that the slipperiness I have examined at the intersections of screen performance, technology, and special effects might play out in other filmmaking cultures. I could examine some of the fascinating developments in the use of CGI in European auteur cinema, just in terms of Lars von Trier's use of digital face-replacement, porn doubles, and recombinant bodies for sex scenes in his two-part film *Nymphomaniac* (2013), or the meta-commentary on prosthetic makeup, disguise, and performance capture in Leos Carax's astonishingly weird *Holy Motors* (2012). However, I will leave the tangled lineages and aesthetic complexities of art cinema for another day. This book is about popular cinema, after all, so it makes sense to look at the most significant popular filmmaking cultures globally: Bollywood and Chinese martial arts cinema.

## Bollywood, Ageless Superstars, and Digital Avatars

The dazzling fantasy epic *Kochadaiiyaan—The Legend* (2014) was touted as the first "performance capture photorealistic" Bollywood film. Notable for using performance capture to enable sixty-four-year-old Tamil star Rajinikanth to play a dashing, young, acrobatic, gravity-defying, godlike version of himself, the film's trailer announces, "SUPERSTAR RAJINIKANTH… IN A NEW AVATAR." This is presumably a pun, evoking both the Sanskrit word for "descent"—a bodily vehicle for a god to descend to earth, speaking to the ageless immortality of the superstar—and positioning the film as a local version of James Cameron's film of the same name. Vibrating with rich colors, textural detail, and movement, the trailer promises impossible action and the spectacle of magnificent idealized digital bodies dancing, fighting, suspended in dynamic postures of heroism, and gazing at each other with beautiful immobile faces. The facial movement, though, is limited to the opening and closing of mouths, and many disappointed reviewers blasted the animation, claiming they were reminded of old video games. My concern is with how the film's publicity communicates a sense of its own appeals and values, particularly in relation to the star's "avatar" body, as well as the visibility or location of the star's performance.

We see some evident similarities to how performance capture and green-screen performance have been discussed and received in Hollywood, but

also some intriguing differences. For a start, the use of the term "avatar" in the trailer signals that the elastic power of this digital warrior body is a vehicle for Rajinikanth's industrial divinity. There are similarities here with the way that digital screen bodies are often positioned as an "avatar" for a human actor to explore other fantastic ways of being that transcend the appearance and identity of their own body. So Benedict Cumberbatch, we are told, *is* Smaug the dragon, Andy Serkis *is* Caesar the chimpanzee, Zoe Saldana *is* Neytiri the blue catlike alien, and Ray Winstone *is* the 6-foot-6 epic hero Beowulf with a six-pack and thighs like tree trunks. Jessica Aldred has argued that the anchoring of digital bodies to actors' physical ones plays out in a context where viewers are likely to spend hours playing videogames and digitally extending their self-identities in online interactions. But such a process of acceptance is complex, bound up in the tensions between old and new, desires for authenticity and material grounding, and the ambivalent fascinated anxiety for techno-futurism.[6]

In *Kochadaiiyaan—The Legend*, however, Rajinikanth is located onscreen in a very different way from Serkis's "soul" in Caesar's digital ape body. Here it is enough that the character is badged with a recognizable, younger, idealized version of Rajinikanth's face and that it has his voice. In this way it seems to bear out Barry King's arguments about the continued reliance on the star image as a reassurance to promote "a living source behind the febrile machinations of techno-culture."[7] Except that I don't actually get the sense that is what is happening here. This feels more like technology in the service of the star's rejuvenation rather than the star in the humanizing service of technology. Moreover, there is only a rudimentary attempt in the promotional behind-the-scenes videos to physically locate the performers in the roles, with footage of them in split-screen doing static grand gestures or holding dance poses mirrored by their avatars. Unlike in the promotional materials for Hollywood performance capture, there is a complete silence around the key values of fidelity and proteanism. None of the actors talk about recognizing their own idiosyncratic gestures and expressions in the digital bodies. Instead, the key repeated terms are "acting to nothing" and a sense of bemusement and disorientation, similar to that expressed by Ewan McGregor. The words "imagination" and "nothing" are used numerous times by the actors and choreographer. "No ground, no sweat, no dust," one actor says, looking lost and tired. There is no harking to a form of actor training or the skillsets in mime and conjuring a world in imagination. It is not seen as a creative endeavor so

much as a chore.[8] There is something more telling again in the matter-of-factness of the discussion around dance doubles and playback singers. There is no attempt to hide the fact that a performance is a collaborative amalgamation and a character body may involve three or four different performers. The singular authenticity of the individual actor does not hold the same value that it is does in the western context.[9] The behind-the-scenes video signals that authentic value lies less in the performing body than in sound design. Besides time given to the discussion of the music score, the behind-the-scenes publicity shows sound designer Resul Pookutty leaving the aircraft hangar–like motion-capture studio to record Foley tracks in dusty exteriors with crowds. This, rather than the performing body, seems to be what anchors the film to the real and the realm of emotion.

In her fascinating history of the playback singer in Hindi cinema, Neepa Majumdar provides some clues to understanding the cultural and industrial differences evident here, in particular, the privileging of sound. According to this account, Hindi sound cinema of the 1930s had many of the same moral and aesthetic misgivings, as we have seen in Hollywood around the dubbing of "ghost voices" for stars in song sequences. Fan letters to the Indian cinema magazines indicated that when such performances were unmasked they were received as fraudulent, with claims that the song lost its thrill. In the experience and meaning of Hindi cinema, however, the song plays a much more central role than it does in the West. The song communicates a "spectacular and emotional excess"[10] that sits much higher in a hierarchy of value than a concern with realism or authenticity. This is not simply an industrial configuration where the music and film industries are fully intertwined. Majumdar explains that this value and appeal is informed by classical Indian performance theories, which posit a direct, pure correspondence between musical stimulants and audience effects. In this frame, it was important to a film that the star could sing. At the same time, however, the visual appeal of the cinema necessitated beautiful faces and figures. The cinema became a medium for the creation of the ideal body, but the ideal body should have the ideal voice. For five decades, according to Majumdar, the ideal female singing voice was defined by Lata Mangeshkar, whose high, piercing, undulating pure tones are synonymous with Bollywood sound tracks from the 1950s through the 1990s. Importantly, Majumdar argues that it is not just that the ideal voice/ideal body combination is more pleasurable than one that is authentic but not necessarily ideal. She makes the point, too, that Mangeshkar's star image (pure,

saintly, ageless, and non-materialistic, so that her clear, bright voice is perceived as a sonic index of a pure soul) has had a key ameliorating function for the anxieties around the sexual decadence of female movie star bodies. The star body is seen as a temporary, spectacular earthly vessel. The voice is ageless and of the soul.

It is significant, perhaps, that Rajinikanth apparently performs his own playback singing.[11] The fact that the star's digital body is promoted as "a new avatar" makes sense: *Kochadaiiyaan—The Legend* signals its appeal as allowing the evergreen rejuvenation of stars in new spectacular bodies, as long as their voice retains its attraction. In this way, there are some similarities with Ray Winstone as the uber-buff Beowulf. In that film, however, there was still a need to locate not just the star's persona but the physicality of the actor's bodily performance and to recognize his performance in the digital body. This is partly because, as we saw in chapter 1, such "fidelity" discourse is about spectacularizing the technology itself and celebrating what it can capture.

## Cultural Authenticity, Impossible Bodies, and Cyber Fu

The Chinese martial arts film is a tradition in which special effects and performing bodies have long intersected, if we consider just the gravity-defying acrobatic wire work of swordplay films and the amplified speed and power of cinematic kung fu. Contrasting "wire fu" with "kung fu," Leon Hunt has argued that "the kung fu film has a history of investing in the 'real'—the physical authenticity of Bruce Lee and Jackie Chan [and] the documentary accuracy of the Shaolin forms displayed in films like *The 36th Chamber of Shaolin* (1978)."[12] Yet, noting the increasing use of digital effects in kung fu action sequences, as such films seek to emulate the elastic spectacular bodies and impossible action of computer games, Hunt wondered in 2003 whether or not the skills of stars such as Chan and Jet Li "fit into this spectacle? With all this technological wizardry, can 'anyone do it'?"[13] Vivian Lee agrees that, in the transition in the performance aesthetic of martial arts films, "the authentic hero-body as spectacle" is being displaced by special effects, especially CGI.[14] In seeking to understand the wider implications of this displacement, however, Lee observes that there is a division along cultural lines in critical approaches to authenticity in the martial arts film. Both Hunt and Lee note that Western critics have been more concerned with the authentic "spectacle

of the body," while Asian critics tend to be more preoccupied with "'identity' and 'traditions,'" and the disappearance of cultural specificity in martial arts styles "with the emergence of a more universal action choreography."[15] Indeed, Yomi Braester has also argued that, more broadly, Chinese cinephilic cultures see digital effects cinema as less of a problem for indexicality than for cultural specificity.[16] Lee says the two issues (the body and cultural identity) are blurred as digital filmmaking technologies and transnational filmmaking together accelerate the disappearance of the "authenticity of the action hero(ine) as real life martial arts experts, and the cultural/nationalistic messages this authentic persona embodies."[17] However, this disappearance of the authentic fighting body in films that Lee designates "cyber fu" seems compensated by the more spectacular nature of the virtual ideal fighting body, which "extends the possibilities of speed and action."[18] Moreover, Lee says, there is a maintenance of links to local traditions through intertextual means, as wuxia swordplay, kung fu, genre tropes, and aging stars are digitally renovated and re-spectacularized in ways that are sometimes serious and sometimes comical, in films like *House of Flying Daggers* (2004) and *Kung Fu Hustle* (2004).

The cultural intertexts and kinetic potential rather than the authenticity of this fictional body are the key attraction. Indeed, as the work of Purse and Whissel suggests, in many ways the most interesting thing about bodies in digital effects cinema generally is not how they got to the screen, but their expressive power and how they make us feel. Similarly, Lori Landay sees that the velocity, motion, and power of digitally animated bodies onscreen, as digital doubles in flying or fighting sequences, affect our bodies as viewers. She argues that if we make sense of the world through our bodies, then "digital and virtual technologies bring us new possibilities for the kinesthetics of performance and spectatorship,"[19] before going on to conclude that "the pleasures of the digital are all about transcending gravity, about bodies exceeding their limits."[20] I well recall the giddy whooping exhilarating yearnings for kinetic power, flight, and speed felt in my body when I first saw *The Matrix* (1999). Certainly, such films draw me into the cinema with the promise of such an experience.

This might be a universal pleasure that speaks to all who have bodies. At the same time, I agree with Scott Bukatman when he criticizes the "vaguely rubberoid action figures harmlessly bouncing each other around" in *Spider-Man 2* (2004) and suggests that "perhaps there's such a thing as being too weightless."[21] In such fight sequences, "there is nothing at stake," for by "removing the body from space, it removes meaning—lived

meaning—from the body." Bukatman's problem seems to be in part with the default replacement of an actor's body with animation: "When Tobey Maguire pulls Spider-Man's mask over his face, the figure onscreen literally ceases to be Tobey Maguire."[22] But the same could be said in any instance of doubling or substitution, as we have seen in chapter 4. For me, the issue of "too weightless" is more a critique of an animation aesthetic that stretches the limits of the body—a body we are invited to imagine shares our world and is subject to the same physical laws as our own—too far. Bodies in such screen contexts can become too plasmatic, lose their weight, their plausibility, and their ability to make us believe and make us care. Bukatman, though, is more troubled by this body and its movement possibilities as "bifurcated"—the human performer "constrains" the plasmatic possibilities of the animation, the plasmaticness of the animation removes the corporeal stakes of live-action filming. For him, this hybrid of human performance and animation is always stuck in a dissatisfying limbo.

In light of Bukatman's argument about weightlessness, and Hunt's concerns about where stars like Jackie Chan "fit into this spectacle," it is worth considering the ways that Chan continues to wrangle his international stardom as a martial arts master and stuntman. On the one hand, in recent years he has lent his voice and star persona to the animated character of Monkey in the *Kung Fu Panda* franchise (comprising, to date, a video game and three movies). As Hunt observes, since 1990 Chan has also licensed his stylized image and voice for fighting video games, such as *Jackie Chan's Action Kung Fu* and *Stuntmaster*. On the other hand, Chan has maintained a commitment in his live-action films to staging action sequences in which spectacular bodies perform *at* their limits. His films have continued to feature a blooper reel over the end credits: the profilmic evidence of injuries and mishaps that authenticate the corporeal stakes and physicality of actual fighting, acrobatics, and falling bodies. Interviewed in the *Wall Street Journal* about *Chinese Zodiac* (2013), Chan says: "What can I do? I don't have James Cameron, Steven Spielberg, George Lucas to create special effects. . . . I have to do it the stupid way, the traditional way, like Buster Keaton, Harold Lloyd."[23] Speaking to a North American audience, he uses North American references and indicates that although his career began in Hong Kong cinema, his work does not share much common ground with the spectacular digitized bodies of Chinese cyber-fu. Chan's body is either replaced wholesale by a cartoonish monkey or digital caricature in animated films or games, or it is presented in his movies as

his own authentic fighting self. In this way he protects the integrity of the bodily values upon which his stardom was built, while also drawing upon that value for a persona that can persist in animated and video game form, even as his actual body ages until it can no longer physically perform.

Are the kinds of discourses which, as I've shown here, have flowered around screen performance in its intersections with technology and special effects something specifically American, or Anglophonic, or perhaps more broadly Western? Perhaps. They do seem to speak to ongoing tensions between a utopian urge to reinvent the self and escape the physical and social limits of one's body, on one hand, and an anxious desire for reassuring certainty and authenticity grounded in earthly flesh, on the other. They seem also concerned with personal identity and a reification of the individual. I am thinking here of the ways that, as with the camera and the microphone, performance capture seems most enthusiastically received when it is seen to reveal something of the human individual that may be usually beneath our notice, such as the idiosyncrasies of gait and expression, while also divorcing those things from the body. I am thinking too of the historical tensions between slippery fascinating proteanism and reassuring knowable typecasting in acting. I am thinking about the historical tensions around which kinds of actors are permitted to transform and which kinds are not, and the ways in which these tensions are intensified in a discourse of digital character bodies and actors' souls. I am thinking too of the way digital face replacement sharpens the moral and aesthetic issues that have often circulated around the use of stunt and voice doubles, and how an actor's authentic bodily transformation seems to gain its cultural power from the way it speaks to a belief about inner character, art, and unity. What is more, these tensions parallel and intersect with the entangled illusionistic and photographic drives and anxieties that run through cinema itself. It is my hope, then, that this book will not just extend our understanding of how our ways of practicing, thinking about, and evaluating screen performance are multiple and change over time. I hope it will also prompt further investigation into how viewers engage with the various levels of illusion and realism onscreen, and the extent to which such engagements are acculturated and historically contextual or universally human.

# Acknowledgments

I would first like to thank Murray Pomerance for ambushing me at the fabulous Magic of Special Effects Conference in Montreal in 2013. His enthusiasm for this project and his intellectual generosity gave me the impetus and, most importantly, the courage to complete it. Many thanks are due as well to Adrienne L. McLean, who read the manuscript and whose judicious, generous, and insightful feedback helped strengthen the work. Eric Schramm did a super job copyediting this book. I appreciate his lightness of touch, eagle eye, and impeccable knowledge of punctuation. To the wonderful Leslie Mitchner at Rutgers University Press for being a pleasure to work with, and for her and Murray's patience and kindness as I recovered in early 2016 from injuries sustained in an accident—I am eternally grateful. Thank you also to Marilyn Campbell, Lisa Banning, Brice Hammack, and everyone else at Rutgers University Press who helped get this book to press and into readers' hands.

This work could not have gotten off the ground without various means of support from the University of Queensland, including a grant from the New Staff Research Fund scheme and a semester off from teaching to do some early exploratory work at the Margaret Herrick Library in Beverly Hills. The unfailingly helpful staff and fantastic collections at the Margaret Herrick Library made this research a pleasure. The completion of this book would have been significantly delayed without a fellowship from the Centre for Critical and Cultural Studies at the University of Queensland. Crucially, since I live in Australia and have limited means to travel, much of the supplementary research in this book has relied on online materials from archive.org and Lantern. So thanks are due also to the folks at the

Media History Digital Library and the University of Wisconsin–Madison Department of Communication Arts for developing such an amazing resource and making it open access.

Chapter 2 was published in substantially shorter form as "Fleshing It Out: Prosthetic Makeup Effects, Motion Capture, and the Reception of Performance" in the anthology *Special Effects: New Histories, Theories, Contexts*, edited by Dan North, Bob Rehak, and Michael S. Duffy (London: BFI-Palgrave, 2015). It is reproduced here with permission from Palgrave Macmillan. I extend my sincere appreciation to Dan, Bob, and Michael for both their friendship and their invaluable feedback on that essay—feedback that also helped me develop the chapter further for this book.

Thanks to my colleague Ted Nannicelli for so kindly reading my chapter drafts and providing keen, logical observations that helped sharpen my thinking. I owe you many beers, Ted. Gratitude is due also to Elliott Logan, who was an exemplary research assistant in the very early days of this project and with whom conversation on screen performance is always a joy. To Rowena Grant-Frost, who chased down references, sent me relevant articles, and kept me laughing with her absurdist wit: you are the best. Thank you to Eric Furie at the University of Southern California for allowing me to sit in on his motion-capture class and for patiently answering my questions. Various other colleagues must be thanked for providing a general climate of support for this project and for suggesting research leads, including Tom O'Regan, Graeme Turner, Greg Hainge, Jason Jacobs, Frances Bonner, and Jane Stadler. I am also grateful to overseas, interstate, and local colleagues and friends who, in one way or another, have inspired me at conferences, via e-mail, or in conversation at bars over the past few years, including Morgan Street, Mihaela Mihailova, Paul Wells, Angela Ndalianis, Deb Thomas, Julie Turnock, Lisa Purse, and Katharina Loew. Last but not least, to Scot McPhee for his cheerleading, proofreading, and Tuesday night pizza: I could not have done this without you.

# Notes

## Introduction

1 Ben Hoyle, "And for My Acting Oscar, I Thank the Special Effects," *TimesOnline*, February 19, 2007, http://www.thetimes.co.uk/tto/arts/film/article2426105.ece.

2 Ibid.

3 Tom Gunning, "Gollum and Golem: Special Effects and the Technology of Artificial Bodies," in *From Hobbits to Hollywood: Essays on Peter Jackson's Lord of the Rings*, ed. Ernest Mathijs and Murray Pomerance (Amsterdam and New York: Rodopi, 2006), 321.

4 Alfred A. Cohn, "What Makes Them Cry," *Photoplay* (September 1918): 52.

5 In some ways the process through which earlier means of artifice in screen performance have come to be accepted or invisible has affinities with how practical and optical effects have been redefined in popular visual effects discourse as more "authentic" than CGI. As Bob Rehak says, "Predigital visual effects were once considered artificial. We used to think of them as tricks, hoodwinks, illusions. Only now that the digital revolution has come and gone, turning everything into weightless, effortless CGI, do we retroactively assign the fakery of the past a glorious authenticity" ("Replicants," *Graphic Engine*, September 21, 2008). However, when we specifically focus on effects and illusionism in relation to acting (as opposed to miniatures, models, and other cinematic practical effects), the argument becomes more complicated, involving issues of intention and embodiment as well as authenticity and materiality.

6 Stephen Prince, *Digital Visual Effects in Cinema: The Seduction of Reality* (New Brunswick, NJ: Rutgers University Press, 2012), 4.

7 Performance capture (or motion capture, or mo-cap) is the complex suite of techniques that has been used most notably to allow Andy Serkis to play Caesar in the *Planet of the Apes* franchise, and Lupita Nyong'o to play Maz Kanata in *Star Wars VII* (2015). Simply put, it requires actors to wear markers on key joints and muscles on their body and face. As they perform, the shifting spatiotemporal positions of the markers are captured by a computer and the shifting positional data are targeted

to the corresponding points on a digital character body. Actors can also record a data bank of static expressions and microexpressions, which can be applied to the performance. Animators then study reference video of the actor's performance to fine-tune and add nuance to the character's expressivity. Face-replacement is exactly how it sounds: the lead actor's facial performance is used to replace that of another performer in the shot who provides the bodily performance. This is often used with stunt doubles or for the production of fantastic bodies. Compositing and green- or bluescreen is an updating of much older matte and optical printing processes. Actors perform in a partial set or location, the entirety or areas of which have been colored a standard fluorescent apple green. As with earlier techniques such as masking chromakey, the green or blue part of the image is subsequently replaced digitally with other image elements, such as shots of a location, virtual sets, or animation.

8  Pamela Robertson Wojcik, "The Sound of Film Acting," *Journal of Film and Video* 58 (Spring-Summer 2006): 71.

9  Armond White, "Cinema Is about Humanity, Not Fireballs," *New York Times*, June 13, 2013, http://www.nytimes.com/roomfordebate/2013/03/07/are-digital-effects-cgi-ruining-the-movies/cinema-is-about-humanity-not-fireballs. As my colleague Ted Nannicelli has helpfully pointed out, White may be confusing André Bazin with Béla Balázs here. See, for instance, Balázs's essays "The Face of Man" and "Nature and Naturalness," in *Early Film Theory: Visible Man and The Spirit of Film*, ed. Béla Balázs and Erica Carter (New York: Berghan Books, 2010).

10  Mark Harris, "Depth Becomes Her," *Entertainment Weekly*, March 24, 2000, http://www.ew.com/ew/archive/0.178.1[28020]meryl%streep.00.html; Simon Houpt, "Liam Neeson Only Looks Cuddly," *Toronto Globe and Mail*, May 11, 1999: C1.

11  Prince, *Digital Visual Effects in Cinema*, 7.

12  See, for instance, Woody Schultz, "C.G.I. Has Inspired a New Era of Filmmaking," *New York Times*, March 12, 2013, http://www.nytimes.com/roomfordebate/2013/03/07/are-digital-effects-cgi-ruining-the-movies/cgi-has-inspired-a-new-era-of-filmmaking; Sean Aita, "Dance of the Uber-marionettes: Towards a Contemporary Screen Actor Training," in *Theorizing Film Acting*, ed. Aaron Taylor (New York: Routledge, 2012).

13  Cynthia Baron, "The Modern Entertainment Marketplace, 2000–Present," in *Acting*, ed. Claudia Springer and Julie Levinson (New Brunswick, NJ: Rutgers University Press, 2015), 143–168.

14  Ann Hornaday, "'Avengers' Proves Actors Still Matter," *Washington Post*, May 3, 2012, https://www.washingtonpost.com/lifestyle/style/essay-avengers-proves-actors-still-matter/2012/05/03/gIQA3nwQzT_story.html; Manohla Dargis, "Ghost in the Machine," *Sight and Sound* (2000), http://old.bfi.org.uk/sightandsound/feature/46.

15  See Julie Turnock, "'I Thought You Brought Us Together to Save the World': The Contemporary International Special Effects Business," paper presented to the Magic of Special Effects Conference, University of Montreal, Montreal, Canada, November 5–10, 2013. Ted Johnson and David S. Cohen, "Visual Effects Artists to Protest Obama's Dreamworks Visit," *Variety*, November 22, 2013, http://variety.com/2013/biz/news/visual-effects-artists-to-protest-obamas-dreamworks-animation-visit-1200870824/.

16  Rachel Abramowitz, "'Avatar's Animated Acting," *Los Angeles Times*,

February 18, 2010, http://articles.latimes.com/2010/feb/18/entertainment/la-et-avatar-actors18-2010feb18.

17 Mihaela Mihailova, "Collaboration without Representation: Labor Issues in Motion and Performance Capture," *Animation: An Interdisciplinary Journal* 11.1 (March 2016): 42.

18 Peter Debruge, "Plotting Motion Capture's Next Move," *Variety*, December 13, 2007, A4.

19 Barry King, "Articulating Digital Stardom," *Celebrity Studies* 2.3 (2011): 247.

20 Tanine Allison, "More Than a Man in a Monkey Suit: Andy Serkis, Motion Capture, and Digital Realism," *Quarterly Review of Film and Video* 28 (2011): 326.

21 Kristen Whissel, *Spectacular Digital Effects: CGI and Contemporary Cinema* (Durham, NC: Duke University Press, 2013), 25.

22 Lisa Purse, "Digital Heroes in Contemporary Hollywood: Exertion, Identification, and the Virtual Action Body," *Film Criticism* 32.1 (Fall 2007): 8.

23 See, for instance, John Goodell, "Is It Real or Is It a Video Image?" *Los Angeles Times*, March 27 1983, 7; and Paula Parisi, "Silicon Stars: The New Hollywood," *Wired* 3.12 (December 1995): 204.

24 Jason Sperb, "I'll (Always) Be Back: Virtual Performance and Post-Human Labor in the Age of Digital Cinema," *Culture, Theory, and Critique* 53.3 (2012).

25 See for instance "Flesh for Fantasy," *Wired* 9.7 (July 2001), http://www.wired.com/wired/archive/9.07/eword.html?pg=4.

26 Lev Manovich, "What Is Digital Cinema?," in *The Digital Dialectic: New Essays on New Media*, ed. Peter Lunnenfield (Cambridge, MA: MIT Press, 2000), 172–192. Similar arguments about animation as the essence of cinema have been made by leading animation scholar Alan Cholodenko in his introduction to *The Illusion of Life: Essays on Animation* (Sydney: Power Publications, 1991). Cholodenko, however, draws on etymology in his argument, asserting that live action and animation are impossible to truly separate because of animation's original shared root with animism or "life."

27 Sidney Eve Matrix, "We're OK with Fake: Cybercinematography and the Spectre of Virtual Actors in SıMoNE," *Animation: An Interdisciplinary Journal* 1.2 (2006): 207–228.

28 Barbara Creed, *Media Matrix: Sexing the New Reality* (Crows Nest, NSW: Allen & Unwin, 2003).

29 This is especially the case in films such as *The Misfits* (1961)—the last film appearances of Clark Gable and Marilyn Monroe, in which the strain of filming in Nevada in poor health seems carried onto the screen in Gable's genial weariness, gruff voice, and lined face, and where Monroe's emotional instability and distress at the immolation of her marriage seem to tremble through her whole body. See George Kouvaros, *Famous Faces Yet Not Themselves: The Misfits and Icons of Postwar America* (Minneapolis: Minnesota University Press, 2010).

30 David S. Cohen, "Synthespians Replacing Thespians? Not Soon," *Variety*, September 15, 2011, 4.

31 See, for instance, Sharon Marie Carnicke, "The Material Poetry of Acting: 'Objects of Attention,' Performance Style, and Gender in *The Shining* and *Eyes Wide Shut*," *Journal of Film and Video* 58 (Spring-Summer 2006); and Rhonda Blair, "The Method and the Computational Theory of Mind," in *Method Acting Reconsidered,*

*Theory, Practice, Future*, ed. David Krasner (New York: St. Martin's Press, 2000), 201–218.

32 Danae Clark, *Negotiating Hollywood: The Cultural Politics of Actors' Labor* (Minneapolis: Minnesota University Press, 1995); Kevin Esch, "The Bond That Unbinds by Binding: Acting Mythology and the Film Community," in *Theorizing Film Acting*, ed. Aaron Taylor (London: Routledge, 2012).

33 Joseph R. Roach, *The Player's Passion: Studies in the Science of Acting* (Ann Arbor: University of Michigan Press, 1993).

34 Cynthia Baron, Diane Carson, and Frank P. Tomasulo, eds., *More Than a Method: Trends and Traditions in Contemporary Film Performance* (Detroit: Wayne State University Press, 2004), 1.

35 Richard deCordova, *Picture Personalities: The Emergence of the Star System in America* (Urbana: University of Illinois Press, 1990/2001), 26–34.

36 Richard Dyer, *Stars*, new ed. (London: BFI, 1998), 136.

37 Jacob Smith, *The Thrill-Makers: Celebrity, Masculinity, and Stunt Performance* (Berkeley: University of California Press, 2012), 4.

38 Richard Rickitt, *Special Effects: The History and Technique* (New York: Billboard Books, 2007).

39 Jacob Smith, *Vocal Tracks: Performance and Sound Media* (Berkeley: University of California Press, 2008).

## Chapter 1  Acting through Machines

1 Carla Hay, "James Cameron and Peter Jackson Gather for a Meeting of Movie-Making Titans," *Examiner*, March 4, 2010, http://www.examiner.com/article/james-cameron-and-peter-jackson-gather-for-a-meeting-of-moviemaking-titans.

2 Mark Harris, "Mark Harris on the 'Acting' in 'Avatar,'" *Entertainment Weekly*, January 22, 2010, http://www.ew.com/article/2010/01/22/mark-harris-acting-avatar.

3 Ibid.

4 Richard deCordova, *Picture Personalities: The Emergence of the Star System in America* (1990; Urbana: University of Illinois Press, 2001), 31–32.

5 David Warfield, "American's Foremost Actor Says He Never Studies Part," *Evening Standard*, February 24, 1913, 7.

6 Ian Failes, "Deep inside Deadpool's Deadliest Effects," *fxguide*, February 15, 2016, https://www.fxguide.com/featured/deep-inside-deadpools-deadliest-effects/.

7 Thank you to Eric Furie at the University of Southern California for allowing me to sit in on his performance-capture class and for patiently answering my questions.

8 See Paul Ekman and Wallace V. Friesen, *Unmasking the Face: A Guide to Recognizing Emotions from Facial Clues* (Los Altos, CA: Malor, 2003).

9 Kristin Thompson, "Motion-Capturing an Oscar," *Observations on Film Art*, February 23, 2010, http://www.davidbordwell.net/blog/2010/02/23/motion-capturing-an-oscar/.

10 "New Technologies Committee Working Hard on 'Performance Capture,'" *Screen Actor*, March 1999, 4–5.

11 Dave McNary, "Mo-Cap Flap Tests Acting's Boundaries," *Variety*, January 1, 2012, 1.

12 "The Jazz Singer," *News* (Adelaide), March 7, 1929, 20.

13  See John Belton, "Technology and Aesthetics of Film Sound," in *Film Sound: Theory and Practice*, ed. Elizabeth Weis and John Belton (New York: Columbia University Press, 1985).

14  James Lastra, *Sound Technology and the American Cinema: Perception, Representation, Modernity* (New York: Columbia University Press, 2000).

15  Jonathan Sterne, *The Audible Past: Cultural Origins of Sound Reproduction* (Durham, NC: Duke University Press, 2003), 222, 259.

16  Michel Chion, *The Voice in Cinema* (New York: Columbia University Press, 1999), 166–167.

17  As I write, Ang Lee is in the news for his decision to shoot his Iraq PTSD war drama *Billy Lynn's Long Halftime Walk* (2016) in not just 4K and 3D but with a frame rate of 120 frames per second. High Frame Rate filming (HFR) is said to be distracting for many viewers due to the unprecedented clarity and detail it brings to the screen image. See Bill Desowitz, "How Ang Lee and His Hyper-real High Frame Rate Could Change Cinema," *IndieWire*, April 18, 2016, http://www.indiewire.com/2016/04/how-ang-lee-and-his-hyper-real-high-frame-rate-could-change-cinema-289590/.

18  "Hamlet's Ghost in Motion Pictures," *Dallas Morning News*, March 22, 1913, 3.

19  David Kehr, "The Face That Launched a Thousand Chips," *New York Times*, October 24, 2004, AR1.

20  See John Belton, "Painting by the Numbers: The Digital Intermediate," *Film Quarterly* 61.3 (Spring 2008): 58–65.

21  James Naremore, *Acting in the Cinema* (Berkeley: University of California Press, 1988), 41.

22  Mala Powers, "With Michael Chekhov in Hollywood," *Afterword to Michael Chekhov's On the Technique of Acting* (New York: HarperCollins, 1991), 165.

23  Other technological developments have of course had an impact on what actors do. Cinemascope and lighter hand-held cameras and Steadicam, for instance, have both in very different ways enabled new possibilities with blocking and staging of action, and enabled actors' freedom of movement in performing a scene. Harper Cosser's book on widescreen cinema, *Letterboxed* (Lexington: University Press of Kentucky, 2011), 95, quotes Darryl F. Zanuck as saying in 1953, "Our actors now can move without fear of moving out of focus. Relatively they've been moving in handcuffs and leg irons" (157). So, too, Automatic Dialogue Replacement (ADR) and wireless microphones have wrought significant changes to what actors do, but it is not my aim to detail an entire history of acting for the cinema against a background of its changing recording technologies. For analysis of aspects of sound design and voice performance see Starr A. Marcello, "Performance Design: An Analysis of Film Acting and Sound Design," *Journal of Film and Video* 58.1/2 (Spring 2006). On performance with Steadicam, wireless microphones, and telephoto lens in 1970s North American cinema, see Julie Levinson, "The Auteur Renaissance, 1968–1980," in *Acting*, ed. Claudia Springer and Julie Levinson (New Brunswick, NJ: Rutgers University Press, 2015). For a terrific account of how various directors during the sound era worked with dialogue and staging, see Lea Jacobs, *Film Rhythm after Sound: Technology, Music, and Performance* (Berkeley: University of California Press, 2015).

24  Jacob Smith, *Vocal Tracks: Performance and Sound Media* (Berkeley: University of California Press, 2008).

25  Ben Brewster and Lea Jacobs, *Theatre to Cinema: Stage Pictorialism and the Early Feature Film* (Oxford: Oxford University Press, 1997).

26  Roberta A. Pearson, *Eloquent Gestures: The Transformation of Performance Style in the Griffith Biograph Films* (Berkeley: University of California Press, 1992).

27  Janet Staiger, "The Eyes Are Really the Focus: Photoplay Acting and Film Form and Style," *Wide Angle* 6.4 (1985); and David Mayer, "Acting in Silent Film: Which Legacy of the Theatre," in *Screen Acting*, ed. Alan Lovell and Peter Kramer (London: Routledge, 1999), 23.

28  John Patterson, "Stage Acting? It's Just Too Hard," *The Guardian*, November 17, 2005, https://www.theguardian.com/film/2005/nov/17/1; Rick De Mott, "'A Christmas Carol': The Performance Capture Experience," *Animation World Network*, November 6, 2009, http://www.awn.com/vfxworld/christmas-carol-performance-capture-experience.

29  Earlier, not dissimilar benefits/problems in the actor's relationship to the recording technology are noted by Julie Levinson in the 1970s. On the one hand, the introduction of Steadicam and wireless mikes freed up movement, allowing actors to move from their marks. But on the other hand Robert Altman's use of zoom lenses to shoot crowd scenes was considered disconcerting for actors unsure of whose facial performance would be the focus in a shot of twenty actors. Levinson, "The Auteur Renaissance, 1968–1980."

30  Chris Baneham, "Acting in the Digital Age," symposium, Academy of Motion Picture Arts and Sciences (AMPAS), Beverly Hills, CA, April 22, 2010, transcript available at Margaret Herrick Library, AMPAS.

31  James S. McQuade, "Chicago Letter," *Moving Picture World*, July 1911, 23.

32  Eileen Bowser, *The Transformation of Cinema, 1907–1915* (Berkeley: University of California Press, 1994), 87.

33  Mayer, "Acting in Silent Film," 23.

34  "Film Manufacture No Easy Task," *Moving Picture World*, August 1908, 138.

35  John E. Ince, *The Manual of the Cinema Schools Incorporated* (Hollywood, CA: Cinema Schools Incorporated, 1928), 66.

36  Richard Koszarski, *An Evening's Entertainment: The Age of the Silent Feature Picture, 1915–1928* (Berkeley: University of California Press, 1994), 132.

37  Helen Klumph and Inez Klumph, *Screen Acting: Its Requirements and Rewards* (New York: Falk, New York, Institute of Photography, 1922), 115.

38  Ibid., 112.

39  Earle Larimore, "The Actor," in *We Present Television*, ed. John Porterfield and Kay Reynolds (New York: W. W. Norton, 1940), 344–345.

40  Lea Jacobs, "The Innovation of Re-Recording in the Hollywood Studios," *Film History: An International Journal* 24.1 (2012).

41  Mordaunt Hall, "The Screen," *New York Times*, October 7, 1927, 24.

42  *New York Post*, quoted in Donald Crafton, *The Talkies: American Cinema's Transition to Sound, 1926–1931* (New York: Charles Scribner's Sons, 1997), 503.

43  Crafton, *The Talkies*, 452.

44  Helen Klumph, "What Can We Do about 'Talkie Voices,'" *Photoplay*, April 1930, 28.

45  Mordaunt Hall, "The Screen," *New York Times*, June 16, 1928, 18.

46  Klumph, "What Can We Do about 'Talkie Voices,'" 28.

47  Albert Boswell, "Trials of the Talkies," *Photoplay*, July 1929, 53.

48 Ben Hoyle, "And for My Acting Oscar, I Thank the Special Effects," *TimesOnline*, February 19, 2007, http://www.thetimes.co.uk/tto/arts/film/article2426105.ece.

49 Belton, "Technology and Aesthetics of Film Sound," 64.

50 Peter Howell, "*A Christmas Carol*: Disney Dips Scrooge in Digital Goo," *The Star*, November 6, 2009, https://www.thestar.com/life/2009/11/06/a_christmas_carol_disney_dips_scrooge_in_digital_goo.html.

51 Ibid.

52 Dan North, "A Christmas Carol," *Spectacular Attractions* (blog) November 11, 2009, https://drnorth.wordpress.com/2009/11/11/a-christmas-carol/.

53 Stacy Abbott, "Final Frontiers, Computer-Generated Imagery and the Science Fiction Film," *Science Fiction Studies* 33.1 (March 2006): 89–108.

54 Jenna Ng, "Seeing Movement: Motion Capture Animation and James Cameron's *Avatar*," *Animation: An Interdisciplinary Journal* 7.3 (2012): 273–286.

55 Simon Wells, "Performance Capture Revealed," SAG Foundation Actors Center, February 29, 2012, https://www.youtube.com/watch?v=PyfrB908zqY.

56 Barry Salt, *Film Style and Technology: History and Analysis*, 2nd ed. (London: Starword, 1992).

57 The interview was accompanied by an image of the actress in character, playing at resisting the lecherous advances of a villain. She is turned face toward the camera, hand pressed awkwardly against his chest, mouth turned down at the corners, and eyes wide, her eyebrows clenching above her brow: a model of codified helpless and distressed resistance. This is clearly meant to illustrate "bad" acting as failed artifice, for the caption reads, "I cannot act well before the camera with a villain I like." Colgate Baker, "The Girl on the Cover," *Photoplay*, May 1915, 63–65.

58 Ince, *The Manual of the Cinema Schools Incorporated*, 41; Klumph and Klumph, *Screen Acting*, 103.

59 Pearson, *Eloquent Gestures*, 92–93.

60 Tony Barr, *Acting for the Camera*, rev. ed. (New York: Harper Perennial, 1997), 4, 7.

61 Ibid., 7.

62 Matthew H. Wikander, *The Fangs of Malice: Hypocrisy, Sincerity, and Acting* (Iowa City: University of Iowa Press, 2002).

63 This belief feeds into the ways film actors are sometimes pathologized. As we saw in the aftermath of Heath Ledger's death, some of the blame for his overdose was placed on his intense preparation for the role of The Joker in *The Dark Knight* (2008).

64 Discussion of Darwin from Richard Sennett, *The Fall of Public Man* (New York: W. W. Norton, 1975), 172–173.

65 Florence Lawrence, "Growing Up with the Movies" (Part I), *Photoplay*, December 1914, 96.

66 Sean Aita, "Dance of the Uber-marionettes: Towards a Contemporary Screen Actor Training," in *Theorizing Film Acting*, ed. Aaron Taylor (New York: Routledge, 2012).

67 Rick DeMott, "'A Christmas Carol'"; Joao Medeiros, "Andy Serkis Is Changing the Face of Film-making," *Wired*, July 6, 2014, http://www.wired.co.uk/article/planet-of-the-apes-andy-serkis; Erin McCarthy, "Andy Serkis and the Evolution of Performance Capture Tech," July 27, 2011, http://www.popularmechanics.com/culture/movies/a6997/andy-serkis-and-the-evolution-of-performance-capture-tech/.

68 Peter Bradshaw, "*The BFG* Review: Spielberg and Rylance's Delicate Touch Proves

Hugely Charming," *The Guardian*, May 14, 2016, https://www.theguardian.com/film/2016/may/14/the-bfg-review-mark-rylance-steven-spieberg-roald-dahl.

## Chapter 2 Behind Rubber and Pixels

1  "A New Generation of Apes," *Rise of the Planet of the Apes Special Features*, Blu-ray region 4, 2011.

2  Andy Serkis, "The Genius of Andy Serkis," *Rise of the Planet of the Apes Special Features*, Blu-ray region 4, 2011.

3  Murray Pomerance, *The Eyes Have It: Cinema and the Reality Effect* (New Brunswick, NJ: Rutgers University Press, 2013), 47.

4  James Naremore, *Acting in the Cinema* (Berkeley: University of California Press, 1988), 93–95.

5  "Your Digital Future: The Basics Actors Should Know," *Screen Actor*, May 1999, 4.

6  Lisa Purse, *Digital Imaging in Popular Cinema* (Edinburgh: Edinburgh University Press, 2013), 55.

7  Adam Duerson, "'Rings: The Two Towers,' Explained by Its Director," "Hobbit Forming," *Entertainment Weekly*, December 18, 2002, http://www.ew.com/article/2002/12/18/rings-two-towers-explained-its-director.

8  Merrick's first name was changed to John for Bernard Pomerance's stage play and Lynch's film.

9  "Digitally, a Star Turn," *Toronto Star*, Section: Entertainment, December 31, 2002, E08.

10  Nick Pinkerton, "Simian Disobedience," *Village Voice*, August 3, 2011, http://www.villagevoice.com/film/simian-disobedience-6431888; Steve Persall, "Did a Chimp Write This Screenplay?" *Tampa Bay Times*, August 3, 2011, http://www.tampabay.com/features/movies/did-a-chimp-write-this-screenplay/1184159.

11  Scott Balcerzak, "Andy Serkis as Actor, Body and Gorilla: Motion Capture and the Presence of Performance," in *Cinephilia in the Age of Digital Reproduction*, ed. Scott Balcerzak and Jason Sperb (London: Wallflower Press, 2009), 195–196.

12  My thanks to Ted Nannicelli for this observation.

13  Michael O'Sullivan, "The Humans Play Second Bananas," *Washington Post*, August 5, 2011, W27, W31.

14  Joe Fordham, "Alien Genesis," *Cinefex* 130 (July 2012): 36.

15  Stephen Prince, *Digital Visual Effects in Cinema: The Seduction of Reality* (New Brunswick, NJ: Rutgers University Press: 2012), 142–143.

16  Joe Morgenstern, "'J. Edgar': Hoover's Life, in a Dramatic Vacuum" (review), *Wall Street Journal*, November 11, 2011, http://www.wsj.com/articles/SB10001424052970204358004577029642549451960.

17  Peter Bradshaw, "J. Edgar—Review," *The Guardian*, January 20, 2012, https://www.theguardian.com/film/2012/jan/19/j-edgar-review.

18  Elizabeth Snead, "How Makeup Transformed Leonardo DiCaprio into 'J. Edgar,'" *Hollywood Reporter*, November 2, 2011, http://www.hollywoodreporter.com/news/how-makeup-transformed-leonardo-dicaprio-256090.

19  Brett Thomas, "Nicole's Dramatic Transformation," *Sydney Morning Herald*,

December 22, 2002, http://www.smh.com.au/articles/2002/12/21/1040174434763.
html.
20 Fred Dangerfield and Norman Howard, *How to Become a Photoplay Artiste: The Art of Photoplay Acting* (London: Odham's Press, 1921), 22.
21 Frederick A. Bennett, "Broadway's a Type Foundry," *New York Tribune*, December 10, 1916.
22 Dangerfield and Howard, *How to Become a Photoplay Artiste*, 48.
23 Hugo Munsterberg, *The Photoplay: A Psychological Study* (New York: D. Appleton and Company, 1916), 117.
24 "Wanted: Man Who Looks Like Lincoln," *Photoplay*, March 1920, 90.
25 "The Vitagraph Girl," *Moving Picture World*, 1910, 187.
26 "Shadows" (review), *Motion Picture World*, October 1914, 97.
27 Norbert Lusk, "Seven Faces," *Picture Play Magazine* (February 1930): 71–72.
28 "Lon Chaney Puts Hours on Make-up," *Los Angeles Times*, November 23, 1924, 35.
29 Ibid.
30 "Lon Chaney Determined to Film Self as Made," *Washington Post*, August 23, 1925, A2.
31 "The Shadow Stage," *Photoplay*, July 1925, 51.
32 As Martin Danahay points out, the late nineteenth-century stage was a culture of increasingly elaborate illusions and optical tricks, and in this context, Richard Mansfield, the famous late nineteenth-century stage actor, caused a sensation when he toured England and the United States with the first stage adaptation of Robert Louis Stevenson's *Dr. Jekyll and Mr. Hyde* in 1887. The purported bodily authenticity of Mansfield's onstage transformation from Jekyll into Hyde was a large part of the publicity, as Mansfield denied any substantial reliance on makeup tricks. Great emphasis was placed on the fact that he used neither a fright wig nor a grotesque rubber mask to effect the transformation from Jekyll to Hyde. Instead Mansfield created the impression of a beastly alter-ego by merely changing his posture and running his hands through his hair (and, as reviews noted, the aid of a greenish spotlight). Martin Danahay, "Richard Mansfield, Jekyll and Hyde and the History of Special Effects," *Nineteenth Century Theatre and Film* 39.2 (Winter 2012): 58–59. By contrast (and to see both how complex and how historically contingent the perception of makeup and artifice for performance is), in the early to mid-eighteenth century, David Garrick, the most celebrated naturalist actor of his time, performed *Hamlet* in a specially constructed mechanical wig that he could activate with a flick of a button to stand on end in a simulation of fright, at the moment when Hamlet sees his father's ghost. In that context, according to theater historian Joseph Roach, artifice and naturalist acting were reconcilable because the dominant scientific conceptions of life at the time saw all living beings in mechanical terms, in a clockwork universe. See Joseph Roach, *The Player's Passion: Studies in the Science of Acting* (Ann Arbor: University of Michigan Press, 1993), 58–59.
33 Frances Winwar, *Wings of Victory: A Biography of Gabriele D'Annunzio and Eleonora Duse* (New York: Harper, 1956).
34 "Makeup Scorned in Double Role," *Los Angeles Times*, June 7, 1925, 18.
35 Ibid.
36 "Chaney's Many Faces," *Washington Post*, May 28, 1922, 50.
37 "Mr. Chaney Studies Human Nature," *New York Times*, August 21, 1927, X3.
38 Evelyn Gerstein, "Old Age Preferred," *Picture Play Magazine*, March 1930, 29.

39  Harry N. Blair, "Short Shots from Eastern Studios," *Film Daily*, February 4, 1931, 5.
40  Vincent Canby, "Film: 'Elephant Man' Study in Genteelness," *New York Times*, October 3, 1980, C8.
41  Roger Ebert, "'The Elephant Man,'" *Chicago Sun-Times*, January 1, 1980, http://www.rogerebert.com/reviews/the-elephant-man-1980.
42  Canby, "Film: 'Elephant Man,'" D15.
43  Tom Hanks, "The Man Who Aged Me: An Actor on the Artist Who Turned Him into Somebody Else," *New York Times*, April 27, 2006, G1, 3.
44  Nancy Harrison, "It's Special Effects That Make the Actor," *New York Times*, November 4, 1990, 125.
45  Tom Buckley, "At the Movies," *New York Times*, September 26, 1980, C12.
46  Donna Peberdy, "The New Hollywood, 1981–1999," in *Acting*, ed. Claudia Springer and Julie Levinson (New Brunswick, NJ: Rutgers University Press, 2015), 127.
47  Stan Barouh, "Elephant Man's Mental Makeup," *Washington Post*, August 16, 1991, 31.
48  David S. Cohen, "F/X Chief Helps 'Iron' Out the Kinks," *Variety*, May 3–9, 2010, 17.
49  Rick Groen, "*Rise of the Planet of the Apes*: The Ape Movie Has Evolved," *Toronto Globe and Mail*, August 5, 2011, http://www.theglobeandmail.com/arts/film/rise-of-the-planet-of-the-apes-the-ape-movie-has-evolved/article629546/.
50  See, for instance, David Denby, "Noble Creatures," *New Yorker*, September 5, 2011, http://www.newyorker.com/magazine/2011/09/05/noble-creatures; Kenneth Turan, "'Rise of the Planet of the Apes,'" *Los Angeles Times*, August 5, 2011, http://www.latimes.com/visuals/video/lanews-rise-of-the-planet-of-the-ap-20110807-premiumvideo.html; Michael Phillips, "'Apes' Prequel Stands Alone, Upright" (review), *Chicago Tribune*, August 4, 2011, http://articles.chicago-tribune.com/2011-08-04/entertainment/sc-mov-0803-rise-of-the-planet-of-the20110805_1_director-rupert-wyatt-apes-caesar.
51  Manohla Dargis, "Looking Apocalypse in the Eye," *New York Times*, August 4, 2011, http://www.nytimes.com/2011/08/05/movies/rise-of-the-planet-of-the-apes-stars-james-franco-review.html?_r=0.
52  Dan North, *Performing Illusions: Cinema, Special Effects and the Virtual Actor* (London: Wallflower Press, 2008), 175.
53  Peter Travers, "Rise of the Planet of the Apes," *Rolling Stone Magazine*, August 4, 2011, http://www.rollingstone.com/movies/reviews/rise-of-the-planet-of-the-apes-20110804; Dana Stevens, "Rise of the Planet of the Apes," *Slate.com*, August 4, 2011, http://www.slate.com/articles/arts/movies/2011/08/rise_of_the_planet_of_the_apes.html.
54  Roger Ebert, "Rise of the Planet of the Apes," *Chicago Sun-Times*, August 3, 2011, http://www.rogerebert.com/reviews/rise-of-the-planet-of-the-apes-2011.
55  Andy Serkis (interview), "The Genius of Andy Serkis," 2011; Barbara Robertson, "Chimp Change," *Computer Graphics World*, August/September 2011, http://www.cgw.com/Publications/CGW/2011/Volume-34-Issue-7-Aug-Sept-2011-/Chimp-Change.aspx; Jon Landau, "Acting in the Digital Age" (panel transcript), Academy of Motion Picture Arts and Sciences, Beverly Hills, CA, April 2010, Margaret Herrick Library.
56  Buckley, "At the Movies," C12.
57  Peter Bradshaw, "*The BFG* Review: Spielberg and Rylance's Delicate Touch Proves

Hugely Charming," *The Guardian*, May 14, 2016, https://www.theguardian.com/film/2016/may/14/the-bfg-review-mark-rylance-steven-spieberg-roald-dahl.

58 Todd McCarthy, "'Rise of the Planet of the Apes'" (review), *Hollywood Reporter*, August 3, 2011, http://www.hollywoodreporter.com/review/rise-planet-apes-film-review-218819; Mark Mohan, "'Rise of the Planet of the Apes,'" *Portland Oregonian*, August 4, 2011, http://www.oregonlive.com/movies/index.ssf/2011/08/rise_of_the_planet_of_the_apes_review_amid_simian_insurrection_james_franco_just.html.

## Chapter 3  In Another's Skin

1 Brad Lemley, "A Virtual You," *Discover Magazine*, July 2001, http://discovermagazine.com/2001/jul/featvirtual.

2 Tom Hanks Q&A, *The Polar Express*, BBC, December 1, 2004, http://www.indielondon.co.uk/film/polar_express_hanksQ&A.html.

3 "Colin Firth's Discomfort in Skin-tight Spandex for A Christmas Carol Animated Movie," *The Telegraph*, November 3, 2009, http://www.telegraph.co.uk/culture/film/film-news/6489121/Colin-Firths-discomfort-in-skin-tight-spandex-for-A-Christmas-Carol-animated-movie.html.

4 Tanine Allison, "Blackface, Happy Feet: The Politics of Race in Performance Capture and Animation," in *Special Effects: New Histories, Theories, Contexts*, ed. Dan North, Bob Rehak, and Michael S. Duffy (London: BFI-Palgrave, 2015), 115.

5 Scott Bukatman, *Matters of Gravity: Special Effects and Supermen in the 20th Century* (Durham, NC: Duke University Press, 2003), 134; Michael Rogin, *Blackface, White Noise: Jewish Immigrants in the Hollywood Melting Pot* (Berkeley: University of California Press, 1996).

6 Pamela Robertson Wojcik, "Typecasting," in *Movie Acting: The Film Reader*, ed. Pamela Robertson Wojcik (London: Routledge, 2004), 185.

7 Edgar Morin, *The Stars: An Account of the Star-System in Motion Pictures* (London: Evergreen Books, 1961), 153.

8 Barry King, "Articulating Stardom," in *Star Texts: Image and Performance in Film and Television*, ed. Jeremy Butler (Detroit: Wayne State University Press, 1991), 143.

9 Wojcik, "Typecasting," 174.

10 Of course, these markers of a life lived can be successfully simulated through makeup, as I explored in the previous chapter. There is, however, a very specific value and pleasure when we see an actor onscreen whose face seems to already naturally fit the role. I am thinking of the perfect casting fit of Mickey Rourke's ruined swollen ham of a face for his role in *The Wrestler* (2008).

11 Wojcik, "Typecasting," 173.

12 For more on these molding processes see Jeanine Basinger, *The Star Machine* (New York: Alfred A. Knopf, 2007).

13 Wojcik, "Typecasting," 171.

14 Michael Chekhov, *To the Actor: On the Technique of Acting* (New York: HarperCollins, 1991), 99.

15 Renee was speaking at "Performance Capture Revealed," Screen Actors Guild Foundation, Los Angeles, February 29, 2012. This line that everything is "stripped

away" from the actor is useful for thinking about the actor's experience of the performance-capture process, but of course there is then a disconnect between what the actor experiences and audience perception of that performance which is anything but "stripped away," as it is cloaked in a fully rendered digital character.

16  Sean Aita, "Dance of the Uber-marionettes: Towards a Contemporary Screen Actor Training," in *Theorizing Film Acting*, ed. Aaron Taylor (New York: Routledge, 2012), 265.

17  Ibid., 265; citing Chekhov, *To the Actor*, 78.

18  Chekhov, *To the Actor*, 100.

19  Ibid., 99–100. This is similar to the methods deployed by Eleanor Duse and Paul Muni that I have detailed in chapter 2, the difference being that Chekhov emphasizes the distinction between the character body and the actor's body, while Muni spoke of merely "thinking old," and conjuring the character's body inside himself, allowing it to manifest outwardly rather than a kind of ghost body or garment that he had to clothe himself in or occupy.

20  Julie Levinson, "The Auteur Renaissance, 1968–1980," in *Acting*, ed. Claudia Springer and Julie Levinson (New Brunswick, NJ: Rutgers University Press, 2015), 111.

21  Christine Geraghty, "Re-examining Stardom: Questions of Texts, Bodies, and Performance," in *Re-Inventing Film Studies*, ed. Christine Geraghty and Linda Williams (London: Arnold, 2000), 185; Karen Hollinger, *The Actress: Hollywood Acting and the Female Star* (New York: Routledge, 2006), 44.

22  Geoff King, *New Hollywood Cinema: An Introduction* (London: I. B. Tauris, 2002), 151–152.

23  Barry King, "Embodying an Elastic Self: The Parametrics of Contemporary Stardom," in *Contemporary Hollywood Stardom*, ed. Thomas Austin and Martin Barker (London: Arnold, 2003), 45–61.

24  Cross-racial casting of white actors in nonwhite roles still occurs regularly, to the dismay of various activist groups. A financial rationale tends to be made for such casting practices now, and such roles are unlikely to be nominated for awards— although Angelina Jolie was nominated for a Golden Globe for playing Mariane Pearl in *A Mighty Heart* (2007).

25  Tom Gunning, "Foreword," in Karla Rae Fuller, *Hollywood Goes Oriental: CauCasian Performance in American Film* (Detroit: Wayne State University Press), xi.

26  See, for example, Tom Shakespeare, "It's Time Dwarfs Stopped Demeaning Themselves in Public," *The Telegraph*, February 6, 2015, http://www.telegraph.co.uk/culture/tvandradio/11394321/Its-time-dwarfs-stopped-demeaning-themselves-in-public.html.

27  *Snow White and the Huntsman* production notes, 28–29, Margaret Herrick Library, Academy of Motion Picture Arts and Sciences, Beverly Hills.

28  Greg Laing, "Warwick Davis Criticizes 'Snow White and the Huntsman' Dwarf Casting," *Digital Spy*, June 8, 2012, http://www.digitalspy.com/movies/snow-white-and-the-huntsman/news/a386203/warwick-davis-criticises-snow-white-and-the-huntsman-dwarf-casting/.

29  Guy Adams, "Dwarfs Threaten '100-Midget March' over Snow White and the Huntsman," *Independent UK*, June 7, 2012, http://www.independent.co.uk/arts-entertainment/films/news/dwarfs-threaten-100-midget-march-over-snow-white-and-the-huntsman-film-7821156.html.

30  For a really great analysis of Jolie's relation to the hypersexualized character body of her character Grendel's Mother, see Mihaela Mihailova's article "Collaboration without Representation: Labor Issues in Motion and Performance Capture," *Animation: An Interdisciplinary Journal* 11.1 (March 2016).

31  King, "Articulating Stardom," 143.

32  Geoffrey Macnab, "How Did Ray Winstone Lose 30 Years and 70 Pounds?," *The Guardian*, July 25, 2007, https://www.theguardian.com/film/filmblog/2007/jul/25/howdidraywinstonelose30y.

33  Richard Dyer, *White: Essays on Race and Culture* (Oxford: Routledge, 1997), 155. This, as he says, differs from the tendency to ascribe the superior physicality of black individuals (at running, basketball, dancing, etc.) to "natural" or innate cultural qualities, rather than moral factors such as discipline or hard work.

34  Macnab, "How Did Ray Winstone Lose 30 Years and 70 Pounds?"

35  Grant Rollings, "Beowulf Ray Is Action Hero at 50," *The Sun*, November 16, 2007, http://www.thesun.ie/irishsol/homepage/showbiz/irishbizarre/470508/Ray-Winstone-Beowulf-Action-hero-at-50.html.

36  Kevin Maher, "Sex on (Digitally Enhanced) Legs," *The Times*, November 15, 2007, http://www.thetimes.co.uk/tto/arts/film/article2426589.ece.

37  Some things don't change. A letter from a black actress to the *New York Times* in 1968, headlined "How Black Do You Have to Be?" complained that she was being passed over for black roles because she was not deemed "black enough." The reason, she claimed, was because the definition of blackness, previously defined in many states by ancestry (but which, as historians of passing note, could be bypassed by looking sufficiently white), was in the wake of the civil rights movement and the rise of identity politics being determined by looks. This, she said, made being black an "exclusive country club to which you only belong if your skin is black, your features generous, your hair worn Afro" (September 15, 1968, D1).

38  In 1973, Quinn, citing his record of playing across races and ethnicities, wanted very much to darken his skin to play the eighteenth-century Haitian revolutionary Henry Christophe, in a film adaptation of John Vandercook's book *Black Majesty*. According to his agent, Richard McFadden, Quinn did not see himself as "white" and believed that if he could "be made to look like Christophe" he could "feel the part." The plans for the film were eventually shelved, perhaps due to the substantial protests against it by African American journalists and organizations. See for instance Emily F. Gibson, "Yes! The Black King Must Be Black," *Los Angeles Sentinel*, September 6, 1973, A7.

39  Gunning, "Foreword," xii.

40  Fuller, *Hollywood Goes Oriental*, 27.

41  Alison Griffiths, "Playing at Being Indian," *Journal of Popular Film and Television* (2001): 107.

42  "Indian Pete's Gratitude," *Moving Picture World*, December 10, 1910, 1359.

43  Henry, "Notes from New England," *Moving Picture World*, December 10, 1910, 1362.

44  *Amos 'n' Andy* spawned a very popular blackface movie, *Check and Doublecheck* (1930).

45  A. Wellington Clarke, "If Amos and Andy Were Negroes: What Negroes in Various Walks of Life Think of the Boys," *Radio Digest*, August 1930, 10.

46  Ibid.

47  This also indicates perhaps why the television adaptation of *Amos 'n' Andy*

(1951–1953) was the target of a successful sponsor boycott by black communities, while the radio show was allowed to remain on the air. The television show recast all the roles with black performers, conforming to the template of blackness defined originally by white minstrels. Without the casting distance, the caricature seemed more troublingly naturalized.

48  "Negroes Made Up for Screen as Carefully as White Players," *Philadelphia Tribune*, March 27, 1930, 6.

49  Stephen Johnson, ed. *Burnt Cork: Traditions and Legacies of Blackface Minstrelsy* (Amherst: University of Massachusetts Press, 2012).

50  Fuller, *Hollywood Goes Oriental*, 234.

51  Megan Gibson, "Ridley Scott Explains Why He Cast White Actors in *Exodus: Gods and Kings*," *Time*, November 27, 2014, http://time.com/3608724/ridley-scott-white-actors-exodus-gods-and-kings/.

52  Jessica Chasmar, "'Noah' Screenwriter Defends White Casting, Says Race Doesn't Matter in a Mythical Story," *Washington Times*, April 16, 2014, http://www.washingtontimes.com/news/2014/apr/16/noah-screenwriter-defends-all-white-cast-race-does/.

53  Richard Corliss, "The Wachowskis' Cloud Atlas at Toronto: Unique and Earthbound," *Time*, September 10, 2012, http://entertainment.time.com/2012/09/10/the-wachowskis-cloud-atlas-at-toronto-unique-and-earthbound/.

54  Richard Lawson, "The Huge Ridiculous World of 'Cloud Atlas,'" *Atlantic Wire*, October 24, 2012; Violet Lucca, *Cloud Atlas*: Review, *Film Comment* (November/December 2012).

55  This is despite the fact that he is playing a Korean man, and despite the fact that in his earlier 1850s incarnation he was first saved by a black slave, and this is how his beliefs about equality evolve. For more on the "white savior" as a problematic cinematic trope, see Hernan Vera and Andrew Gordon, *Screen Saviours: Hollywood Fictions of Whiteness* (London: Rowman & Littlefield, 2003), and Matthew Hughey, *The White Savior Film: Content, Critics, and Consumption* (Philadelphia: Temple University Press, 2014).

56  Jordan Zackerin, "'Cloud Atlas' Slammed for Lack of Asian Actors, 'Yellow Face' Makeup by Advocacy Group," *Hollywood Reporter*, October 25, 2012.

57  Amy Nicholson, "Makeup Artists Talk Challenges of 'Cloud Atlas': Multiple Characters, Movie Stars Hanks and Berry, Yellowface and Political Correctness," November 1, 2012, http://www.indiewire.com/2012/11/makeup-artists-talk-challenges-of-cloud-atlas-multiple-characters-movie-stars-hanks-berry-yellowface-political-correctness-240102/.

58  Allison, "Blackface, Happy Feet," 115.

59  Alice Maurice, *The Cinema and Its Shadow: Race and Technology in Early Cinema* (Minneapolis: University of Minnesota Press, 2013), 212.

60  Kelley L. Carter, "Why Lupita Nyong'o Didn't Want to Be Seen in 'Star Wars,'" *Buzzfeed*, December 14, 2015, https://www.buzzfeed.com/kelleylcarter/lupita-nyongo-didnt-want-you-to-see-her-face-in-star-wars?utm_term=.hpjvwkEDrp#.cv9v9BW31L.

61  Andre Seewood, "Hyper-tokenism II: Othering the Black Female Body in 'Star Wars: The Force Awakens," *Shadow & Act*, January 6, 2016, http://www.indiewire.com/2016/01/hyper-tokenism-ii-othering-the-black-female-body-in-star-wars-the-force-awakens-162223/.

62  Carter, "Why Lupia Nyong'o."
63  James Naremore, "Film Acting and the Arts of Imitation," *Film Quarterly* 65.4 (2012).
64  Dennis Bingham, "Living Stories: Performance in the Contemporary Biopic," in *Genre and Performance: Film and Television*, ed. Christine Cornea (Manchester: Manchester University Press, 2010), 77.
65  Naremore, "Film Acting and the Arts of Imitation."
66  Multiple casting—that is, instances in a single film (as opposed to across a franchise like James Bond) where one character is played by two or more performers—is not that uncommon if we consider how often in biopics a child actor will play the character in flashback or early life scenes. However, Haynes's explicit play with identity as multiple and fluid rather than singular and static has more in common with *Palindromes* (2004), directed by independent screenwriter and director Todd Solondz, in which a thirteen-year-old girl, Aviva, is played by eight actors of different ages, races, and genders.

## Chapter 4  Double Trouble

1  Stephen Prince, *Digital Visual Effects in Cinema: The Seduction of Reality* (New Brunswick, NJ: Rutgers University Press, 2012), 140–142.
2  Bill Desowitz, "Going Backstage for 'Black Swan,'" *Animation World Network*, December 6, 2010, http://www.awn.com/vfxworld/going-backstage-black-swan.
3  Matt Singer, "The 'Black Swan' Dancing Controversy Makes No Sense," *IFC*, March 29, 2011, http://www.ifc.com/2011/03/the-natalie-portman-black-swan.
4  Murray Pomerance, *Moment of Action: Riddles of Cinematic Performance* (New Brunswick, NJ: Rutgers University Press, 2016), 49, 51.
5  Adrienne L. McLean, *Dying Swans and Mad Men: Ballet, The Body, and Narrative Cinema* (New Brunswick, NJ: Rutgers University Press, 2008), 232.
6  See for instance Lisa Mullen, "Black Swan," *Sight and Sound* (February 2011): 49–50; Kirk Honeycutt, "Black Swan," *Hollywood Reporter*, September 1, 2010, 9.
7  See for instance, Adam Markovitz, "Natalie's Dark Victory," *Entertainment Weekly*, January 7, 2011, 32–36; *Black Swan* Blu-ray region 4 extras "in character with Natalie Portman."
8  However, as Adrienne L. McLean has pointed out, the common view of what a ballet dancer's body should look like comes not from the diverse reality of dancer's bodies, but from countless movies about ballet dancers who are invariably thin, white, and female.
9  Murray Pomerance, *The Eyes Have It: Cinema and the Reality Effect* (New Brunswick, NJ: Rutgers University Press, 2013), 42.
10  Adrienne L. McLean, "If Only They Had Meant to Make a Comedy: Laughing at Black Swan," in *The Last Laugh: Strange Humors of the Cinema*, ed. Murray Pomerance (Detroit: Wayne State University Press, 2013), 155–156.
11  Julie Bloom, "Those Undulating Swan Arms? Not So Easy to Do," *New York Times* (Dance), November 26, 2010, http://www.nytimes.com/2010/11/28/arts/dance/28balletfilm.html?_r=0.
12  Lane's credit was the ambiguous title "Lady in the Lane" rather

than "dance double." Christopher John Farley, "How Much Danc-
ing Did Natalie Portman Really Do in 'Black Swan'?" *Wall Street Jour-
nal*, March 25, 2011, http://blogs.wsj.com/speakeasy/2011/03/25/
how-much-dancing-did-natalie-portman-really-do-in-black-swan/.

13 Ibid.

14 Perron complained that "many people believe that Natalie Portman did her
own dancing in Black Swan. I think there has been a propaganda of omis-
sions in the media that has reinforced that belief." Carrie Seidman, "Who Did
the Dancing in 'Black Swan,'" http://ticket.heraldtribune.com/2011/03/29/
who-did-the-dancing-in-black-swan-dance-magazine-editor-weighs-in/.

15 Christian Metz, "Trucage and the Film," trans. Françoise Meltzer, *Critical Inquiry*
3.4 (Summer 1977): 664–665.

16 Sylvia J. Martin, "Stunt Workers and Spectacle," in *Film and Risk*, ed. Mette Hjort
(Detroit: Wayne State University Press, 2012), 100, 109.

17 Jacob Smith, *The Thrill Makers: Celebrity, Masculinity, and Stunt Performance*
(Berkeley: University of California Press, 2012), 74–75.

18 According to Gene Scott Freese, *The Master GunFighter* (1975) was the first film
to credit stunts as opposed to just naming the stunt coordinator. *Hollywood Stunt
Performers, 1910s–1970s: A Biographical Dictionary*, 2nd ed. (Jefferson, NC: McFar-
land, 2014), 5. The 2011–2014 SAG-AFTRA Stunt & Safety Digest decrees that all
performers must receive a credit in a theatrical cast of fifty or less. In films with a
cast of more than fifty, only the first fifty must be listed, the listing of the rest being
at the producer's discretion, and stunt performers do not need to be identified by
role.

19 Kevin P. Sullivan, "How Ryan Gosling Became a Stunt Bike Badass for
'Pines,'" *MTV News*, March 28, 2013, http://www.mtv.com/news/1704551/
ryan-gosling-place-beyond-the-pines-stunts/.

20 Arthur Wise and Derek Ware, *Stunting in the Cinema* (London: Constable, 1973),
222.

21 Ann Chisholm, "Missing Persons and Bodies of Evidence," *Camera Obscura* 15.1
(2000).

22 Smith, *The Thrill Makers*, 174.

23 "How the Cinematographer Works and Some of His Difficulties," *Moving Picture
World*, May 18, 1907, 166.

24 Neil Harris, *Humbug: The Art of P. T. Barnum* (1973; Chicago: University of Chi-
cago Press, 1981), 77.

25 Jennifer M. Bean, "Technologies of Early Stardom and the Extraordinary Body,"
*Camera Obscura* 16.3 (2001): 12.

26 "Recent Films Reviewed," *The Nickelodeon*, December 1, 1910, 306.

27 "Keystone Notes," *The Photoplayers Weekly*, May 14, 1915, 15; *Film Daily*, June 11,
1922, 7.

28 "Real Airship Smash-up," *Motion Picture News* (January 1914): 50.

29 "In the San Gabriel Canyon," *Universal Weekly*, October 31, 1914, 5.

30 *The Photoplayers Weekly*, January 16, 1915, 4.

31 "Movie-Picture 'Mysteries,'" *Pictures and the Picturegoer*, July 3, 1915, 255.

32 Emma-Lindsay Squier, "Nix on the Double!," *Film Fun* (February 1919): 22, 28.

33 Fannie Hurst, "The Young Hercules," *Brooklyn Daily Eagle*, November 29, 1925, 70.

34 L. E. Eubanks, "The Actor's Job," *Motion Picture Magazine* (October 1918): 66, 124.

35  Ibid., 66.

36  Vsevolod Pudovkin, *Film Technique* and *Film Acting*, in *The Cinema Writings of V. I. Pudovkin*, trans. and ed. Ivor Montague (London: Vision, 1954), 25.

37  Quoted in Bean, "Technologies of Early Stardom," 23.

38  Becky Freeth, "Is This the Most Daring Stunt EVER by a Movie Star?" *Daily Mail*, November 3, 2014, http://www.dailymail.co.uk/tvshowbiz/article-2817955/Tom-Cruise-performs-dangerous-stunt-5–000ft-hangs-horizontal-outside-moving-plane.html.

39  And *Black Swan* of course reminds us that publicity comes out of the traditions of ballyhoo and propaganda.

40  It is perhaps telling that the visual effects industry journal *Cinefex* took the unprecedented step of publishing Jody Duncan's article on the visual effects in *Mission: Impossible—Rogue Nation*, without any accompanying images. A statement prefaced the article, explaining that *Cinefex* always uses images submitted by the visual effects companies involved in a film's production. In the case of *Rogue Nation*, the releasing studio, Paramount, refused to approve the majority of the images, instead insisting that stock press-kit images be used "including non-effects movie-star shots, artfully faked still composites, and a few digitally falsified 'behind the scenes' photos." *Cinefex* stated they decided to publish the article without images "rather than insult our readership by illustrating the article with patently dishonest photography." See Jody Duncan, "Keeping It Real *Mission: Impossible—Rogue Nation*," *Cinefex* 143 (October 2015): 97.

41  Dan Reilly, "Meet Heidi Moneymaker, The Stuntwoman Who Helps Scarlett Johansson Kick Ass," *Maxim*, October 10, 2014, http://www.maxim.com/entertainment/meet-heidi-moneymaker-stuntwoman-who-helps-scarlett-johansson-kick-ass.

42  And of course the other professionals who make this performing action machine happen—the production crew, the editors, the digital clean-up artists, etc.—these are not mentioned.

43  H.B.K. Willis, "The Wages of Realism," *Screenland* (May 1923): 37.

44  "Double Trouble," *Los Angeles Times*, August 1, 1927, A4.

45  Frank R. Adams, "Something Just as Good," *Los Angeles Times*, May 6, 1928, L16.

46  "Does the Camera Lie?" *Photoplay* (September 1923): 30–31, 119.

47  Katherine Spring, "'To Sustain Illusion Is All That Is Necessary': The Authenticity of Song Performance in Early American Sound Cinema," *Film History: An International Journal* 23.3 (2011): 292.

48  Marquis Busby, "Film Based on Melody Appealing," *Los Angeles Times*, March 2, 1929, 7. Barthelmess himself was seen to complain a year later in *Picture Play* that he had nothing to do with the advertising. At the same time, he confessed bewilderment as to why audiences were fine with stunt doubles but not voice doubles.

49  *Singin' in the Rain* fans will no doubt note the significance of the Cocoanut Grove: this is the club where Debbie Reynolds's character Kathy Selden works before she becomes Lina Lamont's voice double.

50  "Musicians Committee Declares Singing in 'Weary River' Faked," *Houston Post*, March 3, 1929, n.p.

51  Lilian Bamburg, *Film Acting as a Career* (London: Foulsham & Co., 1929), 118.

52  Ibid.

53 Dan Thomas, "Voice 'Double' Will Vanish Soon, Lubitsch Predicts," *Evening Independent*, September 24, 1929, 7.

54 Muriel Babcock, "Song Doubling Now in Discard," *Los Angeles Times*, July 14, 1929, B13.

55 "Information Please," *Picture Play* (December 1929): 102.

56 *Regional News Pictorial*, July 20, 1929, 14.

57 Babcock, "Song Doubling Now in Discard," B13.

58 Nelson B. Bell, "Who Is Singing for Whom," *Washington Post*, June 16, 1929, A2.

59 Mark Larkin, "The Truth about Voice Doubling," *Photoplay* (July 1929): 110.

60 Alice Tildesley, "The Road to Fame," *Motion Picture Magazine* (April 1926): 43.

61 Benjamin Winters, *Music, Performance, and the Realities of Film: Shared Concert Experiences in Screen Fiction* (London: Taylor and Francis, 2014), 47.

62 George Kouvaros, *Famous Faces Yet Not Themselves: The Misfits and Icons of Postwar America* (Minneapolis: University of Minnesota Press, 2010).

63 Ibid., 32, 34.

64 Kevin Esch, "'I Don't See Any Method at All': The Problem of Actorly Transformation," *Journal of Film and Video* 58 (Spring-Summer 2006): 95–107.

65 Ibid., 98–99.

66 Dan North, "Virtual Actors, Spectacle, and Special Effects: Kung Fu Meets 'All that CGI Bullshit,'" in *The Matrix Trilogy: Cyberpunk Reloaded*, ed. Stacey Gillis (London: Wallflower Press, 2005), 58.

67 Roach, *The Player's Passion*, 213.

68 Darren Aronofsky, "Production Notes," *Black Swan*, 3, Margaret Herrick Library, Academy of Motion Picture Arts and Sciences, Beverly Hills.

69 André Bazin, "The Virtues and Limitations of Montage," in *What Is Cinema?*, vol. 1, trans. Hugh Gray (Berkeley: University of California Press, 1967), 44. That said, as Mike D'Angelo points out, Travolta's dancefloor sequence in *Saturday Night Fever* (1977), although evidently "all Travolta," has fourteen cuts, which serve to enhance dynamism as well as provide onscreen female validation with inserts of admiring women looking on. "Saturday Night Fever's Most Iconic Scene Demonstrates the Power of Editing," *A.V. Club*, June 6, 2014, http://www.avclub.com/article/saturday-night-fevers-most-iconic-scene-demonstrat-205280. McLean also points out the use of jump cuts and special effects in *The Red Shoes* dancing.

70 John Belton, "Technology and Aesthetics of Film Sound," in *Film Sound: Theory and Practice, A Reader*, ed. Elizabeth Weis and John Belton (New York: Columbia University Press, 1985), 64.

## Chapter 5  Performing with Themselves

1 Bill Desowitz, "Winding Down with the Penultimate 'Potter,'" *Animation World Network*, November 23, 2010, http://www.awn.com/vfxworld/winding-down-penultimate-potter.

2 James Naremore, "Film Acting and the Arts of Imitation," *Film Quarterly* 65.4 (Summer 2012): 34, 42.

3 Lucy Fischer, "Two-Faced Women: The 'Double' in Women's Melodrama of the 1940s," *Cinema Journal* 23.1 (Autumn 1983): 24–43; Mary Ann Doane, *The Desire*

*to Desire: The Woman's Film of the 1940s* (Bloomington: Indiana University Press, 1987).

4 My thanks to Adrienne L. McLean for reminding me of the instance of split-screen doubling in *Un Chien Andalou.*

5 "The Shadow Stage," *Photoplay* (August 1920): 92.

6 For a fascinating discussion of the "versatility" function of the double role for Hindi film stars in Bollywood cinema, see Neepa Majumdar, "Doubling, Stardom, and Melodrama in Indian Cinema: The 'Impossible' Double Role of Nargis," *Post Script* 22.3 (2003): 89–103.

7 Eileen Bowser, *The Transformation of Cinema, 1907–1915* (Berkeley: University of California Press, 1994), 245.

8 Ibid.

9 Tom Gunning, "'Now You See It, Now You Don't': The Temporality of the Cinema of Attractions," in *The Silent Cinema Reader*, ed. Lee Grieveson and Peter Kramer (Oxford: Routledge, 2004); André Gaudreault, *Film and Attraction from Kinematography to Cinema*, trans. Timothy Barnard (Urbana: University of Illinois Press, 2008).

10 Richard deCordova, *Picture Personalities: The Emergence of the Star System in America* (1990; Urbana: University of Illinois Press, 2001), 46.

11 Jay David Bolter and Richard Grusin, *Remediation: Understanding New Media* (Cambridge, MA: MIT Press, 1999).

12 J. B. Esenwein and A. Leeds, *Writing the Photoplay: The Revised Edition* (Springfield, MA: Home Correspondence School, 1913, 1919), 99.

13 "King Baggott Famous Imp Star as Both 'The Corsican Brothers,'" *Daily Alaskan Dispatch*, May 27, 1915, 60.

14 "Marguerite Clark Empire Feature in *Prince and the Pauper*," *Montgomery Advertiser*, June 25, 1916, 24.

15 Richard Fotheringham, "Theorising the Individual Body on Stage and Screen; or The Jizz of Martin Guerre," *Journal of Dramatic Theory and Criticism* (Spring 2001): 23.

16 "'Always Audacious' Has Twice as Much of Wallace Reid as the Author Had Intended," *New York Tribune*, November 7, 1920, B4.

17 "'A Blind Bargain' Shows Advantage of Screen over Stage," *New York Tribune*, December 3, 1922, D2.

18 Jennifer M. Bean, "Technologies of Early Stardom and the Extraordinary Body," *Camera Obscura* 16.3 (2001): 15.

19 Wid Gunning, "Hinton's Double," *Wid's Independent Review of Feature Films*, April 26, 1917.

20 Pamela Robertson Wojcik, "Typecasting," in *Movie Acting: The Film Reader*, ed. Pamela Robertson Wojcik (London: Routledge, 2004), 178–179.

21 Fotheringham, "Theorising the Individual Body on Stage and Screen," 21.

22 Ibid.

23 "Hinton's Double," *Variety*, April 20, 1917, 24.

24 J. McQuade, "Identical Identities," *Moving Picture World* (February 1913): 763.

25 "Amusements," *Miami Herald*, March 17, 1917, 27.

26 "Bessie Barriscale at Colonial Today," *Greenville Morning Herald*, May 27, 1917, 22; "Same Girl in Two Roles at Same Time," *Evening News*, May 30, 1917, 3.

27 Louis Reeves Harrison, "The Man from Outside," *Moving Picture World* (March 1913): 976.

28 Esenwein and Leeds, *Writing the Photoplay*, 99.

29 Louis Reeves Harrison, "The Compact," *Moving Picture World* (January-February 1912): 534.

30 "Always Audacious," 6; "Kisses Herself on the Screen!," *Montgomery Advertiser*, October 3, 1916, 7; "Hits at Self in Film," *Miami Herald*, September 13, 1919, 3.

31 "Weird: 'Crosses the Line,'" *Los Angeles Times*, July 15, 1917, 5.

32 Esenwein and Leeds, *Writing the Photoplay*, 99.

33 Edwin Schallert, "Magic Shadows of Mystery," *Picture Play Magazine* (March 1923): 17.

34 "Magic of Double Exposure Explained by Camera Men," *New York Times*, November 15, 1925, 5.

35 Quoted by Kay Armitage, *The Girl from God's Country: Nell Shipman and the Silent Cinema* (Toronto: University of Toronto Press, 2003).

36 Marguerite Clark, "Co-Starring with Myself," *Miami Herald*, September 12, 1915, 14.

37 Ibid.

38 "Girl in the Checkered Coat," *Prahran Telegraph*, October 19, 1918, 8.

39 Ibid.

40 Joseph R. Roach, *The Player's Passion Studies in the Science of Acting* (Ann Arbor: University of Michigan Press, 1993), 167.

41 Jeremy G. Butler, ed., *Star Texts: Image and Performance in Film and Television* (Detroit: Wayne State University Press, 1991), 51.

42 Schallert, "Magic Shadows of Mystery," 17.

43 Richard Coe, "A Stolen Life," *Washington Post*, June 15 1939, 6.

44 Frank S. Nugent, "The Screen in Review: Elizabeth Bergner Plays a Dual Role in 'Stolen Life' at the Rivoli," *New York Times*, June 15, 1939, 31.

45 Coe, "A Stolen Life," 6; Nugent "The Screen in Review," 31.

46 "Studios Returning to the Star System," *Film Daily*, February 17, 1931, 4.

47 Bosley Crowther, "The Screen: 'Deception' Warner Film with Bette Davis and Claude Rains, at Hollywood—'Dark Mirror' New Mystery, at the Criterion," *New York Times*, October 19, 1946, 25.

48 Bosley Crowther, "For Better and for Worse," *New York Times*, May 5, 1946, X.

49 Murray Pomerance, *The Eyes Have It: Cinema and the Reality Effect* (New Brunswick, NJ: Rutgers University Press, 2012), 108–122.

50 John Rosenfield, "Screen in Review," *Dallas Morning News*, November 16, 1950, pt. 2, p. 8.

51 Bette Davis, *The Lonely Life* (New York: G. P. Putnam's Sons, 1962), 141.

52 Nelson B. Bell, "The Psychiatric Cycle Reaches Top of Spin in 'Dark Mirror' Puzzler," *Washington Post*, November 22, 1946, 13.

53 "Spontaneity in Acting," *New York Times*, April 27, 1924, 5.

54 Ibid.

55 Constantin Stanislavsky, *An Actor Prepares*, trans. Elizabeth Reynolds Hapgood (New York: Routledge, 1948/1989), 24.

56 Butler, *Star Texts*, 42.

57 Sharon Marie Carnicke, "Lee Strasberg's Paradox of the Actor," in *Screen Acting*, ed. Alan Lovell and Peter Kramer (London: Routledge, 1999), 75.

58  Lee Strasberg, *A Dream of Passion: The Development of the Method* (New York: Plume, 1987), 44, 45.

59  N. Floyd, "Gynaecology, Symbiosis and Foetal Pigs: David Cronenberg Interviewed," *Shock Xpress* 5 (Winter 1988/89): 12–15.

60  Rita Kempley, "Dead Ringers," *Washington Post*, September 23, 1988, http://www.washingtonpost.com/wp-srv/style/longterm/movies/videos/deadringersrkempley_aoc9ec.htm.

61  Roger Ebert, "Dead Ringers," *Chicago Sun-Times*, September 23, 1988, http://www.rogerebert.com/reviews/dead-ringers-1988.

62  One notable exception to the charge of "surface illustrations" in clone narratives is the BBC America serial television drama *Orphan Black* (2013–), starring Tatiana Maslany in multiple roles as nine distinctive clones. To date, Maslany (with the performance assistance of her body double, Kathryn Alexandre, as Zoë Shacklock astutely points out) has delineated, deepened, and embellished her various clone characters over the extended narrative temporality of four seasons of television. This performance work has been met with critical acclaim, acting awards and nominations, and an emerging scholarly fascination. See Zoë Shacklock, "Two of a Kind: Revaluing the Work of Acting Doubles in *Orphan Black*," *Journal of Film and Video* 68.3–4 (Fall/Winter 2016): 69–82; Staci Stutsman, "The Unruly Clones: Tatiana Maslany's Melodramatic Masquerades in *Orphan Black*," *Journal of Film and Video* 68.3–4 (Fall/Winter 2016): 83–103.

63  M. Beck and S. J. Smith, "Keaton Needs to Clone Himself to Handle All This Work," *Los Angeles Daily News*, September 19, 1995, https://www.highbeam.com/doc/1P2-25018893.html.

64  Joe Morgenstern, "Multiplicity," *Wall Street Journal*, July 17, 1996, A10.

65  Janet Maslin "Doublemint Twins Times Two, Plus Chaos: Multiplicity," *New York Times*, July 17, 1996, C9.

66  K. McManus, "Multiple Murphys: All 'Nutty,'" *Washington Post*, June 28, 1996, 41.

67  Mary Ellen O'Brien, *Film Acting: The Techniques and History of Acting for the Camera* (New York: Arco, 1983), 152.

## Chapter 6  There Is No There There

1  McGregor is misremembering the film itself here, as the shot in question shows the planet's twin suns rather than its three moons, and his character arrives on a camel-like creature, not a lizard.

2  See Mark Sawicki, *Filming the Fantastic: A Guide to Visual Effects Cinematography* (Burlington, MA: Focal Press, 2007), 157–166.

3  None of this necessarily would matter if we were to read this film as one that flaunts its artifice like other storybook films, such as Baz Luhrmann's *The Great Gatsby* (2013) or Kerry Conran's *Sky Captain and the World of Tomorrow* (2004). After all, Lisa Purse points to "non-naturalistic" compositing in films like *Charlie's Angels: Full Throttle* and *Resident Evil: Afterlife* where there is a deliberate strategy to "separate out the spatiotemporalities of the different elements of the shot" for the purpose of parody or thematic expression. Purse, *Digital Imaging in Popular Cinema* (Edinburgh: Edinburgh University Press, 2013), 70–73. We might say the same

here. If we think of the prequels as a retelling of a mythic story ("a long time ago in a galaxy far far away") rather than reality unfolding in the moment of viewing, then its status as "mythic past" allows us to reframe the flatness of the performances and dialogue and painterly magnificence of setting as less aesthetic flaws than matters of authorial intent.

4 Stephen Prince, *Digital Visual Effects in Cinema: The Seduction of Reality* (New Brunswick, NJ: Rutgers University Press, 2012), 156.

5 Stein in *Everybody's Autobiography* (1937) was describing the experience of returning to the house where she grew up in Oakland to find that it no longer existed. The phrase has subsequently come into common use to describe suburbia, shopping malls, or places or things deemed to be without meaningful substance.

6 Jim Vejvoda, "Alice in Wonderland" (review), *IGN.com*, March 3, 2010, http://au.ign.com/articles/2010/03/04/alice-in-wonderland-review-2.

7 Julie A. Turnock, *Plastic Reality: Special Effects, Technology, and the Emergence of 1970s Blockbuster Aesthetics* (New York: Columbia University Press, 2015).

8 Aylish Wood, *Digital Encounters* (Oxford: Routledge, 2007), 48.

9 Mark J.P. Wolf, "The Technological Construction of Performance," *Convergence* 9.4 (December 2003): 52.

10 S. S. Wilson, *Puppets and People: Dimensional Animation Combined with Live Action in the Cinema* (San Diego: A. S. Barnes, 1980).

11 See, for instance, Kwan Min Lee, "Presence Explicated," *Communication Theory* 14.1 (February 2004): 27–50.

12 Ariel Rogers, *Cinematic Appeals: The Experience of New Movie Technologies* (New York: Columbia University Press), 9.

13 Ben Child, "Star Wars: Episode VII to Limit Cheap CGI Tricks and Keep It Real," *The Guardian*, July 29, 2013, https://www.theguardian.com/film/2013/jul/29/star-wars-episode-vii-cgi.

14 Jose Otero, "*Star Wars* Celebration: Why *Star Wars 7* Uses Practical Effects," *IGN.com*, April 16, 2015, http://au.ign.com/articles/2015/04/16/star-wars-celebration-why-star-wars-7-uses-practical-effects.

15 Julie Turnock, "The ILM Version: Recent Digital Effects and the Aesthetics of 1970s Cinematography," *Film History* 24.2 (2012): 162.

16 Michael O'Sullivan, "The Humans Play Second Bananas," *Washington Post*, August 5, 2011, W27, W31.

17 Barbara Robertson, "ILM VFX Supervisor Roger Guyett on Star Wars: The Force Awakens," *Studio Daily*, January 8, 2016, http://www.studiodaily.com/2016/01/ilm-vfx-supervisor-roger-guyett-on-star-wars-the-force-awakens/.

18 Joe Fordham, "Skywalker," *Cinefex* 143 (October 2015): 34.

19 Ian Failes, "Step-by-Step: A Walkthrough of *The Walk*," *FXguide*, October 11, 2015, https://www.fxguide.com/featured/step-by-step-a-walkthrough-of-the-walk/.

20 Vivian Sobchack, *The Address of the Eye: Phenomenology and Film Experience* (Princeton, NJ: Princeton University Press, 1992).

21 Murray Pomerance, *The Eyes Have It: Cinema and the Reality Effect* (New Brunswick, NJ: Rutgers University Press, 2013), 44.

22 For more on how movies and shifting kinds of knowledge about spaces have been imbricated in each other, particularly in representations of outer space, see Bob Rehak, "Shooting Stars: Chesley Bonestell and the Special Effects of Outer Space,"

in *Special Effects: New Histories, Theories, Contexts*, ed. Dan North, Bob Rehak, and Michael S. Duffy (London: BFI-Palgrave, 2015), 196–209.

23 Lisa Kennedy, "'Blue-Screen' Acting a Challenge, but Actor and Director Up to It," *Denver Post*, July 11, 2008, http://www.denverpost.com/2008/07/09/blue-screen-acting-a-challenge-but-actor-and-director-up-to-it/.

24 Devan Coggan, "Joseph Gordon-Levitt Walked a High Wire with the Real Philippe Petit for *The Walk*," *Entertainment Weekly*, September 27, 2015, http://www.ew.com/article/2015/09/27/joseph-gordon-levitt-the-walk-philippe-petit-nyff.

25 Ethan de Seife, "Ectoplasm and Oil: Methocel and the Aesthetics of Special Effects," in North, Rehak, and Duffy, *Special Effects*, 22.

26 Kim Masters, "How Leonardo DiCaprio's 'The Revenant' Shoot Became 'A Living Hell,'" *Hollywood Reporter*, July 22, 2015, http://www.hollywoodreporter.com/news/how-leonardo-dicaprios-revenant-shoot-810290.

27 Quoted in Lise-Lone Marker, *David Belasco: Naturalism in the American Theater* (Princeton, NJ: Princeton University Press, 1975), 172.

28 Ibid., 99.

29 Brian R. Jacobson, *Studios before the System* (New York: Columbia University Press, 2015), 22.

30 "Stanton Invents Method to Cut Production Cost in Half," *Moving Picture World*, July 24, 1920, 430.

31 For more on this process and how it worked, see Katharina Loew, "Magic Mirrors: The Schufftan Process," in *Special Effects: New Histories/Theories/Contexts*, 62–77.

32 "The Indian Raiders," *Moving Picture World* (1910): 479.

33 "A Masterpiece in Movies," *Kansas City Star*, July 7, 1914, 8.

34 "No Expense Spared for Realism," *Photoplayers Weekly* (May 1915).

35 David Bordwell, Janet Staiger, and Kristin Thompson, *Classical Hollywood Cinema: Film Style and Mode of Production to 1960* (London: Routledge, 1985).

36 Cyril Vandour, "None of This Is Real," *Modern Screen* (February 1935): 82.

37 James Reid, "We Cover the Studios," *Photoplay* (November 1936): 50.

38 Philip K. Scheur, "A Town Called Hollywood," *Los Angeles Times*, August 13, 1933, A1.

39 Laura Mulvey, "A Clumsy Sublime," *Film Quarterly* 60 (Spring 2007): 3.

40 Mack Stengler, "Camera Tricks That Build 'Production Value,'" *American Cinematographer* (August 1941): 380.

41 Ryan Lambie, "Hobbits, Greenscreen Acting, and 48fps," *Den of Geek*, December 18, 2013, http://www.denofgeek.com/movies/the-desolation-of-smaug/28640/luke-evans-on-the-hobbit-green-screen-acting-and-48fps.

42 Alan David Vertrees, *Selznick's Vision: Gone with the Wind and Hollywood Filmmaking* (Austin: University of Texas Press, 1997), 93.

43 Interestingly, Leigh was the only member of the principal cast who was present when the set was burning. According to David Hinton's 1988 documentary *Making of a Legend: Gone with the Wind*, she had not yet been cast, but she was brought to the set on the day of the burning to meet Selznick. We might wonder if Leigh's performance drew on her first-hand observation of the actual fire, and the intense heat it radiated.

44 Gilberto Perez, *The Material Ghost: Films and Their Medium* (Baltimore: Johns Hopkins University Press, 1998), 39. Of course we might think of plenty of films in which the setting is treated expressively as a character in its own right, or where

rooms, staircases, windows, and furniture are designed to frame the form and motion of actors in meaningful ways. However, the return to attentive detailed naturalism in sets and setting is associated with a realism of the mid-1960s and later.

45 "Does the Camera Lie?," *Photoplay* (September 1923): 119.

46 Bordwell, Staiger, and Thompson, *Classical Hollywood Cinema*, 54.

47 Cynthia Baron, "Crafting Film Performances: Acting in the Hollywood Studio Era," in *Movie Acting: The Film Reader*, ed. Pamela Robertson Wojcik (New York: Routledge, 2004), 90–91.

48 From "What Are the Sets Like?," an article in MGM's in-house publication *The Lion's Roar*, quoted in Charles Affron and Mirella Jona Affron, *Sets in Motion: Art Direction and Film Narrative* (New Brunswick, NJ: Rutgers University Press, 1995), 6.

49 Andrew Klevan, *Film Performance: From Achievement to Appreciation* (London: Wallflower Press, 2005), 11.

50 Charles Affron, *Star Acting: Gish, Garbo, Davis* (New York: Dutton, 1977), 178–182.

51 Lloyd A. Jones, "Address to AMPAS on Monochrome Sets and Incandescent Lighting," *AMPAS Newsletter*, 1928, 39.

52 "Riddle Me This," *American Cinematographer* (August 1934): 164.

53 Turnock, *Plastic Reality*, 3.

54 Bordwell, Staiger, and Thompson, *Classical Hollywood Cinema*, 349.

55 Thomas M. Pryor, "Manhattan Doubles as Movie Set," *New York Times*, May 11, 1947, X5.

56 Kenneth MacGowan, "A Change of Pattern," *Hollywood Quarterly* 1.2 (January 1946): 149.

57 Charles Champlin, "A Film That Will Never See a Sound Stage," *Los Angeles Times*, March 6, 1969, D1.

58 Walter Kerr, "Live Theater Loses When Spooks Get In," *Washington Post*, September 27, 1964, G3.

59 Kerr is writing these observations in the context of a larger piece warning against what he sees as the increased mechanization of the theater—with the use of microphones, recorded music, screens, and such—as diluting the aliveness and "presence" of the theater. For him, performance must be "genuinely and uninhibitedly 'there' or it is not living theater at all."

60 Gary Arnold, "'Trader Horn': A Half Baked, Faked Remake at Grade B Rates," *Washington Post*, July 7, 1973, B7.

61 David Sterritt, "Postwar Hollywood 1947–67," in *Acting*, ed. Claudia Springer and Julie Levinson (New Brunswick, NJ: Rutgers University Press, 2015), 75–76.

62 Virginia Wright Wexman, "Masculinity in Crisis: Method Acting in Hollywood," in Wojcik, *Movie Acting: The Film Reader*.

63 See Julie Levinson, "The Auteur Renaissance: 1968–1980," in Springer and Levinson, *Acting*.

64 Quoted in "Acting in the Digital Age," Symposium, Academy of Motion Pictures Arts and Sciences (AMPAS), Beverly Hills, CA, April 22, 2010, transcript available at Margaret Herrick Library, AMPAS, 54.

65 John Bigham to Ben Rock, "It's Not Easy Being Green," *Backstage*, April 7, 2011.

66 See Phillip B. Zarrilli, *Psychophysical Acting: An Intercultural Approach after Stanislavski* (New York: Routledge, 2009).

67  Rogers, *Cinematic Appeals*, 132–133.

68  Texture and tactility in CGI had in part gained their value because of earlier perspectives in the 1980s that the computer was best used to produce objects that were smooth, shiny, geometric, and plastic in appearance. See, for instance, Charles Solomon, "'Hard Woman': Soft Computer Graphics," *Los Angeles Times*, October 31, 1985, I1.

69  Thomas Elsaesser and Malte Hagener, *Film Theory: An Introduction through the Senses* (London: Routledge, 2009).

70  Michael Mallory, "Like Talking to a Wall," *Los Angeles Times*, May 6, 2001, http://articles.latimes.com/2001/may/06/entertainment/ca-59785.

71  Quoted in "Acting in the Digital Age," transcript, Margaret Herrick Library, 59–60. The objects built for the actors in this case were not like the visually detailed ones of *Oz the Great and Powerful*, but purely built for shape. This is similar to the scene in *Life of Pi* in which the protagonist is stroking the starving dehydrated tiger: instead of the tiger's head in his lap, the actor was stroking a blue cushion, roughly the size and shape of the tiger's head.

72  Jami Bernard, "Force Fails 'Phantom'/ Latest 'Star' Episode Has Great FX, Lifeless Human Characters," *New York Daily News*, May 18, 1999.

73  John Beck, "Lucas Unleashes Genius: Dialogue Suffers in Menace," *Press Democrat*, Santa Rosa CA, May 12, 1999, A1.

74  Simon Houpt, "Liam Neeson Only Looks Cuddly: The *Star Wars* Actor Does His Bit to Sell the New Film and Hates Every Moment of It," *Toronto Globe and Mail*, May 11, 1999, C1.

75  Sharon Marie Carnicke, "The Material Poetry of Acting, 'Objects of Attention,' Performance Style, and Gender in *The Shining* and *Eyes Wide Shut*," *Journal of Film and Video* 58 (Spring/Summer 2006): 26.

## Conclusion

1  Tom Gunning, "Moving Away from the Index: Cinema and the Impression of Reality," *Differences: A Journal of Feminist Cultural Studies* 18.1 (2007): 36.

2  Stephen Prince, *Digital Visual Effects: The Seduction of Reality* (New Brunswick, NJ: Rutgers University Press, 2013), 116.

3  Christian Metz, "'Trucage' and the Film," *Critical Inquiry* 3.4 (Summer 1977): 657–675.

4  Ian Failes, "Deep Inside *Deadpool*'s Deadliest Effects," *fxguide*, February 15, 2016 (online). LaSalle, billed as "facial performance artist" rather than "actor," performed in the MOVA system, similar to the one used to capture Brad Pitt's facial expressions for earlier scenes in *The Curious Case of Benjamin Button*, where he was playing the older faced/younger version of the character.

5  Kristen Whissel, *Spectacular Digital Effects: CGI and Contemporary Cinema* (Durham, NC: Duke University Press, 2014); Angela Ndalianis, "Baroque Facades: Jeff Bridges's Face and Tron Legacy," in *Special Effects: New Histories, Theories, Contexts*, ed. Dan North, Bob Rehak, and Michael S. Duffy (London: BFI-Palgrave, 2015), 154–165.

6 Jessica Aldred, "From Synthespian to Avatar: Reframing the Digital Human in *Final Fantasy* and *The Polar Express*," *Mediascape* (Winter 2011).

7 Barry King, "Articulating Digital Stardom," *Celebrity Studies* 2.3 (2011): 248.

8 Behind-the-scenes video at http://www.cartoonbrew.com/cgi/indias-first-3d-motion-capture-film-looks-like-an-epic-trainwreck-98720.html.

9 The meaning of a term like "authenticity" in relation to "performance" in Bollywood cinema is, it seems, rarely attached to the body of an individual performer. "Authenticity" is much more commonly used in relation to the particular linguistic, musical, or dance styles attached to different cultural traditions and ethnic groups. The maintenance of such forms of "intangible heritage" (thanks to my colleague, Tom O'Regan, for pointing me in the direction of this term) appears to be of greater importance than whether or not an individual actor's performance has been manipulated or augmented with special effects.

10 Neepa Majumdar, "The Embodied Voice: Song Sequences and Stardom in Popular Hindi Cinema," in *Soundtrack Available*, ed. Pamela Robertson Wojcik (Durham, NC: Duke University Press, 2001), 163.

11 "Rajini Sings for Rahman," *The Hindu*, March 16, 2012, http://www.thehindu.com/features/cinema/rajini-sings-for-rahman/article3000136.ece.

12 Leon Hunt, "'I Know Kung Fu!' The Martial Arts in the Age of Digital Reproduction," in *ScreenPlay Cinema/Videogames/Interfaces*, ed. Geoff King and Tanya Krzywinska (London: Wallflower, 2002), 195.

13 Leon Hunt, *Kung Fu Cult Masters: From Bruce Lee to Crouching Tiger* (London: Wallflower, 2003), 199.

14 Vivian Lee, "Virtual Bodies, Flying Objects: The Digital Imaginary in Contemporary Martial Arts Films," *Journal of Chinese Cinemas* 1.1 (2006): 12.

15 Ibid., 11–12.

16 Yomi Braester, "The Spectral Return of Cinema: Globalization and Cinephilia in Contemporary Chinese Film," *Cinema Journal* 55.1 (Fall 2015): 29–51.

17 Lee, "Virtual Bodies," 12.

18 Ibid., 14.

19 Lori Landay, "The Mirror of Performance: Kinaesthetics, Subjectivity, and the Body in Film, Television, and Virtual Worlds," *Cinema Journal* 51.3 (2012): 132–133.

20 Ibid., 134.

21 Scott Bukatman, "Why I Hate Superhero Movies," *Cinema Journal* 50.3 (Spring 2011): 120–121.

22 Ibid., 121.

23 Don Steinberg, http://blogs.wsj.com/speakeasy/2013/10/19/jackie-chan-on-chinese-zodiac-and-making-a-musical/.

# Index

Abbott, Stacey, 34

Abrams, J. J., 15, 159–160

acting: awards, 18, 48–49, 76, 148; and blurred line with animation, 4; codes of early cinema, 27; cognitive theories, 38, 152; crisis in conception of, 4; internal, 34–35, 38; material conditions of, 4–5, 26, 115, 135, 140, 164–165, 173–174; mechanistic approaches, 141–143, 147; as mental labor, 122; mimesis, 10, 57–58, 63, 106, 153; mimicry, 67, 85, 129–130, 147; organic approaches, 141, 147, 185; for performance capture, 21–22, 32–35, 38–41, 45–46; and psychology, 146, 149, 177; psychophysical approaches, 38, 159, 179; "in a vacuum," with greenscreen, 15, 150, 152, 161, 188. *See also* Method acting; multiple roles, played by one actor; performance, screen; proteanism

acting, discourse on: "acting as reacting" (Strasberg), 147–148, 150, 178, 182; early cinema, 10, 20, 36–37, 54, 133; evolutions in, 15–17, 121; expressive unity, 114–115, 119; with makeup, 52, 57–58; proteanism as "true acting" (Chekhov), 74, 94–95, 137; sincerity versus hypocrisy, 2–3, 37–38, 40; and stardom, 144–146; synthespians, 9–10; valorization of self-transformation, 106, 122–123. *See also* Method acting; proteanism

actors: and blackness, 82, 85, 92, 94–95, 209n37, 210n47; as conduits for belief and meaning, 12, 16, 157, 181–183; as creative laborers, 4, 9, 11–12, 21–22, 27; with disabilities, 76–77; as graphic elements, 157, 182–183; humanizing function, 5–6; idiolects (Naremore), 32–33, 41, 68; labor market, 5, 14, 71, 75, 79, 95, 136; as living bodies, 5, 8–9, 70–71, 111–113; Native American, 84; protean (*see* proteanism); as puppeteers for performance capture, 39–40, 186; as "puppets," 2, 38–40, 141; short-statured, 77–79; transgender, 77; as types, 70, 72–75, 82, 94; and whiteness, 71, 76, 79, 81–86, 90–95, 208n24, 210n55

ADR. *See* automatic dialogue replacement

Affron, Charles, 174

Affron, Mirella Jona, 174

Aita, Sean, 38, 74

Aldred, Jessica, 188

*Alice in Wonderland* (2010), 156

Allison, Tanine, 6, 71, 92

Alonso, Laz, 93

*American Beauty* (1999), 32

*Amos 'n' Andy* (radio sitcom), 85, 209n44

animation: and actors, 5, 192; and blurred line with acting, 4; digital, 8, 51; and digital compositing, 155; as dominant cinematic form, 8, 199n26; and expressive qualities of bodies, 6, 191; labor, 5–6, 48,

## About the Author

LISA BODE is a lecturer in Film and Television Studies at the University of Queensland, Brisbane, Australia. Her research and publications focus on screen acting, digital and special effects, posthumous stardom, and historical and critical reception. Bode has published articles in journals such as *Cinema Journal, Animation: An Interdisciplinary Journal, Celebrity Studies,* and *Screening the Past,* and is on the editorial board of *Celebrity Studies.* She has contributed chapters to *Special Effects: New Histories, Theories, Contexts* and *Lasting Screen Stars: Images That Fade, Icons That Endure.*